DRAWING FROM OBSERVATION

AN INTRODUCTION TO PERCEPTUAL DRAWING

Brian Curtis

University of Miami
Coral Gables, Florida

Higher Education

Boston Burr Ridge, IL Dubuque, IA New York San Francisco St. Louis
Bangkok Bogotá Caracas Kuala Lumpur Lisbon London Madrid Mexico City
Milan Montreal New Delhi Santiago Seoul Singapore Sydney Taipei Toronto

 Higher Education

Published by McGraw-Hill, an imprint of the McGraw-Hill Companies, Inc., 1221 Avenue of the Americas, New York, NY 10020. Copyright © 2009, 2002. All rights reserved. No part of this publication may be reproduced or distributed in any form or by any means, or stored in a database or retrieval system, without the prior written consent of the The McGraw-Hill Companies, Inc., including, but not limited to, in any network or other electronic storage or transmission, or broadcast for distance learning.

1 2 3 4 5 6 7 8 9 0 RRD/RRD 0 9 8

ISBN: 978-0-07-337918-0
MHID: 0-07-337918-2

Editor in Chief: *Michael Ryan*
Publisher: *Lisa Moore*
Executive Editor: *Lisa Pinto*
Developmental Editor: *Meredith Grant and Betty Chen*
Marketing Manager: *Pamela S. Cooper*
Senior Production Editor: *Carey Eisner*
Manuscript Editor: *Darlene Bledsoe*
Design Manager: *Allister Fein*
Manager, Photo Research: *Brian J. Pecko*
Lead Production Supervisor: *Randy Hurst*
Interior Design and Technical Illustrations: *Brian Curtis*
Composition: *11/13.2 Verdana by Thompson Type*
Printing: *60# Pub Matte, R. R. Donnelley & Sons*

Front cover: M.C. Escher's "Three Spheres II" © 2008 The M.C. Escher Company-Holland. All rights reserved. www.mcescher.com
Back cover: Courtesy the author

Library of Congress Cataloging-in-Publication Data

Curtis, Brian.
 Drawing from observation: an introduction to perceptual drawing / Brian Curtis.—2nd ed.
 p. cm.
 Includes bibliographical references and index.
 ISBN-13: 978-0-07-337918-0 (alk. paper)
 ISBN-10: 0-07-337918-2 (alk. paper)
 1. Drawing—Technique. 2. Space perception. 3. Realism in art. I. Title.
 NC730.c87 2009
 741.2–dc22

 2008049417

The Internet addresses listed in the text were accurate at the time of publication. The inclusion of a Web site does not indicate an endorsement by the authors or McGraw-Hill, and McGraw-Hill does not guarantee the accuracy of the information presented at these sites.

www.mhhe.com

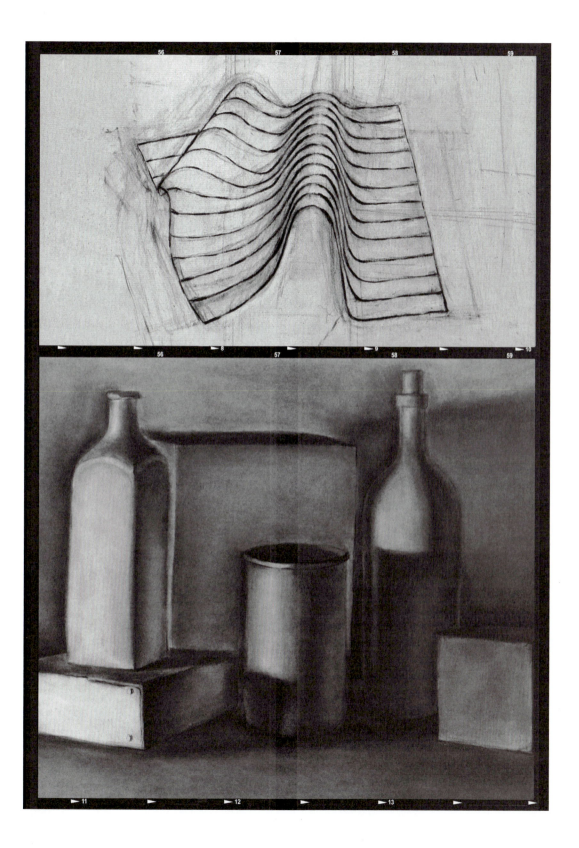

ACKNOWLEDGMENTS

My decision to build a perceptual drawing book around my students' class assignments grew out of the observation that the students in my introductory perceptual drawing courses consistently produced more focused and more sensitive drawings after being exposed to successful student projects from previous semesters. I attributed this positive change in their performance to two factors: the images presented to them depicted successful solutions to the problems they were being asked to address, thereby providing excellent visual guides that clarified the relevant issues of each lesson; and showing current students the accomplishments of former students generated a healthy sense of peer competition that substantially "raised the bar" in terms of what each student should expect to accomplish in his/her drawings. As a result, this book can best be understood as an annotated "slide show" that documents what beginning drawing students can accomplish when they focus intelligently on the task of learning to record their observations in a drawing.

STUDENT CONTRIBUTORS

STUDENT ART PROJECT CONTRIBUTORS

Nela Ahmed
Daphne Alvarado
Evelyn Alvarez
David Anesta
Marie Antoon
Sofia Auricchio
Michelle Barros
Matthew Bennett
Elizabeth Barenis
Remberth Bernal
Elizabeth Bodkin
George Booruji
Kip Brown
Dirk Brandon
Mariana Buigas
David Burch
Laura Burch
Denise Cabrera
Christian Cameron
Ressa Canton
Melissa Casey
Sidarth Chaturvedi

Brian Cichocki
Meredith Chin-Sang
Helen Cho
Alisa Cleary
Malinda Cleary
Allanah Coggins
Steve Cohen
April Compare
Eric Cram
Steve Cruz
Ada Davila
Diane DeGuglielmo
Allison DeMajistre
Farah Dosani
Rosemary Dunbar
Paul Eckloff
Michele Edelson
Sharief Eissa
Christina Eldridge
Salvatore Engel-DiMauro

Dori Shorr Faerman
Kelley Fennik
Elena Figueroa
Cynthia Fleischmann
David Flores
Christopher Fontes
Sandra Frost
Ameeta Ganju
Juan Garcia
Lisa Guo
Kristin Vaccaro Gilliland
Courtney Grant
Liz Greiwe
Daisy Guell
Gregory Gursky
Greg Hadsel
Donna Harris
Tara Hartman
Ray Hassan
Rebecca Henderson
Adriana Hernandez

ACKNOWLEDGMENTS

Bizi Hernandez
Cassandra Hock
Melissa Hock
Wendy Hofberg
Cindy Hogan
Suzanne Hue
Kathleen Hudspedth
Oriente DaVila Issa
Hongzhao Ji
Kam Kahn
Bruce Kassover
Stuart Kauffman
Robert King
Melissa Krizner
Susan Laessig
Gisselle Lafaurie
James Lau
Joe Lazaro
Marvin Lee
Johanna Leicht
Anne Craft Lemos
Maria Lemos
Rachel Lerner
Patti Jane Levinson
Jessica Levy
Jonathan Lipsom
Robert Lowery
Diana Lu
Mary Malm
Zaydee Martinez
Omar Masri
Hilda Mateo
David Matthews
Carol Maxfield
Margaret McGowan
Mia McGregor
Roger McMane
Louis Meunch

Angela Meyer
Heidi Miller
Mason Moody
Barbara Mooney
Matt Moore
Mark Mueller
Marina Mugious
David Munoz
Josh Neel
Marilia Nery
Scott Neubauer
Kyle Newton
Timmy Nguyen
Nhan Nguyen
Scott Nixon
Alison Northup
Stephen Palme
Megan Paniewski
Yvette Paroz
Carol Lewis Passaro
Danny Patel
Bethany Pelle
Anne Marie Perez
Brian Petit
William Pittack
David Portfiri
Beatriz Quintairos-
 Martinez
Humberto Ramirez
Brian Reedy
Julie Rega
Hiram Rodrigues
Jose Ruiz
Danica Rybicki
Rafeal Emerick
 Salas
Kelle Saltzbach
Nancy Sapanara

Mabel Sarduy-
 Estebanez
Reeve Schumacher
Lisa Schwal
Moises Serrano-
 Soto
Mohammed Shanti
Karen Shiers
Michella Silvestros
Dionne Skeete
Scott Smerczniac
Jaycee Smith
Tassey Sorin
Mark Sprader
Jenessa Sprague
Philip Spence
Tony Stover
Oneith Suba
Lisa Supek
Kyla Swart
Jacqueline Tai
Runcie Tatnal
Kristen Thiele
Antonio Torres
Ann Traverse
Lily Johnson-Ulrich
Frans VanDyck
Tina Vothang
Sean Wallace
Raymond Wheldon
Amy White
Michelle White
Gabriel Widi
Lesley Wheatley
Shuohan "Sherry" Wu
Jeffery Yee

STUDENT CONTRIBUTORS

IN APPRECIATION

A LITTLE HELP FROM MY FRIENDS

SPECIAL THANKS

I am grateful to Cynthia Ward, my sponsoring and developmental editor for the first edition, and Meredith Grant, developmental editor for the new chapter in this second edition, for their insight, understanding, and patience as they fine-tuned the words I used to convey the intuitive visual process that underlies observational drawing. They contributed to whatever clarity and cohesiveness can be found in the following pages.

I also thank my wife, Sue Kogan, for her loving support.

DEDICATION

This book was initially conceived as simply a "portable slide show" of successful student projects that would, by example, instruct, motivate, and inspire beginning students in perceptual drawing. Over time the book evolved into something considerably more complicated than what was initially planned, but I am satisfied knowing that it has, at the very least, recorded and showcased the enthusiasm, energy, intelligence, sensitivity, insight, patience, and accomplishments of a wonderful and diverse group of hard-working, self-disciplined students from my introductory classes in perceptual drawing at the University of Miami.

CELEBRATE!

PREFACE

I began this drawing text with the understanding that dozens of texts on the subject already exist. What this book has that the others do not is a focus on basic rendering skills and the spatial understanding needed for translating three-dimensional perceptions onto a two-dimensional surface.

Drawing from Observation builds upon the perceptual platform that was constructed in the fifteenth century by Brunelleschi, Alberti, Piero, and Leonardo. Although Modernist art movements of the last two hundred years have challenged the Renaissance notion of rational illusionistic space, there is tremendous value in learning to draw a "realistic" image from observation. Perceptual drawing offers the opportunity to develop insights into the very mechanisms of visual perception and is a versatile tool for visual problem-solving in every artistic discipline. And, in that it works well as a conceptual baseline against which to compare and contrast alternative aesthetic and conceptual approaches, it may even shed some light

on the possible motivations of those who have consciously chosen to make art without it. ***Drawing from Observation*** grew out of the belief that a thorough understanding of perceptual drawing is fundamental to artistic self-awareness.

As a practicing artist, I understand and vigorously defend the preeminence of freedom in an art-making environment. However, as a teacher of art, I have come to understand the parallel importance of discipline, visual sensitivity, patience, eye/hand coordination, a rigorous work ethic, and a solid conceptual base as the essential tools needed to take full advantage of one's freedom.

This book systematically shows students how to develop their ability to accurately render what they see. Numerous drawings and diagrams support the verbal explanations. Students who complete the entire text will have gained a solid foundation for more advanced work.

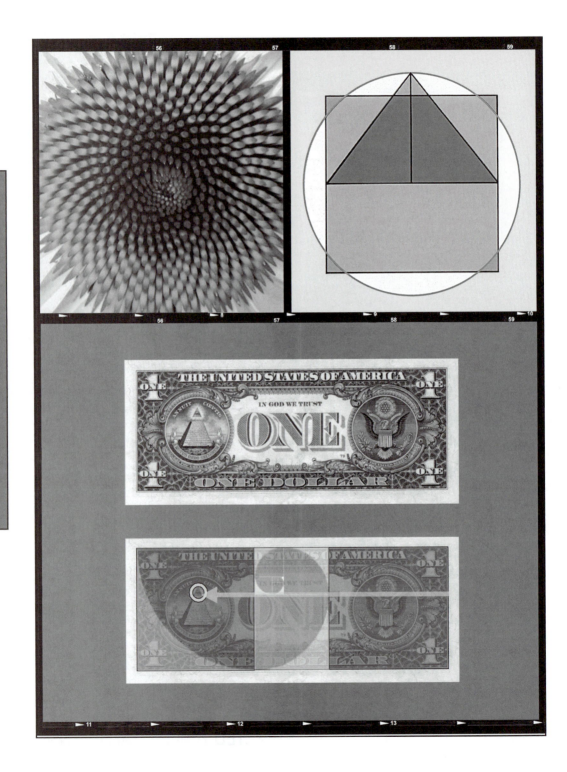

CONTENTS

CHAPTER 1 GETTING STARTED. 1

CHAPTER 2 MATERIALS 7

CHAPTER 3 DRAWING MECHANICS. . . . 15

CHAPTER 4 INTUITIVE GESTURE 29

CHAPTER 5 INTUITIVE PERSPECTIVE . . 45

CHAPTER 6 POSITIVE/NEGATIVE SHAPE 57

CHAPTER 7 THE PERCEPTUAL GRID . . . 61

CHAPTER 8 PROPORTION. 75

CHAPTER 9 THE "GOLDEN MEAN". 93

CHAPTER 10 CROSS-CONTOUR 115

CHAPTER 11 FORESHORTENED CIRCLES 139

CHAPTER 12 BIOMORPHIC FORM 173

CHAPTER 13 CHIAROSCURO 197

CHAPTER 14 HISTORICAL PERSPECTIVE 221

CHAPTER 15 LINEAR PERSPECTIVE part 1 235

CHAPTER 16 LINEAR PERSPECTIVE part 2 261

CHAPTER 17 COMPOSITION. 279

APPENDIX A DRAWING ASSIGNMENTS . 304

APPENDIX B MASTERWORKS LIST 317

SELECTED BIBLIOGRAPHY 319

INDEX 321

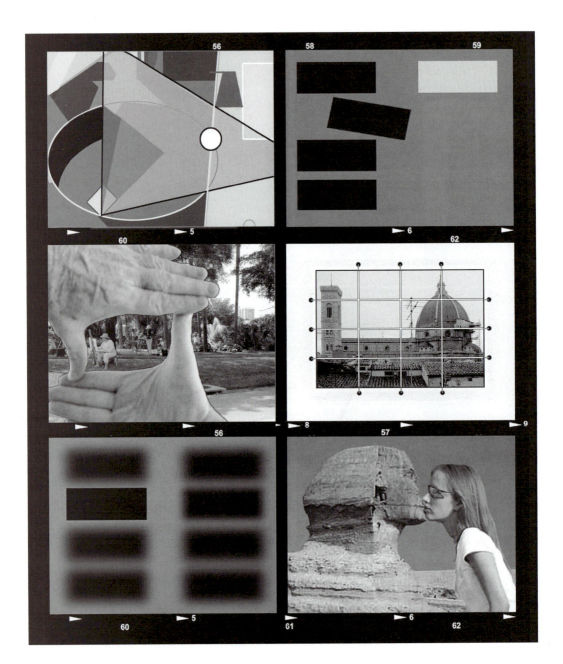

CHAPTER 1 GETTING STARTED

Heightened sensitivity. . . . 1
Purposeful awareness 2
Energized markmaking . . . 3
Visualization. 4
Kinesthetic sensitivity 5
Physical sensations 6

"A journey of a thousand miles begins with a single step."
Chinese proverb

Sensitivity to the touch of the drawing tool to the drawing surface and the ability to discriminate subtle changes in the marks as the tool is "drawn" over the surface are the most important components of the drawing process. These are very basic sensitivities but ones that, because of the refinement and energy they require, are both sophisticated and challenging. It is challenging to invest extraordinary concentration in an activity that is generally perceived as utilitarian. Focusing attention on something as routine as using a hand-held tool to make marks on paper requires that you temporarily detach yourself from the distractions of your overstimulating environment and devote your attention to the simple experience of direct sensory awareness. Drawing demands an active and purposeful participation like that which is alluded to in the timeless Roman admonition **carpe diem** (seize the day). This phrase is a concise exhortation to actively explore, experience, and embrace each unfolding moment. Such focused concentration on immediate experience lies at the

HEIGHTENED SENSITIVITY

1

<div style="float:left"></div>

very heart of the drawing process. It also alludes to parallels between the act of drawing and the life-affirming tenets of Zen philosophy. Both Zen and drawing are all about fresh and direct seeing. They also share in the understanding that beauty and wonder are accessible through simple and routine activities, if and when you care for and identify with what it is that you are doing. Drawing, like Zen, is active, engaged, and purposeful awareness.

Drawing relies on heightened sensitivity toward tactile and visual experience in ways that are simple and routine. It is important that you understand from the outset that the effectiveness of a drawing is, first and foremost, determined by the richness and variety of the marks from which it is made. Awareness of, sensitivity to, and control over the mark-making characteristics of the drawing tool and the surface texture of the paper are what determine the vitality of a drawing. The amount of visual interest generated by a drawing depends primarily on the energy, clarity, variation, rhythm, and immediacy of its constituent marks. Marks first make meaning by preserving, documenting, and communicating the sensory experience of the act of drawing itself. The very first level of content in a drawing is always in the marks themselves.

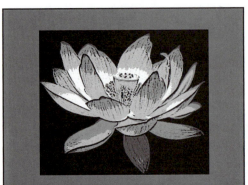

THE FLOWER SERMON

The story goes that Siddartha Gautama, alias the Buddha, decided to use a prop, a Zen tool, for one of his sermons. Having gone up on a hillside to preach, he silently held up a lotus flower. Everyone in the crowd below awaited his words. Everyone, that is, except one person, Kashyapa. Kashyapa smiled. He had caught on to something. Gautama walked down to the smiling Kashyapa, handed him the flower, and conferred upon him the honor, the power, and the task of being the first Zen patriarch.

Guidebook to Zen and the Art of Motorcycle Maintenance, by Ron Di Santo and Tom Steele

"*Beauty is the expression of the rapture of being alive.*"
Joseph Campbell

"Art without life is a poor affair."
Henry James

1.1 Oscilloscopes, medical devices that monitor vital signs of patients, mirror the fluctuating energy and irregular patterns found in biological life. In a drawing, fluctuations in line quality can incorporate much of that same feeling of energy and vitality.

"The overall effectiveness of a drawing is, first and foremost, determined by the quality, variety, and sensitivity of the marks from which it is made."

Sensitivity to sensory stimulation is an excellent first test to determine whether an organism is vital or necrotic (lifeless). Healthy cells react to stimulation; necrotic cells do not. Your quotient of being alive, then, is in large measure proportional to your **receptivity** and **responsiveness** to sensory stimulation. These two indicators of vitality serve to reflect the fullness with which you experience life. They are also essential elements in our current drawing investigation. Line variation is capable of mimicking the fluctuating energy found in biological life. Like the constantly changing "blips" on an oscilloscope that is monitoring the vital signs of a patient (**Fig. 1.1**), a line that switches from thick to thin, light to dark, angular to flowing, rough edges to smooth provides a perceptual spark that energizes a sensitively rendered drawing. The physical energy that produces a drawing is recorded and crystallized within the marks of the drawing. Once completed, the marks become vehicles through which the responsive viewer reconstitutes a real time experience of the movement, energy, rhythm, character, and "feel" of the original drawing experience.

The previous references to sensations of movement, energy, and rhythm that can be found in a drawing are more than metaphorical.

ENERGIZED MARKMAKING

3

CHAPTER 1: GETTING STARTED

Visual stimulation, whether real or imagined, can affect both the **psyche** (mind) and **soma** (body). Indian fakirs (ascetic Hindu monks known for their extraordinary mental and physical discipline) (**Fig. 1.2**) are able, through intense visual imaging, to cause fluctuations in specific body functions that Western science had long held to be beyond the control of the conscious mind. In one particular demonstration, a monk raised the skin temperature of one hand while lowering it in the other by means of concentrated visualization. He imagined that he was holding fire and ice, respectively, and was so effective in his imagining that his body responded accordingly. While fakirs use extraordinarily disciplined visualization techniques to achieve this remarkable control over what are otherwise considered "involuntary" functions, we can all relate to this experience. Tears, chills, sweaty palms, goose bumps, a warm flush, stomachache, heartache, a pounding heart, physical disorientation, or a sense of general well-being are common responses to internalized imagery. Our ability to respond to visual stimulation with noticeable physical reactions in our muscles, tendons, joints, and organs is, in fact, at the very core of aesthetic sensitivity. Internalized images generate body sensations that can be

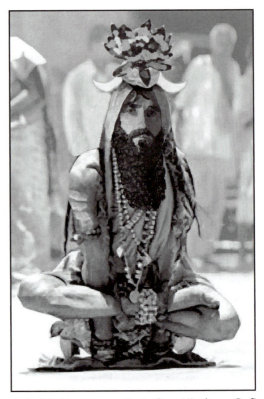

1.2 A fakir, an ascetic Indian Hindu or Sufi holy man, is an initiate of a strict spiritual brotherhood that lives on charity and follows an extensive regimen that traditionally includes physical meditation in the form of seclusion, sleep deprivation, and fasting. The word *fakir* derives from the Arabic word for poverty. Unfortunately, the term is also often applied to wandering Indian magicians who claim supernatural powers as they engage in illusionistic stunts like the Indian rope trick (climbing a rope that rises unsupported from the ground) and levitation that is more theatrical than spiritual.

1.3 Line variation (changes in thickness, darkness, and direction) is capable of producing very real physical sensations in the observer. The human eye is drawn to smoothly flowing lines that exhibit variation in thickness, range of value intensity, and direction of movement. The more the lines change, the more intriguing they become. When that same variety of line is skillfully applied to a representational image, the pure joy of the optical experience is enhanced by the thrill of object recognition.

kin ◆ es ◆ the ◆ sia n.
1. the perception of body position and movement and muscular tensions etc.

"Intelligence, aside from the native faculty, is largely a function of independence, courage, and aliveness."

Erich Fromm

discussed in both physiological (kinesthesia) and psychological terms. These sensations can be as intense as feeling your heart race as you recall a near-miss on the highway or as subtle as experiencing the flow and movement of a charcoal line as it moves across the drawing surface.

Line, possibly because it is so simple, is among the most direct and effective visual tools for triggering a sensation of movement in our mind, which is then transferred to our muscles and joints. As our eyes move along a line, we internalize very real sensations of movement, speed, energy, acceleration, weight, rhythm, and texture as well as the excitement and pleasure associated with those sensations (**Fig. 1.3**). **It is these very real sensations and not some vague intellectual musing that we are referring to when we speak of "feeling" in a drawing.**

As luck and the topic of this book would have it, drawing is a uniquely effective and accessible activity for developing this life-affirming sensitivity and putting it into a form that can be preserved and shared.

KINESTHETIC SENSITIVITY

"The true mystery of the world is the visible, not the invisible."

Oscar Wilde

TRIGGERING KINESTHETIC SENSATIONS

The strength of the physical sensations that result from visual stimulation are surprisingly powerful. It is not uncommon, when sitting in a train at a station, to feel that your train has started moving backward only to realize that it is actually the train on the next track that is going forward. This optical illusion carries with it a convincing sensation of physical motion. This illusion of movement can also be experienced in wide-screen amusement centers where the audience stands in the center of a room as a 360º movie is projected on the walls. These theaters have rows of railings for the participants to grasp to maintain their balance because they regularly sway back and forth as though they themselves were moving in relation to the pictures on the screen.

CHAPTER 2 MATERIALS

Drawing Tools 7
Charcoal 8
Tool maintenance 9
Other drawing tools 10
Brief history of paper 11
Paper terminology. 12
Erasers 13
Supply list 14

"Limitation is not a source of weakness but rather a source of strength for art."
E. H. Gombrich

To develop heightened sensitivity to and control over the process of mark making it is recommended that you restrict the materials you use throughout your lessons in this text. Experimenting with a variety of drawing tools and paper surfaces is certainly an essential part of any long-range drawing experience. However, learning to control a single drawing tool on a specific drawing surface is difficult enough on its own, and especially hard while simultaneously being introduced to a broad range of mechanical techniques and underlying theory. In an effort to keep things as simple as possible, every lesson in this text has been designed to work with compressed charcoal and newsprint paper. Both of these drawing materials are moderately priced and well suited to perceptual drawing. Experimentation with other drawing materials, while enthusiastically encouraged, is recommended only after you have developed a feel for the mark-making capabilities of compressed charcoal and absorbed a solid understanding of the mechanical and theoretical lessons presented in this text.

DRAWING TOOLS

2.1 The drawing material in a charcoal pencil is wood that has been turned into coal. It gets its name from the medieval word *charren,* meaning "to burn." It is mixed with clay (for hardness) and binder (to hold it together and adhere to the paper).

Charcoal is believed to be the oldest drawing medium, and today it comes in a variety of forms. **Stick charcoal** is composed of the dry carbon that remains after wood is burned. It is a dry, crumbly material that leaves marks easily and comes off most surfaces just as easily. The highest grade of stick charcoal is **vine charcoal**. It comes in thin sticks with a smooth, even texture. This material is sometimes used for sketching and lends itself to quick gestures and subtle gradations. However, its impermanence (it literally falls off the paper) and its lack of a deep black restrict

CAUTION
DON'T DROP YOUR PENCIL

● Charcoal pencils are fragile, and the charcoal core often shatters if the pencil is dropped.

● Charcoal pencil points can break when used with a hand-held sharpener. Traditionally, charcoal pencils are sharpened with a sharp knife or an X-acto knife. (Extreme caution needs to be taken if you attempt to sharpen your charcoal with a sharp instrument—always keep the direction of the blade moving away from any part of your body.) A good-quality, high-speed electric sharpener can also be used effectively.

● Some charcoal pencils are wrapped in paper and have a string enclosed along the barrel of charcoal that can be pulled to expose more of the tip. Generally these pencils do not need to be sharpened.

its usefulness as a drawing tool. Vine charcoal's limitation as a drawing tool benefits oil painters because it can be easily blown off the painting surface to prevent the charcoal from neutralizing the colors. **Compressed charcoal,** on the other hand, is a far more versatile drawing instrument (**Fig. 2.1**). It is made from ground charcoal that is mixed with varying amounts of clay and a binder to hold it together. The more clay that is added, the harder the compressed charcoal becomes. The binder helps the pigment adhere to the surface of the paper and adds richness to the black. Compressed charcoal comes in wooden pencils, paper-wrapped pencils, compressed cylinders, and compressed blocks.

Graphite (from the Greek *graphein*: "to draw/write") was discovered in England in 1564. It was originally believed to be a type of lead and thus the term *lead pencil.* This popular misnomer has survived for nearly five hundred years. Graphite was not popularized as a drawing tool until 1795, when it was manufactured as wooden-barreled pencils by a Frenchman, Nicholas Conté. Graphite, like charcoal, is mixed with varying amounts of clay to create differing degrees of hardness and darkness. Pencils range from 8B (softest and darkest) through the midrange of HB and

F to the hard range, with 10H being the hardest and lightest. With these pencils, as with most drawing tools, there is considerable variation in handling characteristics from one manufacturer to another. Graphite also comes in solid, unwrapped, rectangular sticks, in "woodless" cylindrical pencils, and in powdered form that can be rubbed directly onto the drawing surface (**Fig. 2.2**).

Conté crayons were also invented by Nicholas Conté and are made by compressing a pigment and gum binder paste into small rectangular sticks. These crayons come in black, white, gray, reddish-orange, dark brown, and a dark reddish-brown and are available in HB (hard), B (medium), and 2B (soft). The Conté crayon is a very smooth and versatile tool.

Paper comes in a wide variety of **sizes, weights,** and **surfaces.** It's made from cellulose fibers from either cotton or wood. **Rag paper,** made from cotton fibers, is the most durable and versatile and is the most permanent paper when used with nonacidic drawing tools and kept from chemical pollution. Papers made from **wood pulp** are less expensive and can have excellent permanency ratings if chemically treated during manufacture. **Newsprint,** the least expensive paper, is made

2.2 Nicholas Conté's contributions to the world of drawing include the development of wooden-barreled graphite pencils, as well as small rectangular crayon sticks made of pigment and a gum paste (Conté crayons).

2.3 The weight of a paper stock is determined by the measured weight of a ream (500 sheets) of 17 x 22 inch sheets of that particular paper.

BRIEF HISTORY OF PAPER

The word *paper* comes from *papyrus*, a writing and drawing material first used by the Egyptians around 2400 B.C. It was made by hammering criss-crossed papyrus stalks into sheets of meshed fiber. Animal skins were introduced in Asia Minor in the second century B.C. as a substitute writing surface. What was originally called *vellum* but is now called *parchment* is made from the processed skin of young animals. The tradition of referring to a college diploma as a *sheepskin* reflects the widespread use of parchment as a writing material during the Middle Ages. Paper, similar to what we manufacture today, was invented in China around A.D. 105 but was kept secret from the rest of the world for 700 years until invading Arab armies took the technology back to the Middle East. Paper making involves breaking plants down to their individual fibers in a watery pulp that is then scooped out onto screens and dried. The Moors introduced paper to Spain in the twelfth century, and it gradually spread throughout Europe. The first paper mill in America was established in Philadelphia in 1690.

from untreated wood pulp and is highly impermanent. Its price and its surface make it a good paper to use when you are starting out but you must remember that the acids in the fibers cause the paper to yellow and deteriorate fairly quickly when it is exposed to light and air. Newsprint has a warm gray tone and can be smooth or moderately rough.

The **weight of a paper** refers to the measured weight of five hundred (a ream) 17 x 22 inch sheets of a particular paper (**Fig. 2.3**). It can vary from thirteen pounds (lightweight ink jet paper) to four hundred pounds (heavy watercolor paper).

The **surface of the paper** can range from very smooth to extremely rough with a full range in between. **Tooth** is the surface feel of paper. The more tooth a paper has, the rougher it feels to the touch. Some inks may adhere poorly to papers with very little tooth. A pronounced tooth is the preferred surface texture for charcoal and pastel art. **Cold-pressed** papers, the most common, have moderate surface texture and absorbency and accept the widest range of media. Rough paper has a pronounced surface texture and is most commonly used with watercolor or ink washes. **Hot-pressed** papers are hard and smooth and best

suited to detail work with pen or hard pencil. They are not very absorbent.

The designation **bond paper** refers to an assortment of writing, ink jet, and drawing papers that vary in **weight, rag content,** and **surface.** They are generally cold-pressed. They all work well with pen-and-ink drawing, and those designated as drawing paper (slightly rougher surface) are receptive to most dry media. **Bristol papers** are manufactured by bonding together two or more sheets of single-ply paper (**Fig. 2.4**). Each additional layer of paper makes it heavier and tougher than single-ply bond paper. Bristol can be made from rag but is often made from wood pulp that has been chemically treated for permanence and whiteness. The surface ranges from hot-pressed to cold-pressed. Bristol papers are usually sold in pads and offer a particularly receptive ground for most media. **Charcoal paper** (pastel paper) is manufactured with a pronounced **tooth** or texture and is designed for soft charcoal, pastel, crayon, and chalk. **Illustration board** refers to the gluing of drawing papers to a rigid backing (**Fig. 2.5**). Like the papers themselves, illustration board varies in quality and surface. Many papers combine rag and chemically treated wood fiber in varying percent-

2.4 Bristol paper is manufactured by gluing together two or more sheets of single-ply paper. Bristol papers gain extra moisture stability because the fibers on each sheet are oriented at right angles to each other.

2.5 Illustration board is made by adhering a piece of drawing paper to a rigid backing whose thickness is equivalent to somewhere between 14 ply and 28 ply of bond paper. Since it is generally used for commercial graphic arts, the rigid supporting board is often made of non-archival ground-wood fiber. As illustration board has become more popular for fine art applications, manufacturers have begun making panels from a rigid plastic foam with a paper or plastic facing. Despite the many advantages of this type of board over most wood-fiber boards, they cannot be considered archival because the core is polystyrene or some variant that naturally decomposes over time and is said to give off acid vapors.

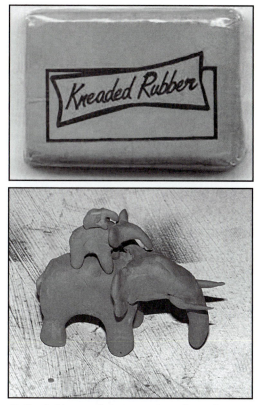

2.6a-b Newsprint paper is soft and erasing marks on soft surfaces requires a soft eraser. A kneaded eraser is not only very soft and easily molded into shapes that allow for precise erasing. This plastic (moldable) characteristic of the kneaded eraser also makes it an excellent material for exploring 3-D forms which can then be used as subjects from which to draw.

ages. This improves performance characteristics while keeping the cost of the paper lower.

Erasers similar to those we use today became popular in the late eighteenth century. Surprisingly, this was almost two hundred years after it had been discovered that rubber could be used to remove pencil marks from paper. Before this time the most common eraser was crustless white bread.

Modern erasers contain a variety of ingredients, including rubber, synthetic rubber, vinyl, pumice, and fractice. Fractice is vulcanized oil that gives most erasers the critically important capacity to crumble as they are used.

Kneaded (putty) erasers work particularly well with charcoal on newsprint (**Fig. 2.6a**). A kneaded eraser absorbs the charcoal particles and leaves no residue. Because they don't crumble or wear away, they can last a long time. A particularly attractive attribute is that they can be easily shaped for precise erasing. However, kneaded erasers do not work well when erasing large areas. When the surface of this eraser becomes covered in charcoal, kneading it like dough will usually restore its capacity to absorb more charcoal. A kneaded eraser will eventually become exhausted, unable to absorb any

SUPPLY LIST

2 18" x 24" <u>Newsprint pads</u> (total of 100 Sheets)
1 Drawing board
2 Large clips to hold end of pad to drawing board
6 <u>Compressed charcoal pencils</u> either Soft or Very Soft
1 Box of <u>compressed charcoal sticks</u> (at least 4 sticks)
2 Erasers: 1 <u>kneaded</u> rubber, 1 <u>gum</u>

<u>Recommended:</u> Artist's easel (relatively sturdy models are available for between $150.00 and $250.00)
(Web sites with information about easels can be found on page 304.)

more charcoal, in which case it will smear and actually make marks instead of erasing them.

Another eraser type that is popular with artists is the **art gum** eraser, made of soft, coarse rubber (**Fig. 2.7a**). Like the kneaded eraser, art gum is gentle on the surface of the paper. It is especially suited to removing large areas of charcoal. The downside of art gum erasers is that they are not very precise in their erasure.

Art gum erasers tend to crumble as they are used, leaving a lot of eraser residue. Broad dusting brushes are effective for sweeping away the loose eraser residue (**Fig. 2.7b**).

2.7a-b Another soft eraser is the art gum eraser. Art gum is gentle and good for erasing large areas. Because it leaves a lot of eraser residue, you might want to use a dusting brush to clear the residue from the drawing surface.

CHAPTER 3 DRAWING MECHANICS

First position 15
Dancing line. 16
Stepping back 17
Retuning your eye 18
Fixed drawing position. . . . 19
Setting up the pad 20
Drawing grip 21
Grip variations 22
Positioning the pad 23
Fluid arm movement. 24
Line variety 25
Fluctuating line. 26
Line for line's sake 27
Mark-making exercises . . . 28

"All knowledge cannot be expressed in words, yet our education is based almost exclusively on its written or spoken forms. . . . But the artist, dancer, and mystic have learned to develop the non-verbal portion of intelligence."
Robert Ornstein

Your choice of drawing tool, the characteristics of your drawing surface, the way you set up your drawing pad, the manner in which you hold your drawing tool, and the position of your body while you draw all have a direct impact on the marks that you will make. These factors are often over-looked, but they directly affect the overall look and feel of your drawing. So let's take a moment to address each one individu-ally. Having already discussed the drawing tool and paper sur-face, we can move directly to the mechanical issues that will help you realize the goals of each of the chapters that follow.

Drawing is a physical activity that, like its spiritual cousin dance, demands considerable concen-tration and a surprising amount of physical exertion. Both drawing and dancing are direct expres-sions of energy and movement and both require that their prac-titioners understand how these two elements can be controlled and transformed into the vocab-ulary of the art form. Not sur-prisingly, drawing and dance are frequently described in terms of

FIRST POSITION

15

each other's characteristics. The "line" and "flow" of the dancer and the "rhythm" and "movement" of a line are the most obvious examples of this intimate interrelationship (**Fig. 3.1**). Among dancers the value and importance of stamina, muscle tone, and proper technique are clearly understood, but among those who draw these elements are all too frequently overlooked. Drawing, too, demands good posture, a flexible and energized stance, and a high level of physical involvement.

Standing at an easel while drawing is the best position for the exercises that are outlined in this text. Standing promotes a higher level of energy than sitting. Standing promotes physical tension, a slight but meaningful level of discomfort and muscular involvement that helps focus the mind and eye on the activity at hand. Physical activity has recently been given much attention as a method for increasing the attentiveness, energy, and productivity of workers in factories and corporations. It is equally effective for increasing the intensity of a drawing experience. When you stand, you involve your entire body. This position promotes sensory alertness and physical responsiveness. "Drawing" is based on movement, and if you are too tired to tolerate the physical requirements of

<div style="writing-mode: vertical-rl">DANCING LINE</div>

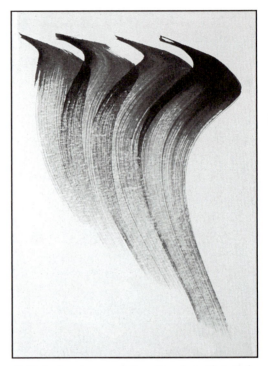

3.1 A dancing, swirling line has the ability to capture and then communicate the energy and sensitivity that produced the marks on the page.

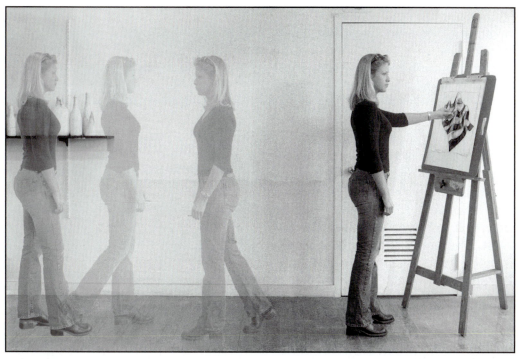

3.2 Stepping back away from the easel changes your visual relationship to the image. This change gives you a fresh eye that helps you identify distortion and inaccuracy in your drawing.

drawing, it is possible that you are too tired to maintain the intensity that is required for heightened tactile and visual sensitivity.

Standing also makes it more likely that you will periodically back away from your drawing (**Fig. 3.2**). This simple change of relative position enables you to look at and evaluate your drawing with a surprisingly **fresh eye.** Moving back several feet from your drawing not only is an energizing physical activity but also counteracts the eye's natural tendency to become complacent and less discriminating when exposed

to an unchanging image over a prolonged period. Human perception relies heavily on changing stimulation when interpreting sensory data, and this is particularly true of vision. The eye is our most fickle sensory organ. It functions optimally when exposed to changing information. **Every time you view your drawing from a different distance, you are actually retuning your powers of visual discrimination.** The advantage of frequently moving back from the drawing is repeatedly illustrated in drawing classes when students are asked to display their work after an extended drawing session. It is not uncommon for students who have neglected to step back from their easel to approach the display area with a sense of satisfaction that fades only too quickly after they return to their easel and view their work from across the room. Seeing the drawing "fresh" from across the room immediately reveals distortions and inaccuracies that the students had grown to tolerate and accept because their eyes had grown stale from only working up close. Backing away from your easel is a simple but effective technique for improving the overall quality and accuracy of a drawing (**Fig. 3.3**). The more frequently you step back, the faster your drawings will improve.

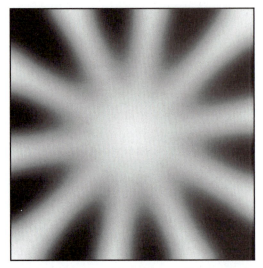

3.3 The image above has nothing whatsoever to do with keeping your eye fresh and engaged by regularly moving away from your drawing. It does, however, provide a remarkable illusion of an expanding and contracting circular form as the viewer moves toward and away from the surface of the page. Please allow this tangentially related (but hopefully entertaining) illustration to serve as a reminder of the importance of regularly stepping back from your easel while drawing.

TENSION/FRUSTRATION

Contrary to popular belief, tension is an essential element of life and human consciousness. In spite of the fact that modern society consumes incredible quantities of numbing substances (Valium, alcohol, and TV) in an attempt to escape from tension, tension is an ingredient of a meaningful life where mind and body are constantly involved in a struggle to maintain equilibrium. Seen in this way, tension is to be experienced, engaged, managed, appreciated, and understood as a path to accomplishment and a gateway to satisfaction. The more constructively we work with our tension, the more satisfying our life experiences will be. Work can often be difficult, frustrating, and even painful, but resolving work-related tension is its own reward. "Peak experience" and being "in the zone" are expressions that refer to moments in life when we become acutely aware of the "joys of tension." Valuable lessons can be found in the maxims "No pain, no gain" and "A little pain lets you know that you're alive."

As helpful as it is at each stage of the drawing process to regularly move back away from your drawing to view it with a fresh eye, it is equally important that you return to the exact same viewing spot each and every time you resume drawing. If you inadvertently change the position from which you have been drawing, the relative positions of the objects will change, as will the relative angles of their edges. Even shifting your weight from one leg to the other can substantially change how objects appear in relation to one another. **You need to draw from a consistent fixed position.**

As stated earlier, sitting while drawing is not as conducive to encouraging a heightened sense of perception and physical involvement as is standing. For those who are unable to stand at all or for extended periods, the shortcomings that arise from sitting are not insurmountable. Active concentration and consistent self-discipline can contribute significantly to a high energy level. Perhaps the biggest handicap to drawing while seated is the fact that seated people rarely ever get back away from their drawing. Drawing accurately from a seated position is more mentally demanding, but it can be done.

FIXED DRAWING POSITION

CHAPTER 3: MECHANICS

When you draw, it is important to position the surface of your paper at a right angle (90°) to your line of sight (Fig. 3.4). The center of the paper should be at your shoulder level. Establishing this 90° relationship with the drawing surface occurs naturally when you are standing or seated at an easel. Drawing at a drafting table that has an adjustable top can allow for the necessary 90° viewing relationship, but drawing on a surface that is parallel to the floor is unacceptable because it results in substantial distortions in both proportion and perspective (**Fig. 3.5**). Traditional drawing benches hold a drawing board relatively well if they are used properly with the board positioned so that the viewing angle is approximately perpendicular to the drawing surface (**Fig. 3.6**). If you do choose to work at a drawing bench, be sure to keep the end of the drawing board out of your lap. Putting the board in your lap causes serious deterioration of the viewing angle (**Fig. 3.7**).

Drawing and handwriting have a shared origin but have evolved quite differently, particularly in the Western world. With the exception of occasional flourishes in our signatures, we generally approach the physical act of writing as a small-scale utilitarian activity. When we write, we gen-

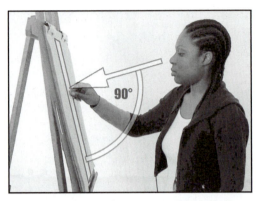

3.4 Maintaining the proper 90° relationship between the line of sight and the drawing surface helps reduce the likelihood of distortion in the drawing.

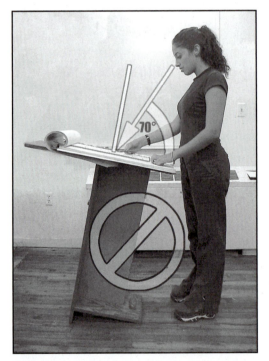

3.5 Using a drawing bench as a drawing table results in an unsuitable viewing angle and often leads to distortion in both proportion and perspective.

20

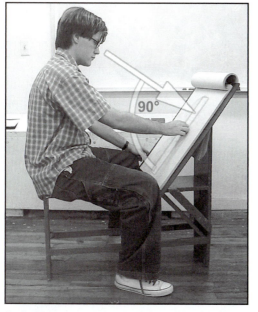

3.6 Correct posture allows for an effective viewing angle and free arm movement.

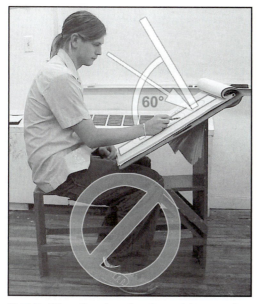

3.7 Putting the drawing board in your lap reduces arm movement and discourages you from moving back away from the drawing.

erally cradle the barrel of the writing tool against the knuckle of the index finger and hold the tip between the thumb, index, and middle fingers (**Fig. 3.8**). This grip provides the limited range of movement that is necessary to form the letters of the Phoenician alphabet. But that grip is totally unsuited to the movement, scale, tonal range, touch sensitivity, and directional control that are essential to drawing. For drawing, the tool should be held between the thumb and index finger (**Figs. 3.9, 3.10**) with the barrel of the tool positioned across the palm of the hand. In contrast to writing, where the fingers do the majority of the work, the movement for drawing originates in the shoulder, the elbow, and the wrist. With the **drawing grip** the fingers are relatively static and are responsible only for holding on to the drawing tool and registering the "feel" of the tip of the drawing tool against the drawing surface. Beginners using the drawing grip for the first time are often surprised by how frequently the drawing tool unconsciously works its way back into the writing grip. Regardless of how many times you slip, make sure you return to the drawing grip. The drawing grip dramatically improves the physical mechanics of moving the drawing tool across the surface of the paper. The wrist offers more mechanical

21

movement than the finger joints but certainly not as much as the hinge joint at the elbow or the ball-and-socket joint at the shoulder. The shoulder is far and away the most versatile and fluid anatomical mechanism with which to draw. Holding the drawing tool in the drawing grip, while relatively uncomfortable at first, has such a beneficial impact on the sensitivity of the marks and lines of the drawing that it is imperative to overcome any sense of frustration you may encounter and work through the clumsiness. By the time you are finished with the lessons in this text, the drawing grip will feel quite natural.

With the drawing grip there are two ways in which the pencil can make contact with the paper surface. The first way uses the tip of the drawing tool as the only point of contact with the drawing surface (**Fig. 3.9**), whereas the second way allows for the fingernails of the middle and ring fingers to make continuous contact as the hand moves across the paper (**Fig. 3.10**). Keeping your fingers in contact with the surface gives slightly more control. The fingers that are touching the surface continuously help to monitor the pressure being exerted by the muscles of the arm and also provide tactile feedback and mechanical leverage. This increased control over the

3.8 The traditional writing grip cradles the barrel of the writing tool upward between the thumb and the index finger.

3.9 With this drawing grip the barrel of the pencil passes through the palm of the hand with only the tip of the pencil making surface contact.

3.10 With this variation the tips of the fingers remain in contact with the drawing surface. This grip provides greater control over the pressure of the tip against the drawing surface but does have an inherent drawback in that it frequently causes smudges in marks that have already been put on the surface.

3.11 To prevent smudging when your fingertips touch the surface, you may choose to hold a clean sheet of paper under your hand as you draw.

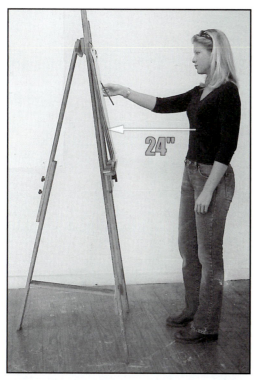

3.12 Stand approximately 24 inches away from the drawing surface. The middle of the pad should be even with your shoulder.

pressure of the drawing tool, though, does have a disadvantage: the grip can result in inadvertent smudging when the fingers move across marks that are already on the surface. While it may be argued that a certain amount of smudging can actually add to the variety of marks and the richness of the surface, you want to be fully aware of the limitations of any technique you adopt. If smudging is unacceptable but you prefer to keep your fingers in contact with the surface, you can use your other hand to hold a second sheet of paper over your drawing as a mask (**Fig. 3.11**). This protects the marks underneath. If you use a mask while you are drawing, the fact that you are covering up part of the drawing makes it even more critical that you regularly back away from your easel. This helps maintain consistency in handling over the entire drawing as well as providing greater accuracy in the proportion and placement of objects.

Whether you're standing or sitting while drawing, it helps if you position yourself so that your elbow is slightly bent as you make contact with the paper (**Fig. 3.12**). On average, there should be approximately 24 inches from your breastbone to the drawing surface. This distance allows you to see the entire surface of

POSITIONING THE PAD

FLUID ARM MOVEMENT

your paper at a glance, and it gives your arm the room needed to move freely about the page. Beginners frequently stand less than a foot from the drawing surface. This relationship feels comfortable and familiar because of our experiences with penmanship and coloring books, but it leads to a variety of unnecessary difficulties with mechanics and viewing angle. The 24-inch distance is easily maintained if you are using an easel or sharply tilted table. It can be problematic if you are working at a standard drawing bench and are over 5 feet 10 inches tall. While each successive generation since the 1940s has been slightly taller than the previous, the size of most furniture has remained unchanged. If you are taller than 5 feet 10 inches and are sitting on a standard drawing bench with your arm properly extended, you will find yourself perched precariously near the back edge of the bench. If you move forward to a more stable position, you not only reduce the angle of your line of sight to well below 90°, but you also reduce the range and freedom of arm movement.

When compressed charcoal is applied with moderate pressure, it produces a dense black mark or line. This rich, deep ebony is bold in its stark contrast to the light warm gray tone of the newsprint. **Ebony** in Swahili means

CLASSIC DUALISTIC OPPOSITIONS

Black/white
Light/dark
Good/evil
God/devil
Mind (Platonic form)/
 matter
Spiritual/physical
Life/death
Male/female
Vertical/horizontal
Yin/yang
Love/hate
East/West (philosophy)
Positive/negative
Mortal/immortal
Mechanical/biomorphic
Apollo/Dionysus
Reason/emotion
On/off . . . In/out . . .
Up/down
Abstract/concrete
Science/intuition
Left brain/right brain

3.13a-b Sensitivity to the touch of the drawing tool to the drawing surface and the ability to discriminate subtle changes in the marks as the tool is "drawn" over the surface are the two most crucial components of the drawing process. Start with simple exercises where you concentrate on varying the pressure of the pencil on the surface of the paper. The sensitivity to touch of the drawing tool and the variety of marks you can make is as important as any lesson in this text.

black, as it does in English, but in Swahili it also means beautiful. The stark black against the light (back)ground resonates with such strength and clarity that it gives renewed meaning to the 1960s civil rights slogan "Black is beautiful." Our attraction to the high contrast of solid black against a light ground parallels our fascination with the conceptual dualism that lies at the heart of many of our myths, religious beliefs, and philosophical inquiries. Although we may come to believe that in drawing, as in many of our life experiences, not everything is black or white, this classic dualism is certainly an interesting place to start.

Because soft compressed charcoal makes thick velvety black marks so effortlessly, the challenge of this medium rests in your ability to find ways to create a full range of line thicknesses and degrees of darkness. Varying the pressure on the tip of the charcoal obviously has a direct effect on the thickness and darkness of the marks being made (**Fig. 3.13a-b**). As you draw, the tip of the charcoal undergoes subtle changes. Becoming sensitive to these changes can be extremely helpful in expanding the kinds of lines you can make. As the tool is drawn across the surface, facets, crisp edges, and points are constantly being formed and then

25

reformed on the tip as a result of the friction between the drawing tool and the drawing surface. These facets and edges change size and position in a constantly evolving series of planes, sharp edges, and points. To take advantage of these edges and points, you must develop a "feel" for the tip of the tool against the drawing surface. By focusing your attention on the touch of the charcoal's tip to the surface of the paper, and by cataloguing how this tactile sensation translates into line, you will gradually develop control over these crisp, delicate points of contact. Once you are aware of these delicate points, you can begin using them by rolling, turning, and tilting the charcoal as you draw it across the paper.

After experimenting with thick, bold ebony marks and marks as delicate as the threads of a spider's web, you are ready to explore the rich variety of lines and marks that lie between those extremes (**Fig. 3.14**). Focusing your attention on line variation demands a very high level of concentration that initially feels synthetic and arbitrary, but this variation is the essential building block of a successful drawing. **Fluctuating line is the single most crucial element for establishing the overall level of sensitivity in a drawing.** It is so fundamental that the presence of sensitive and

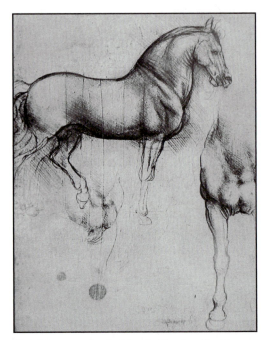

3.14 Leonardo da Vinci, *Study of a Horse, no. 105*, Gabinetto dei Disegni e delle Stampe, Florence. Leonardo da Vinci's study for an equestrian monument not only demonstrates the effectiveness of line fluctuation for attracting and engaging the eye but also points toward its ability fluctuating line to suggest three-dimensional form on the paper surface.

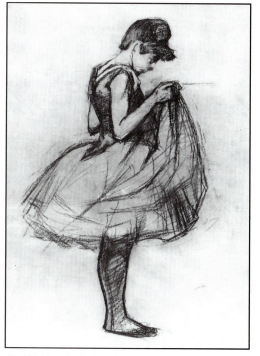

3.15 Henri de Toulouse-Lautrec, *Drawing of a Dancer*, 1889 (Musée Toulouse-Lautrec, Albi). Toulouse-Lautrec not only uses fluctuating line to describe the form of a young female dancer but actually exaggerates it in a way that suggests a restless energy entirely appropriate to the subject matter.

varied line is reason enough for a drawing to be classified as a masterpiece even when it contains inaccuracies of proportion or distorted spatial relationships. The lack of line variation, correspondingly, consigns countless drawings that accurately transcribe every object in the visual field to the realm of artistic mediocrity. At the risk of being repetitive, I will say that the overall effectiveness of a drawing is, first and foremost, determined by the quality, variety, and sensitivity of the marks from which it is made. Every mark that you make needs to be in constant flux to embody the restless energy and tension that underlie the functioning of our biological organism and, more specifically, our perceptual experience (**Fig. 3.15**).

Later in this text we will address specific spatial effects that can be created or enhanced by varying thickness and darkness of a line, but at this stage you need to concentrate on varying the thickness and darkness of the line as frequently and as smoothly as possible. Don't worry about the rationale for the variation. Just do it!

Before you move ahead to the lessons in Chapter 4, experiment with your compressed charcoal drawing tool. Familiarize yourself with its mark-making characteristics.

MARK-MAKING EXERCISES

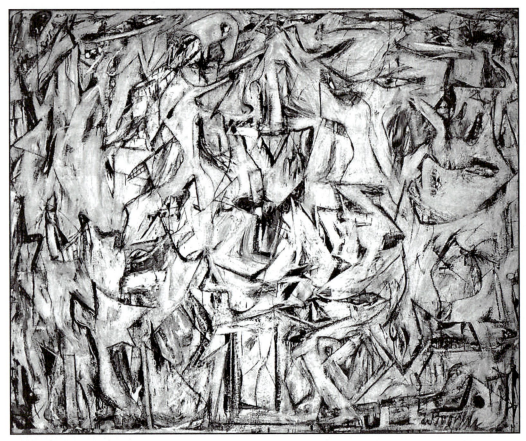

3.16 *Excavation* by Willem de Kooning displays a powerful combination of highly varied dark marks surrounding lighter shapes. His lines move from thick to thin, angular to curved, and dark to light.

Initially, don't bother imitating the appearance of anything recognizable (**Fig. 3.16**). Focus all your attention on maximizing the variation of the line as you move the tool. Try straight lines, sweeping curves, large circles, and small meandering squiggles. Constantly vary the pressure and rotate the tip. **Remember, sensitivity to line is the single most important element in drawing.**

CHAPTER 4 INTUITIVE GESTURE

Rational limitations 29
Types of intelligence 30
Concept vs. percept 31
Cognitive style (rational) 32
Cognitive style (intuitive) 33
Direct perception 34
Intuitive approximations . 35
Intuitive gesture part 1 . . 36
Intuitive gesture part 2 . . 37
Big picture relationships . 38
Phantom gesture 39
Evolution of a gesture . . . 40
Mental flexibility 41
"Female" intuition 42
Name that shape 43
Spatial continuity 44

Drawing from observation doesn't require you to change the way you see, but it does require you to alter the way you think about what you see. Paradoxically, this means that when you are drawing you must **not think** about what you see. **Look now, feel now, think later.** Let me explain.

Rational thinking is characterized by a preponderance of preconceived ideas and a heavy reliance on language. Rational thinking is an essential and valuable component of our brain's ability to make sense of countless aspects of our lives, not the least of which is helping us interpret our visual environment. However, when you draw from observation, relying heavily on rational thinking obscures and distorts your visual perceptions because doing so substitutes preconceived, generalized mental constructs for specific and concrete sensory data. When you rationalize your perceptions with preconceived ideas, what you think becomes more important than what you see, and the clarity of your direct visual perceptions becomes severely compromised.

RATIONAL LIMITATIONS

CHAPTER 4: INTUITIVE GESTURE

To safeguard the accuracy of your perceptions you will need to temporarily suspend the rationalizing influence of analytical information processing in order to allow your intuitive spatial awareness to react directly to the visual information in your visual field. A straightforward illustration of how the differences between these two cognitive styles affects the appearance of an object in a drawing is presented in **Figs. 4.1-4.3**. In **Fig. 4.1,** the drawing of the coffee mug is based on general ideas regularly associated with any coffee mug. This is a **conceptual drawing.** It is a logical construction that uses clear stylized symbols to represent our most basic understanding of a coffee cup. This conceptual drawing is a straightforward, informative, and highly intelligent drawing. It includes the circular opening out of which we drink the coffee, the flat bottom upon which the cup sits securely, the parallel sides that connect the circular top to the flat bottom, and the curved handle that is attached to the side. This image contains general ideas that relate to most coffee mugs. However, this drawing makes no attempt to tell us how our very own personal coffee mug appears on the table in the morning. **Fig. 4.2,** on the other hand, depicts the appearance of a specific coffee mug seen from a unique viewing posi-

TYPES OF INTELLIGENCE

Language skills
Math/logic skills
Analytic reasoning
Short- and/or long-term
 memory
Pattern recognition
Body awareness and
 coordination
Spatial awareness
Sound discrimination
Rhythm/time sensitivity
Interpersonal skills
Sensitivity to nature
Artistic sensitivity
Intuitive problem solving

con ◆ cept n.
1. A general idea derived or inferred from specific instances or occurrences. 2. Something formed in the mind; a thought or notion.

per ◆ cept n.
1. The object of perception. 2. A mental impression of something perceived by the senses, viewed as the basic component in the formation of concepts; a sense datum.

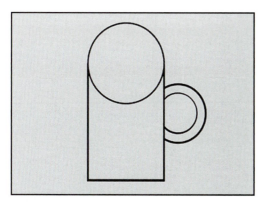

4.1 A conceptual drawing emphasizes what we "know" about a coffee mug.

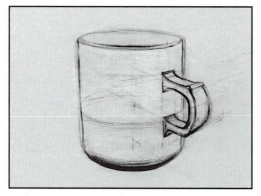

4.2 A perceptual drawing records information directly from our observations.

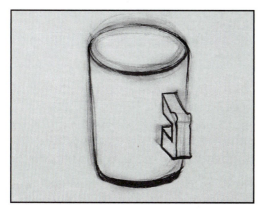

4.3 This combination drawing has a certain naive charm but no integrity because it mixes the conceptual approach with the perceptual.

tion slightly above the top lip. In this image generalized conceptual ideas have been replaced by direct perceptions that reveal individualized characteristics of a particular coffee mug and its relation in space to an observer. The opening we know to be circular now appears as a tightly compressed ellipse, the stable flat bottom appears as a pronounced curve, and the handle angles downward. To translate the visual experience of the cup into this image requires a substantially different vocabulary than that used in conceptual drawing. **Fig. 4.2** is a **perceptual drawing.** This image reflects a substantial cognitive shift, a different way of knowing about the mug than does conceptual drawing. **Fig. 4.3** illustrates an attempt at perceptual drawing that fails to break free of its conceptual baggage and is considerably less effective as a result. Even though this drawing does have a certain naive charm, it is a **damaged hybrid.** When rational preconceived notions are mixed in with intuitive spatial perceptions, both the intellectual clarity of the conceptual drawing and the complex, sensuous information of direct perceptual experience are seriously compromised. Hybrid images lack consistency and integrity and vacillate unconvincingly between the idea-based and the perception-based styles of processing information.

COGNITIVE STYLE (RATIONAL)

Limiting the influence of rational thinking on your immediate perceptions is essential for accurately recording your observations in a drawing, and in its place you need to substitute intuitive, non-verbal approaches to informational processing. This should be a natural process but one that is surprisingly challenging because our formal education actively perpetuates the misconception that one's facility with the three "R's" (language skills, reasoning, and math/logic) is the only true indicator of intelligence. This bias is reflected in the importance given SAT or ACT scores in one's academic record and the fact that language, scientific reasoning, and math are required, whereas courses emphasizing nonlinear, intuitive methods of information processing are offered as electives or relegated to extracurricular status. Overcoming this cultural bias takes a surprising amount of effort because your daily thought processes have been trained to rely primarily on language-driven concepts. You will need to actively counteract this bias and shift your attention away from "thinking" about what you see and toward a nonverbal, big picture–oriented, three-dimensionally sensitive, intuitive style of visual processing. Shifting your experience away from the familiarity of ideas and toward the concrete immediacy of sensory

RATIONAL COGNITIVE STYLES

Logical
Scientific skill
Intellectual
Deductive
Rational
Discrete
Pragmatic
Directed
Objective
Sequential
Clear and direct
Constructive-/step-
 oriented
Temporal
Verbal reasoning
Symbolic/abstract
Analytic (linear)
Successive
Trial and error
Rule of laws
Explicit
Narrow focus
Digital watch

in ◆ tu ◆ i ◆ tion n.
1. a. The act or faculty of knowing or sensing without the use of rational processes; immediate cognition. Knowledge gained by the use of this faculty; a perceptive insight.
2. A sense of something not evident or deducible; an impression.

INTUITIVE COGNITIVE STYLES

Emotional
Artistic sensitivity
Sensuous
Imaginative
Metaphoric
Continuous
Impulsive
Free
Subjective
Gestalt
Complicated pattern
Global/simultaneous
Nontemporal
Nonverbal understanding
Concrete
Synthetic (holistic)
Simultaneous
Educated guess
Open to ambiguity,
 complexity, and paradox
Tacit
Encompassing
Analog watch

perception will depend on your ability to tolerate patterns of information that are ambiguous, complex, and, at times, at first glance, seemingly contradictory (paradoxical).

One way to encourage this shift toward direct sensory perception when you draw is to begin your drawing with an **intuitive gesture.** (NOTE: *The following definition is paradoxical in that it relies on rational, linear, language-based information to describe what is essentially a nonverbal, intuitive style of recording holistic sensations of three-dimensional forms and their relationships in space.*) **An intuitive gesture is a quick, all-encompassing, simultaneous overview of the wholeness of forms and their relationship in space**. **It is energetic, flexible, nonlinear, nonspecific, intuitive, and constantly open to adjustment.** Intuitive gesture focuses on where the sources of sensation (material things or changes in light intensity) appear on the drawing surface, how big these sources of sensation are relative to one another, and how much space there is between these sources of sensation. Intuitive gesture does not approach visual information sequentially, systematically, or through symbolic representations. Instead, it tends to jump illogically around the

par ◆ a ◆ dox n. *seemingly contradictory or absurd statement that expresses a possible truth.*

visual field as it attempts to capture the "big picture" without getting bogged down with specific shapes or details. This method of information processing, by definition, lacks clear linear instructions or sequential, step-by-step procedures. No matter how clever we might be with words, words can't describe the comprehensive awareness we are seeking. We need to get beyond words, to get beyond conventional logic, to get beyond the ideas in our heads. We need to open ourselves directly to the pure immediacy of our perceptions (**Fig. 4.4**).

Getting beyond words is a particularly challenging task for a language based book but since this is a book about drawing it makes perfect sense to take advantage of the power of images to illustrate aspects of the experience that words can't adequately express. Fortunately, we won't have to abandon words entirely as long as we keep in mind that even though there will be times when words can't define the intuitive experience, they usually can point in its general direction. Words are also helpful in identifying styles of information processing that are incompatible with intuitive gesture. Ironically, this means that although we can't find words to define intuitive processing we can come up with some very clear definitions of what it is not.

"Luke, turn off the computer. Use the Force."
Obi Wan Kenobi
Star Wars: A New Hope

4.4 A rarely discussed shortcoming associated with the use of computers as learning tools is their reliance on simulation over hands-on manipulation of the physical world. It is important to remember that learning is, at its best, a broad-based emotional, intellectual, and tactile experience. It flourishes when all five senses are engaged. Knowledge is enhanced when we learn with our senses and experience the physical world through our muscles and reflexes as opposed to substituting something as mechanical and synthetic as a computer interface for our physical experiences. Without direct awareness of our physical bodies and how our bodies react to and affect wider natural systems we become unable to separate the natural from the artificial, real from unreal. Among scientists there is growing belief that artificial intelligence will never be achieved because without a body a computer cannot "feel," and therefore cannot experience intuitive and emotional information processing, which is the cornerstone of what it means to be a creative thinker.

"The hallmark of the post-medieval artist has been constant alertness. Its symptom is the sketch, or rather the many sketches, which precedes the finished work and, for all the skill of hand and eye that marks the master, a constant readiness to learn, to make and match and remake till the portrayal ceases to be a secondhand formula and reflects the unique and unrepeatable experience the artist wishes to seize and hold. It is this constant search, this sacred discontent, which constitutes the leaven of the Western mind since the Renaissance and pervades our art no less than our science."

Ernst Gombrich
<u>Art and Illusion</u>

On the following pages you will see eight stages of an intuitive gesture drawing in progress (**Fig. 4.5a-h**). **Fig. 4.5a** represents a rapid depiction of the approximate positioning of where things might be located. The marks relate only to the relative "where" and "how big" of these positions and purposely avoid any reference to individualized characteristics of the objects. At its beginning, an intuitive gesture is about size and placement of the spaces occupied by things (positive shape) and about the size and placement of spaces not occupied by things (negative shape). It is not about the things themselves. Making intuitive guesses about where things are is a fluid process and, as such, should not be viewed as right or wrong but as progressive stages of perceptual sensitivity. **Gesture drawings must be flexible, spontaneous, and continuously open to reevaluation, adjustment, and refinement.** The more carefully we look and the longer we can remain receptive, the better will be our understanding of the overall relationships among the complex visual patterns being perceived. At the earliest stages, therefore, you must "feel" your way along and avoid making marks that are definitive statements about spatial relationships that you have really only begun to experience and understand.

INTUITIVE APPROXIMATIONS

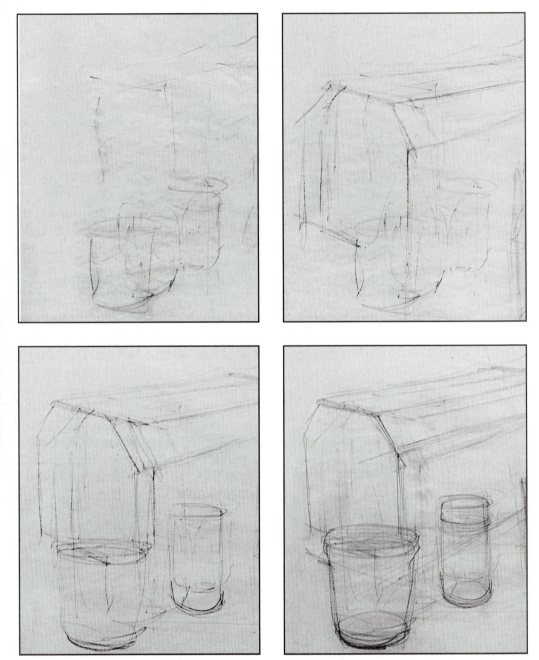

4.5a-d In its earliest stages, an intuitive gesture is primarily concerned with establishing a graphic notation that suggests the "where" and the "how big" of each of the visual elements. It is important to jump quickly from one element to another in order to develop all areas of the gesture simultaneously. It is helpful to gesture very lightly and delicately for the first three to five minutes of drawing.

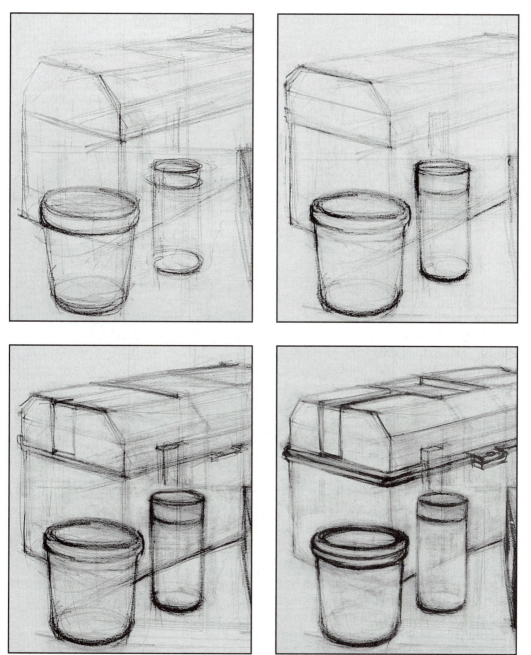

INTUITIVE GESTURE Part 2

4.5e-h The less specific the reference to shape or surface detail of the objects, the easier it will be to make any necessary adjustment to their size and placement. When the gestural notation becomes an enclosed, recognizable shape, we tend to encounter psychological resistance to altering it. Only after you are satisfied with the size and placement of your estimations should you begin adding specific detail to the objects.

When you apply rational information processing to your perceptions, you are relying on sequential analysis of the constituent parts of the objects, but this logical approach generally doesn't allow you to see the big picture. You "can't see the forest for the trees." In other words rational processing reacts to the separateness of objects more than to their interrelatedness. To grasp the big picture you must react intuitively and ignore details. Suspending rational processing when you begin a drawing demands mental toughness. The greater your tolerance for working through the predictable frustration that inevitably arises during this rapid, nonlinear, gestural estimate of the size and placement of the overall "whereness" of things, the greater will be your ability to resist falling back on the familiarity of symbolic, conceptual, rationalized representations.

An **intuitive gesture** is not a drawing of objects, **it's a flexible search for information about the placement, size, and relative proportion of "where things are" and of "where things aren't."** Specific edges, shapes, and/or detailed information of any sort during the first three to five minutes is usually an indication that you fallen back on a rational cognitive style and that you are not giving your sensuous

Ge ◆ stalt n. *a form or configuration having properties that cannot be derived by the summation of its component parts.*

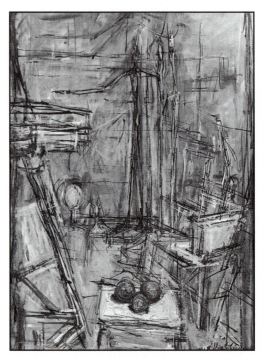

4.6 Albert Giacometti, *Studio with a man on the right and three women* (Private Collection). As can be seen in this drawing of the artist's studio by Giacometti, in an intuitive gesture drawing the emphasis is on line sensitivity and a rapid estimation of the relative position of the "whereness" of things as opposed to enclosed shapes and detailed renderings.

"The only occasion when the eye moves steadily and smoothly is when it is following a moving target."

Howard S. Hoffman

intuition the free reign it deserves in determining big picture spatial relationships (**Fig. 4.6**).

To encourage intuitive spatial processing it is recommended that you apply an exceptionally light touch with the drawing tool. This allows for a considerable amount of gesturing without clogging up the drawing surface. In fact, it can be helpful to start the intuitive gesture without even touching the paper. "Stealth" movement around the drawing surface allows you to consider size and placement information before making any marks at all. **When the pencil eventually does make physical contact, it should initially leave only the faintest notations of approximate placement, relative size, and estimations about the distance between the objects.** The pencil should skim lightly and rapidly across the surface, constantly flitting from one area to another, imitating as it goes the spontaneous, nonlinear, nonsequential, and impulsive movements of your eyes (**Fig. 4.7a-b**). These quick, darting movements that occur as the eye scans a visual field are necessary because the fovea (a tiny region in the back of the eye that is packed with rods) can only register about 2% of your visual field in sharply focused detail. Incredibly, this means that even though our field of vision extends

4.7a-b A human eye can focus on only a small area at any one time (2% of the visual field). We compensate by scanning the visual field with quick, darting eye movements.

PHANTOM GESTURE

to at least 180°, any object larger than a thumbnail at arm's length must be scanned if it is to be seen sharply focused.

At the risk of being redundant, the freshness of an intuitive gesture will be seriously compromised if you allow yourself to think too much about what you are looking at. Draw quickly and impulsively. Speed inhibits linear, logical mental processing. Moving the pencil quickly over the drawing surface and allowing it to mimic the erratic and complex scanning pattern of your eyes that we have just discussed, jumping freely around the page, greatly increases your responsiveness to the holistic complexity of your perceptions. Keeping a drawing fluid in this way means you must be prepared to tolerate a moderate degree of frustration over the lack of recognizable shapes. **You need to work through this frustration and allow your intuition a free reign.** The longer you delay clearly defining shapes and adding details, the greater the likelihood that your drawing will correspond accurately to your perceptions. Gesture drawings are most effective when the depiction of the objects remains sketchy and incomplete for as long as three to five minutes. Implementing the rational approach too early in the gesture process consistently produces unfortunate and

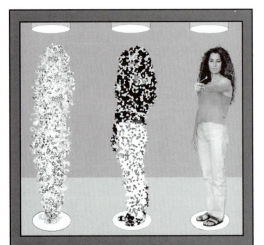

BEAM ME UP, SCOTTY

There is a striking similarity between the sci-fi transporter and an intuitive gesture drawing. Both start out with empty spaces, both introduce vague, generalized approximations of the size and location of forms, both become more detailed as the process gets into full swing, and both require a focused and knowledgeable operator if the transfer of information is to be successful. Of the two procedures, gesture is the simpler by far. Lawrence Krauss, a professor of physics at Case Western Reserve University, calculated that to operate a transporter one would need to heat matter to a million times the temperature of the sun, expend more energy than all of mankind currently uses, and improve computers by a factor of 1,000 billion billion.

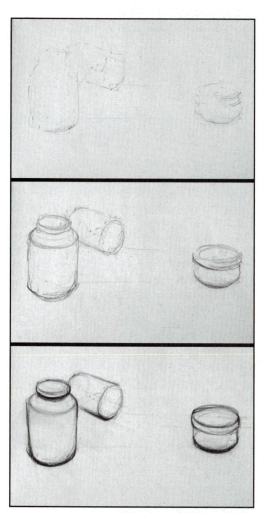

4.8 As you can see in the uppermost drawing, a loose and delicate notation of placement and relative size of all three objects was established in the very first minutes of the gesture process. This initial intuitive "guesstimate" of the big picture relationships is an intuitive right brain response to spatial relationships. Focusing on the "big picture" generally speeds the drawing process and increases your understanding of the relative placement and size of the objects in your visual field.

undesirable distortions of size, placement, and proportion. **Don't think, draw!**

As we again see in **Fig. 4.8,** a gesture drawing begins as vague, all-over notations of size, placement, and proportion and slowly, slowly evolves into a depiction of recognizable objects. Layers of delicate, energetic marks gradually congeal into the individualized "parts" of the perceptual "whole." When you can finally attach names to these emerging shapes, it is an indication that the rational, cognitive style is gradually reemerging. Rational thinking is both unavoidable and necessary, but you must consciously limit its interference with the immediacy of your initial perceptions. Even though there will be instances in this very text where you will be encouraged to apply conceptual analysis of objects as a means of increasing your visual understanding of them, do not allow yourself to consider rational symbolic depictions from preconceived ideas at the early stages of the intuitive gesture process. You must work at starting with a fresh eye and resist the natural inclination toward surrendering to formularized abstractions to represent what you see. Such rationalized abstractions limit your mental flexibility and erode your tolerance for the complexity of your perceptions. An intuitive

MENTAL FLEXIBILITY

gesture is a progressive process of **perception, evaluation, correction, and reevaluation.** You must be prepared to continuously make adjustments to your gesture drawing. You need to stay "loose" and resist the tendency to define emerging shapes and to fixate on details at the beginning stages. **When you start with a recognizable shape of an object, it is most frequently based more on what you think than on what you see.** When you begin a drawing relying primarily on a rational processing style, you are prone to produce generalized symbolic shapes and details. Implementing the rational processing too early in the gesture consistently generates unfortunate and undesirable distortions of size, shape, placement, and proportion. **Don't think, look!**

Unwanted rational information processing in the initial stages of gesture drawing reveals itself in two ways. First, you'll develop each of the objects individually (one at a time) rather than bringing all of them along simultaneously. Second, you prematurely define the shape of each object with a continuous and often wire-like line that closes back on itself, creating something that is easily identified by a word (i.e., bottle, box, etc.). When shapes that you can attach a name to occur in the first three to five minutes

THE MYTHOLOGY OF THE LEFT

Ancient myths consistently assign a female nature (anima, alma, shakti, yin) to the left side of the body and a male nature (virtu, yang) to the right. In Hinduism, the "right-hand path to the gods" was considered male, solar, and ascetic, while the left-hand path was female, lunar, and sensual. Maps have traditionally been drawn as if being viewed facing the celestial still point of the northern celestial pole. In this position the West is on the left and the East is on the right, with the West being identified as the female womb of Eternity. This ancient assignment of gender to the lateral division of the body is interesting in light of brain testing that began in the 1950s. Although it remains an area of scientific controversy, there are indications that the right hemisphere of the brain (which controls the left side of the body) is the primary location for intuition, empathy, fantasy, visual imagery, and a variety of other modes of information processing that are often grouped under the somewhat dismissive banner of "women's intuition."

PYGMALION'S MESSAGE

Stories from all over the world tell of a vital energy that is created when a representational image is completed. In Egyptian tombs, all hieroglyphics that depicted dangerous creatures were either left incomplete (removing the threatening element) or cut in two by incising a line through the middle of the image. Folk tales that tell of statues that have to be chained at night to prevent them from running away and of artists who refuse to put the final "finishing touches" on a work of art for fear that it will come to life are commonplace around the world. The familiar Greek story of Pygmalion tells of an artist whose reverence for and faithfulness to beauty is rewarded by Venus when she brings his statue of a woman to life. In *The Picture of Dorian Gray*, by Oscar Wilde, the painted portrait of Mr. Gray ages while Gray himself remains youthful. Completeness has traditionally been understood to generate a unique visual power.

of a gesture, the rational brain has become too actively involved in the drawing process. When a shape becomes recognizable, it is a dominating visual presence rather than an ambiguous, sketchy, searching intuitive gesture. Enclosed shapes in the early stages of an intuitive gesture are highly symbolic, and as such, they often relate more to what you know than to what you see. You are by nature more comfortable with enclosed symbolic shapes than with scratchy notations of intuitive gesture. **The brain is predisposed to respond to recognizable shapes, so it is easily understandable why you would gravitate toward them.** But during the first five minutes of an intuitive gesture you must resist rational and symbolic representations and concentrate instead on your immediate, flexible, spontaneous intuitive investigation. An enclosed shape is a definitive statement of conceptual fact. Be mindful that a closed, symbolic shape is psychologically far more resistant to being adjusted, moved, or erased than is a gestural suggestion of a shape that has developed slowly and has been kept sketchy, flexible, and open to change. Defining shape at the early stages of a gesture interferes with your perceptual accuracy. Focus, instead, on developing your drawing with intuitive, big picture sensitivity.

NAME THAT SHAPE

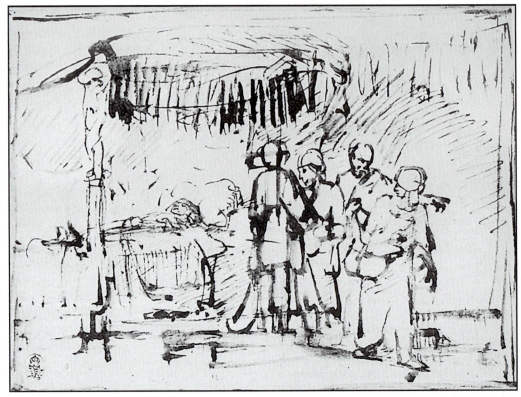

4.9 Rembrandt, *Peter at Deathbed of Tabitha* (Kupferstichkabinett, Dresden). This pen drawing illustrates Rembrandt's mastery over the sketchy, open, all-over, intuitive gestural approach that concentrates on the relationships of forms in space and sensitive mark making. Note especially that all parts of the drawing were being developed simultaneously.

Intuitive gesture, when coupled with concentration and self-discipline, will allow you to capture surprisingly complex and accurate spatial relationships as fluidly and as thought-free as are the movements of a trained athlete, dancer, or musician (**Fig. 4.9**).

SPATIAL CONTINUITY

CHAPTER 5 INTUITIVE PERSPECTIVE

Parallel convergence 45
Clock angle tool46
Imaginary clocks. 47
Clock angle transfer.48
Mechanical transfer 49
Keep it simple. 50
Rate of convergence 51
Eye-level variations 52
From top to bottom 53
Closer is lower 54
Lateral variations. 55
Added depth.56

Lines that are parallel in the real world and are receding from the observer appear, when depicted in a drawing, to converge at a single point. We are familiar with this convergence of "parallel" lines from the classic depiction of railroad tracks vanishing into a distant horizon (**Fig. 5.1**). As familiar as this image is, it is important to acknowledge that there is meaningful conflict between what is perceived (convergence of parallel tracks) and our rational understanding (Euclid's theorem that parallel lines never meet). We need to acknowledge this conflict because if we fail to anticipate and compensate for the influence of rational thinking on our sensory perceptions, we will consistently underestimate the apparent angle of convergence of receding parallel lines. Underestimating convergence flattens the illusion of space and seriously compromises your ability to estimate proportion and object placement in your drawing.

To overcome the tendency to rationalize and thereby underestimate the convergence of receding parallel lines it is recommended

5.1 "Parallel" lines appear to converge at a single point on the horizon as they move away from the observer.

that you apply the straight-edged **clock-angle tool** (**Fig. 5.2a-c**). The clock-angle tool, when held at arm's length and perpendicular to your line of sight, is capable of capturing the angular tilt of any receding line or edge of a rectilinear object in your visual field. When applied carefully the clock-angle tool contributes to a solid approximation of linear perspective (also called optical, scientific, or Renaissance perspective). Although we will address the mechanics, history, and underlying conceptual framework of linear perspective at considerable length in Chapters 14, 15, and 16, those technical and theoretical underpinnings are not, in all honesty, as critical to the actual making of an accurate representational drawing as is your ability to respond directly to your visual perceptions. The clock-angle tool focuses your attention directly on your visual perceptions. Holding the straight edge perpendicular to your line of sight and then rotating it until it is aligned with a receding edge reveals the apparent tilt of the edge to which it is applied. When the clock angle tool is applied in combination with intuitive gesture you are able to produce surprisingly effective depictions of three-dimensional spatial recession on a two-dimensional drawing surface. Look now, think later.

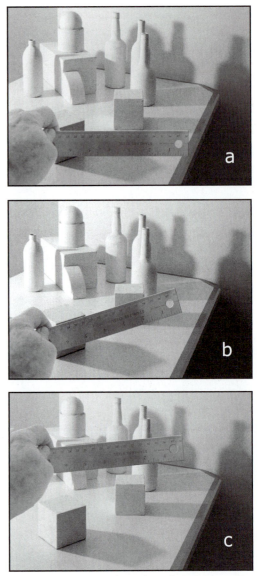

5.2a-c Any straight edge that is easy to hold and is at least 4" in length works well as a clock-angle tool. It is important to keep the clock-angle tool perpendicular to your line of sight when you are aligning the tool with the edge whose angular tilt you intend to capture.

CLOCK ANGLE TOOL

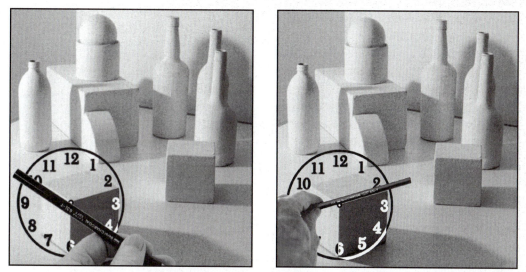

5.3a-b To keep your straight-edged clock-angle tool perpendicular to your line of sight it is helpful to imagine a floating analog clock face centered on an end point of the edge whose tilt you wish to determine. The clock-angle tool then becomes the "minute hand" of this imagined clock.

pic ◆ ture plane n.
1. An imaginary transparent "window" superimposed over the subject being drawn that is understood to be floating perpendicularly to the observer's line of sight and/or the imaginary transparent "window" through which the observer looks when experiencing illusionistic space
2. The actual flat surface, or opaque plane, on which the artist draws

A clock-angle tool gets its name from the fact that it can be used in combination with an imaginary, analog clock face understood to be floating perpendicularly to your line of sight (**Fig. 5.3a-b**). To take full advantage of the clock-angle tool, extend your arm fully toward the object and rotate your clock-angle tool until it is perfectly aligned with the receding edge you wish to analyze. **For the tool to work, you need to keep the straight-edged tool in the same plane as that of the imagined clock face, perpendicular to your line of sight.** Aligned this way the straight edge not only duplicates the angle of the receding edge but also mimics the position of what would be the minute-hand on your imagined

47

CLOCK ANGLE TRANSFER

5.4 By holding the straight-edge at arm's length and perpendicular to the line of sight (parallel to the picture plane), you can rotate it like the hand of an imaginary clock until it is aligned with the receding edge of the rectangular object.

clock face. Once the tool is aligned with the receding edge, you can transfer the angle to your drawing in one of two ways. You can either estimate where on the imaginary clock face the straight edge (minute hand) is pointing and then use this estimated clock position to reproduce the angle on the drawing surface (**Figs. 5.4, 5.5**), or you can lock your hand at the correct angle and then pivot slowly and deliberately until the accurately angled straight-edge comes to rest in the appropriate location on the drawing surface (**Fig. 5.6**).

When aligning the clock-angle tool with a receding edge, mimic the apparent angle of the edge but **don't mimic the actual**

5.5 You can use an imagined analog clock face on the drawing surface to duplicate any angle you observe in your visual field.

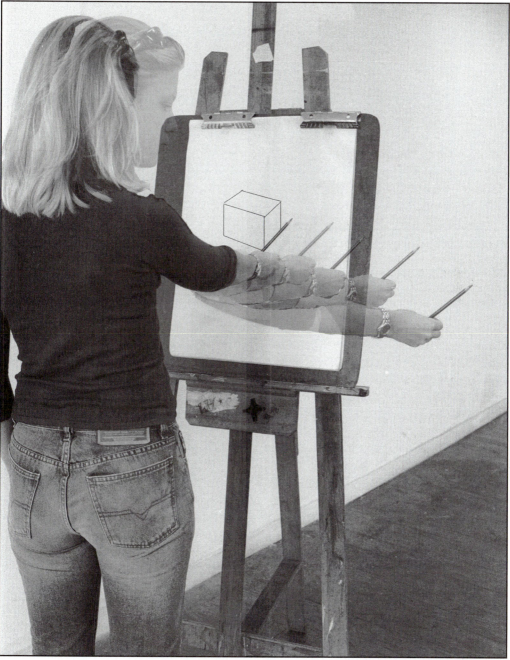

5.6 By carefully rotating your body while keeping your hand and wrist locked, the clock-angle tilt of a receding edge that you observe in your visual field can be transferred directly to the drawing surface. When transferring the clock-angle to your paper, take special care not to allow your wrist to rotate as you pivot toward the paper.

5.7a-b Avoid tilting the straight-edged clock-angle tool in the direction of the receding edges. When the tool is held in this position, it cannot effectively transfer observed angles mechanically to the paper surface. Tilting the straight-edge in this way also compromises your ability to estimate angles in terms of their relationship to the position of the straight-edge on an imaginary clock face (above left). Always keep the tool perpendicular to your line of sight, which is identical to keeping the tool and the clock face parallel with the picture plane (above right).

recession of that edge. Tilting the tool forward so that it leans away from you (oblique to your line of sight) undermines the tool's ability to mechanically transfer the angle because a tilted clock-angle tool cannot align properly when you rotate it toward the drawing surface. Tilting the tool in the direction of the recession also compromises the imaginary clock method for transferring the apparent angle of a receding edge to the drawing surface because you have no reliable sense of the coordinates of an imaginary clock whose planar orientation is tilting away from your picture plane (**Fig. 5.7a**). In contrast, the clarity, simplicity, and accuracy that result when you keep both the

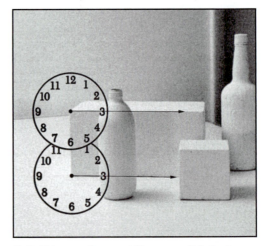

5.8 Edges of a rectilinear solid that are aligned parallel to the observer's picture plane appear as horizontal lines. They both are and appear parallel. In this one unique orientation, what we "know" and what we "see" are completely compatible. In a later chapter on perspective we will come to know this as a one-point perspective relationship.

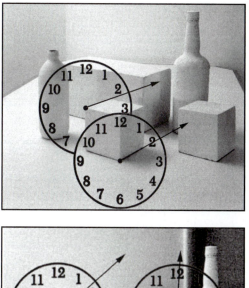

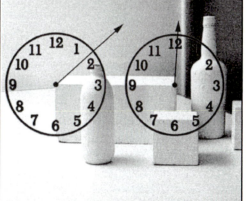

5.9a-b One factor that affects the apparent angular tilt of two parallel edges is the steepness with which the edges are moving away from the picture plane. In the top image the edges are receding moderately (approximately 50° from the picture plane) and have an apparent angular difference of approximately 12° (the equivalent of two minutes on a clock face). The more steeply receding edges in the bottom image (moving away from the picture plane at a 90° angle) differ by about 45° or 7.5 minutes. Additional factors that affect angular tilt can be seen on the following pages.

clock-angle tool and the imaginary clock face perpendicular to the line of sight (**Fig 5.7b**) make it well worth applying the clock-angle tool correctly.

Sets of edges that are parallel to one another and are perpendicular to your line of sight do not recede and do not appear to converge (**Fig. 5.8**). All parallel edges and sets of edges that are receding in space do appear to converge and do so at a single point. This optical phenomenon (convergence of receding parallel edges) occurs because the *apparent* angle of each individual receding edge *appears* slightly different from that of any other receding edge with which it is physically parallel (**Fig. 5.9a-b**). The difference in the perceived angle can be subtle or pronounced, depending primarily on three separate factors: how rapidly the actual edges of the rectangular solid tilt away from the observer's picture plane; the height relationship between the receding plane and the observer's eye-level; and the distance of the object from the observer.

Angles in the physical world that are formed by two edges that are 90° to each other can appear more than 90° (obtuse) or less than 90° (acute), depending on the angle from which they are being viewed. Vertically shifting

RATE OF CONVERGENCE

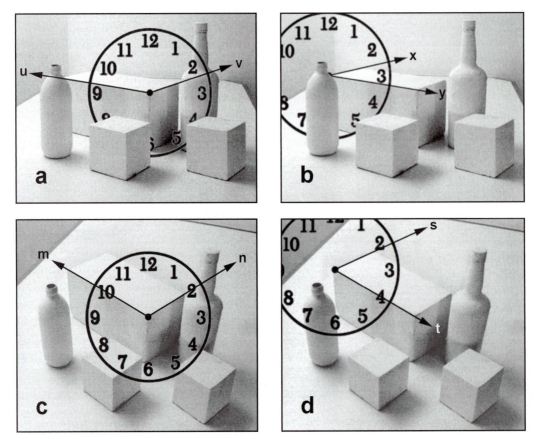

5.10a-d The sum of all the angles of a rectangle equals 360°. The same is true of the apparent shape (trapezoid) that represents the rectangular plane moving back into space. When viewing a rectangular plane that is receding in space, the right angles of that plane (concept) appear as either obtuse or acute angles (percept). The lower the eye-level, the more the obtuse angles expand toward 180° while the acute angles contract correspondingly (**a,b**). When your eye-level moves up, away from the top edges, the reverse occurs and both obtuse and acute angles move toward a 90° angle. In this case the obtuse angles contract and the acute angles expand (**c,d**).

one's eye-level produces substantially different apparent angles between receding edges of rectilinear forms (**Fig. 5.10a-d**). If the shift brings the edges of the rectilinear object closer to eye-level, the apparent angles move away from 90°. This means the apparent angles appear to move

ob ◆ tuse adj. *(of an angle) more than 90° and less than 180°*

a ◆ cute adj. *(of an angle) less than 90°*

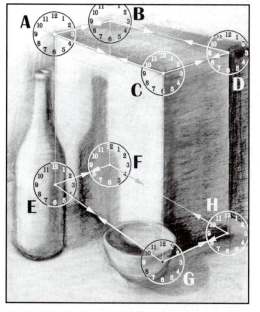

5.11 The bottom plane of a rectangular solid is by definition a duplicate of the top plane but one that is, obviously, further away from the observer's eye-level. As you can see in this illustration, the apparent angles of the bottom plane shift in the direction of a 90° angle. Acute angles expand toward 90° and obtuse angles contract toward 90°. The change in the appearance of its 90° angles is identical to what we just witnessed in the previous illustration: the vertical change was the result of a shift in the observer's eye-level.

either toward 180° or toward 0°. This change continues until the edges reach eye-level, at which point they appear as horizontal lines. As you might anticipate, the exact opposite happens when the observer's eye-level moves up from the edges of the solid. In this case, the apparent angles shift toward a 90° angle so that the acute angles expand and the obtuse contract.

An identical change in the appearance of the apparent angles of a receding rectilinear plane also occurs when it is the height of the plane that changes rather than the eye-level of the observer. This change is noticeable when you compare the apparent angles in the top of a rectangular solid with those at the bottom. In **Fig. 5.11,** each corresponding set of angles illustrates a recognizable shift in angle toward 90° when the observed plane is further away from the observer's eye-level (angles **A** and **E**, **B** and **F**, **C** and **G,** and **D** and **H**). Once again the apparent acute angles expand and the apparent obtuse angles contract toward a right angle.

Apparent angles shift toward 90° not only when the rectilinear planes move vertically from the observer's eye-level but also when the objects move forward in space relative to the position of the observer.

FROM TOP TO BOTTOM

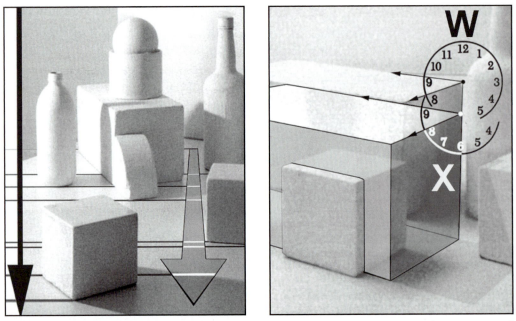

5.12a-b When a rectangular solid that is below eye-level is closer to the position of the observer (above left), it appears lower on the vertical axis of the picture plane. The apparent shift in the angles that occurs (above right) is also the same as that which occurs between the top and bottom planes of a box or when the observer's eye-level changes.

When objects that are below the eye-level are brought forward (or the observer moves closer to the objects), they appear lower on the vertical axis of the picture plane (**Fig. 5.12a**). As you will see in Chapter 7 (The Perceptual Grid), an object's movement toward the observer appears as movement down the vertical axis of the picture plane. Somewhat surprisingly, this apparent movement down the picture plane as an object moves forward results in the same angular shift that we experienced when the change was in reaction to change in the viewer's eye-level. As a rectilinear

OUTLINE vs. CONTOUR

Although the terms **outline** *and* **contour** *are generally used interchangeably, they have different meanings in a drawing. An outline is understood as a mechanical, unchanging line that surrounds a flat shape. A contour is a constantly changing line representing the outer edge of a three-dimensional form.*

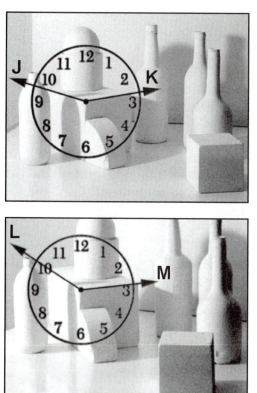

5.13a-b When the observer moves laterally in relation to a rectilinear object, the angles formed by its receding perpendicular edges also appear to change. Between the top and bottom photographs the observer has moved slightly to the right and this has resulted in a clockwise angular shift that creates a more steeply receding line segment **L** moving approximately twice as far in the clockwise direction as line segment **M**.

par ◆ al ◆ lax n. *the apparent displacement of an observed object due to a change in the position of the observer*

plane comes forward, its apparent angles shift in precisely the same manner that was observed in the two previous examples (acute angles expand and obtuse angles contract) (**Fig. 5.12b**).

If the observer moves laterally in relation to the observed objects, the angles again appear to change but the change is different than in the previous examples. A lateral shift in the position of the observer causes all sets of receding parallel edges to rotate around the imaginary clock face. Both edges move in the same direction around the clock face, but the edge that is tilting most sharply away from the observer moves in larger increments than the edge that is nearer to the horizontal axis (**Fig. 5.13a-b**).

As we have now seen in a variety of cases, change in the viewing position of the observer, either vertically or horizontally has an immediate impact on the apparent angular tilt of the receding edges of observed rectilinear forms. This amounts to an important reminder that **it is absolutely essential to maintain a fixed viewing position throughout the entire drawing process in order to render accurate depictions of planar recession with the clock-angle tool**.

LATERAL VARIATIONS

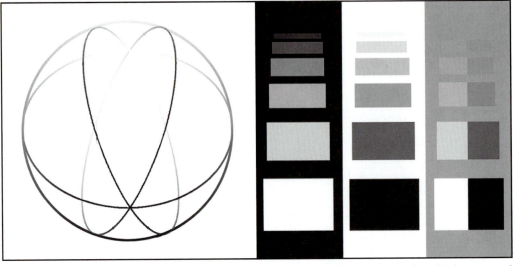

5.14 We reinforce the illusion of three-dimensional space by varying the thickness and contrast of lines as they move into the distance. This is known as atmospheric perspective. It is based on the perceptual principle that objects nearer to the observer appear more focused and in greater contrast to the background than those further away.

The clock-angle straight-edge is a most valuable addition to our observational drawing tool kit. Although a more formal presentation of the underlying principles and mechanics of linear perspective will be presented in Chapters 14, 15, and 16, the basic mechanics of the clock-angle tool are all you need to capture highly accurate estimates of angular recession of lines and/or planes in perspective so that they appear to exist in coherent and unified space. When intuitive gesture, sensitive contour line variation, and exaggerated atmospheric perspective are combined with intuitive perspective (the clock-angle tool), the illusion of three-dimensional recession is enhanced (**Figs. 5.14, 5.15**).

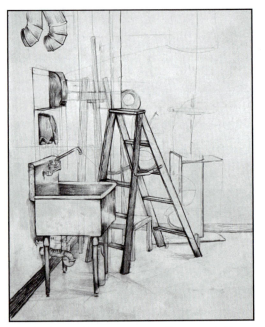

5.15 Sensitive contour line variations and exaggerated atmospheric perspective can be used to effectively communicate spatial depth in a drawing.

CHAPTER 6 POSITIVE/NEGATIVE SHAPE

Figure/(back)ground 57
Shape identification. 58
Perceptual switch 59
Psychological importance . . 60

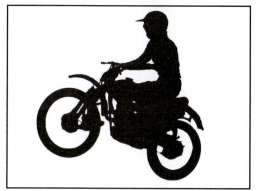

6.1 The black figure above can be distinguished from the (back)ground by the ease of its identification and by the specificity of the names that we can attach to it.

It has been suggested that our survival as a species is, in large measure, dependent on our ability to recognize and identify meaningful shapes in our surroundings. We are the descendants of individuals whose visual sensitivity enabled them to escape the saber-toothed tiger while there was still time, of sharp-eyed gatherers who could spot food when it was scarce, and more recently of agile pedestrians who made it across busy streets before the cars came speeding by. This long chain of biological survival has programmed our eye and brain to assign particular importance to self-contained shape because there is a distinct evolutionary advantage in being able to identify objects (tigers, fruit, automobiles, etc.). Identifying these shapes depends on your ability to distinguish them from their surroundings.

Traditionally, we refer to the identifiable shape as the **figure** and the surrounding area as the (back)**ground** (**Fig. 6.1**). A figure generally attracts more attention than the (back)ground and is said to carry more visual

FIGURE/(BACK)GROUND

SHAPE IDENTIFICATION

"weight" than the surrounding area. The need to identify shape is so ingrained in our perceptual mechanisms that it is nearly impossible to look at **Fig. 6.2** without seeing a white triangle as the strongest visual element in the composition even though, technically, there is no such triangle in the picture. This propensity to join diverse elements together to form meaningful figures is called **closure** in Gestalt psychology. The importance of identifiable shape is also implicitly encoded in the hierarchical terms that we use to describe the figure-(back)ground relationship. We call the identifiable figure the **positive shape.** It implies goodness, rationality, and importance and refers to shapes that can be named or described with words. **Negative shape** is used to describe the (back)ground. It carries with it the suggestion of insignificance. In everyday use it refers to ambiguous and undifferentiated space whose most noteworthy characteristic is that it serves as the place in which positive shapes can be found.

Everyday visual perception is rooted in identifying positive shapes. When an image provides insufficient clues as to which shape is dominant, it produces spatial ambiguity most commonly known as **figure-**(back)**ground reversal.** When viewing an image with

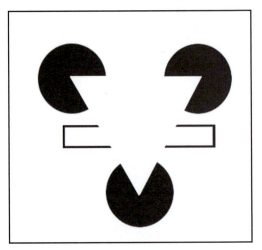

6.2 We are so powerfully predisposed to respond to identifiable shape that when we encounter an image where the arrangement of positive shapes suggest an easily identifiable shape in what is ordinarily understood to be background, we project meaning (positive shape) by choosing the simplest visual solution, even if that means constructing a positive shape out of the background (negative shape). This predisposition makes it difficult to look at the illustration above without seeing a crisply delineated triangle in the center of the composition even though there is no triangle depicted. The predisposition is so powerful that you begin to see edges to the triangle where none actually exist. Gestalt psychologists call this tendency to mentally construct implied shape *closure*.

Gestalt psychology *a type of psychology focusing on the mechanisms by means of which a subject responds to the totality of the image (integrated wholes) rather than its constituent parts*

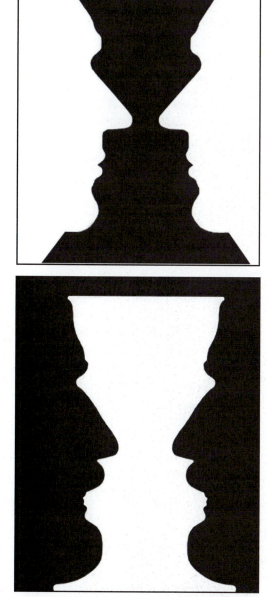

6.3a–b In the classic illustration of figure-(back)ground ambiguity the viewer can choose to see either the faces or the cup, but not both at once.

figure-(back)ground reversal, you can flip a shape in or out of dominance simply by concentrating on it as the positive image (**Fig. 6.3a–b**). By consciously shifting your attention back and forth between the black and the white shapes, you can actually begin to "feel" the flip of your "perceptual switch" as one figure takes center stage and the other dissolves. Our brain responds to only one figure at a time, so that with a completely ambiguous image the area surrounding the "figure" forfeits its object clarity as soon as it is relegated to the status of non-differentiated background.

When you draw from observation, there is usually considerably less spatial ambiguity. You naturally respond to the clarity and visual appeal of the positive (figure) shapes while essentially ignoring the "negative" space surrounding them. This tendency, while it is an effective perceptual mechanism for reacting to things of biological importance, becomes a pronounced handicap when you are attempting to reproduce your perceptions on a two-dimensional drawing surface. After all, putting your perceptions down accurately and developing control over the dynamics of pictorial composition are as dependent on the relationships among objects and the spaces in between them as they are on the shape of the objects

themselves. Not only are we unfamiliar with focusing our attention on negative shapes in our visual environment, we even have difficulty talking about them. We have names for positive shapes, but negative shapes can only be clumsily described as **shapes that are meant to represent the spaces where the objects of biological importance are not**. With images that have clearly established figure-(back)ground relationships (**Fig. 6.4a**) it takes considerable conscious effort to flip the negative shape forward. The visual weight of a recognizable figure normally overpowers the background even when the surrounding shapes have very distinctive visual characteristics (**Fig. 6.4b**).

Focusing on background shape and assigning it the kind of psychological importance that is ordinarily given only to things with clear object identification such as chairs, flags, or bottles demands a surprising amount of concentration. But to draw accurately you must cultivate the ability to fixate on and identify empty negative shapes despite the fact that it is an unnatural process. Negative shape recognition is an extremely effective technique for helping determine proportion, placement, and size of the positive shapes in your drawing.

6.4a–b Shapes that suggest easily identifiable objects (girl drawing on drawing bench) receive more visual attention than do shapes that have no language-based identification. Interestingly, background shapes, when isolated against a neutral background, often display surprisingly engaging visual characteristics. Learning to concentrate on the specific character of each negative shape in your visual field will contribute mightily to the accuracy of your drawing.

CHAPTER 7 PERCEPTUAL GRID

The X/Y axes 61
Universal symbols.62
Hail Mondrian! 63
Conceptual conflicts 64
X/Y axis alignment65
Perceptual grid 66
"Mondrian" lines67
Delicate web of grid lines. . 68
Parallax69
Keep it on the paper 70
Fixed viewing position. . . . 71
Spatial analysis 72
Levels of content73
Complex relationships74

"The constant search for unique and ever more discriminating experience constitutes the core of the Western mind since the Renaissance and pervades our art no less than our science."

E. H. Gombrich

THE X/Y AXES

Humans possess a natural perceptual predisposition toward the vertical and horizontal. Our sensitivity to what is straight across and straight up and down serves as the fundamental baseline against which we constantly compare and contrast the orientation of objects in our visual field. Our reliance on this **x/y perceptual grid** is so deeply embedded in our consciousness that references to its **x/y axes** regularly serve as metaphors for dignity, truth, strength, well-being, balance, and stability. As we mature we are encouraged to "grow up straight and strong," to be "level-headed" in our decisions, to be "square" in our dealings with others, and to "stand up" for what is important to us. This same predisposition toward the vertical and horizontal is also reflected in timeless cultural symbols. The x/y axes dominate the visual character of the *ankh* (the Egyptian hieroglyph for life), the *Hindu Tantric six-pointed star* (more commonly known as the *Star of David*), the Roman *Vesica Pisces* (the pointed oval of the Universal Mother), the Greek five-pointed *Pythagorean star*, the *Christian Crucifix*, and

7.1 The Egyptian symbol for life (*ankh*), the almond-shaped symbol of the Universal Mother (*Vesica Pisces*), the Greek pentangle of good omen (Pythagorean star), the Christian Crucifix, the interlocking triangles forming a six-pointed star (Star of David), and the astronomical (and astrological) symbol for planet Earth, the Cross of the Zodiac, are all organized in accordance with the x/y grid that serves as the perceptual baseline of our visual experience.

the astrological symbol for Earth (**Fig. 7.1**). These symbols reflect the ordered cosmic world-view of our ancient ancestors. Each design, either explicitly or implicitly, utilizes the vertical and horizontal perceptual grid as the foundation of its pictorial organization. This shared underlying structure probably tells us as much about the importance our cultural ancestors attached to the x/y axes as it does about the specific beliefs of any of these venerable traditions.

Our spatial sensitivity to the x/y axes can easily and effectively be transformed into an observational drawing tool. By once again taking a straight-edged object and this time aligning it to the **x** or **y** axis, and then holding it in front of objects in your visual field the straight-edge becomes the basis of comparison for identifying both

7.2 In his *Homage to Piet Mondrian* the author attempted to capture the pictorial order and compositional equilibrium that distinguish Mondrian's paintings. His compositions were derived from the study of ancient wisdom and sacred symbols. Because x/y axis relationships dominate his compositions, the straight-edge used to establish the perceptual grid will be referred to as the "Mondrian tool."

 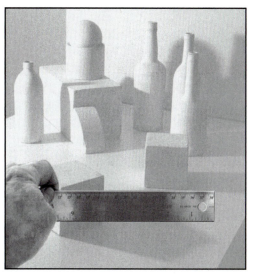

7.3a-b Any easily held straight-edged tool—pencil, ruler, stick, and so on—that is at least four inches in length can be used as a Mondrian tool. To function properly it must be held so that the straight-edge is perpendicular to your line of sight.

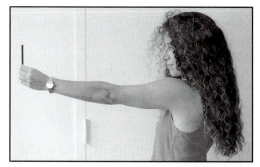

7.4 The Mondrian tool, a straight-edge aligned to either the vertical or horizontal axis that is held perpendicular to your line of sight, serves as a movable x/y axis that can be projected onto both your field of vision and the surface of your drawing. Establish your **x/y** orientations while looking straight out in front of you (toward what would normally be the horizon) before carefully moving it to check alignments in either your visual field or your drawing.

the **x** or **y** axial relationships. In homage to the modernist painter Piet Mondrian, whose paintings are structured around the x/y axes, we will refer to our straight-edge as the *Mondrian tool* (**Fig. 7.2**). The Mondrian tool serves as a moveable x/y axes grid that can be projected onto both your field of vision and the surface of your drawing (**Fig. 7.3a-b**). It works best when held perpendicular to your line of sight (parallel to your picture plane) with your arm fully extended (**Fig. 7.4**). This tool provides a surprisingly simple yet effective way to collect important visual information about the placement, size, shape, and even the proportion of objects in your visual field and allows you to accurately transfer that information

CONCEPTUAL CONFLICTS

to your drawing. By applying a delicate grid of Mondrian lines to the surface of your paper that duplicates the x/y axis relationships that occur in your visual field, you concretize your perceptions of the relative placement and size of the objects in your drawing (**Figs. 7.5**).

Considering how powerfully attuned we are to the x/y axes, you might be curious as to why it is necessary to go to the trouble of learning to use a Mondrian tool. The reason is simple. The Mondrian tool helps us distinguish between what we actually see and what we think about the objects in our visual field. As we saw in the previous chapter, we need to constantly work at preserving the integrity of our visual perceptions and minimize our dependence on rational thought processing. Rational information processing interferes with our ability to react directly to what we see. Rational thought processing frequently substitutes what we know for what we perceive. For example, rectilinear objects sitting flat on the ground plane (the floor) do not always appear as horizontal (x axis) or vertical (y axis). We do, however, have a tendency to mistakenly presume that the edges of a rectilinear object sitting flat on the ground appear as horizontal lines even though a simple application of

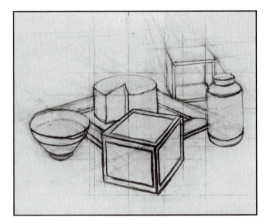

7.5 Using a Mondrian tool to superimpose an **x/y** perceptual grid of Mondrian lines on the objects in our visual field allows us to identify when salient features of an object are vertically or horizontally aligned (or not) with salient features of other objects.

LINE VARIATION

Line variation not only engages the eye, making the drawing more enjoyable to look at, but it also contributes directly to the illusion of space.

Creating space by varying the thickness and darkness of line

1. When a line is closer to the observer
2. When a line is underneath object to indicate weight
3. When a line represents the edge of an object that overlaps another object
4. Contour lines (outside edge of 3-D forms) should vary from thick to thin

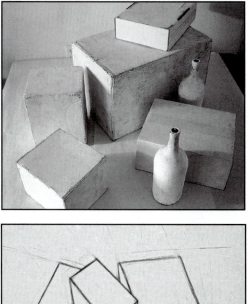

7.6a-b Because of the complexity of the optics involved in human sight, the concept that a rectilinear object that is sitting on the ground has sets of edges that are parallel with and perpendicular to the ground plane does not always correspond to our immediate perception of those edges. As we can see in the "bird's-eye view" above, edges that we would ordinarily refer to as straight across or straight up and down often appear as oblique angles. We will address issues of bird's-eye view and other three-point perspective relationships in detail in Chapter 16.

the Mondrian tool will quickly and clearly demonstrate that they appear to the viewer as oblique angles (**Fig. 7.6**). This tendency to conceptualize spatial relationships in your visual field and presume rather than perceive orientations is so pervasive that it frequently overpowers your ability to recognize when lines or edges in your environment appear tilted. **What we "know" is frequently not what we "see."** Drawing from observation demands that you be able to distinguish the apparent (what you see) angular tilt of all edges in your visual field from their conceptual orientation (what you know). The Mondrian tool, properly applied, is a marvelously effective tool for making sure that we can distinguish this difference.

This tendency to conceptualize the orientation of objects in your visual field is so pervasive that it is actually necessary to make sure that this rationalizing tendency doesn't distort the way you utilize the Mondrian tool. If you attempt to align your straight-edge while holding it in front of an object in your visual field, you run a considerable risk that your rational understanding of that object's orientation will interfere and substitute inaccurate preconceptions in place of your direct intuitive sense of the vertical and horizontal.

X/Y AXIS ALIGNMENT

To safeguard the immediacy of your perceptions you need to establish the alignment of your Mondrian tool to the vertical or horizontal axis while staring at a blank wall or neutral space (**Fig. 7.7**). Once you have successfully aligned your straight-edge in this way with either the x or y axis, you can then move it in front of any two elements that you intend to compare. It is important to **start fresh** every time you use your Mondrian tool. Constantly realigning your Mondrian tool protects your spatial intuition and prevents your direct perceptions from being influenced by what your rational mind "knows."

The Mondrian tool is intended as a supplement to intuitive gesture, not as a substitute for it. It should be applied only after you have made extensive sketchy references to the "where" and the "how big" of each and every element that you intend to draw. Once you have established your extensive gesture, the Mondrian tool is then applied to generate numerous vertical and horizontal comparisons between any two prominent elements within your visual field. These perceptual grid comparisons should then be transferred to the drawing as a corresponding delicate web of vertical and horizontal lines (**Figs. 7.8, 7.9a-b, 7.10**).

7.7 The most reliable way to align your straight-edged Mondrian tool is to position it where there are no objects in your line of sight. A blank wall works best. After aligning it, carefully lower the straight-edge until it is in front of the objects you intend to analyze.

7.8 Mondrian grid lines are most effective when used to compare relative positions at opposite ends of the composition (e.g., the right edge of the umbrella near the top to the tricycle at the bottom).

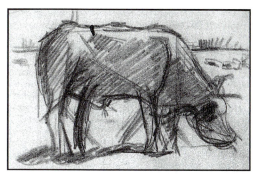 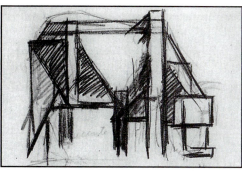

7.9a-b Theo van Doesburg, *Study 1 and Study 3 for Composition (The Cow)*, 1917 (MOMA, NY). This artist was closely allied with the ideas and aesthetic approach of Piet Mondrian. He was so sensitive to the presence of the vertical and horizontal in his visual surroundings that when he did several studies of a cow, the cow all but disappears from the last drawing. Although you are being asked to work in the opposite direction (toward more accurate rendition of what you see), both approaches share a fundamental appreciation for the importance of the x/y axes to perception.

7.10 The gesture drawing above is an excellent example of a thorough and effective application of delicate **x/y** axis grid lines. As with the other student drawings in this chapter, the perceptual grid provided the mechanism for creating remarkably accurate estimations of sophisticated spatial relationships.

Applying the Mondrian tool before you gesture restricts your spontaneity (**don't do it**) and causes you to lose sight of the "big picture" relationships. **Intuitive gesture first, Mondrian second.** Apply the grid as often as necessary and then apply it some more. **Whenever you encounter discrepancies between your initial gesture drawing and the complicated web of x/y grid lines, change your gesture so that it corresponds to the spatial grid.** Making sure that the **x/y** relationships in your gesture drawing conform to those in your visual field increases the accuracy in the placement, the size, the proportion, and even the shape of the objects that you are observing. When the Mondrian relationships in your drawing match those in your visual field, your drawing is alive and well.

7.11 Superimposing an extensive, delicate web of x/y perceptual grid lines on an intuitive gesture drawing provides an effective mechanism for evaluating the accuracy of your initial estimates in determining the "where" and the "how big" of the elements in your drawing.

To accelerate the development of your skills in intuitive gesture, clock-angles, positive/negative shape, and the perceptual grid, it is recommended that you make a concerted effort to keep each and every object you intend to draw within the borders of the draw-ing surface (**Figs. 7.11, 7.12**). Keeping everything on the page forces you to deal more intensely with issues of placement and size, and while it might raise the frustration level slightly, this dis-comfort is solidly offset by the confidence and control that it will eventually provide.

7.12 Mondrian grid lines should be applied to your drawing only after you have intuitively estimated the size and place-ment of each of the objects. Applying the Mondrian tool before your loose and flexible intuitive estimations of size and location inhibits your engagement with the overall composition.

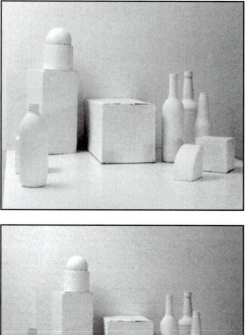

7.13a-b As we saw on page 55, with objects that are relatively close to the observer, even a slight change in the viewing position results in a substantial change in how the objects appear relative to one another (parallax). Drawing from observation requires a fixed viewing position. Drawing from more than one position (parallax) compromises the integrity of an observational drawing.

In an earlier chapter you learned that regularly stepping back from your drawing keeps your eye from getting stale and complacent. However, keep in mind that after stepping back it is equally important to return to the precise viewing position from which you began when you resume drawing. Any shift in your viewing position will cause considerable changes in the relative positions of the objects and the relative angles of their receding edges (*parallax*) (**Figs. 7.13a-b, 7.14, 7.15a-b**). Even shifting your weight from one leg to the other changes how objects appear in relation to one another. **Always draw from the same fixed viewing position.**

As your intuitive gesture develops, you should generously apply Mondrian lines at each progressive stage to establish x/y grid alignments between each and every noteworthy visual characteristic in your visual field. The linear grid of delicate weblike lines that gradually develops on the drawing surface embodies your perceptual sensitivity to the **x/y** axes. The spontaneous marks of the gesture and the gossamer **x/y** grid add a textured richness to the surface while expanding the drawing's content to include the perceptual process itself. A perceptual drawing is as much about perception as it is about the objects being depicted.

7.14 In 1435, in his treatise on painting (De Pittura), Leon Battista Alberti discussed the construction of a simple tool for the direct transcription of objects as they appear to the eye. He suggested weaving thread in a network of parallel squares on a wooden frame. By viewing objects through this "intersection" from a *fixed viewing position*, the arrangement of forms in space can be duplicated on a drawing surface that is divided into similar squares. Leonardo, Raphael, and Albrecht Dürer, along with countless other artists, designed similar mechanical drawing devices to study nature. Leonardo is on record, however, as having been critical of those who could not draw without this type of mechanical assistance. Today photography and digital imaging have replaced Alberti's "veil" as the artists' preferred tools for gathering visual information. Meanwhile, the debate about whether mechanical imitation leads to aesthetic and intellectual barrenness continues unabated.

7.15a-b Alberti's proposed mechanical drawing device is too impractical for most artists, but his description remains an effective model for visualizing how the picture plane functions. The two images in this illustration depict the *imaginary window* through which the observer is viewing several objects from a fixed viewing position. In these illustrations the white dots represent those points where the line of sight intersects the imaginary picture plane. As the line of sight shifts further back in space, the progressive depth appears as movement up, higher on the picture plane. For the majority of drawings this relationship holds true, but when the line of sight goes above eye-level, objects higher on the picture plane are closer.

70

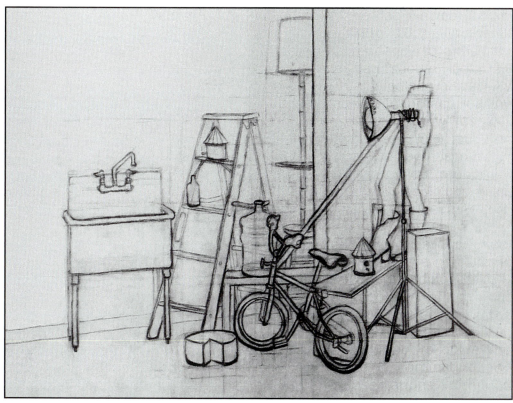

7.16 In an extended gesture drawing (a half-hour or more) keeping each object within the borders of the paper is an excellent way to become more sensitive to the "big picture" relationships. This restriction forces you to work directly and flexibly while determining the maximum size that still allows everything to fit on the page.

pic ◆ ture plane n.

1. the actual flat surface, or opaque plane, on which an artist draws

2. an imaginary transparent "window" that the observer superimposes over the subjects being drawn and/or the imaginary transparent "window" through which one looks when experiencing illusionistic space

When you combine the perceptual grid with an intuitive overview of complex relationships in space (intuitive gesture), an intuitive perspective, and a positive/negative shape sensitivity in **an extended gesture** of twenty minutes or more, you have at your disposal all that is necessary to capture complex spatial relationships (**Fig. 7.16**). Your drawing needn't be detailed or "finished" to be successful. It need only be an energetic overview of the

FIXED VIEWING POSITION

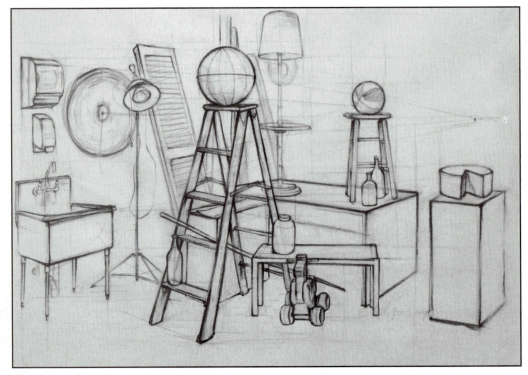

7.17 An extended gesture drawing has multiple levels of content. With the help of the perceptual grid an extended gesture reinforces your intuitive estimates of the relative size of each object, and the location of each object in relation to the others, as well as revealing the location of specific visual characteristics of the objects themselves. Sensitively tying this spatial analysis together is line variation.

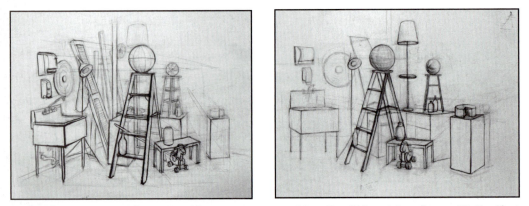

7.18a-b Starting with an intuitive gesture provides the "big picture" sensitivity that enables you to properly estimate the size of the objects so that everything fits on the page. We will discuss compositional dynamics in Chapter 17 that often include intentionally allowing objects to go off the edges, but for now it will increase your spatial sensitivity to work at keeping it all on the page.

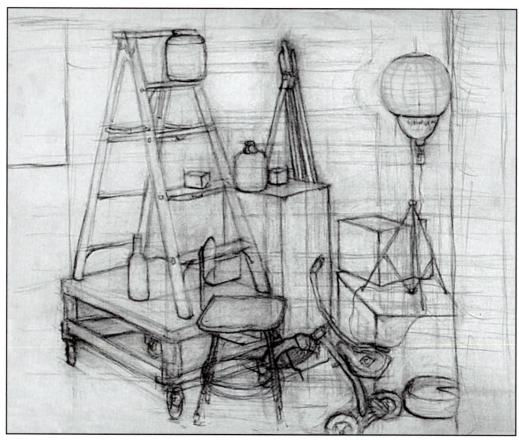

7.19 If you generously apply perceptual grid lines, clock-angles, positive/negative shape correspondence, and the proportion tool at each and every stage of an extended gesture drawing, you will gradually fine-tune your initial intuitive estimates and arrive at surprisingly accurate depictions of sophisticated spatial relationships.

7.20 An extended gesture of the relation of forms in space is open to continual adjustment.

relation of forms in space and remain fluid, flexible, and open to continual adjustment (**Figs. 7.17, 7.18a-b, 7.19, 7.20**). It should be evident from the student drawings reproduced in this chapter that convincing illusions of objects in space can be captured in a drawing through a rigorous application of these surprisingly simple yet effective techniques (**Fig. 7.21**).

LEVELS OF CONTENT

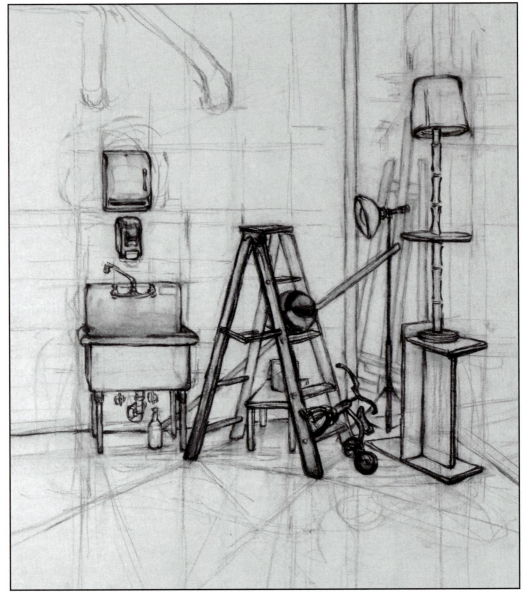

7.21 The extended gesture drawing above was worked on for approximately five to six hours (two class periods and a two-hour weekend homework session). At this point in the semester, students have little or no clear understanding of the spatial mechanisms underlying linear perspective but are nonetheless able to resolve complex spatial relationships by relying heavily on intuitive gesture, intuitive perspective, and by generously applying a delicate grid of Mondrian lines.

COMPLEX RELATIONSHIPS

CHAPTER 8 PROPORTION

Ratios and relationships 75
Intuitive comparisons . . 76
Duplicating proportions 77
Proportion tool 78
Basic unit of comparison 79
Larger to smaller 80
Smaller to larger 81
Constant proportions . . 82
Cylinders vs. planes . . . 83
Double-wide cylinders. . 84
Foreshortened cylinders 85
Planar foreshortening . . 86
Conceptual interference 87
Proportional recession. . 88
Center of rectangles . . . 89
Inflated perception 90
Size constancy 91
Interior proportions . . . 92

A proportion is the comparative relationship between two things with respect to size, amount, or weight. Medical professionals, for example, calculate one's ideal weight in relation to one's height. Proportion in drawing generally refers to relative size and is commonly used to compare the exterior dimensions (width/height) of a shape or an object, the relative size of its constituent parts, the size of any of its constituent parts in relation to the whole, or the overall size of a shape or object as compared to another shape or object.

Study the pairs of line segments in **Fig. 8.1** and work at developing your sensitivity to the size relationship of each pair by mentally comparing the lengths of the line segments. Before attempting to use a mechanical tool to calculate each proportion, "feel" the relationship. Don't measure; rely instead on your intuition. Do any size comparisons appear the same? (The first and fourth pairs of lines are identical in proportion even though they are very different in size—the size order has been reversed.)

RATIOS AND RELATIONSHIPS

8.1 This illustration contains five pairs of line segments of varying proportions. Can you detect whether any two pairs from this series share identical proportions?

From the line segments above we can also construct a series of rectangles with corresponding proportional relationships (**Fig. 8.2**). The uppermost rectangle is half as wide as it is tall, the second rectangle is as wide as it is tall (a square), and the middle rectangle is approximately 1.6 as wide as it is tall. This last proportion, known as the Golden Mean, has intriguing mathematical and scientific characteristics that, along with a long and rich history in art and architecture, will be discussed in the next chapter. The fourth rectangle from the top is twice as wide as it is high, whereas the bottom rectangle is three times wider than its height.

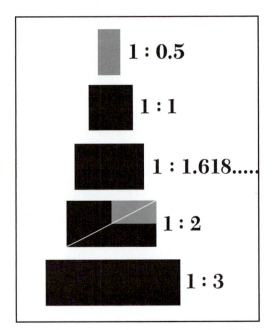

8.2 The first and fourth rectangles differ in size but are identical in proportion. When two rectangles share a corner, two edges, and a diagonal, they are identically proportioned.

8.3a-b All rectangles that share a diagonal when two of their edges are aligned are identical in proportion. We can use this characteristic to establish the maximum proportional surface area when transferring an image to papers of different sizes (**b**).

As was true with the line segments, the first and fourth rectangles are identical in proportion. Proportion is a statement of relative size, not physical size. Physical size is not a factor in determining proportion. The fact that they have considerably different dimensions and that the orientation has shifted 90° does not affect the ratio of the sides of each rectangle. That the first and fourth rectangles are of identical proportion is reflected in the fact that they share a common diagonal when they are aligned at a corner and along two of the edges (**Fig. 8.3a**). This sharing of a diagonal by identically proportioned rectangles of varying sizes provides an easy-to-use method for duplicating proportion when you need to transfer an image to a larger or smaller drawing surface (**Fig. 8.3b**).

Turning your attention to the proportions of everyday objects is a good way to begin developing sensitivity to proportion. The standard newsprint pad has a 1:1.3 ratio, which also happens to be the proportions of old-fashioned TV screens and early computer monitors. Credit cards, drivers' licenses, 35mm negatives, and business cards are approximately 1:1.6, while the standard plastic CD carrying case is just slightly off square at 1:1.1.

CHAPTER 8: PROPORTION

The more you practice relying on your intuition to establish the proportions of an object, the more accurate you'll eventually become in your initial estimates. Making rapid gestural "guesstimates" of the proportion of objects is an essential step in processing perceptual information. Once you have gestured the proportion of an object, it is always a good idea to check your estimate. With the same straight-edged tool that served us well in determining the angle of receding edges and the x-y axes of the perceptual grid, you will now be able to establish a flexible unit of measure with which to compare the proportion of any two linear dimensions that appear in your visual field (**Fig. 8.4a-b**).

To create a proportion tool, hold the straight-edged, tool perpendicular to your line of sight **at a constant distance from your eye.** Keeping it at a constant distance allows you to establish a consistent unit of measure when comparing the relative size of any two dimensions. You can use this straight-edged proportion tool to calculate the relative size of one object to another, the overall dimensions of a single object, the relative size of a part to the whole, or the relative sizes of two constituent parts. Each comparison is achieved by holding the tool in front of the first of the two

8.4a-b When using a straight-edged tool to determine the proportion between any two dimensions, it is critical that you hold the tool perpendicular to the line of sight and at a constant distance from the eye while you make the comparison. Extending your arm to its full length is the most dependable way to ensure that the unit of measure established by the straight-edge is consistent throughout the comparison. Sometimes the straight-edge is too small to encompass the dimension of the object(s) when your arm is fully extended. If this is the case, bend your elbow to bring the tool closer to your eye. When your arm is not fully extended, extra care is required to prevent the proportion tool from edging closer to or away from your eye while making the comparison. Maintaining the straight-edge at a constant distance from your eye while making a size comparison is absolutely crucial to determine an accurate proportion with this straight-edged tool.

8.5a-b A straight-edged proportion tool (in this case a charcoal pencil) is being used to establish a consistent unit of measure with which to compare the overall horizontal dimension of a bottle to its overall vertical dimension. Once you have established a basic unit of comparison, you can carefully rotate the tool 90° while making sure to keep it perpendicular to your line of sight and at precisely the same distance from your eye. In this way you can accurately compare the width to the overall height.

dimensions you want to compare by adjusting the exposed portion of the straight-edge so that it matches the dimension you are looking at. Once you complete this first step, carefully rotate the tool 90° (**REMINDER: keep tool at a constant distance from the eye throughout the comparison**). After rotating the tool 90° compare the tool's exposed length to that of the second dimension (**Fig. 8.5a-b**). In this illustration the smaller dimension was used as the base unit of comparison,

BASIC UNIT OF COMPARISON

but it doesn't matter whether you choose the smaller or larger dimension as the basis of the comparison because the proportion will be the same either way. As you can see in the following illustrations, if you start with a still life and choose the larger dimension as the basis of comparison (**Fig. 8.6a-b**), the proportion is one unit (three thirds) in width and two thirds (of one unit) in height. If, on the other hand, you begin with the smaller dimension (**Fig. 8.7a-b**), the proportion is expressed as one unit (two halves) in height and three halves (of one unit) in width. The change in the base unit of measurement in these two comparisons changes only the numerical labels for each relationship, but the proportion for the two procedures actually proves to be identical. The numerical difference reflects the order of the comparison. They are identical in proportion even though they are different numerically. They are inverse proportions. A defining characteristic of an **inverse proportion** is that they are the same proportion turned upside down and will always equal one when multiplied together. The product from multiplying one over two-thirds by one over one and one-half is one. This means that one proportion is the inverse (upside down) version of the other.

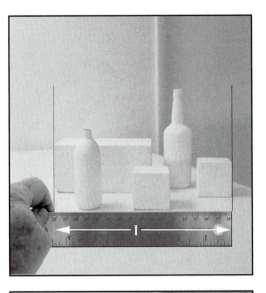

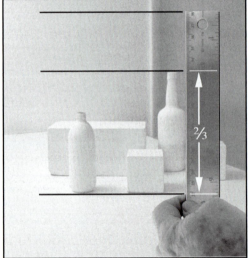

8.6a-b It can be helpful during the early stages of a gesture to check the overall proportion of everything your are drawing. To do this you will need to imagine a rectangle that defines the extreme edges of the object(s) being observed. If using a ruler, you must ignore any measured increments that may appear on the ruler. Rely instead on the idea that the length of the initial measurement is always equal to one unit.

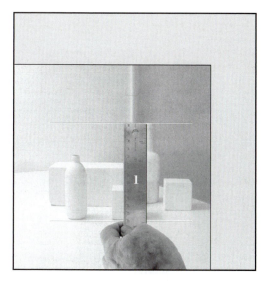

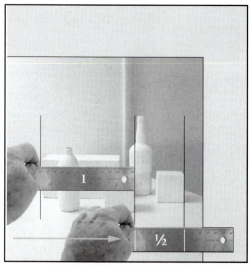

8.7a-b If you use the smaller dimension as the basic unit of measure, you will have to reduce the length of the exposed portion of the proportion tool so that it matches the smaller dimension (top). With the new base unit of measure, carefully rotate the proportion tool. Be sure to keep the tool at a constant distance from your eye and perpendicular to your line of sight. Once rotated you can accurately compare the basic unit (overall height) to the overall width of the still life.

When calculating the overall proportion of an individual object (comparing its apparent width with its apparent height), it is important to keep in mind several factors: the geometric character of that object (cylinder, rectilinear solid, etc.), the object's orientation in space, and the object's position in the visual field relative to the viewer. Each can cause the observed proportion to appear quite different from what you would expect based on your conceptual knowledge of that object. In other words, the object's proportions that we know are frequently not the proportions that we see. Whereas our reliance on rational information processing in our daily routines can be quite helpful in making sense of our visual world, if we want to draw objects as they actually appear, we must, once again, not allow our logical mind to substitute rational thinking about an object for our direct sensory perceptions of that object. To prevent your concepts from distorting your perceptions you must **record the proportion you see, not the proportion you know.** Frequent application of the proportion tool will go a long way in safeguarding accurate perceived proportions.

CONSTANT PROPORTIONS

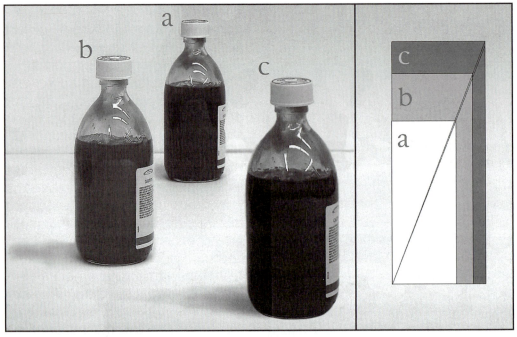

8.8 Upright bottles whose diameter is considerably less than their height show little change in apparent proportion regardless of their distance from the observer. Bottles closer to the observer do appear ever so slightly elongated because the circular cross sections (ellipses) at the top and bottom open wider as they appear lower on the page. As illustrated in the chart on the right, this opening of the ellipse has little impact on the overall proportion.

However, before addressing the myriad cases where preconceptions about an object's physical dimensions challenge accurate estimations of its observable proportions, it is worth noting two types of objects that we frequently encounter—spheres and upright cylindrical forms whose diameters are considerably smaller than their overall height (this includes most glasses and bottles)—whose conceptual and perceptual proportions are surprisingly similar. Spheres always appear perfectly round no matter

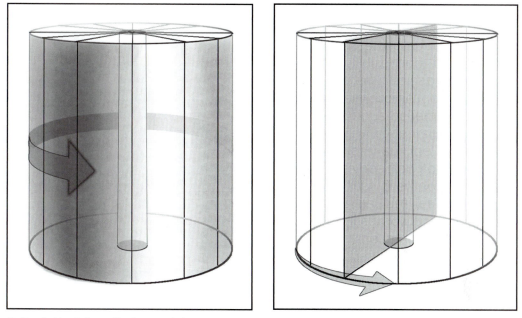

8.9a-b Upright cylinders exhibit no apparent proportional adjustment when rotated on their central axis. Their width and height remain constant. Rectilinear planes, on the other hand, appear progressively and dramatically foreshortened as they are rotated in space. The height of a rotating plane changes very little, but the changes in width can be drastic. As the plane is rotated, the receding edges converge at increasingly steep angles.

how they are positioned. The proportions of a narrow upright cylinder hardly change when the cylinder is spun around on its vertical axis or when it is moved closer to or further away from the observer (**Figs. 8.8, 8.9a**). As a result, upright bottles are among the easiest of objects from which to estimate proportional relationships.

In stark contrast, when we rotate vertical rectangular planes, they show a substantial difference between their conceptual and perceptual proportions (**Fig. 8.9b**).

CYLINDERS VS. PLANES

83

CHAPTER 8: PROPORTION

The apparent proportional consistency of an upright narrow cylinder does not apply when the cylinder's diameter approaches or exceeds its height, when it is tilting away from the observer, or when it is resting on its side and receding back into space (**Figs. 8.10, 8.11, 8.12**). In these three cases there is substantial difference between the perceived and the physical proportion.

8.10 Cylinders that are wider than they are high and are sitting flush with the ground plane undergo considerable change in apparent proportion when they move toward or away from the viewer. The furthest roll of masking tape appears nearly three times as wide as it is tall, whereas the roll nearest the viewer appears a little over two times as wide as it is tall.

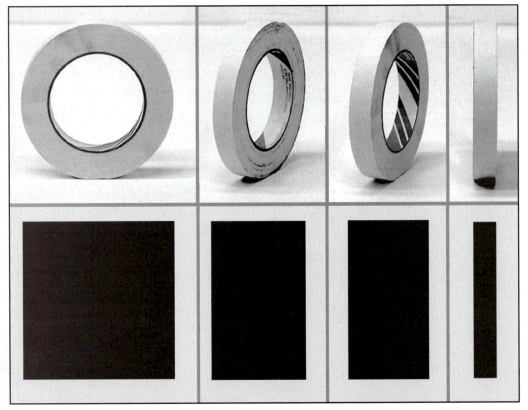

8.11 The apparent overall proportion of a cylinder that is wider than it is high and is standing on its side will vary considerably depending on its degree of rotation.

DOUBLE-WIDE CYLINDERS

8.12 Cylinders also appear to have greatly varying proportions when tilted back away from the observer's picture plane. Here a bottle of painting medium appears 4/5 of its upright height when leaning back at a 45° angle and 2/3 of its upright height when leaning back at about a 60° angle.

8.13 The two bottles above are of identical physical proportions. The smaller of the two, however, appears ever so slightly elongated in its height (thereby slightly altering its apparent internal proportions) because its ellipse near its top is slightly less compressed due to its lower vertical position relative to the observer's eye level.

As we continue our discussion of proportion it is worth repeating that when calculating the apparent perceptual internal proportion of an object, the actual physical size of the object is irrelevant. Objects of vastly different physical sizes can frequently share identical proportions. Whether or not two objects share identical proportion is based solely on whether the size relationship between their various internal dimensions is the same (**Fig. 8.13**).

Doors and windows make particularly good subjects for proportion studies. When looked at squarely from the front (a 90° angle formed by the viewer's line of sight and the surface of the object), they have a height-to-width

ratio that is identical to the proportion of their physical measurements. When, however, the viewing angle between the viewer's line of sight and the rectangular plane is an oblique angle (neither perpendicular or parallel), the proportion of the overall height to the overall width of each rectangular object changes in relation to the acuteness of that viewing angle. If we start with a square window and imagine that it is opening away from the observer who is maintaining a constant distance from its closest vertical edge (or, if you prefer, moving gradually in a circular arc toward the wall the window is in), the apparent width of the window diminishes (becomes foreshortened) as it tilts back in space relative to the observer (**Fig. 8.14**). Along with the apparent foreshortening in the width of the window, there is also a change in the angles of the receding edges (clock-angles). As we discussed in Chapter 5, parallel edges that are moving away from the observer appear to converge. We also noted that receding edges converge more rapidly as the plane tilts back more sharply in space. Combining carefully estimated proportion of the overall height and width of the window with accurately calculated clock-angles provides a powerful illusion of recession and a convincing illusion of spatial depth.

8.14 As a rectangular plane tilts back in space, the height of its nearest edge remains unchanged, its receding edges appear to converge, and its width appears to diminish. The window in this illustration reads as one that is gradually opening away from the viewer or one that is being viewed from a progressively acute angle.

8.15 Creating a believable illusion of a plane tilting back in space requires foreshortening and accurate clock-angles. One consistent and problematic obstacle to achieving this illusion is allowing oneself to be influenced more by what is known about the tilted plane in question (e.g., a square is as tall as it is wide) than by what is actually seen. In the illustration above, the top image depicts a square window that is parallel to the viewer's picture plane (or perpendicular to the viewer's line of sight). The image of the window depicted in the center has appropriately converging edges, but its foreshortening has been compromised by the conceptual expectation that the width of a square window is equal to its height, and as a result it winds up suggesting a window that is substantially longer than the window we originally set out to draw. The image on the bottom is correctly foreshortened.

Failure to correctly foreshorten a rectilinear plane that is moving back in space is the most common error in observational drawing. Foreshortening depends on a delicate balance between changing proportions and the convergence of receding parallel edges. As with all perceptions, proportion sensitivity is a direct sensuous experience and needs to be protected from being overwhelmed by rational thinking. Intellectual knowledge of an object's proportion (e.g., a square is a rectangle whose sides are all equal) is both an essential and a useful element of abstract/symbolic reasoning that does provide us important information. However, this same intellectual knowledge will, if left unchecked, seriously compromise your ability to capture the way objects appear in your immediate visual environment. **Fig. 8.15** illustrates the distorting influence of abstract/symbolic reasoning on your perceptions. It depicts a square window looked at frontally and two versions, one conceptually distorted and one perceptually accurate, of that square window tilting back in space. We would like to believe that just knowing about how rational thought distorts our perception would be enough to eliminate the distortion—but that is wishful thinking. The only sure-fire safeguard is to constantly apply the proportion tool.

CONCEPTUAL INTERFERENCE

PROPORTIONAL RECESSION

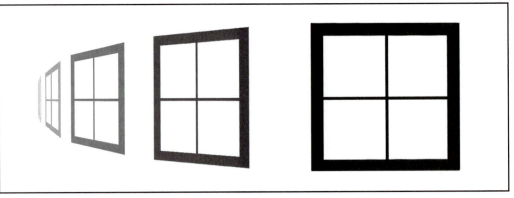

8.16 By placing the images from Fig. 8.14 in a horizontal band and progressively reducing the size and width (foreshortening) and the interval between each of them while increasing the angle of convergence of the receding edges (clock-angles) and adding atmosphere perspective, we create a powerful sense of depth in the picture plane.

An illusion of spatial recession is greatly enhanced when multiple monocular cues are used in combination. For example, if you take the window series from **Fig. 8.14** and present it as a horizontal progression where the overall size of each window is reduced, where there is a reduction in the interval between each window, and where you add atmospheric perspective by reducing the contrast of each window relative to the background color as it moves back in space, you increase the physical sensations of movement and the illusion of spatial depth (**Fig. 8.16**). Drawing doors and windows that are oblique to the observer is an excellent exercise for practicing your sense of proportion (**Fig. 8.17**). When it comes to establishing the illusion of spatial recession in a drawing, applying more space-generating techniques is always better.

8.17 Sketching doors and windows is an excellent proportion and clock-angle exercise. As with most drawings in this book, it is recommended that you begin by relying on your intuition and then check the accuracy of the drawing with the proportion tool and the clock-angle tool only after you have established a rough guesstimate.

8.18 For rectangles that are parallel to the viewer's picture plane and for rectangles receding from it, we find their centers by drawing diagonal lines through the diametrically opposed corners. The center of the rectangle occurs precisely at the intersection of these diagonals. In the receding rectangle, the "center" of the rectangle appears closer to the back edge than to the front because the back half, as expected, appears smaller than the front half.

The way to locate the center of a receding rectilinear plane is, interestingly enough, the same as that for finding the center of a rectangle that is parallel to the picture plane. In both cases you locate the center of the rectangle by drawing diagonal lines through the opposite sets of corners (top). The center will always be located at the intersection of the diagonals. The center will always be located at the juncture (intersection) of the diagonals. With receding rectangular planes, the apparent convergence of the receding edges causes the intersection of the diagonals to be positioned closer to the edge that is understood to be furthest from the observer (**Fig. 8.18**). In the illustration, this means that the two panes of glass closest to the viewer appear, as you would expect, taller and wider than the two panes further away.

Estimating the relative apparent proportion between two different objects is influenced by both the physical size of the objects in the comparison and the relative distance of each from the position of the observer. It should come as no surprise that objects appear smaller as they recede into space. This means that the physically larger of two objects can (and frequently does) appear equal to or smaller than its physically smaller companion. Again, this occurs because objects appear to diminish in size as they move back in space.

CENTER OF RECTANGLES

When bottles of equal physical size are positioned at different distances from the observer, they appear different in size (**Fig. 8.19a-b**). However, the conceptual information processing that enables us to interpret diminishing size as movement away from the observer rather than as a reduction in the size of the object has a tendency to distort the accuracy of our perception. When we see a familiar object in the distance, conceptual thinking becomes so entangled with our perception that we consistently think that the object appears larger (what we know) than it actually does (what we see). Our knowledge of its physical size inflates our perception of size. What we "know" and what we "see" are once again in serious conflict. This inflationary perceptual mechanism is called **size constancy,** and it contributes to objects appearing larger than their perceptual size warrants (**Fig. 8.20a-b**). Size constancy is a valuable mechanism for interpreting and making sense of our environment because it helps us predict the physical size of objects. However, the perceptual inflation that accompanies size constancy seriously distorts our estimation of apparent size, thereby compromising our ability to calculate proportion in a drawing. **We have a tendency to make objects that are in the distance appear too large.**

8.19a-b The four long-neck bottles pictured above are identical in physical shape, size, and internal proportion. Although they are identical in physical size, the apparent size (or retinal size—the size projected on the back of the eye) of each bottle is different depending on its distance from the observer. Changes in apparent size do not affect internal proportion any more than changes in physical size, but they do have an immediate impact on the apparent size relationships among the bottles. In chart **b** you can see that bottle **w** appears approximately half as large as bottle **x,** 80% as tall as bottle **y,** and 60% as tall as bottle **z.**

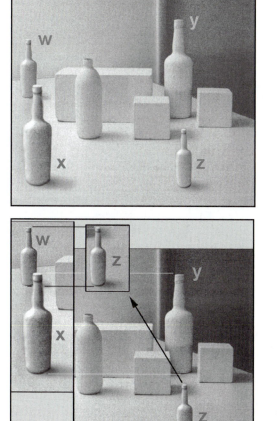

8.20a-b In the top illustration, bottle **y** is understood to be physically larger than bottle **x** and bottle **w** physically larger than **z.** Not only do we know that **y** and **w** are physically larger than **x** and **z,** respectively, but because we have an involuntary perceptual mechanism, *size constancy*, that purposefully distorts our perception to compensate for the reduction in apparent size that results when an object moves back in space, we also perceive them to be larger than they actually are. Although size constancy helps us interpret our visual environment, it frequently causes problems when estimating the relative size of objects as they recede into the background.

Drawing these background objects larger than they actually appear should be avoided because it contributes to a flattening of the spatial illusion that we are working so hard to establish. The best way to compensate for this involuntary perceptual distortion is to apply the proportion tool early and often.

In addition to comparing the sizes of different objects or the overall dimensions of a single object, the straight-edged proportion tool is very effective for calculating the proportion of different segments of an object or for comparing a single segment with an overall dimension of the object (**Fig. 8.21a-b**). You usually can and should make multiple proportional comparisons in any observed object by checking the majority of them with your porportion tool. Presuming that the object is properly proportioned on the basis of one comparison is a risky proposition. Making multiple comparisons contributes to greater accuracy in your drawing.

Accurately calculating proportional relationships is an invaluable observational drawing skill. It is also much, much more. The study of proportion is intimately linked to a remarkably ancient and venerable intellectual tradition that believes geometry to

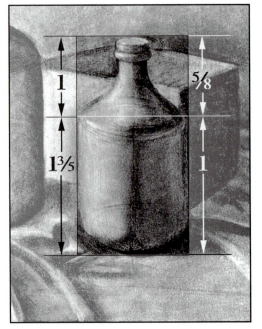 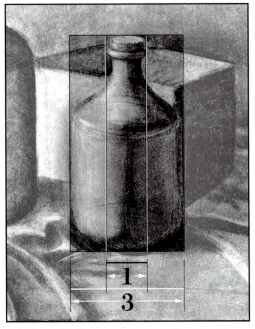

8.21a-b The proportion tool is effective not only for calculating the overall proportions of an object (its width compared with its height), but also for calculating proportional relationships of parts to the whole or parts to each other. In the illustration on the left, the height of the bottle has been divided at the point where its sides begin to slope inward (shoulder). The numbers on the left side describe the proportion when the smaller measurement is used as the basis of comparison, whereas the numbers on the right of the bottle describe the proportion when the larger unit is used. These numerical descriptions are inverse proportions. In the image on the right, the widest part of the neck of the bottle is compared with the width of the entire bottle.

be a vehicle for spiritual and intellectual enlightenment. In the next chapter, we take a look at evidence that supports the tradition of a specific mathematical proportion that provides insights into the mystery of life. The evidence comes not only from the study of art, architecture, and geometry, but also from intriguing scientific discoveries made over the last 250 years.

CHAPTER 9 THE GOLDEN MEAN

A visible echo. 93
Ad infinitum 94
φ (Phi). 95
Search for perfection. 96
Squaring the circle 97
The Hyperboreans. 98
Cosmic calculator 99
Solomon's Temple. 100
Dwelling of the infinite . . 101
Pythagorean star 102
Theory of Ideal Forms . . . 103
Harmonic structures 104
Fibonacci sequence 105
Divina proportione 106
Neo-Platonism 107
Masonic influence 108
Annuit coeptis 109
Plato's honeybees 110
Smile revisited 111
19th-Century painting . . . 112
Underlying dynamic 113
An unbroken wholeness. . 114

"Let no man ignorant of geometry enter here."

Plato

(Reported to have been inscribed above the entrance to the Field of Akademos, the olive grove in Athens sacred to Athena, where Plato conducted his institute of higher learning, The School of Athens.)

The history of art provides a rich storehouse of human visual expression stretching back into the early days of humankind. This record of human activity gives shape and form to the ideas, emotions, physical experience, spiritual awareness, and aesthetic sensitivity of the people who made them. Architecture, sculpture, and painting resonate with the energy of human creativity. Within this visual record there is no shortage of examples that are capable of engaging our imagination by offering insights into the life-affirming beliefs of the people who produced them. Among the insights and beliefs that have been incorporated into humankind's visual record, none is more intriguing than the tradition surrounding the transcendent capacities of a unique proportional relationship. This proportional relationship is most commonly called the **Golden Mean.**

When and where the notion began that a specific geometric relationship could shed light on cosmic mysteries is somewhat unclear. Although the study of geometry is generally considered to have

A VISIBLE ECHO

been developed in Alexandria by Euclid in the 4th century BCE, circumstantial evidence points to the study of geometry in general, and the tradition of sacred geometry in particular, as having a much earlier origin. Before addressing those speculations or reviewing the historical record of this unique proportion, let's first address the unique mathematical character of the Golden Mean. Fortunately, for those of us who are mathematically challenged, the Golden Mean is mechanically quite simple (**Fig. 9.1a-b**). Its structure, while simple, is nevertheless so conceptually unique and engaging that from its structure alone it just might be possible to derive a satisfying explanation for the long-standing wonder associated with this proportional relationship.

The Golden Mean can be mechanically created by combining a circle and a square. The only tools necessary are a straightedge and a compass. Absolute precision with the forms is as unnecessary as it is unattainable. We need only a close visual approximation to trigger an intuitive understanding of this unique internal relationship. The Golden Mean is a unique proportional relationship in that it generates an infinite progression of identically proportioned line segments or rectangles (**Fig. 9.2a-b**). Because

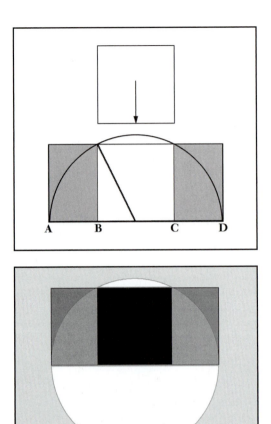

9.1a-b These diagrams demonstrate the simplest method for constructing the Golden Mean (ratio), which is to bisect the bottom edge of a square, draw a line from the bisection to the corner of the square, use that line as a radius to draw a circle, and then extend the baseline to the edge of the circle. In the uppermost illustration, the line segment AB and the line segment CD are both in a Golden Mean relationship with line segment BC.

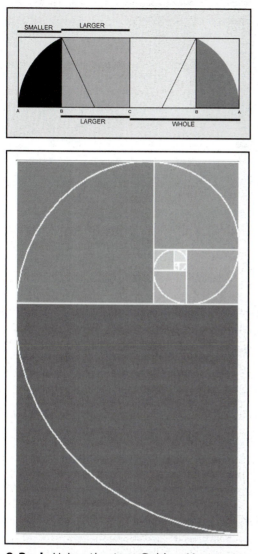

9.2a-b Using the two Golden Mean segments as sides of a rectangle creates a *Golden Rectangle*. Attaching a square to the long dimension of any Golden Rectangle results in a larger, identically proportioned rectangle. This process can be repeated infinitely. It can also be reversed by inserting a square into a Golden Rectangle, thereby creating an ever smaller copy of the Golden Rectangle. For this reason the Golden Mean has been called a "door to infinity."

of this self-generating capacity it has often been referred to metaphorically as a "visible echo of the infinite" or a door to infinity."

The Golden Mean is represented by the Greek letter φ (phi) in homage to the Athenian sculptor **Phidias** (ca480–430 BCE), who had achieved fame as the designer of monumental statues of the Greek gods. The numerical approximation for the Golden Mean is generally expressed as the smaller unit being .6180... of the larger unit of 1, or the larger being 1.6180... of the smaller unit of 1.

Pythagoras, a Greek mathematician and mystic from the 6th century BCE, was the first to openly declare that the essence of all things was accessible through simple mathematics. Pythagoras was the first to write about this belief, but considerable circumstantial evidence suggests that sacred geometry had permeated intellectual tradition thousands of years earlier.

Geometry is a Greek word that means "to measure the Earth." The ancient name for Egypt was *Al Khem,* and one popular translation for this name is "the land of measure." If that is correct, it would be consistent with the fact that the priesthood of ancient Egypt was well schooled in using

φ (PHI)

95

sophisticated geometric prin-
ciples to survey the farmland
to reestablish ownership rights
each year after the annual flood.
Egyptian interest in precise geo-
metric calculations did not end
there; it also extended to the
design and construction of large-
scale architecture (**Fig. 9.3a-b**).
This is reflected in the facts that
the base rock of the thirteen-
acre plateau on which the Great
Pyramid of Cheops is built is less
than one inch out of level over
the entire sight and that the
Great Pyramid's thirty-five square
foot limestone casing stones were
cut and assembled with a preci-
sion that rivals the tolerances
used by modern opticians. Clearly
the Egyptians were committed to
geometric perfection both in their
daily activities and when working
on a monumental scale.

Because there is no surviving
documentation, we can only spec-
ulate about what this Egyptian
preoccupation with precise geo-
metric calculations might mean.
However, it is of interest to our
investigation into possible ancient
origins of a spiritual geomet-
ric tradition to note two other
intriguing structural characteris-
tics of the Great Pyramid at Giza.

In medieval alchemy, the fore-
runner of modern chemistry and
whose very name (*Al Khem*)
points to an ongoing connection

9.3a-b The top illustration is a digital
representation of what the Pyramid of
Cheops might have looked like shortly
after its completion, with its stunning
white limestone casing stones and its
gleaming gold ben-ben at the apex. The
grandeur and majesty with which the
three pyramids rise above the Giza plain
caused modern Egyptians to observe
that "man fears time but time fears the
pyramids." These imposing structures are
draped in many levels of mystery, not
the least of which stems from curious
internal proportions that to some imply
an ancient spiritual tradition based in
sophisticated geometric calculations.

SEARCH FOR PERFECTION

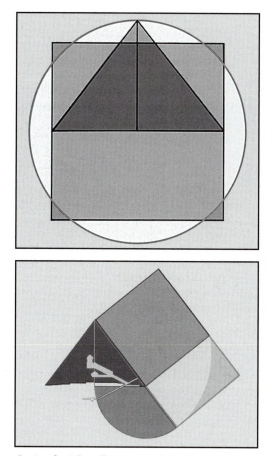

9.4a-b The "union of opposites" is an alchemical metaphor for transcendental experience. Symbolically, the square is associated with humankind, the circle with divine perfection, and the triangle with the act of transcendence. All three of these symbols are integrated into the design of the Great Pyramid so that the perimeter of the pyramid's base equals the circumference of a circle whose radius is equal to the pyramid's height. In addition, the profile of the Great Pyramid contains a direct visual reference to the one proportion that has a capacity for infinite regeneration (half the width in relation to the sloped side).

with the intellectual traditions of ancient Egypt, science and mysticism were intricately intertwined. Within alchemy the search for perfection was understood as having both spiritual and material implications. For alchemists, being able to turn base matter (lead) into perfection (gold) and the intellectual search for the unity within opposites ("squaring the circle") were avenues that point toward a mystical understanding of the mystery of life. Remarkably, the construction of the Great Pyramid seems to address both issues. It not only rose up from the rock of the Giza plateau to a glimmering peak of gold (ben-ben) at its top, but is proportioned so that the perimeter of its base is equal to the circumference of a circle whose radius is equal to the pyramid's height (**Fig. 9.4a**). In this way the Great Pyramid can be said to be a union of complementary opposites where the square (man/earth) is reconciled with the circle (eternal/infinite/divine). More important, half of the Great Pyramid's base is .6180 of its sloping side (**Fig. 9.4b**). This proportion establishes the visual character of the elevation of the pyramid and can be interpreted as a proportional technique for bringing the eternal (infinite) into the realm of space and time. While acknowledging that this suggestion (that the Egyptians encoded spiritual insights in their

architecture) is speculative, it is worth noting that there are other ancient monuments that seem to anticipate the Greek fascination with φ as a vehicle for exploring the riddle of the cosmos.

Diodorus, a Greek historian of the 1st century BCE, wrote about a race of people who lived in the north beyond the Pillars of Hercules (Strait of Gibraltar) who had constructed a temple to the sun god Apollo. These people lived in the land of the cold north wind (Boreas), and Diodorus referred to them as Hyperboreans. It is believed that he was referring to the people living in what we now call the British Isles. Curiously, there are numerous earthen, wooden, and stone monuments in Britain whose internal alignments suggest that they were designed to function as astronomical observatories, with major emphasis being placed on the movement of the sun (Apollo). The best known of these monuments, **Stonehenge**, was built on the Salisbury Plain in England between 3100 and 1900 BCE. Gerald S. Hawkins, an early archeoastronomer, calculated that twenty-two of Stonehenge's possible viewing sites aligned thirty-two times with fifteen of eighteen unique positions of the sun and moon. The likelihood of such correlations being coincidental has been calculated to be one hundred million to one. As

9.5 This aerial photo shows Stonehenge with an overlay of a Golden Rectangle that precisely connects four distinctive points on the inside edge of the circular earthen mound that was completed during the earliest stage of the monument's construction circa 3100 BCE.

"We know that we are related and one with all things of heaven and the earth . . . the morning star and the dawn that comes with it, the moon of the night and the stars of the heavens . . . only the ignorant sees many where there really is one."

Black Elk
Medicine Man
Oglala Sioux

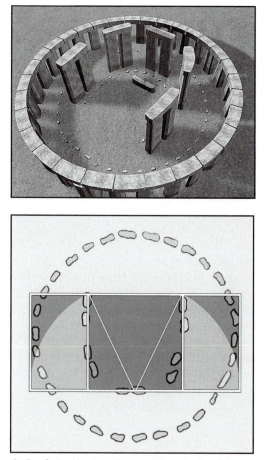

9.6a-b In the top image the circle of large gray sandstones surrounding the larger horseshoe of trilithons that stand at the center of Stonehenge are depicted as they would have looked shortly after having been installed nearly four thousand years ago. The stone circle and horseshoe are arranged so that the relative positions of these two distinctive formations create the unique proportion that is self-generating to infinity, the Golden Mean. At a time when the heavens were understood to be the realm of the divine, it is not much of a stretch to speculate that Stonehenge was designed as a mechanism to funnel the celestial infinite into the realm of space and time.

we entertain the assumption that Stonehenge was built to funnel celestial order into the lives of the Hyperboreans, it becomes of great interest to note that the first and third stages of the monument's design are laid out in strict accordance with the proportion of the Golden Mean. The fact that what is believed to be the central astronomical alignment of this monument—the sighting of the rising sun as it moves across the tip of the "heel" stone on the Winter Solstice—intersects its underlying Golden Rectangle at a 90° angle lends support to the hypothesis that its designers were not only skillful and sophisticated astronomers but active participants in the tradition of sacred geometry as well (**Figs. 9.5, 9.6a-b**). Although we do not know who was responsible for the design and construction of Stonehenge, the monument itself provides a challenging glimpse into the complexity of the minds of the amazing individuals who planned and built it. As with the Great Pyramid, this combination of astronomical precision and mystical geometry coexist in what has proven to be one of the most powerful and intriguing visual messages from the distant past.

Seven hundred years after the last stage of construction at Stonehenge, **Solomon's Temple** was constructed in Jerusalem (**Fig. 9.7**). Here again we come across circumstantial evidence of a belief in geometry as a tool for revealing a transcendent reality. In the interior of the temple, the Holy of Holies, the sacred chamber that housed the Ark of the Covenant (the dwelling place of the Most High God) was designed as a perfect cube, while the main hall of the temple was configured to be twice as long as it was wide. Both reflect a concern for unique geometric relationships, but the main hall is of particular interest because a rectangle formed by two adjacent squares contains a subtle but precise expression of the Golden Mean (**Fig. 9.8a-b**). In keeping with this speculation, you might recall that the pivotal source of Jewish understanding about the divine was reported to have been a man trained in the geometric secrets of the Egyptian priesthood (Moses). Even if we question the likelihood of a continuous tradition from the time of Moses to the time of the temple's design, the Torah makes it clear that the Israelites had considerable opportunities to reabsorb sacred geometry from neighboring spiritual traditions.

Because there is no written historical proof that the presence of

9.7 The Temple of Solomon was built by the Jews to house the *Ark of the Covenant,* which, in addition to housing the Ten Commandments, was believed to also be the dwelling place of the Most High God. The Holy of Holies was configured as a perfect cube, and the plan for the floor in the main hall with the vestibule at the entrance (designed as two squares laid side by side) contains what can be described as a hermetic (hidden) reference to the unique proportion that is found in the Great Pyramid and at Stonehenge.

hu ◆ man ◆ ism n.
A cultural and intellectual movement that began in Ancient Greece and centers on human beings and their values, capacities, and worth is based on the assumption that rational thought will lead to truth. It can be said, ironically, to have developed simultaneously out of rational study of geometry and a mystical tradition associated with the Golden Mean.

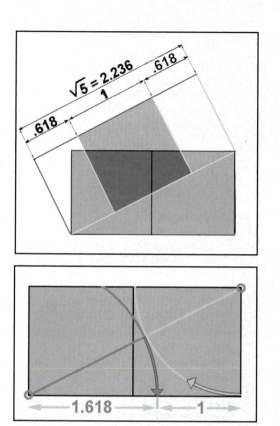

9.8a-b The main hall of the Temple of Solomon was twice as long as it was wide. Rectangles of this proportion have a diagonal that is 2.236 times longer than the height. This proportion is identical to that of a square with lateral Golden Rectangles at each end. The bottom diagram illustrates that this architectural configuration is also an easily used tool for constructing a Golden Mean proportion. Although there is no written evidence that those who designed this structure understood the significance of its proportion, the very purpose for which the building was constructed begs for it to be interpreted as a secret mystical reference to the presence of the divine.

the Golden Mean in the design of the Great Pyramid, Stonehenge, or the Temple of Solomon was part of an ongoing intellectual tradition, there are those who suggest that its presence is merely a coincidence. That may be so. It is possible that three of the most impressive, important, and visually engaging monuments of our ancestors were designed around the unique proportion that is capable of generating an infinite progression of identical proportional segments without any understanding of the principles involved. It may be a coincidence. Stranger things have happened. While a stiff dose of skepticism is always a good way to approach this sort of speculation, the notion of coincidence gets stretched somewhat thinner when we turn to ancient Greece.

Pythagoras taught that number was the essence of all things and that one can arrive at an understanding of the dynamic force of the universe by using small numbers. He taught that the divine (infinite) is not to be discerned in the multiplicity of forms that are around us, but in a unifying principle running through these forms. **He believed that the divine is manifest in both shape and number** (**Fig. 9.9**). Because this manifestation can be synthesized through geometry and because geometry can

be made visible through art and architecture, Pythagoras believed that a temple or a sculpture could be tuned (proportioned) in accordance with the cosmic dynamics and resonate with the presence of the divine. Similar ideas were put forth in the fifth century BC by the renowned sculptor **Polyclitus** in a treatise known as the *Canon of Polyclitus*. It was considered to be a guide for revealing the mystical perfection in the proportions of the human form. For the ancient Greeks, the male body was the ultimate expression of mystical geometric perfection in nature.

The **Parthenon** was constructed between 447 and 432 BCE. This temple, designed by Ictinus and Callicrates, was dedicated to the city's patron goddess, Athena. Unlike the Great Pyramid, Stonehenge, and Solomon's Temple, the design of the Parthenon grew out of the historically verifiable tradition of Pythagorean ideas that had, by this time, thoroughly infiltrated Greek thought. The Parthenon was described by its designers to be an embodiment of the sacred principles of the Golden Mean (**Figs. 9.9–9.11**). It is also worth noting that the Parthenon is widely held to be one of the most beautiful buildings ever built.

Plato, born in Athens to the generation that constructed the

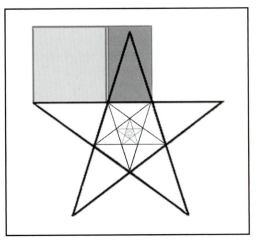

9.9 The pentagram contains multiple Golden Mean relationships in its linear segments. The pentagon at the center of the pentagram can be used to generate an infinite number of smaller pentagrams. A pentagon can be inscribed around the outside of the large pentagram and that, in turn, can generate a larger pentagram: an infinite number of smaller and larger pentagrams and pentagons. For the Pythagorean brotherhood the pentagram, "the window on infinity," was a sign of good omen.

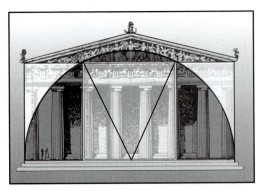

9.10 The dominant architectural elements of the façade of the Parthenon clearly reflect the proportion of infinite progression.

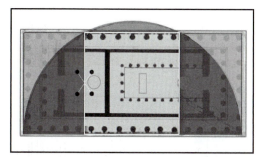

9.11 The platform upon which the Parthenon sits is a double Golden Rectangle. The Golden Mean division on the left passes precisely through a point in the center of four columns in the Treasury room.

"ϕ (Phi) is the key to the physics of the cosmos."

Plato

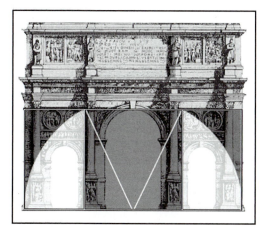

9.12 The proportions of the Arch of Constantine (AD 325) clearly reflect an awareness of the ongoing mystical geometric tradition as it applied to establishing beauty, power, and order through architecture.

Parthenon, is considered to be one of the most important thinkers of Western culture. Central to his philosophy was his *Theory of Forms* (also known as the Doctrine of Ideas). It is based in the rational notion that abstract concepts have more reality than do physical things. Plato was influenced by Pythagorean thought and, not surprisingly, made the study of mathematics central to his educational system (The Academy). In Plato's *Timaeus*, his Pythagorean roots are clearly revealed as he describes his search for counterparts of the infinite in the realm of space and time. With his search for divine truth so clearly stated, there can be little doubt about the mystical implications when he calls ϕ the most binding force in the universe.

Because so much of the art of Rome was modeled after or copied from Greek art, it should come as no surprise that the design of Roman monuments and temples frequently conforms to the proportion of infinite generation (**Fig. 9.12**). Roman belief in the mystical implications of geometric relationships is documented in *Ten Books on Architecture* by the 1st century BCE Roman architect Vitruvius. In his books he advises architects to design temples according to the proportions of the human body. With a statement that is reminiscent of

103

the ideas of Pythagoras, Plato, and Polyclitus, he goes on to add that the human body is beautiful because its proportions are the expression of the order of the universe.

The tradition of using the Golden Mean in sacred buildings does not end with the fall of the Roman Empire but continues on in the ecclesiastical architecture of the Christian church (**Fig. 9.13a-b**). There is very little specific information to document the beliefs surrounding the use of a sacred geometry in the Early Christian period, but there are colorful tales of a secret brotherhood of architects and stonemasons preserving mysterious ancient wisdom. Secret brotherhoods are difficult to verify, but it can be argued that the present-day *Order of Freemasonry* was at one time just this sort of secret organization. Even though Freemasonry is not directly affiliated with either Christianity or Judaism, its oral tradition claims it to have descended directly from a Phoenician architect named Hiram, who is thought by Freemasons to have designed the Temple of Solomon. Regardless of the role of the Secret Brotherhood of Masons during the Middle Ages, it is clear that the Golden Mean appears countless times throughout medieval church architecture.

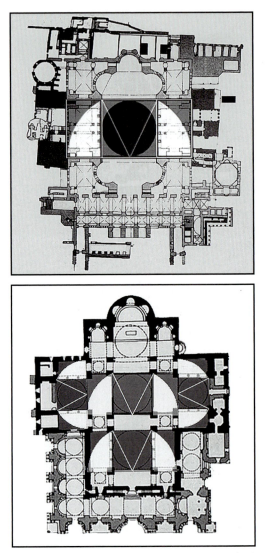

9.13a-b Hagia Sophia (top) in Istanbul (sixth century) and St. Mark's Cathedral in Venice (twelfth century) are examples of the widespread use of the Golden Mean as a template for establishing the proportions for ecclesiastical architecture. The gender in the name, Hagia Sophia, hints at a reference to the ancient Greek goddess of sacred wisdom.

THE FIBONACCI SEQUENCE

Leonardo Bigollo da Pisa (**Fibonacci**) was born in Italy in 1179. Fibonacci was the most renowned mathematician of the Middle Ages. In 1202, after returning from Egypt, he published *Liber Abaci*, the book that introduced Hindu-Arabic numbers to Western Europe. Even though the ancient Greeks had constructed Golden Sections and Rectangles with straight-edges and compasses, they could not describe them numerically because they had not adopted a Hindu-Arabic numbering system. Despite the profound importance of Fibonacci's contribution to the development of Western science and technology, he is actually more widely known for a curious series of numbers that were generated when answering a riddle concerning the number of ancestors of a male bee going back twelve generations (HINT: male bees emerge from eggs that have not been fertilized, whereas fertilized eggs produce females). He constructed this riddle to encourage people to practice using the new numbers. The number of bees in each of the generations formed the beginning of an infinite summation series where each succeeding number in the series is the sum of the preceding two. Although he was most likely unaware of the mathematical implications of this progression (to be discussed later), it is still primarily referred to as the Fibonacci Sequence:

<div align="center">

1,1,2,3,5,8,13,21,34,55,89,144,233...

</div>

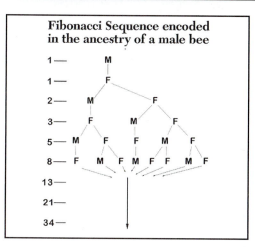

Fibonacci Sequence encoded in the ancestry of a male bee

The term *Renaissance* literally means "rebirth." It is used in reference to the reintroduction of classical Greek and Roman art and ideas into the culture of the Italian peninsula. The Renaissance began in the 13th and 14th century, gained considerable momentum in the 15th century, and culminated in what is often described as the High Renaissance in the early 16th century. Many of the intellectual

traditions that had driven the ancient world but had apparently lain dormant during the medieval period energetically burst forth once again. Renaissance connections to the intellectual traditions of the past were conscious and direct. Starting with the second quarter of the 15th century, scholars, artists, and architects contributed to this revival of Pythagorean ideas. In 1462 the Florentine philosopher Marsilo Facino founded the "New Academy" to reconstruct ancient traditions of beauty and meaning. He promoted contemplation of the world of Ideal Forms as a way of coming to an understanding of man's place in the divine order. By 1480 Fra Luca Pacioli had published *Divina Proportione*, a Neoplatonic treatise on the spiritual implications of harmonious proportion. This text was illustrated by Leonardo da Vinci (**Fig. 9.14**). Seventy years later, in a book of artists' biographies, titled *Lives*, Giorgio Vasari describes a transcendental connection to the divine through art that is rational, ineffable, true, and beautiful. He called this connection *The Mystic Way* and suggested that through it, art can edify the public and raise spiritual consciousness.

The renewed interest in the figure, and particularly the nude male figure, ranks as one of the most identifiable characteristics

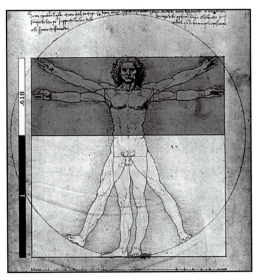

9.14 Leonardo da Vinci, *Vitruvian Man,* c. 1485–1490. 13.5 × 9.6 inches. Gallerie dell' Academemia, Venice, Italy. Leonardo illustrated Fra Luca Pacioli's treatise *Divina Proportione* with an image of the human figure that was modeled after the proportions recommended by Vitruvius in the 1st century BCE.

"In the human body are found every proportion through which God reveals the innermost secrets of the universe."
Fra Luca Pacioli
Divina Proportione
(1480)

DIVINA PROPORTIONE

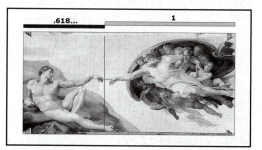

9.15 Michelangelo, *Creation of Adam* (Rome, from the ceiling of the Sistine Chapel, Vatican, 1508–1512). Michelangelo places the spark of human enlightenment, the height of the dramatic action, precisely at the point of infinite (eternal/ divine) progression.

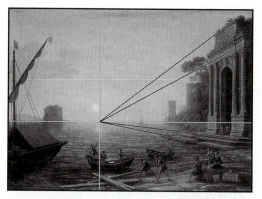

9.16 Claude Lorraine, *A Seaport* (Alte Pinakothek, Munich). In this seascape, Lorraine, a 17th-century French painter, anticipates the transcendentalist poets and painters of the 19th century with his depiction of the grandeur of the rising sun (Apollo) just after it has emerged from the horizon. Lorraine utilized the Golden Mean ratio to establish the location of the horizon and the position of the sun and also made the intersection of these divisions the focal point of the architectural perspective.

of Renaissance art, even in religious devotional images (**Fig. 9.15**). The inclusion of nudity as an object of spiritual contemplation is problematic, though, only if we fail to recognize it as an outgrowth of the influence of the Neoplatonic tradition on the theology and iconography of the 15th and 16th centuries. It is evident from the writings of this period that the tradition of the Golden Mean was well understood in the Renaissance. Furthermore, the frequency with which φ appears in the art of the period clearly suggests that it was embraced as an expression of a mystical truth.

Following the period of the Renaissance, much less is written about the spiritual tradition associated with the Golden Mean. The use of the proportion itself, however, continues uninterrupted as an effective formula for arranging elements in an artwork. Although in some cases it does seem to have lost its spiritual implications, there continue to be sufficient engaging examples to indicate a conscious continuation of the long-standing spiritual concern with the visual manifestation of the eternal (**Fig. 9.16**).

Throughout the 18th century neoclassical art and architecture continued to rely on the Golden Mean as a formula for

NEO-PLATONISM

composition and design. In a number of instances, the subject matter is so well integrated with the implied spiritual aspects of the geometry that it is certainly reasonable to propose that an understanding of the hermetic tradition was still alive and well. It was during this century that the *Brotherhood of Freemasons* first publicly announced its existence with the opening of the London Grand Lodge (1717). The guiding principles of this secretive society were rooted in liberty, equality, brotherhood, and the nobility of man (**Fig. 9.17**). As the century unfolded, Freemasons were among the leaders who initiated sweeping social and political transformations that forever changed the face of Western society. Some have gone so far as to suggest that the American Revolution was a Masonic experiment in ideas of government that were, in turn, rooted in ancient mystical traditions. Whether or not there is any substance to this particular claim, it is easy to verify the fact that Freemasons were prominent in the Revolution and made critical contributions. Among the most important of these were George Washington, John Hancock, John Marshall, Baron Von Steuben, the Marquis de Lafayette, and (for the conspiracy theorists among us) all of the British generals. Not only did St. Andrew's Masonic Lodge

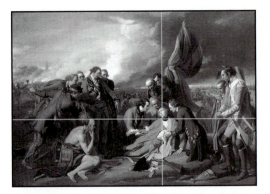

9.17 Benjamin West, *The Death of General Wolfe* (1770, National Gallery of Canada). The Anglo-American school of history painting created a new genre by combining themes from religious painting with contemporary events presented in costumes of the day. In this painting the death of a war hero is elevated to mythic proportions by referencing images depicting the dead Christ taken down from the cross. West also references the ancient geometric traditions by placing the head of General Wolfe precisely at the intersection of the vertical and horizontal Golden Mean divisions of the overall composition.

her ◆ met ◆ ic adj.
1. Completely sealed, especially against the escape or entry of air. 2. Impervious to outside interference or influence: the hermetic confines of an isolated life. 3. Often Hermetic Mythology **a**. *Of or relating to Hermes Trismegistus or the works ascribed to him.* **b**. *Having to do with the occult sciences, especially alchemy; magical.*

MASONIC INFLUENCE

9.18 The flag of 1777 with thirteen stripes and thirteen pentagrams arranged in a circle is a familiar image today even though its design was rarely used. While the connection to the thirteen colonies is clear, it should be noted that thirteen is the Masonic number of transformation and rebirth. As such, the number of colonies was itself a symbol of the revolution.

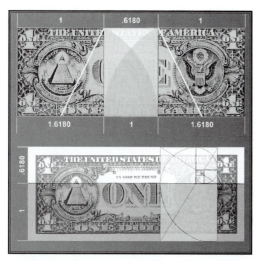

9.19a-b The reverse side of the dollar bill is comprised of two Golden Mean rectangles that overlap in the center. In the obverse side (left) of the Great Seal the All-Seeing Eye of Divine Providence sitting atop the thirteen-tiered pyramid is located precisely at the Golden Mean of the overall height of the bill.

play an important role in the Boston Tea Party at the start of the conflict, but the very first oath of office was administered to a Freemason (George Washington) by a Masonic Grand Master on a bible from St. Johns Masonic Lodge #1 of New York. Even though there is no direct evidence that Thomas Jefferson, the primary author of the Constitution, was a Mason, he was trained as a neoclassical architect. It is also curious to note that the reverse side of the dollar bill contains multiple hidden references to the belief in the edifying character of sacred geometry (**Figs. 9.18, 9.19a-b**). Growing interest in the revolutionary principles of liberty, equality, and brotherhood soon contributed to sweeping social and political transformations in France, South America, Texas, and Mexico. The fact that Freemasons again played crucial roles in each of these revolutions lends credibility to the notion that they were in fact an outgrowth of ancient spiritual traditions. Prominent Masons among them were Simón Bolívar, José de San Martín, Benito Juárez, and Sam Houston.

The use of the Golden Mean in 19th-century art continued uninterrupted as a tool for arranging compositions, but integration of the pictorial content with a spiritual sensibility seems to have been compromised by

MATHEMATICAL DISCOVERY IN 1753

Over two thousand years after the design and construction of the Parthenon, an 18th-century mathematician who was playing with the numbers from the Fibonacci Sequence realized that hidden in this summation series is a progressively more accurate numerical approximation of the Golden Mean.

X,Y	X/Y	Y/X
1,1	1	1
1,2	0.5	2
2,3	0.666...	1.5
3,5	0.60	1.666...
5,8	0.625	1.60
8,13	0.6153	1.625
13,21	0.6190	1.6153
21,34	0.6176	1.6190
34,55	0.61818...	1.6176
55,89	0.61797	1.61818...
89,144	0.616055	1.61797
144,233	0.618025	1.618055

The larger the pair of sequential numbers that is used to establish the ratio, the more accurate the numerical approximation of the Golden Mean becomes. For practical purposes ϕ is said to be *1 to 0.6180* or *1.6180 to 1,* but no rational number can ever be completely accurate. ϕ is an irrational number. This means that although we can directly experience the Golden Mean visually, it is beyond the power of our rational mind to numerically define it. *It is beyond reason.* This serendipitous discovery marked the first time in the more than two-thousand-year history of the Golden Mean that a relationship had been scientifically established between a natural phenomenon (the reproductive pattern of bees) and ϕ, the proportion said by Plato to be the "most binding principle in the universe" and "the key to the physics of the cosmos."

FLOWERS FOR FIBONACCI

THE FLOWER SERMON REVISITED

The story goes that Siddartha Gautama, the Buddha, decided to use a prop, a Zen tool, for one of his sermons. Having gone up on a hillside to preach, he silently held up a flower. Everyone in the crowd below awaited his words. Everyone, that is, except one person, Kashyapa. Kashyapa smiled.

In **1835** a botanist observed that the seeds in the center of a sunflower are arranged in two sets of multiple spirals that begin in the center but curve outward in opposite directions, and that the number of spirals in each direction always conforms to sequential numbers from the Fibonacci series. This means that if there are 21 spirals in one direction, there will be 13 or 34 in the other. This has been found to occur in 97% of all sunflowers. The largest sunflower on record had 144 and 233 spirals, respectively. With this discovery science had again established a concrete connection between a growth pattern (sunflowers, bees) and the mystical mathematical tradition identified with Pythagoras, which held that the dynamic generating force of the universe, ϕ, was accessible through the study of number and shape. This discovery was the first of numerous observations that have discerned a unifying principle running through the multiplicity of forms in nature.

an overriding preoccupation with opulence, the erotic, and exaggerated theatricality (**Fig. 9.20**). Mawkish sentimentality and exaggerated emotionalism replaced commitment to enduring and universal values. Curiously, just as this shift toward theatricality began to dominate the official art of the period, natural science began to record observations and collect data that can be interpreted as corroborating ancient mystical speculation. Once botanists found that sunflowers grew in accordance with ϕ, it was not long before scientists discovered the same proportion was subtly disguised in a seemingly endless variety within the visible structure of living organisms. Plants, seashells, insects, birds, reptiles, fish, and mammals were all found

9.20 Jean-Dominique Ingres, *La Grande Odalesque* (1814, The Louvre, Paris). The erotic opulence and theatricality of neoclassical artworks of the 19th century overshadowed the mystical significance of the Golden Mean in spite of the fact that it was still customary to incorporate its geometry into the compositional arrangements. *La Grande Odalesque* forfeits its spiritual clarity because of a material fascination with the exotic sensuality of the Middle-Eastern harem.

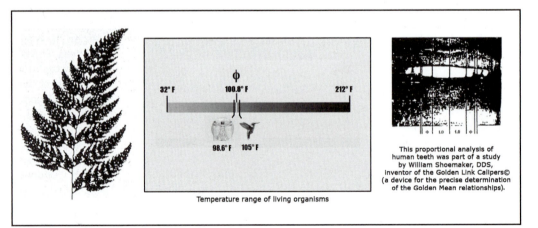

Temperature range of living organisms

This proportional analysis of human teeth was part of a study by William Shoemaker, DDS, inventor of the Golden Link Calipers© (a device for the precise determination of the Golden Mean relationships).

9.21 The Golden Mean (ϕ) that is fundamental to the design of many ancient man-made monuments and that had an important role in the development of Western philosophical thought has been found, during the last hundred and fifty years, to occur as a pattern-forming dynamic underlying the structure of the natural world.

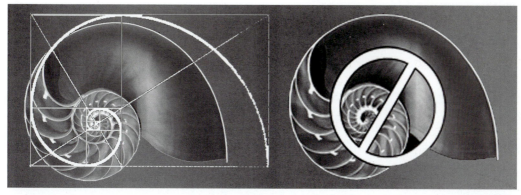

9.22a-b The spiral chambered nautilus is the most commonly reproduced image used to illustrate the Golden Mean in nature. It appears in hundreds of books and on tens of thousands of Web sites devoted to the topic of Sacred Geometry. Unfortunately, however, as beautiful as is the unfolding of the chambered nautilus, it does not unfold with the proportion of a Golden Mean spiral.

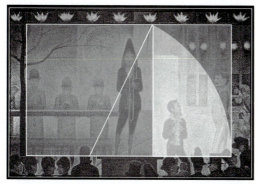

9.23 Georges Seurat, *La Parade (The Sideshow)* (1887–1888, Metropolitan Museum, NYC). A schematic overlay has been added by the author illustrating one of several schemata used to organize important elements of the composition in accordance with the Golden Mean. This ancient proportion appears with surprising regularity in works of those 19th- and 20th-century artists who are credited with rediscovering the integrity and clarity that had been the hallmark of Egyptian, ancient Greek, and Renaissance art. These artists include Monet, Van Gogh, Cézanne, and Seurat.

to share a growth pattern that reflects the presence of a universal harmony (**Fig. 9.21, 9.22a-b**). Perhaps in response to the discoveries being made by science or perhaps in response to a general increase in interest in spirituality in the latter half of the 19th century, artists began to challenge the theatrical superficiality that had become so popular. These artists not only utilized ϕ as a compositional formula but made a conscious return to a simpler, yet more profound understanding of the Golden Mean's mystical resonance (**Fig 9.23**).

This chapter is certainly not meant to encourage irrational beliefs in New Age superstitions. New Age movements offer answers, whereas the Golden Mean tradition raises only aesthetic, scientific, and non-dogmatic spiritual questions. It is

UNDERLYING DYNAMIC

113

Mandelbrot Set

9.24a-c A logarithmic, equiangular spiral moves outward at a constantly expanding rate that duplicates the geometric progression of the Golden Mean. As with Fibonacci numbers, this progression generates an infinite series of identically proportioned segments or modules. This proportion of infinite generation can be found in the swirling arms of hurricanes, in every self-similar progression of the randomly generated images of a Mandlebrot set (chaos), and in the structure of our cosmic neighborhood, the Milky Way galaxy.

part of our cultural tradition and is presented here only as an example of a sensitizing mystery that has been deeply woven into our visual heritage. And like all great mysteries, it is really useful only as an aid for contemplating the mystics' claim that we are, indeed, "one with all things of heaven and the earth" and that "everything that lives, lives not alone nor for itself" (**Figs. 9.24a-c**).

"The universe, at its most fundamental level, is an unbroken wholeness. All things, including space, time, and matter, are forms of that-which-is. There is an order that is enfolded into the very process of the universe."

David Bohm
University of London

"I submit that there are pre-cultural needs—such as those of the extraordinary, the transcendent, and for reconciliation with and reverence for natural environments and natural phenomenon—that art is and must be concerned with. These needs are not accessible to verbal language but exist to be perceived by nonverbal, premodern ways of knowing."

Ellen Dissanayake
Homo Aestheticus

"If the doors of perception were cleansed, man would see everything as it is; Infinite."

William Blake

(The quote from which the rock group *The Doors* took their name.)

AN UNBROKEN WHOLENESS

CHAPTER 10 CROSS-CONTOUR

Three-dimensional form. . 115
Circling the globe 116
Atmospheric perspective . 117
Official drawing flag 118
Proportional variation . . . 119
Embracing frustration . . . 120
Continuous stripes 121
Undulating surfaces 122
Exaggerating cues 123
Binocular cues, no 124
Monocular cues, yes 125
Contradictory signals. . . . 126
Accelerated convergence 127
Fading away. 128
Exaggerated atmosphere 129
Spatial exaggeration 130
Lemming syndrome 131
Chiaroscuro lite 132
Flags with object I 133
Flags with object II 134
Flags with objects III . . . 135
Armed and unarmed 136
Soft cloth, hard chair I . . 137
Soft cloth, hard chair II. . 138

Capturing three-dimensional form on a two-dimensional surface requires a broad range of illusionistic techniques. Sensitivity in mark making, intuitive gesture, the Mondrian grid, clock-angle perspective, positive and negative shape, and proportional measurement provide the basic tools for translating our perceptions. While sensitive line variation is always the premier element in any drawing, the techniques listed above and the ones that are about to be introduced contribute meaningful form to mark making. Keep in mind that successful implementation of these new drawing concepts will depend on the continued application of the techniques from the previous chapters.

Cross-contour is the next technique you will investigate. It is a versatile technique for translating three-dimensional objects to the drawing surface. It can describe regularized geometric forms as well as transitions between regularized forms but is most effective for describing the irregular forms that are frequently found in nature.

THREE-DIMENSIONAL FORM

115

Generally speaking, a cross-contour is a straight line or series of parallel lines moving across the surface of a three-dimensional object from one outside edge (contour) of the object to the other. Familiar examples of such lines are found on globes that represent Earth (**Fig. 10.1**). The latitude lines (understood to be parallel to one another and to the equator) and longitude lines (vertical bisections that pass through the poles) are placed on globes as geographic orientation devices, but they are also excellent examples of cross-contours. They substantially increase our perception of the volume of the spheres they encircle. A ball of string or yarn is another such familiar image in which each surrounding strand functions as a volume defining cross-contour.

For an initial cross-contour exercise, start by drawing latitude and longitude lines on an imagined globe. As you draw these lines completely around the spherical form, vary the line pressure so that the lines become thinner and less distinct as they move back around the sphere and, conversely, thicker and darker as they come forward (**Fig. 10.2**). Varying line thickness in this manner adds additional depth because marks that are applied in stark contrast to the background are perceived to be near the observer

10.1 We locate points on the surface of Earth by standard, geographic coordinates called latitude and longitude. These coordinate, values are measured in degrees and represent angular distances calculated from the center of Earth.

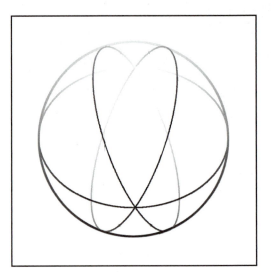

10.2 By reducing the thickness and darkness of the cross-contour lines as they go completely around the sphere, we reinforce the illusion of three-dimensional space with line variation and exaggerated atmospheric perspective.

10.3 Atmospheric perspective is based on the principle that objects nearer the observer appear more sharply focused and in greater contrast to the background than those further away.

10.4 M.C. Escher, *cubic space division* (1952, Friedrich A. Lohmueller, 2000). Escher's application of exaggerated atmospheric perspective helps compensate for the fact that the surface of the image does not allow us to experience stereoscopic vision, parallax, or the muscle contractions in our eyes that ordinarily contribute to the fullness of our experience of depth.

while those that are close in value to the background seem to be fading into the distance (**Figs. 10.3, 10.4**). This space-creating technique is known as *atmospheric perspective*. On black surfaces, white marks look closest. On white surfaces, black appears nearest. On a gray surface, both black and white come forward.

Varying the thickness of the line also contributes to the illusion of volume in a drawing. Whereas the outside of a flat two-dimensional circle is defined by a wire-like **outline** that naturally reinforces flatness through its constancy, a three-dimensional sphere is most effectively suggested by a **contour line** that changes as it moves around the edge of the three-dimensional form. The outside edge (contour) of a three-dimensional form is perceived differently than an outline of a two-dimensional form because with a three-dimensional form we actually see different locations on the edge with each eye. This makes the edge of a three-dimensional form more an event (the fusing of two separate images of where the form turns away in space) than a specific place. This fluctuating character of the outside edge of a three-dimensional form is best described by lines that fluctuate in thickness and in value.

ATMOSPHERIC PERSPECTIVE

CHAPTER 10: CROSS-CONTOUR

To draw cross-contour from observation you will need an object whose surface is covered by parallel lines. A small striped flag fills this need and is easy to make. If you carefully follow the manufacturing instructions on this page, you will find, like others before you, that this flag is conveniently lightweight, portable, inexpensive, and easily manipulated into a wonderful variety of visually engaging and technically challenging volumetric configurations (**Fig. 10.5**).

Before getting started, though, let's use our flag to review the basic principles and techniques that we have already covered. Start by positioning the flag flat on a horizontal surface at chest height with one corner pointing toward you (**Fig. 10.6**). Begin with a quick gesture that loosely records your reaction to its shape and proportion. As the flag begins to emerge from the gesture, apply Mondrian lines to validate the accuracy of your initial response by comparing the horizontal and vertical relationship of the corners. After Mondrianing, put a rectangle around the edges of the flag and compare the proportion of your drawing against the actual flag. To make this review of drawing fundamentals slightly more challenging, try putting three drawings on one piece of paper with each successive image rep-

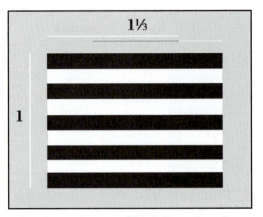

10.5 To make an official **Drawing from Observation** flag, fold a sheet of 18 inch × 24 inch newsprint paper in half vertically and in half again horizontally (it now measures 9 inches × 12 inches). Carefully tear the crease against a straight-edge. Take one sheet and mark off its shorter sides with nine divisions of 1 inch each. After connecting each parallel pair of increments, neatly fill in every other stripe with either charcoal pencil or black marker (the marker is neater). Keep the edges crisp and fill them in solid black.

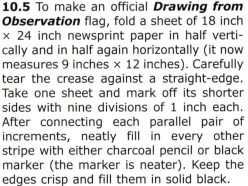

10.6 To calculate the overall proportion of an inclined plane, imagine it to be enclosed in a rectangle that is placed around the flag parallel to the picture plane. In this relationship the rectangle duplicates the vertical and horizontal extremes of the flag so that the ratio of the sides of the rectangle equals the overall proportion of the inclined flag.

118

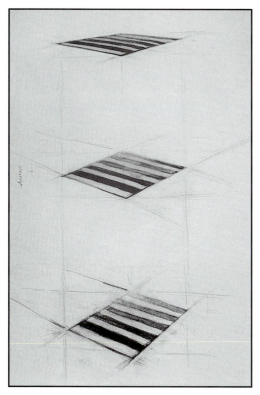

10.7 For this drawing the official drawing flag was moved three times and drawn successively at each of the three different heights (shoulder, hip, and knee). As you can see, careful application of contour-line variation, intuitive gesture, Mondrian lines, converging clock-angles, and foreshortened proportional measurement contributes to a remarkably accurate sense of the spatial recession of the inclined plane of the flag.

resenting the flag viewed at varied heights (**Fig. 10.7**). Ordinarily there is a tendency to anticipate what the flag should look like before actually looking, especially given that you manufactured the flag yourself and "know" its proportions intimately. The fact that we know that the flag has four 90° angles, has an overall proportion that is 1 to 1.3, and contains a series of parallel stripes will conspire to prevent you from accurately recording what you see. To defend against the predictable onslaught of misleading conceptual data, regularly refresh your intuitive gesture by relying on the Mondrian tool, clock-angle tool, and proportion tool to guide you toward more discriminating and accurate observations. Although making frequent corrections is understandably frustrating, this frustration is an unavoidable part of the perceptual drawing process. After all, frustration is a part of the fabric of everyday life and should be embraced both in art and in life as something to be worked through rather than something to be avoided. **Frustration is a temporary but inevitable reaction to a challenging situation. It dissolves into delicious satisfaction once you realize your goal.**

Before starting a cross-contour flag drawing, you need to arrange the surface of the flag so that

it moves three-dimensionally. You then need to **make sure that this surface movement is clearly reflected in observable changes** in both the width and the direction of the parallel lines from the position from which you have chosen to draw. As a general rule, the more dramatically the lines change direction and the more the width of the lines appears to vary, the more effectively will the cross-contours contribute to the illusion of depth.

As you experiment with the different ways you can arrange your flag, you will find that the two factors requiring the most attention are the direction of the curl or fold in relation to the stripes and the relationship of the observer to the direction of the stripes. Curls or folds in a flag that run parallel to the stripes add little or nothing to the overall suggestion of three-dimensional space (**Fig. 10.8a**), nor do lines whose movement is negated by an ill-chosen viewing angle (**Fig. 8.6b**).

Cross-contour lines that change width and direction in plain sight are particularly effective at communicating volumetric information when compared to those that disappear over the edge of the curl or fold (**Fig. 10. 8c**). It's therefore helpful to arrange the flag with maximum observable variation in the width and direc-

10.8a-c The top two drawings, while sensitively rendered, don't effectively use the spatial illusion–generating capabilities of cross-contour. In the uppermost flag the stripes are parallel with the curl and appear straight. In the middle flag the viewing angle restricts the observable movement of the stripes. The bottom flag produces an effective illusion of surface undulation where the linear movement translates successfully as illusionistic space. For best results find a viewing angle that provides maximum observable movement of the cross-contour stripes.

10.9 It is important to find a viewing angle where the cross-contour lines dramatically change direction as they move up and over the surface. Considerable spatial illusion is added if the chosen viewing angle depicts substantial fluctuation in cross-contour width when the stripes radically change direction.

10.10 A drawing from observation often contains marks and lines that record multiple levels of the perceptual and drawing process. The energy of the drawing and the variety of the mark making are substantially enhanced by progressive levels of intuitive gesture, Mondrian lines, clock-angles, proportion boxes, and erasures.

tion of the parallel lines. As you position your flag, walk completely around it, taking in every possible alternative viewing position until you are confident that you have found the one position that offers the best variety in the width and direction of the cross-contours (**Fig. 10.9**). As you begin to draw, include quick estimates of the placement of the cross-contour stripes as you gesture. You need to overcome the natural tendency to focus on only the outside shape of the flag before considering the cross-contour stripes. You will be better off gesturing them all at once at a relatively early stage. This way you avoid substituting a narrowly focused sequence of ideas about the flag and focus broadly on the complex immediacy of what you actually see in front of you. While you might initially feel more comfortable working on individual details one at a time, working intuitively on all parts of the flag simultaneously is the path to greater overall accuracy. You need to develop all of the elements of gesture together with repeated application of intuitive gesture, Mondrian gridlines, clock-angles, and proportion boxes. These are the mechanisms that accurately capture perceptions (**Fig. 10.10**).

For a variety of reasons, it will never be possible in a drawing to reproduce all the visual

10.11 This drawing is an excellent example of the effectiveness of being able to follow uninterrupted cross-contour movement across the majority of an object's surface. From this viewing angle, these stripes interact so directly with the undulations in the surfaces that they enable us to experience both tactile and kinesthetic (movement) sensations. These sensations add considerable fullness to our understanding of the visual character of the objects being presented.

information that you see when you look at the world around you: a considerable amount of information is always lost when we translate our binocular (two-eyed) vision to a two-dimensional drawing surface that is capable of recording only monocular (one-eyed) information. For example, our everyday experience of spatial depth relies heavily on two binocular mechanisms: sensitivity to the changing pressure in the muscles in and around the eyes as they focus on objects that are at varying distances (feel how your eyes cross when you look at things very close to your face); and the brain's ability to

10.12 Setting up the flag so that the receding edges are convincingly converging enhances the dimensionality of the drawing, as does the sensitive line variation on the leading edge.

10.13 Although simple, this drawing is extremely effective at creating the illusion of receding space because the flag appears spatially consistent. This consistency was generated through use of Mondrian lines, proportion measurements, and clock-angles. The sense of space was also considerably enhanced by sensitive line variation.

LINE VARIATION

Line variation not only engages the eye, making the drawing more enjoyable to look at, but it also contributes directly to the illusion of space.

Creating space by varying the thickness and darkness of line

1. When a line is closer to the observer
2. When a line is underneath object to indicate weight
3. When a line represents the edge of an object that overlaps another object
4. Contour lines (outside edge of 3-D forms) should vary from thick to thin.

organize two slightly differing images into a stereoscopic experience of depth. Because neither of these mechanisms comes into play when you are looking at a flat image, you will need to compensate for the loss of this important spatial information by maximizing the spatial expressiveness of **monocular cues.** These very effective, spatial illusion–creating, two-dimensional, one-eyed visual techniques include chiaroscuro, cross-contour, contour line variation, overlap, and converging parallel edges (**Figs. 10.11–10.13**). By purposefully exaggerating any or all of these cues, we can increase the illusion of depth and construct satisfying approximations of the fullness of our real-world experience of three-dimensional space (**Figs. 10.14, 10.15**).

EXAGGERATING CUES

123

10.14 Careful observation of the changes in the movement and thickness of the cross-contours as they meander from edge to edge allows for remarkable subtlety in the depiction of surface irregularities. These include dips, flips, ripples, twists, curls, folds, slopes, peaks, valleys, lumps, indentations, swellings, undulations, and protuberances.

As you learned in Chapter 8, the height of an object diminishes (appears foreshortened) when the object leans away from the observer. In a drawing you can increase the suggestion that the object is tilting away from the observer if you exaggerate the amount of foreshortening while

"Movement of the senses (as we scan a static image) is as emotionally charged as bodily movement because artistic perception causes a return to sensuous, concrete, pre-logical thought, which cannot differentiate between the two."

Sergie Eisenstein
1898–1946
Russian Film Pioneer

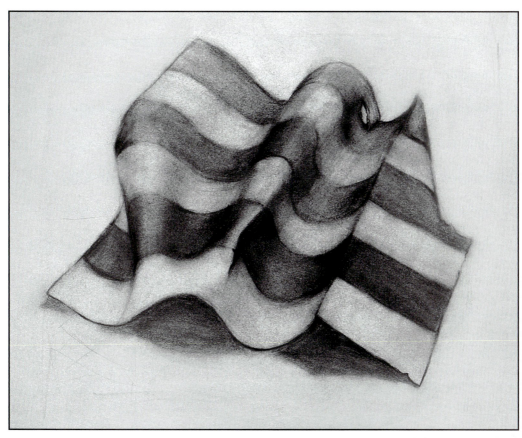

10.15 To compensate for the loss of binocular cues in creating a three-dimensional illusion on a flat surface, it helps to exaggerate monocular cues in the direction of the illusion. We should consciously foreshorten the proportion (slightly more than that which we actually measure), increase the curve and degree of change of the cross-contours, subtly increase the convergence of receding parallel edges, and exaggerate the line variation so that the contrast is stronger when we are describing forms as they come forward.

simultaneously increasing the speed at which its edges converge. To achieve this in your drawing, you can make adjustments to the actual flag either by curling or folding it more or by purposefully exaggerating the object's foreshortening and the convergence of the edges in your drawing. A little exaggeration can be a wonderful thing, and as a

MONOCULAR CUES, YES

general rule, a little too much is better than too little. Think exaggeration!

Because there is a tendency to underestimate both foreshortening and the convergence of parallel edges, you don't need to be overly cautious when exaggerating most monocular cues. Underestimating the convergence of receding edges flattens the illusion of space (**Fig. 10.16a–b**), whereas exaggerating the convergence accelerates the movement away from the picture plane. Since you are more likely to underestimate the angles at which the edges appear to converge, a conscious attempt to increase the convergence usually contributes a more successful illusion of space in a drawing (**Fig. 10.17a–d**).

Converging lines, when used to represent parallel edges going back into space, convey the illusion of depth. You also interpret progressively diminishing size of similar objects as an indicator that the objects are getting further away from the viewer. In the flag drawings this means that stripes at the front of the flag should be drawn as thicker than those at the back. Making sure there is a reduction in the thickness of each successive stripe positively reinforces the illusion of depth we are seeking (**Fig. 10.18**).

10.16a-b The illustrations above effectively incorporate multiple techniques for creating the illusion of spatial recession. The strength of both illusions is compromised by the divergence of the receding edges as they move back away from the picture plane. In the upper flag, however, the counterintuitive widening of the flag is kept in check for the most part by the radical foreshortening and by the dramatic changes in the width and direction of the cross-contours, whereas the lower flag presents little in the way of proportional foreshortening.

CONTRADICTORY SIGNALS

10.17a-d We can maximize the illusion of depth either by adjusting the actual flag so that it is considerably more narrow at the back than at the front or by intentionally exaggerating the rate of convergence of the receding edges in our drawing. Exaggeration is a valuable technique that helps compensate for the loss of binocular cues. Stripes generally appear to get narrower (closer together) the further they are from the observer. Having the stripes diminish in size to make them appear further away takes a consciously exaggerated effort, especially when the width of each cross-contour fluctuates from thick to thin as it moves up and over the form.

As described at the beginning of this chapter, atmospheric perspective is the progressive reduction of value contrast and detail as objects recede from the observer (**Figs. 10.19a-b, 10.20**). Atmospheric perspective

ACCELERATED CONVERGENCE

127

10.18 Because the curls that were introduced into the flag actually made the back end wider than the front, the convergence of the edges that ordinarily occurs when a rectangular plane recedes does not take place. As a result, the rear end of the flag seems to come forward slightly. However, the drawing succeeds at creating an effective illusion of form in space by the presence of many other spatial cues: sensitivity to proportion, using the Mondrian tool to align important transitions in the flag, exaggerating the reduction of width of the stripes that are further back in space, exaggerating atmospheric perspective, consistent application of chiaroscuro so that the flag appears to be illuminated from above, strategic use of overlap, and sensitive contour line variation.

occurs because light becomes diffused as it passes through water particles that are suspended in the air. The distance of the objects from the observer and the amount of moisture content in the air directly effect how clearly we can see. We are all somewhat familiar

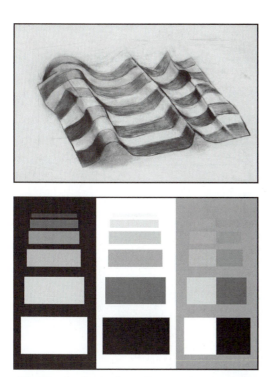

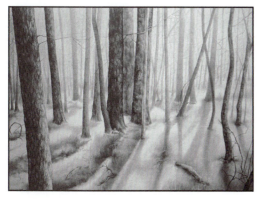

10.19a-b Reducing the contrast of an object with its background as it recedes in space is a powerful tool for creating the illusion of spatial recession.

10.20 Katherine Liontas-Warren, *East Texas* (Graphite on paper, 2005). An illusion of considerable spatial recession is achieved by combining disproportionate scale (objects getting smaller as they recede) with an exaggerated reduction of contrast (atmospheric perspective).

with this perceptual phenomenon because it commonly occurs in nature (mountaintop vistas and foggy mornings) and also because it frequently appears in photographs. What is somewhat less appreciated, though, is how effective it is to add exaggerated atmospheric perspective to a drawing whose content contains limited spatial recession and where there is no atmospheric perspective to be observed. The spatial illusion of objects in a relatively shallow space can be substantially enhanced by purposefully exaggerating the reduction in the contrast in objects as they are understood to be located further back in space. When you are exaggerating atmospheric perspective in this way, it is important to maintain a smooth progression in the reduction of contrast and the reduction of detail.

Arranging the flag so that the cross-contour stripes remain visible across the entire surface of the flag intensifies the spatial illusion. This makes it easier to extract visual logic from the observed changes in size, width, and direction of the cross-contours (**Fig. 10.21**). There are situations, however, in which it is necessary to draw a flag from a viewing angle where one or more of the cross-contours disappears completely behind a steep curl or fold. When the cross-contours

SPATIAL EXAGGERATION

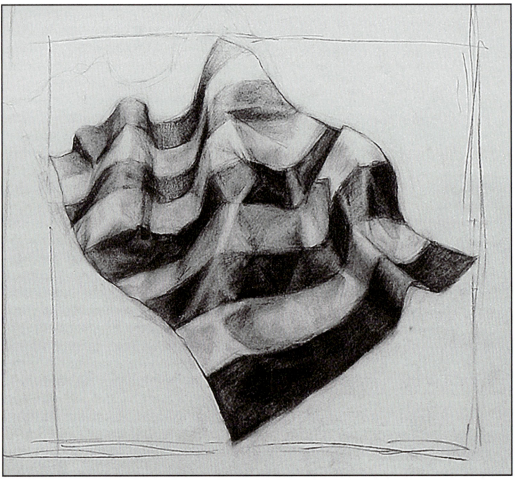

10.21 An image in which the majority of the cross-contours are visible to the viewer as they move across the surface of the depicted object allows for considerable complexity and subtlety in the rendering of the object's surface. Atmospheric perspective (reduction of value contrast and detail), contour line variation, and foreshortening are monocular cues that compensate for lost binocular information.

completely disappear from view, there are two monocular cues you can use to restore visual continuity to a form. One cue is overlap: strengthening the thickness and darkness of an overlapping edge so that it clearly stands out in front of the form behind. The second cue is the lemming syn-

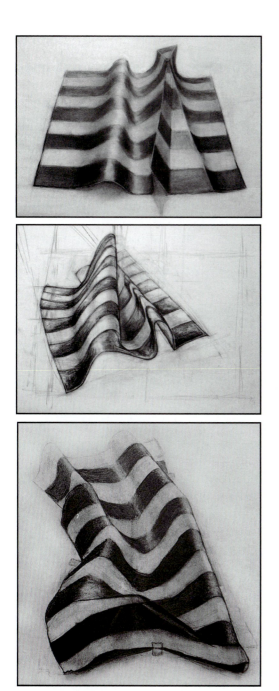

10.22a–c When a cross-contour is interrupted, exaggerating the leading edge of the overlapping form and continuing the cross-contour over the edge reestablishes continuity.

drome: exaggerating the change of direction of a cross-contour as it approaches the edge by anticipating the direction in which it will go after it disappears. The lemming syndrome got its name from a fictitious belief that certain Scandinavian rodents periodically commit mass suicide by hurling themselves headlong over cliffs. It turns out that they don't actually jump off cliffs, but let's not allow scientific accuracy to prevent us from using the image of a hurtling horde of leaping lemmings to describe the exaggerated movement of a cross-contour line as it graphically carries the eye up to and emphatically over an object's edge (**Fig. 10.22a–c**).

The last addition to our recommended list of techniques for exaggerating the illusion of depth on a two-dimensional surface is chiaroscuro. As the roots of the word suggest (*chiaro* means "light" and *oscuro* means "dark"), this technique creates the illusion of three-dimensional form by applying appropriate values from a continuous tonal scale to suggest varying intensities of light being reflected off the surface of an object. We devote an entire chapter to the way light defines form, but for now we need only attempt a shorthand version as a way of reinforcing the monocular cues already introduced. As you might already have

LEMMING SYNDROME

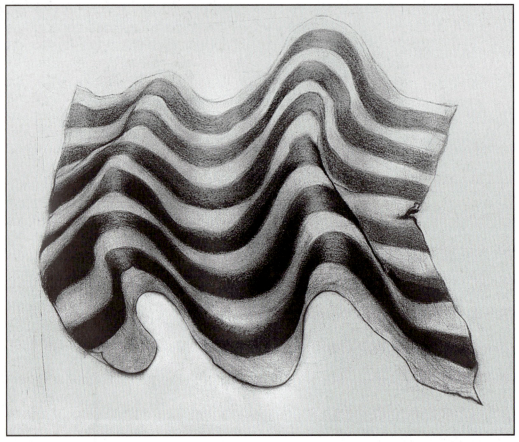

10.23 Combining careful rendering of the strong movement in the cross-contours, exaggerated atmospheric perspective, effective use of overlap, sensitive contour line, and consistent chiaroscuro results in a convincing illusion of form in space.

noticed, almost every drawing in this chapter incorporates some suggestion of light hitting the surface of the flag. In most cases these drawings were done in a room with overhead fluorescent bulbs and, as one might expect, the light is coming directly from above. Surfaces that are perpendicular to the direction of the light appear brighter than those that are oblique. Therefore, when

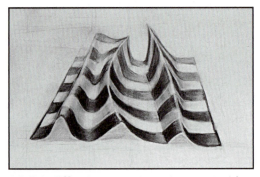

10.24 Effective cross-contour provides the means for a seemingly endless variety of surface undulations.

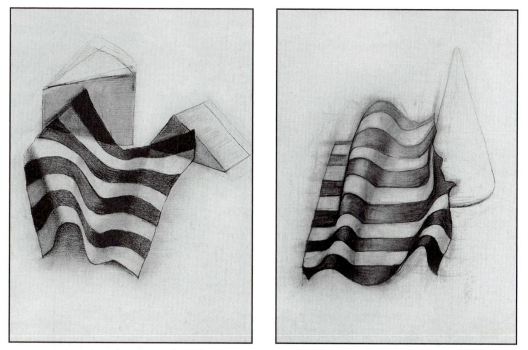

10.25a-b When you are applying chiaroscuro to the flag, beware of the preconception that white stripes will always appear white and black stripes will always appear black. As with so many things in life, it really is just so many shades of gray.

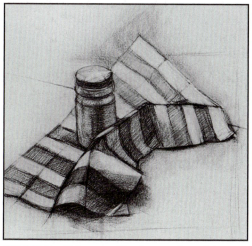

10.26 In this sensitively rendered image the diagonal line that represents the edge of the wall behind the flag provides important visual information that helps in interpreting the raised back portion of the flag.

the light comes from above, the sloping sides of the curls and folds appear darker than the surfaces receiving perpendicular illumination (**Figs. 10.23–10.26**). As you might have anticipated, chiaroscuro complicates the way you can render the white and black stripes. Pure white needs to be limited to only those portions of the white stripes with the highest illumination, and the deepest black should be reserved for representing those sections of the black stripe that are least illuminated. Paradoxically, this means that when you draw from an illuminated

FLAG WITH OBJECT I

133

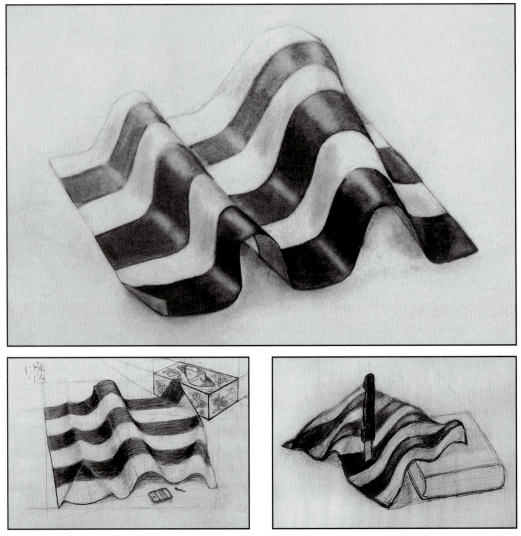

10.27a-c A considerable investment of time, energy, and determination is essential for achieving the kind of results you see throughout this chapter. As you can see from the two bottom images, it is not uncommon for a love/hate relationship to gradually develop toward the flag during the long drawing sessions.

black and white flag, the drawing that is made from it will mostly consist of multiple shades of gray (**Fig. 10.27a–c**).

Chiaroscuro is effective in combination with any of the techniques

FLAGS WITH OBJECT II

10.28 Drawings that incorporate monocular spatial cues can be so effective at communicating three-dimensional form that they trigger tactile sensations. These cues enable us to enter into the imaginary realm of the drawing and "feel" the surface changes as we look across the surface. When combining objects with the flag be sure to establish the proportions of each so that they appear to be viewed from the same eye-level.

10.29 Careful duplication of the changes in the direction and thickness of the stripes creates remarkably subtle changes in the appearance of the flag's surface.

that we've already discussed but especially so when applied as cross-contour modeling where the marks used to suggest changes in illumination are themselves made to follow the cross-contour movement across the surface of the form (**Figs. 10.28, 10.29**).

In the next chapter you will expand your undestanding of cross-contour. You will use it to describe the underlying structure of complicated, irregular volumetric

forms. But before moving ahead you might want to attempt the granddaddy of cross-contour assignments: an object that is draped in a striped fabric. For this project you will need a couple of yards of striped fabric (two-inch stripes work best) and an object (to drape it over) that has a clear and strong visual character. As with the flags, an important part of this drawing occurs before you pick up your pencil. **The stripes need to be arranged on the chair so that they reveal the visual character of what is underneath.** Remember to attach the cloth to the chair in a number of places using tape, thumbtacks, safety pins, or staples. This helps to reveal the structural characteristics under the cloth.

Although the striped chair project is certainly more demanding than a flag drawing, it generally results in extraordinarily sensitive and illusionistic images (**Figs. 10.30a–b –10.32**). The only drawback to tackling the striped chair drawing is that it requires at least two full weeks of class time and homework to do it justice. For the students who have taken this challenge, the increased difficulty brings out an intensely focused energy. The results almost always make the effort worthwhile.

10.30a-b The shape of an object can be described in remarkable detail by duplicating the apparent changes in direction and width of a set of parallel stripes that are draped over the form.

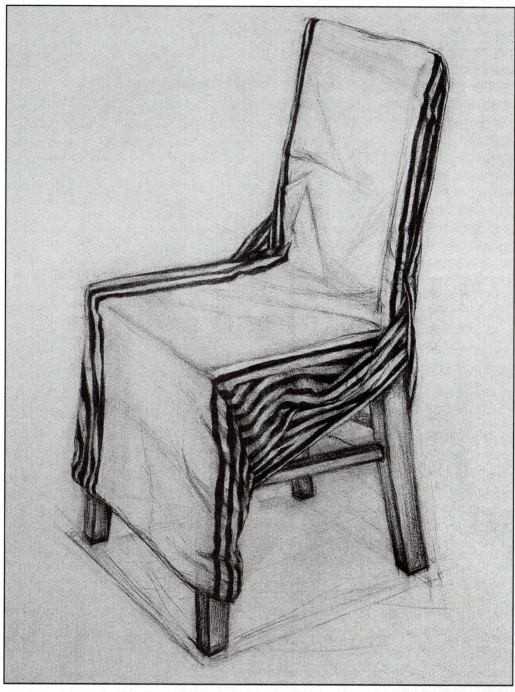

10.31 More detail could be added, but this drawing is complete. A drawing is considered complete when it is sensitively constructed and internally consistent.

SOFT CLOTH, HARD CHAIR I

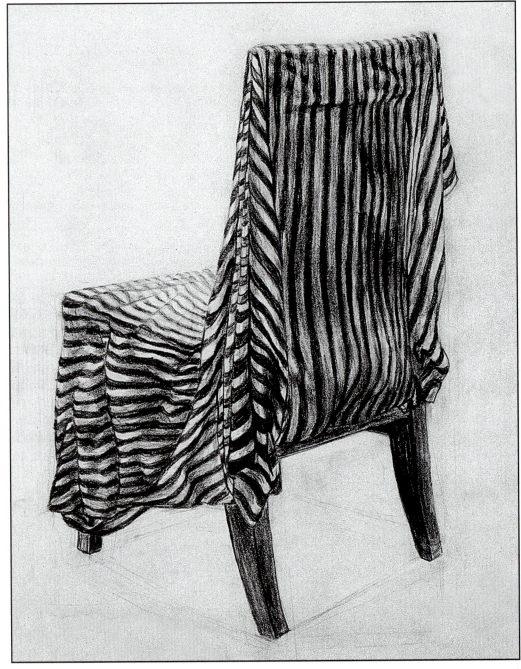

10.32 It is unreasonable to expect to be able to draw an extremely complicated arrangement of flowing stripes exactly as they appear. Instead, we must rely on close approximation and exaggeration to create convincing cross-contours that suggest the fluid movement of the cloth reacting to the solid form underneath.

CHAPTER 11 FORESHORTENED CIRCLES

Circe's circles 139
Foreshortened circles . . . 140
Portrait of an ellipse 141
Elliptical proportions 142
Drawing through the form 143
Conceptual cup (revisited) 144
Perceptual cup (revisited) 145
Horizontal similarity 146
Vertical decompression . . 147
Horizontal decompression 148
Universal elliptical tilt rule 149
The cylindrical axis 150
Curved picture plane . . . 151
Curvilinear perspective . . 152
Finding the center. 153
Exaggerated circles. 154
Changes in compression . 155
Circles on cylinders. 156
Similar but different 157
Row of circles. 158
Column of circles 159
Spherical cross sections. . 160
Shifting poles 161
Longitudinal tilt 162
Circles on rectangles. . . . 163
Imaginary birdhouses I . 164
Imaginary birdhouses II . 165
Imaginary birdhouses III 166
Imaginary birdhouses IV . 167
Imaginary birdhouses V. . 168
Imaginary birdhouses VI . 169
Variations on a theme I. . 170
Variations on a theme II . 171
Elliptical exaggeration . . 172

The next step in broadening your observational drawing skills is to learn the basic principles governing how the shape of a circle appears to change as its position and orientation relative to the observer change. This lesson is particularly valuable because the same principles that govern circles in perspective also apply to cylindrical cross sections and spherical cross sections. All three share essential characteristics: a circle is a closed curve on a plane whose every point is equidistant from a fixed point called the center (**Fig. 11.1**), a cylinder is a solid with parallel sides and circular ends, and a sphere is a three-

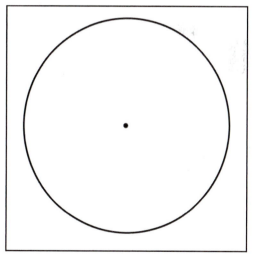

11.1 The word *circle* is taken from the ancient Greek goddess Circe, who was believed to weave the fates of mankind on her cosmic spinning wheel.

11.2a-b A cylinder is a solid with a curved side that is bounded by two parallel circles. A sphere is a three-dimensional surface whose points are all equidistant from a fixed point. The fact that these solids share essential characteristics with circles allows you to apply the same fundamental elliptical principles governing the appearance of foreshortened circles to both of them.

dimensional solid whose surface points are all equidistant from a fixed central point. Everything you learn about foreshortened circles, with some slight adjustment can be applied to cylinders and spheres (**Fig. 11.2a-b**).

Because of the unforgiving regularity of a circle, it is difficult to draw one without using a mechanical tool. Fortunately, unless you are engaged in a study of geometry or making technical diagrams, you will rarely need to draw a true circle. This might sound a little surprising given the obvious frequency with which circular forms occur in our environment, but the only time a circular form actually appears to an observer as a circle is when it is both parallel with the observer's

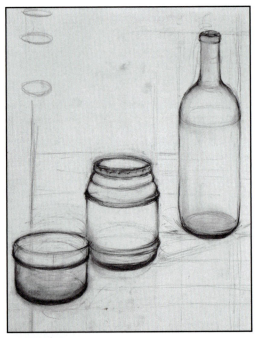

11.3 In the visual world, circular objects rarely appear as circles. Most commonly, observed circles appear as ellipses.

FORESHORTENED CIRCLES

11.4 An ellipse is a geometric figure that resembles a circle that has been compressed along a single axis. The longest diameter of the ellipse is called the major axis while the shortest is called the minor axis (above left). An ellipse is bilaterally symmetrical (exact correspondence) on both sides of each axis. Although there will be no need to use the following mechanical device to construct ellipses as we draw, it might be helpful to understand how they are formed. The sum of the two line segments that connect any point on the curve of ellipse with the two foci on the major axis is always the same (above, right). This means that if you attach a length of string longer than the distance between the foci to the two foci and then press a pencil tightly against the stretched string, the string's resistance will determine the curvature of the ellipse.

11.5 The two most common errors that occur when drawing an ellipse as a foreshortened circle are the flattening out of longer curving sides and the substituting pointed ends like those of an American football for the fluid curve that actually occurs. Both errors can be eliminated by moving your pencil through a series of continuous, sweeping, and delicate gestures that approach the entire ellipse as a unified and seamless entity.

picture plane and directly in front of her/his eye(s). Any deviation from this singular spatial relationship causes noticeable perceptual distortion in the visual character of the circle. Instead of appearing perfectly round, circles that move up, down, or across the picture plane or those that tilt away from the observer appear visually foreshortened, compressed along one axis. A foreshortened circle that is compressed along one axis looks exactly like an ellipse (**Figs. 11.3, 11.4**). An ellipse is a smooth and continuous curve that is bilaterally symmetrical around a major and minor axis with the outside edge having no flat spots and no football ends (**Fig. 11.5**). The amount of axial compression exhibited by a particular fore-

shortened circle is dependent on several factors: the degree of tilt away from the picture plane, the distance of the circle from eye level, a lateral shift in position, or a combination of the above.

A circle that is parallel to the ground plane should be understood to be tilting away from the observer's picture plane at a 90º angle. At eye level, such a circle will appear as a straight line. When the circle moves up or down from eye level, it appears to the viewer as an ellipse. As long as the circle remains parallel to the ground plane, its widest axis will always be horizontal. The overall proportion of the ellipse changes depending on how far it is from eye level. The further the circle is from eye level, the more open is the ellipse that is used to represent it (**Fig. 11.6**). The ratio of the major and minor axes moves progressively toward a one-to-one relationship the further the foreshortened circle is from eye level, but it can never actually reach this proportion because only circles that are parallel to the picture plane and directly in front of the observer can appear perfectly round. In any other position relative to the observer there is always some degree of axial compression that makes the foreshortened circle appears as an ellipse.

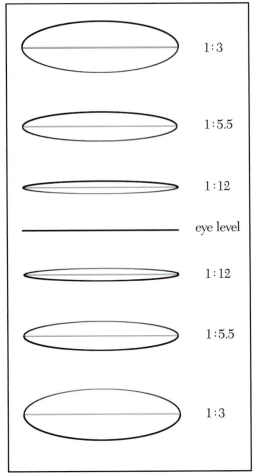

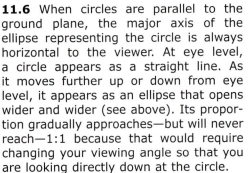

11.6 When circles are parallel to the ground plane, the major axis of the ellipse representing the circle is always horizontal to the viewer. At eye level, a circle appears as a straight line. As it moves further up or down from eye level, it appears as an ellipse that opens wider and wider (see above). Its proportion gradually approaches—but will never reach—1:1 because that would require changing your viewing angle so that you are looking directly down at the circle.

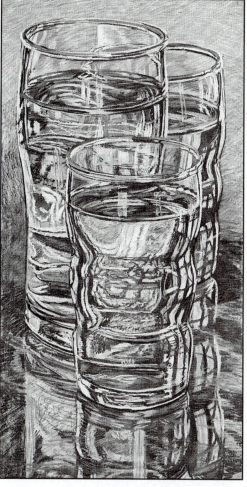

11.7 Janet Fish, *Three Restaurant Glasses* (1974, pastel on paper, 304 x 16 inches, Collection of the Minnesota Museum of American Art, Acquisition Fund Purchase [74.43.08]. © Janet Fish, Licensed by VAGA, New York). Fish's drawing of restaurant glasses contains no fewer than eleven ellipses that progressively decompress as they get further from eye level. Art © Janet Fish/Licensed by VAGA, New York, NY.

It takes practice to draw fluidly around the contour of an elliptically shaped foreshortened circle. Maintaining the continuous curve, preserving the bilateral symmetry around both axes, and establishing the appropriate proportion of the ellipse so that it reflects its proper distance from the eye level is a challenge (**Fig. 11.7**). Drawing an ellipse is easier if you don't stop the pencil until it has gone completely around at least twice, if not more. It also helps to maintain a delicate touch with the pencil so that if the ellipse needs adjustment, you can continue to gesture without the surface of the drawing becoming too congested. Gesturing lightly around and around the ellipse generally creates a more symmetrical and even ellipse. It also helps to gesture in the major and minor axes as you create the ellipse because it further encourages bilateral symmetry.

Before moving on to some of the other characteristics of foreshortened circles, let's take one more look at the way ellipses open up as they get further from eye level. This is worth repeating because there is a strong tendency to draw from conceptual understanding of cylinders rather than from their actual appearance. For example, each morning most of us start the day looking into the wide circular mouth of a cup/glass/can as we

11.8a-b Even though you probably won't ever respond quite as inaccurately as is depicted in the manipulated photo (above left), it is important to recognize how powerful our tendency is to substitute what we know for what we see. The preconceived notion that the mouth of the cup is circular and the bottom is perfectly flat will lead to serious underestimation in the progression of elliptical compression. Preconceived notions certainly had a strong distorting influence on the ancient Roman artist's rendering of the glass vase (above right) in *Still life with peaches and glass vase*, Herculaneum, circa AD 56, Museo Archeologico Nazionale, Naples.

sip/slurp/gulp our breakfast beverage, and when we then put the container down onto the tabletop, we are confident that its perfectly flat bottom will keep it stable and upright (**Fig. 11.8a-b**). The intimacy of this daily ritual solidly reinforces practical, analytical thinking about the general characteristics of cylinders that, while being tremendously useful for everyday functioning, are often in serious conflict with the visual appearance of cylindrical objects. To prevent this conceptualization from distorting your perceptions you need to be sensitive to the conflict between "what you know" and "what you see." By recognizing this difference you

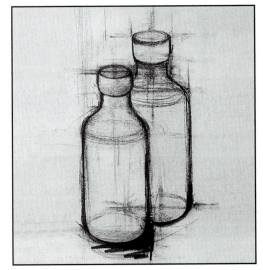

11.9 Including lines for both the major and the minor axes encourages bilateral symmetry in each ellipse. Drawing a central axis down through the center of the bottle serves to promote lateral symmetry in the larger cylindrical form.

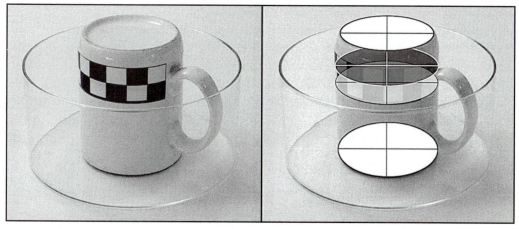

11.10a-b To capture the apparent increased curvature that occurs when foreshortened circles (ellipses) are progressively positioned further away from our eye level takes a concerted effort to render each foreshortened circle fuller than the one preceding it.

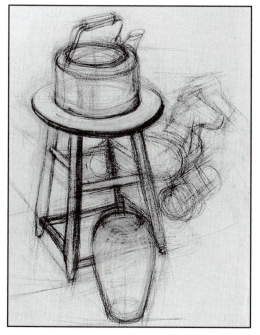

11.11 When drawing ellipses, keep your pencil moving through at least one complete rotation. Drawing "through the form" contributes to the illusion of three-dimensional space by suggesting a sense of transparency that leads the eye through to the back side of the object.

will control the rational tendency that overstates the fullness of ellipses at the top of vessels and simultaneously understates those at the bottom (**Figs. 11.9– 11.11**).

Foreshortened circles that are parallel to the ground plane appear more circular not only when they move away from eye level in the physical world but also when they move toward the observer. As we saw earlier in the chapters on the perceptual grid, objects that are below eye level appear lower down on the picture plane as they come forward. This apparent vertical movement down the picture plane results in precisely the same change in elliptical proportion as does movement along a vertical axis. Because these two types of movement (up/down, in/out) result in identical elliptical

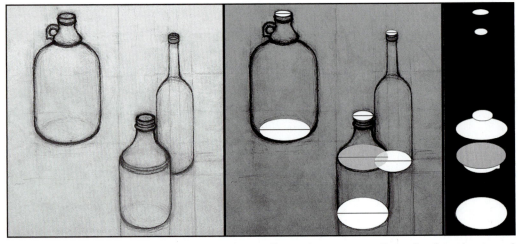

11.12 The amount of decompression in an elliptical representation of a foreshortened circular cross section ultimately depends on the its vertical position on the picture plane. The most compressed ellipse is closest to the top of the page and the fullest ellipse is located closest to the bottom of the page with a full range in between.

compression, the proportion between the major and minor axes of any two ellipses that are horizontally aligned on the picture plane are always identical even when one ellipse represents the bottom of a cylinder in the background and the other the top of a cylinder close to the viewer. It is an ellipse's vertical placement on the picture plane, not the height of the cylindrical object, that determines its degree of compression (**Figs. 11.12, 11.13**).

Because the vertical placement of a foreshortened circle on the picture plane can be caused by two very different spatial relationships, care must be taken to safeguard against any spatial ambiguity that may arise (**Fig. 11.14**).

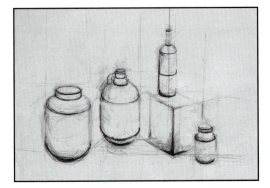

11.13 Circular cross sections appear to open up (become less compressed ellipses) the further they are from eye level. As a result, the bottoms of cylindrical forms are always more curved than the tops. This is important to remember given that we conceptually understand the bottom to be flat and are thus predisposed to underrepresent the observed curvature (see page 31).

HORIZONTAL SIMILARITY

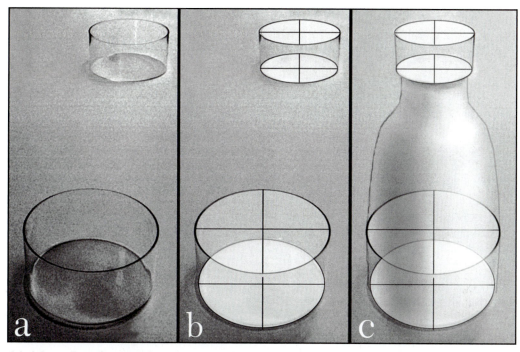

11.14a-c Foreshortened circles appear fuller (less compressed) when they move down a vertical axis from eye level. You see this difference in the tops and bottoms of individual cylinders (**a**). Foreshortened circles also become fuller when they move toward the picture plane. You can see this by comparing the ellipses from the two identical glass cylinders positioned at different distances from the observer (**b**). **Although the two types of movement (down vs. out) are quite unrelated in terms of real space, they actually produce identical changes in elliptical decompression**. Any two ellipses whose major axes are horizontally aligned on the picture plane, regardless of whether that position is determined by physical height or by distance from the picture plane, share identical proportions. This can be seen in image **c** where the more distant cylindrical object, by being repositioned directly above the closer object with the addition of some unifying chiaroscuro, now appears as the cap of a bottle in the foreground with the addition of some unifying chiaroscuro.

Because circles and cylinders often appear in positions other than parallel to the ground plane, you need to look at how alternate orientations affect the angular tilt of their major and minor axes. The simplest variation comes from shifting the central axis of the observed circle/cylinder by 90° (**Fig. 11.15**). This shift in position aligns the central axis of

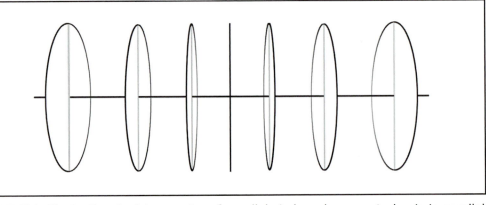

11.15 This illustration depicts a series of parallel circles whose central axis is parallel to both the ground plane and the picture plane. In this relationship the foreshortened circles appear as progressively less compressed ellipses as they move out toward the sides (away from the viewer). As in **Fig. 11.6** (here rotated 90°), the widest part of the ellipse (the major axis) is always perpendicular (90°) to the central axis.

all the foreshortened circles so that the axis appears parallel to both the ground plane and the picture plane (in this orientation the axis appears as a horizontal line). When circles are aligned in this way, the circle that is directly in front of the observer appears as a vertical line while those that move laterally toward the edges appear as progressively fuller (less compressed) ellipses. You can see that in each of these ellipses the major axis is vertical and once again the major axis of each ellipse crosses the central axis of each circle at a 90° angle. Comparing this arrangement to the group of circles whose central axis was perpendicular to the ground plane (**Fig. 11.6**), you will observe that in both cases the major axis of each foreshortened circle is always perpendicular to the central axis. In fact,

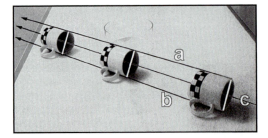

11.16 The three coffee cups above have been aligned so that they all share a common cylindrical axis (**c**). That axis is, by definition, parallel to the cup's outside surface, and because the cups are moving back away from the viewer, the axis converges with those edges (**a&b**) as they recede in space (remember the railroad track phenomenon). This shared cylindrical axis intersects the major axis of each of the ellipses that represent the ends of the foreshortened cylinders at exactly a 90° angle.

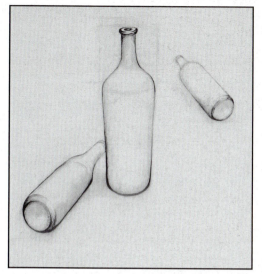

11.17 When a bottle stands straight up with its base flush with the ground plane, the cylindrical cross sections at the lip and foot appear as horizontal ellipses whose major axis is literally 90° to the vertical axis of the bottle. When a bottle tilts away from the observer, its cylindrical cross sections appears as an ellipse whose major axis is literally 90° to the oblique angles of the bottle's central axis.

this 90° relationship between the major axis of the ellipse and the axis that runs through the center of the circles is a universal characteristic for every orientation of foreshortened circles. This means simply that there is a **Universal Rule for Elliptical Tilt** that states the widest part of an ellipse is always perpendicular (a measurable 90°) to the cylindrical axis that is understood to emerge from the center of the foreshortened circle at an actual 90º angle (**Figs. 11.16– 11.18a-b**).

To locate the central axis of a cylinder that is going back in space, simply use clock-angles to find the point at which the edges of the cylinder converge and then draw a line equidistant between

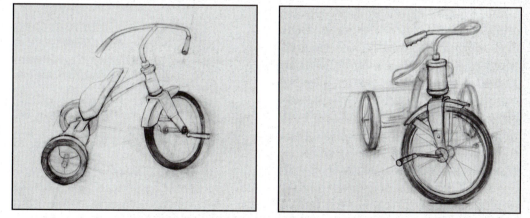

11.18a-b There is certainly no shortage of foreshortened circular forms to be found in your everyday visual environment, from bicycles, automobile tires, and clocks to dishes, cups, bottles, and lamps. However, it is rare that a circular form in the physical world will actually appear perfectly round in a drawing. Only circular forms at eye level and directly in front of the observer appear round.

UNIVERSAL ELLIPTICAL TILT RULE

them that also converges at that point (**Fig. 11.19a-b**). The major axis of each foreshortened cylindrical cross section will intersect the cylindrical axis at a precise right angle.

Of all possible orientations for circles and/or cylinders there is one alignment to which applying the Universal Ellipse Rule creates a slightly ambiguous perception that complicates our clear-cut definition of the picture plane as a flat surface. This complication arises when the rule is applied to all circles that are parallel to the picture plane but not directly in front of the viewer. Applying the Universal Rule's foreshortening to these circles results in a subtle but distinct illusion that the circles closer to the edges of the picture plane are tilting back in space. Applying this rule to any lateral, vertical, or diagonal shift in position automatically changes the angle of the cylindrical axis, and any change in this axis automatically results in a corresponding shift of both the major and minor axes of the ellipse that represents the foreshortened cylindrical ends (**Fig. 11.20**). Since we have already suggested that this tilt of elliptical axes is an indication that a circle is at an oblique angle to the picture plane and are now intending it to represent circles that are parallel to the picture plane, we are left

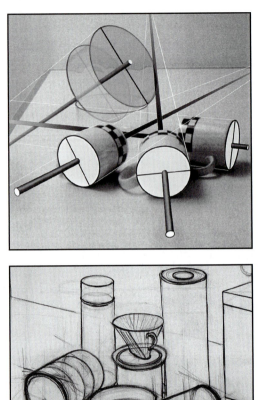

11.19a-b In the physical world a cylindrical axis is, by definition, equidistant from and parallel to the outside surface of the cylinder. When the cylinder is receding in space, the cylindrical axis and the outside edges all converge at a common point (like receding railroad tracks). REMEMBER: All circular cross sections of cylinders that tilt back in space appear as ellipses that are compressed along their minor axes and whose major axis is precisely 90° to the cylindrical axis.

THE CYLINDRICAL AXIS

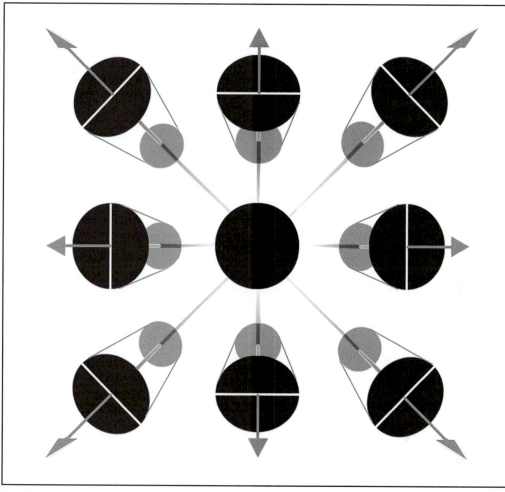

11.20 In this illustration nine cylinders are aligned with their circular ends parallel to the picture plane. However, only the end of the cylinder that is directly in front of the viewer at eye level appears perfectly round. All the other cylindrical ends appear foreshortened. They are always compressed along the minor elliptical axis (perpendicular to the major elliptical axis).

with distinctly contrasting impressions. Perhaps the stronger of the two sensations is that the circles are curving back from the picture plane even though the cylinders all share a common point of convergence, which means that their cylindrical ends are all parallel

CURVED PICTURE PLANE

to the picture plane. Ambiguity is unavoidable because we are using one approach to describe two substantially different spatial configurations, but even though spatial clarity is always a priority in perceptual drawing, we can tolerate this ambiguity because the subtle loss of spatial consistency is positively offset by an exaggerated illusion of depth. The unintentionally implied curvature of the picture plane helps compensate for the loss of the binocular depth we discussed earlier. On a theoretical level, despite the fact that we have defined the picture plane as conceptually flat, there are those who suggest that it is actually more accurate to think of it as curved because points on the periphery of the picture plane are further from the eye of the observer than those nearer to the center (**Figs. 11.21, 11.22**). We will address the synthetic nature and the structural limitations of linear perspective later in the text, but for now, you need only acknowledge the ambiguity and proceed with applying the Universal Ellipse Rule to establish the axial tilt of each and every foreshortened circle you draw.

The next important element to consider when drawing foreshortened circles is understanding that the center of a geometric ellipse that represents a foreshortened circle is not in the same place as

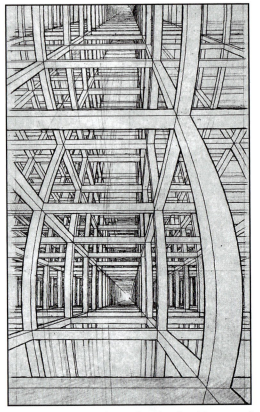

11.21 M.C. Escher, *Study for House of Stairs* (1951, M.C. Escher Foundation, Baarn, The Netherlands. © 2001 Cordon Art B.V., Baarn, Holland. All rights reserved). Although the *Universal Rule for Elliptical Tilt* referred to in this chapter does produce a subtle sense of curvature in the surface of a drawing, the lessons in this book are rooted in the rectilinear perspective principles of the Renaissance where the surface of the drawing is understood as a stationary, flat picture plane. Escher, however, relished stretching the perceptual limitations of Renaissance perspective and frequently rejected the notion of a fixed viewing position by including visual information that indicates a change in the viewer's line of sight. To accomplish this he used a curvilinear perspective that causes the surface of the drawing to appear as though curving back in space.

11.22 Around 1850, cameras were invented that rotated in one direction while the film was being moved past the lens opening in the opposite direction. These "cirkutcameras" capture curvilinear panoramas ranging from 100° to 360° where lines that are straight appear to curve back in space—the curved driveway above is, in reality, perpendicular to the walkway from which the picture was taken. This image captures 180°.

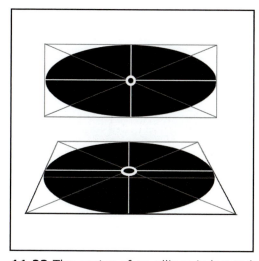

11.23 The center of an ellipse is located where the major and minor axes of the ellipse intersect. The center of a fore-shortened circle (a circle in perspective), however, is slightly more complicated. To locate it mechanically you can inscribe it in what would be a foreshortened square with converging edges and then cross diagonals from the corners to locate the center of both the foreshortened square and circle. You might, however, find it simpler to just remember that the center of a foreshortened circle is always slightly closer to the back edge of the foreshortened circle than to the front.

the center of the foreshortened circle (**Fig. 11.23**). The center of an ellipse occurs at the intersection of its major and minor axes. The center of a foreshortened circle, on the other hand, is always located on the minor axis closer to the back edge of the foreshortened circle. Unlike an ellipse, horizontally bisecting a foreshortened circle will always result in the front half appearing slightly larger than the back half. This is consistent with our previous observation that things appear to get smaller as they recede into space, and since apparent size diminishes with distance, it follows that the back half would not appear as large as the front half. Since there isn't a technique for locating the precise center of the foreshortened circle, it's best to approach it intuitively. First find the center of the actual ellipse, and then gradually move the point

153

back until you find a place that "feels" like it's the center of the foreshortened circle. As with all previously introduced monocular cues (line variation, atmospheric perspective, cross-contour, clock-angles), you are encouraged to exaggerate the shift in the position of the foreshortened circle's center away from the center of the ellipse. Try nudging it a little further back in space (toward the receding edge). Then think about nudging it a smidge more. When it comes to exaggeration, a little too much is usually better than a little too little (**Fig. 11.24a-c**).

Before moving on to the next section, let's take one more look at how foreshortened circles vary in proportion as their positions change in relation to the viewer's eye level. The lower it appears on the picture plane, the less compressed along its minor axis it becomes. This can be the result of a change in height such as the top and bottom of a cylinder or the result of one ellipse being closer to the observer than another. This progressive difference in curvature means that the distance between matching edge points is greater toward the front edge of the foreshortened circle and decreases as the edge moves away (**Figs. 11.25, 11.26**).

Accurately establishing proportions for a cylindrical cross section

11.24a-c This illustration represents three levels of exaggeration that can be used when locating the center of a foreshortened circle. Accurately positioned, the center of a foreshortened circle is slightly behind where the major axis crosses the minor axis (**a**). It is possible, however, to apply varying degrees of exaggeration with regard to the placement of the center of the foreshortened circle as a way to compensate for the loss of binocular, stereoscopic information and increase the overall illusion of depth. In the middle image (**b**), the only adjustment was to nudge the center of the foreshortened circle toward the back edge. In the bottom image (**c**), the center was pushed even further back and the front edge of the large black ring was enlarged to bring it forward.

EXAGGERATED CIRCLES

154

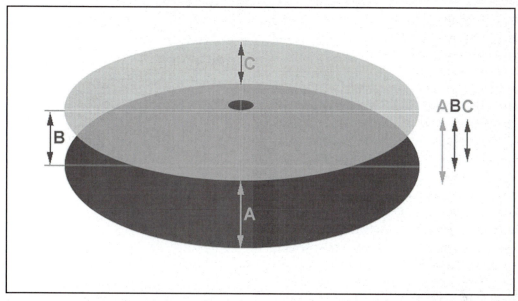

11.25 As foreshortened circles move away from eye level, they appear as progressively less compressed ellipses. This change in elliptical proportion causes the distance between matching edge points on two foreshortened circles at different heights to decrease constantly as the edge moves away from the observer.

11.26 Gustave Caillebotte, *Le Déjeuner* (1876, Private Collection). Caillebotte worked from photos taken with a wide-angle lens. This accounts for the exaggerated speed with which the ellipses representing the foreshortened circles in the plates, glasses, carafe, and serving dishes become compressed as they move up the picture plane. This exaggeration of the progressive compression of the ellipses makes the space appear curved.

relative to eye level and being able to differentiate between the center of a foreshortened circle and the center of the ellipse that represents it are important skills that will enable you to draw circular forms attached to the surface of cylinders and spheres with convincing illusions of depth.

Attaching circles and/or cylinders to the outside of a preexisting cylinder requires that you first establish a central axis up through the central core cylinder. This axis, by definition, will be a measurable 90° to the major axis (widest part) of any of its cylindrical cross sections and, by

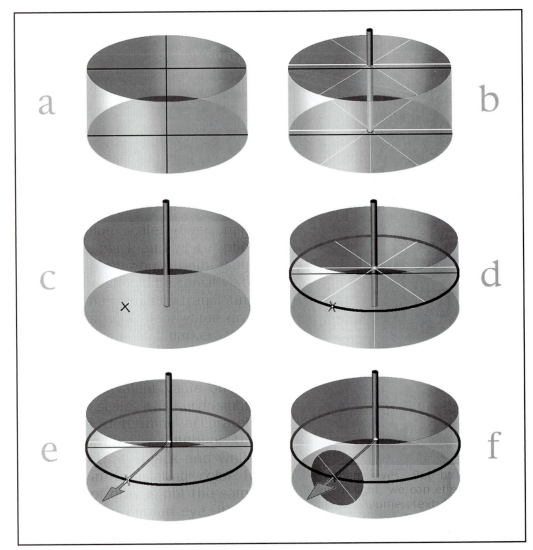

11.27a-f To attach a circle to the surface of a cylinder you must first locate the central axis of the core cylinder. Because the central cylindrical axis is, by definition, equidistant from and parallel to the outer edges of the cylinder, it always mimics the minor axes of any cylindrical cross section (**b**). Mark the point on the surface of the cylinder where you intend to position the circle (**c**), and draw a cylindrical cross section (an ellipse) that passes through that point (**d**). Take care to proportion this cross section properly relative to its vertical location on the cylinder. From the center of this latest cylindrical cross section (REMEMBER: it's always on the cylindrical axis slightly behind the center of the ellipse that represents the foreshortened cross section), draw a line out through the point you have marked (**e**). This line becomes a secondary axis (understood conceptually to intersect the surface of the core cylinder at a 90° angle). A circle attached at this point will appear as a ellipse whose major axis intersects this secondary axis at an actual 90° angle (**f**).

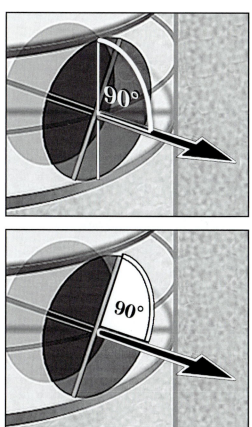

11.28a-b When you establish a secondary axis following the steps outlined in the previous illustration, this new axis is to be conceptually understood to penetrate the side of the cylinder at a 90° angle (top). As can be seen in the uppermost illustration, this is a **conceptual** 90° and not a literal one. It actually measures out on the surface of the illustration to be more like 105°. The tilt of the major axis of the ellipse that represents the foreshortened circle, however, does intersect the secondary axis at a **perceptual** and **measurable** 90° (bottom).

default, perfectly aligned with the minor axes of the ellipses at the top and bottom of the cylinder (**Fig. 11.27a-b**). With the central axis established, you are ready to choose a point on the outside of the cylinder where you want to position a circle or attach a new cylinder (**Fig. 11.27c**). After marking this point, create a cylindrical cross section directly through your chosen mark whose major axis is perpendicular to the main cylindrical axis. Take care to proportion the cross section appropriate to its position on the cylinder (**Fig. 11.27d**). Next, find the apparent center of this newly established foreshortened cross section (remember, it is always slightly closer to the back edge of the ellipse that represents the cylindrical cross section). Now, draw a new axis line out from this center and through the point you have marked on the surface. This new axis (and any other that is similarly constructed) is understood to be perpendicular to both the cylinder's central axis and its outside surface (**Fig. 11.27e-f**). Any circle/cylindrical cross section that is attached to this new axis will appear foreshortened with its major axis crossing the new cylindrical axis at an measurable 90° angle (**Fig. 11.28a-b**).

Applying identically sized circular forms to the surface of a cylinder in a horizontal row requires

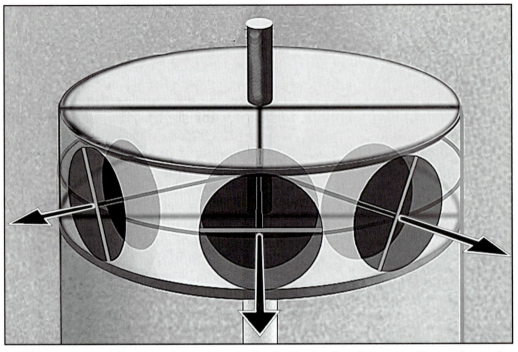

11.29 To create a horizontal ring of equally sized circular shapes on the surface of a cylinder, you must start by establishing three equally spaced cylindrical cross sections (ellipses) through the core cylinder. The middle cross section is used to align the centers of the circles in the row. The upper and lower cross sections determine the height of each circle relative to its position on the curved surface of the cylinder. The secondary central axis for each new circle penetrates the new circle at a point slightly behind the major axis of the ellipse that represents it because, as we saw in Fig 11.24, the center of the foreshortened circle is always slightly behind the center of the ellipse.

three equally spaced cylindrical cross sections. The first determines where you want the row of circles to be centered. The second and third, one above and one below the initial cross section, will determine the relative height of each attached circle. After indicating on the first cross section where you intend to place each circle, draw lines out from the center of that cross section, through the points you have chosen. This establishes the secondary

ROW OF CIRCLES

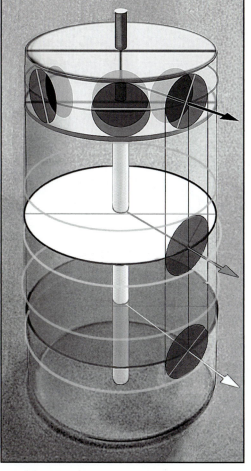

11.30 Attaching a vertical column of identically sized circular elements to the outside of a cylinder requires establishing vertical guidelines from the left, right, and the center of the initial circular element.

axes with which to calculate the tilt of each of the foreshortened circles that you are attaching. Cylindrical cross sections two and three create a simple mechanism for standardizing the apparent size of each of the circles in the row (**Fig. 11.29**). As you saw in an earlier illustration, although the three elliptical bands are conceptually understood to be parallel in the physical world, the actual distance in the drawing between the bands varies at any given point because each of the cross sections is compressed differently depending on its position relative to the viewer's eye level.

To apply a vertical column of identically sized circles to the outside of a cylinder, begin by drawing a vertical line through the center of the first circle and down the side the cylinder (**Fig.11.30**). On this line mark off the locations where you want the additional circles to be positioned and then draw three equally spaced foreshortened cylindrical cross section at each of these locations to establish the relative height of each circle. To ensure that all the circles in the column will be the same width, extend vertical lines down from the left and right sides of the first ellipse that you draw.

Attaching circles to a sphere is much simpler than attaching them to a cylinder. The overall shape of

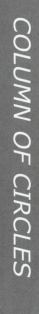

COLUMN OF CIRCLES

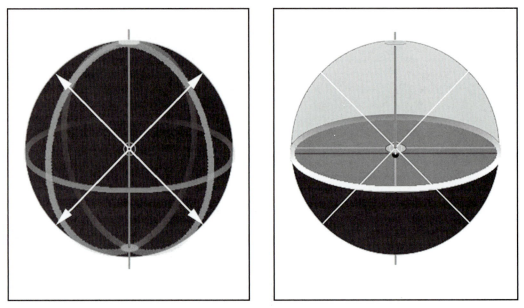

11.31a-b The outside contour of a sphere does not become visually compressed like circles do when they are foreshortened. It always appears circular regardless of the angle at which you view it. The center of the sphere is always located precisely in the center of the sphere's circular contour (**a**). All spherical cross sections, however, because they are foreshortened circles, do appear as ellipses compressed along the minor axis. When we bisect the sphere (cut it in half), that cross section's center coincides perfectly with the center of the sphere. However, the center of the ellipse that represents this cross section will always be located slightly off-center (**b**).

a sphere is not subject to foreshortening, so the center of the sphere is always located directly in the center of its circular contour regardless of the angle from which it is being viewed (**Fig. 11.31a**). Any axis drawn from the exact center of a sphere is understood to penetrate the outer surface of the sphere at 90°. The center of the sphere is also where you find the **apparent** center of any foreshortened circular cross section that cuts the sphere in half (**Fig. 11.31b**). As we saw earlier in this chapter, in order for

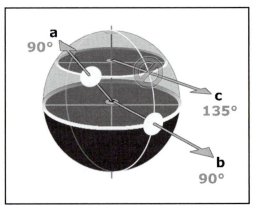

11.32 Only line segments that originate from the center of a sphere intersect the surface at a 90° angle and are suitable for establishing the tilt of an attached circle or a cylindrical cross section.

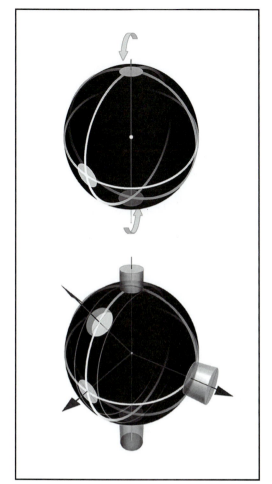

11.33a-b When a sphere is below eye level the poles appear to shift. The north pole moves forward and down while the south pole disappears up and back behind the lower edge (**a**). Any line drawn out from the sphere's center is understood to penetrate any given point on the sphere's surface at a 90° angle. The tilt of an attached foreshortened circle is then determined by positioning the widest part (major axis) of the foreshortened circle at a 90° angle to the axis emerging from the center of the sphere (**b**).

the center of the circular cross section to appear in the center of a cylinder, the actual center of the ellipse that represents the circular cross section must shift slightly forward. The same is true for spheres. (NOTE: The difference between the location of the center of the circular cross section and the center of the ellipse that represents that cross section was illustrated in **Fig. 11.23**).

The ease of locating the center of a sphere simplifies the procedure for establishing a secondary axis through any point on the surface of the sphere. Once you have chosen the point on the surface where you want the circular attachment or hole to be, it is simply a matter of establishing a secondary axis line by starting at the center of the sphere and exiting the sphere at the point where you intend to attach the circle. An axis line that originates in the center of the sphere is understood to penetrate the surface of the sphere at a 90° angle. Any such secondary axis line can be used to determine the tilt of a foreshortened circle or circular hole that is placed where the axis emerges (**Figs. 11.32, 11.33a-b**). Once again, any circular element (either a hole or a cylindrical attachment) will have its major axis at precisely 90° to an axis originating at the center of the sphere.

161

As we saw when aligning identically sized circular shapes or holes on the surface of a cylinder, doing so on a sphere necessitates drawing three equally spaced cross sections through the sphere. The center cross section positions the center point for the row of circular forms while the top and bottom cross sections makes all the circles appear equal in size (**Fig. 11.34**). If the circular attachments are placed along a spherical cross section that doesn't bisect the sphere, be sure to remember that the axis for drawing circular holes or cylindrical attachments must always originate in the center of the sphere and not, as in the case of a cylinder, in the center of the cross section upon which they are positioned (**Fig. 11.32** axis line **c**).

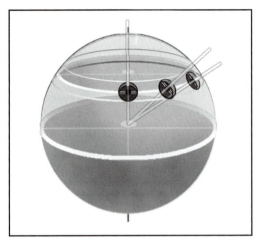

11.34 Standardizing the size and alignment of multiple circular attachments on the surface of a sphere requires three equally spaced spherical cross sections as guidelines. Keep in mind, however, when attaching circles on cross sections that do not bisect the sphere, the secondary axis that determines the tilt of the foreshortened circle must originate in the center of the sphere, and not from the center of the nonbisecting cross section.

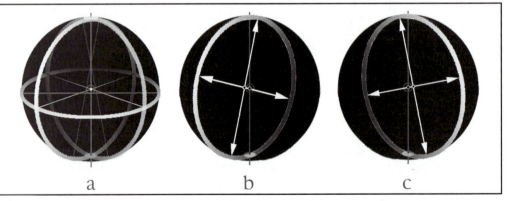

a b c

11.35a-c When bisecting a sphere through its vertical axis, the spherical cross section must pass through the two poles and makes contact twice with the outside edge of the sphere. The center of each of these cross sections is, as you have seen, located at the center of the sphere, but the center of the actual ellipse that is used to represent the cross section is positioned a little off center. This shift allows the center of the foreshortened spherical cross section to be properly positioned closer to the back edge of the cross section than to the front edge.

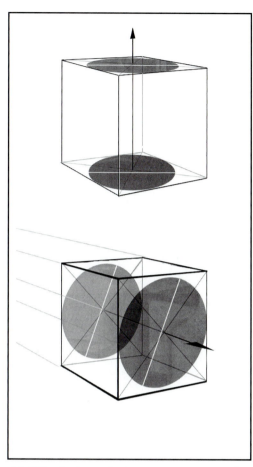

11.36a-b An axis penetrates two sides of a rectilinear solid at a 90° angle when it is parallel to edges that are perpendicular to the plane through which it passes. When those edges are vertical, the central axis will be vertical (top). When the edges are receding in space, we can establish the apparent tilt of the central axis by having it converge with the edges with which it is parallel. As expected, when attaching a circle/cylinder to the surface of a rectilinear solid, the widest part (major axis) of the foreshortened circle will cross its central axis at an actual 90° angle.

A spherical cross section that intersects the poles of a sphere bisects the sphere like *longitude lines* on a globe. When viewed from above or below the equator, the ellipse that represents the vertical spherical cross section touches the outside edge of the sphere at two points and tilts away from vertical. The center of the ellipse that is used to represent the foreshortened cross section shifts forward away from the sphere's center. This tilted shift is what allows the apparent center of the foreshortened circular cross section to appear closer to the back edge of the cross section than to the front while still being positioned at the center of the sphere (**Fig. 11.35a-c**).

To place a circle on the side of a rectilinear solid, it is necessary to draw an axis line through the solid in a way that can be understood to penetrate the solid at a 90° angle (**Fig. 11.36a**). The new axis line must be understood to be parallel with all edges of the rectangular solid that are perpendicular to the side that the axis is understood to penetrate (**Figs. 11.36b, 11.37**). If you want the circle to appear at the center of the rectilinear solid, you will need to draw diagonals across the chosen surface and use this intersection to position the penetration point for the new axis.

This concludes (whew!) this chapter's rather technical description of the changes in the appearance of circular forms in space. Fortunately, applying the rules in a drawing is far more satisfying and considerably less difficult than reading about them. Because there is certainly no shortage of foreshortened circles in your visual surroundings, you will have plenty of opportunities to apply what you have learned in this chapter.

To strengthen your ability to render observed forms containing foreshortened circles it is recommended that you postpone applying the principles of ellipses to drawings of foreshortened circles in your visual field and instead apply what you have learned in this chapter to the construction of *imaginary birdhouses*. Whether or not you choose to take on this assignment, you can refer to the numerous student projects reproduced here to review the issues that are fundamental to creating a reliable illusion of space with circular, cylindrical, and spherical forms.

When drawing a birdhouse begin with basic geometric forms such as cylinders, spheres, cones, and tori (doughnut shapes). Start by imagining that all the geometric forms are below eye level (**Figs. 11.38, 11.39**). Establishing a clear and

11.37 Katherine Liontas-Warren, *The Global Watcher* (pastel on paper, 2007). In her delicately detailed rendering Liontas-Warren has captured the energy and delicacy of a bird sitting atop a peaked-roof rectangular birdhouse in an abstracted landscape reminiscent of those by Grant Wood. The end of the ridge pole, the opening to the interior of the birdhouse, and the end of the perch below the opening all conform to the "universal law of elliptical tilt."

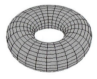

to ♦ rus n.
A ring-shaped surface generated by rotating a circle around an axis that does not intersect the circle.

11.38 Drawing imaginary birdhouses is an effective, focused, and challenging exercise for improving your understanding of and control over the illusionistic depth that can be created by applying the rules governing foreshortened circles. The goal of this exercise is always first and foremost to develop logical, clear, and convincing spatial relationships among the constituent parts of the imaginary structures. In the illustrations above, the eye level is above the top of the birdhouses, so the ellipses used to represent the cylindrical and spherical cross sections become fuller (less compressed along the minor axis) when positioned further down the picture plane. Keep in mind that effective spatially illusionistic drawings also display considerable variation of line.

IMAGINARY BIRDHOUSES II

165

consistent eye level at the earliest stage of the drawing is essential. Obviously, you need to have a clear understanding of the relationships of the forms to your eye level in order to determine the direction in which the ellipses will become more or less compressed.

Once you have succeeded at drawing a birdhouse below eye level, try drawing one that appears to be above eye level (**Fig. 11.40**). The third variation of the birdhouse has you imagining the structure beginning below eye level and, then continuing up to completion somewhere above eye level. With objects that extend both above and below your eye level, it is important to remember that the section of the birdhouse that is at eye level is particularly ineffective for communicating dimensional information. Circles and rectilinear planes that are parallel to the ground plane appear as straight lines when viewed at eye level. The same is true of circles and rectangular planes that are directly in front of the observer and are perpendicular to the ground and perpendicular to the viewer's picture plane (**Fig. 11.41**). Three of the most effective techniques for creating consistent and readable illusions of space—convergence of parallel edges, cross-contour, and elliptical curvature of foreshortened

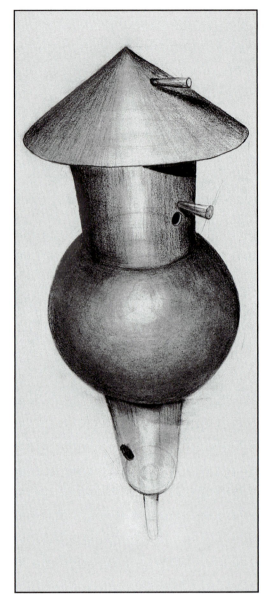

11.39 Drawing a cylinder so that its edges converge is an effective method for exaggerating an object's movement away from the viewer's eye level. Without other cues, however, the converging edges create a certain degree of spatial ambiguity, making it hard to determine whether the object is a cone-like form that tapers or a receding cylinder.

IMAGINARY BIRDHOUSES III

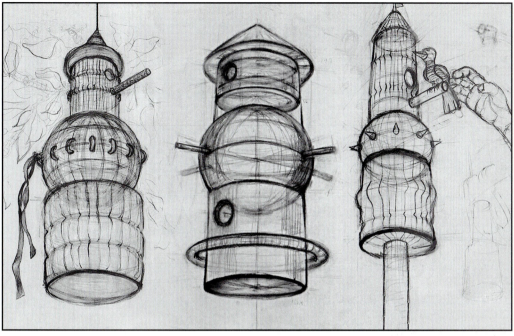

11.40 In the illustrations above, the eye level is below each of the birdhouses so the ellipses used to represent the cylindrical and spherical cross sections become fuller (less compressed along the minor axis) when positioned further up the picture plane.

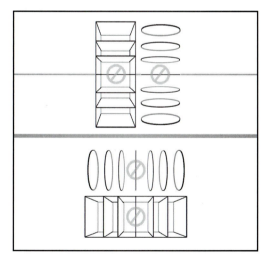

11.41 For maximum spatial illusion position dimensional information above or below eye level (top) or coming forward at an angle away from the position of the observer (bottom).

circles—are rendered totally ineffective when applied to three-dimensional forms in either of the relationships mentioned above. Definitely avoid putting spatial information at eye level, and try to keep it out of the center of the object as well.

With the information you have now absorbed from this chapter regarding how circles and circular cross sections of cylinders and spheres appear when observed in your visual field, you will be able to draw just about any regularized curvilinear form that you can either imagine or observe.

167

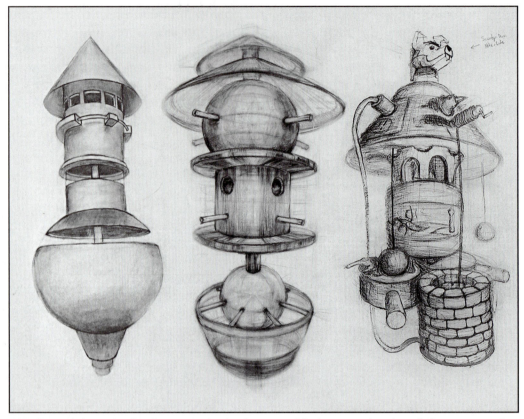

11.42a-c When the birdhouse is both above and below eye level and the progression from flattened ellipses in the center toward fuller, rounded ellipses at the top and bottom occurs gradually and consistently, the illusion of space appears quite convincing and is usually referred to as a "normal" progression. For the birdhouse to look "normal," the elliptical decompression of the cylindrical cross sections must appear the same when the ellipses are equidistant above and below the eye level. As you will see in some of the later illustrations, interesting spatial effects can be generated by purposefully exaggerating the rate of change from one ellipse to the next. Slight exaggeration in the rate of elliptical decompression of foreshortened circular cross sections strengthens the illusion of space in a drawing. Substantial exaggeration can create a sense of curvature of the picture plane itself or create the illusion that the depicted form is bending back in space. You might want to experiment with both normal progressions and exaggerated progressions in order to develop greater control over the space-making mechanism involved. Keep in mind, however, that no matter how rapidly or slowly the ellipses change proportion, the illusion is most successful when the ellipses open up at a constant rate. Birdhouses can be fairly simple or made quite complicated. If you decide to add complicated elements to your drawing, be sure to make every effort to present the new information in a way that is spatially consistent with the eye level of the birdhouse. That means that if you choose to put a Scooby-Doo nightlight on the roof of your birdhouse (above right), it needs to be seen from below. Clever additions are wonderful but not if they compromise the spatial consistency of your drawing.

IMAGINARY BIRDHOUSES V

11.43a-c When the viewer's eye level occurs somewhere between the top and bottom points of the imaginary birdhouse, the ellipses representing cross sections of the core cylinder become progressively less compressed in two directions. Combinations of cylinders, cones, spheres, and rectangles can be used to create a seemingly endless variety of structures with distinctive personalities. The "disco-ball" birdhouse on the left is straightforward and exhibits a smooth, albeit slightly exaggerated, progression of ellipses up and down. It also makes excellent use of line variation to increase its visual interest and its spatial illusion. The colonnaded structure on the far right is reminiscent of the Renaissance in its clarity and massiveness of its forms. The highly fanciful "Zardoz" birdhouse in the center shares many of the same volumes and techniques, but because the ellipses near eye level in its core sphere are unexpectedly full (thereby causing the opening on the far side to be unrealistically tiny), the overall effect is a powerful, albeit grossly exaggerated, depiction of depth. Distorting the elliptical progression in this way creates an interesting ambiguity that can be read either as a form that is bending away from the viewer at the top and bottom or as a perfectly vertical structure that is being viewed by an observer who, instead of seeing it all at once (so-called normal vision), scans the image through a wide-angle lens that mechanically exaggerates recession and curves the forms back at the top and bottom.

169

CHAPTER 11: FORESHORTENED CIRCLES

11.44 As you become more familiar with the techniques and spatial issues underlying birdhouse construction, you gradually become "absorbed" into the spatial illusions you are creating. This imaginary "participation" provides direct access to your lifetime of stored spatial experience. When applied to your drawing, your intuitive understanding of moving in space will allow you to depict more complicated and fanciful combinations than you had previously thought possible. Cylindrical forms dominate the poolside tropical bird "watering hole" on the left. Eye level is slightly below the top of the bar. In the center is an Early American version of the birdhouse proudly displaying the class flag (with arriving bird). In this drawing the cross-contours have been cleverly transformed into wooden planks that not only add to the illusion of depth but also expand the content. This drawing also makes excellent use of exaggerated atmospheric perspective (the darkness of the lines fades into the paper as they are understood to go back in space). The birdhouse on the right, seen from above, depicts steel bolts to form a three-quarter circular colonnade supporting a spherical chamber juxtaposed to a cylindrical tower.

Although the rules governing foreshortened circles (ellipses) can feel somewhat daunting at first, they quickly become second nature the more you use them. The consistency of the student drawings throughout this chapter is clear testimony to the effectiveness and versatility of these techniques, as are the convincing and entertaining illusions that they help create. However, keep in

11.45a-c When you add information to your drawing, concentrate on presenting each additional element in the appropriate position relative to the viewer's eye level. In the drawing at top right, the hand holding the birdhouse not only adds to the content in an engaging way, but it also effectively reinforces the overall sense of space because the hand is being observed from below. Every added element needs to be spatially consistent with the established eye level. Personalizing your imagery is a wonderful way to maintain a high level of involvement with the project, but be prepared to remove elements that fail to reinforce the illusion of readable, three-dimensional space.

ELLIPTICAL EXAGGERATION

11.46 Extreme exaggeration of the elliptical decompression of cylindrical cross sections carries with it a high degree of spatial ambiguity that either suggests that the cylinder is so large or so close that you need to look up to see the top and down to see the bottom (a wonderfully expressive spatial effect but, as we will see in the chapters on linear perspective, a Brunelleschian no-no), or that the object is actually bent back away from the picture plane (left and center). Extreme exaggeration usually results in the cylinder appearing to be twisted back like a pretzel. The M.C. Escher–like birdhouse (right) illustrates the problem one student encountered. She remembered that ellipses become less compressed as they move away from eye level, but she accidentally lost track of which elliptical edge was meant to represent the closer edge of each foreshortened circular cross section. Oops!

mind that these student drawings not only depict the skillful use of ellipses to represent foreshortened circles but they also demonstrate the importance of sensitive and varied mark making in creating successful spatial illusions (**Figs. 11.42–11.46**).

CHAPTER 12 BIOMORPHIC FORM

Structured irregularity. . . 173
Simple schema 174
Compound schema 175
Underlying framework I . 176
Underlying framework II . 177
Conceptual armature . . . 178
Anticipated percepts . . . 179
Structural integrity 180
Irregularized geometry . . 181
Think volume! 182
Familiar schema 183
Undulate, bulge, and ripple 184
Think volume, not shape 185
Polymorphous perversity 186
Renaissance clarity 187
The "missing link". 188
Dimensional doggy 189
Nature's schemata 190
Multiple armatures 191
Multiple schemata. 192
Exaggerated clarity. 193
Clarity and integrity 194
Transparent form 195
Drawing through the form 196

Your next challenge is rendering biomorphic forms. Biomorphic forms (whether living organisms, forms shaped by natural physical processes, or forms manufactured to mimic nature) are characterized by varying degrees of irregularity of surface or shape or both but nonetheless maintain clearly discernible suggestions of underlying geometric structure. The complex character of biomorphic forms will require you to combine several of the mechanical techniques that you have covered so far (cross-contour, rectilinear convergence, clock-angles, and spherical and cylindrical cross sections). It also requires, in contrast to most of the previous lessons, that you give considerable emphasis to conceptual information processing in order to analyze and clarify biomorphic irregularity before converting it into visually meaningful form.

Although biomorphic forms generally appear more complex than basic geometric forms, their readability depends, in large measure, on their approximate visual correspondence to elementary geometric solids (cone, sphere, cyl-

STRUCTURED IRREGULARITY

SIMPLE SCHEMA

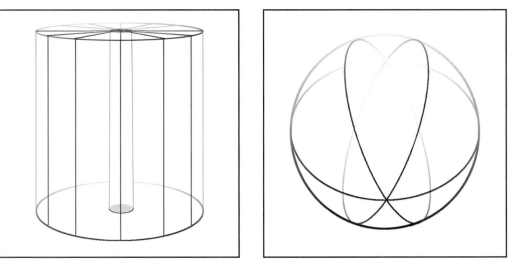

12.1a-b A cylinder (with evenly spaced cross-contours originating from its central axis at the top) and a sphere (with cross-contours that resemble latitude lines that meet at a common axis) are two examples of basic geometric volumes that can provide clarifying conceptual structure for irregular biomorphic forms. These basic geometric volumes function as schemata or armatures that provide underlying organization for irregular variations in surface and form.

inder, rectangular solid, pyramid, etc.) or combinations thereof (**Figs. 12.1a-b, 12.2a-b**). The majority of biomorphic forms do exhibit a discernible underlying structure. Those so highly irregular that they resist comparison to any familiar geometric solids are said to be *amorphous* (without identifiable form). **Amorphous forms are totally unsuitable subjects for perceptual drawing.** It is best to avoid objects that are so irregular that they have little or no correspondence with easily identifiable geometric models.

For biomorphic forms that do permit comparisons to geometric solids, the challenge is to combine

sche ◆ ma n.
pl. **sche ◆ ma ◆ ta**
or **sche ◆ mas**
1. *A diagrammatic representation; an outline or a model.*
2. *A pattern imposed on complex reality or experience to assist in explaining it, mediate perception, or guide response.*

ar ◆ ma ◆ ture n.
A framework serving as a supporting core for sculpture.

174

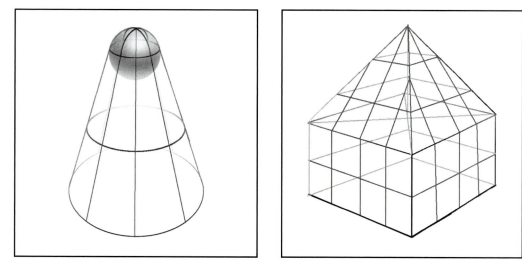

12.2a-b In order to create an imaginary armature that accurately and specifically corresponds to the underlying volumetric character of a biomorphic object, it is sometimes necessary to visualize composite structures that combine the characteristics of two or more basic geometric volumes.

"We hear a lot about training the eye or learning to see, but this phraseology can be misleading if it hides the fact that what we learn is not to see but to discriminate. . . . We notice only when we look for something, and we look when our attention is aroused by some disequilibrium, a difference between our expectations and the incoming message. It is this constant search, this sacred discontent, which constitutes the leaven of the Western mind and pervades our art no less than our science."

E. H. Gombrich
Art and Illusion

the structural clarity of the underlying geometry with a sharp-eyed sensitivity to surface irregularities. This requires you to fuse two distinct styles of information processing—conceptual and perceptual—into a single drawing strategy. This fusion of cognitive strategies is a very different approach from what has been recommended in the previous chapters. Until now, your lessons have been making a clear distinction between what you observe (percepts) and what you think about what you see (concepts). The text has generally sided with the reliability of direct perception over that of conceptual thinking. It has even gone so far as to suggest suspending analytical thinking entirely in order to minimize what has been characterized as

COMPOUND SCHEMA

175

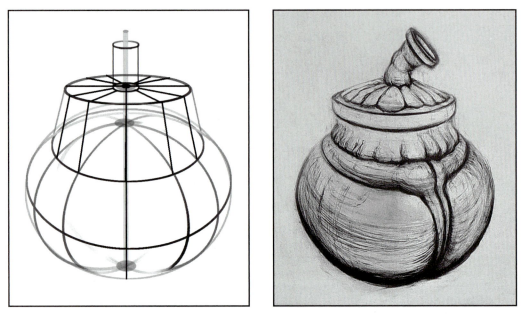

12.3a-b Invented schemata need to be simple, clear, familiar, and predictable geometric forms to function effectively as guides for cross-contour. They also need to be flexible enough to approximate the unique character of complicated volumes and surfaces. You must constantly strive for a delicate balance between predictable structure and an irregular fluctuating surface.

the distorting influence of rational thought on the accuracy of direct perceptions. Well, that was then and this is now. We have encountered a new wrinkle in drawing where the volumetric complexity of biomorphic form necessitates taking advantage of the brain's logical, analytical capacity. For this chapter in particular you will need to understand that rational thinking is an effective tool for identifying the structure that provides the visual character for all but the most shapeless of biomorphic forms (**Figs. 12.3a-b, 12.4a-b**).

3-D DANGER ZONES

◆ Don't place important dimensional information at or near eye level.
◆ Avoid having dimensional forms come directly toward the viewer (angle them to the side—an angle of approximately 45° works very well).
◆ Avoid placing important spatial transitions on the apparent edges (profile) of the form.

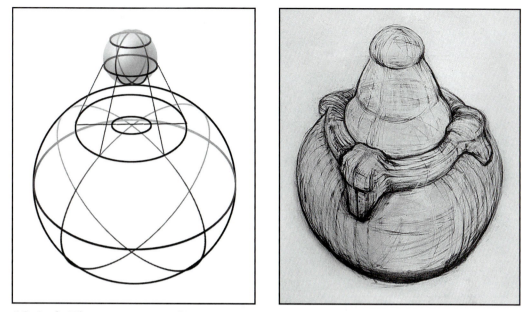

12.4a-b When you are combining one or more of the basic geometric solids to create an armature for an imaginary biomorphic form, draw through the simplified armature as though each element was transparent and vary the line quality to make it look like it's moving away from the picture plane. This helps you experience the volume of the form and understand its surface.

"We should recognize that whatever else it does, the brain must be able to simplify and categorize the structures in the patterns it processes if it is to deal with the images delivered by its visual receptors. This means that the machinery of its visual system must place constraints on how we see."

Howard S. Hoffman
Vision and the Art of Drawing

Imagining a simplified core within an irregular form encourages increased understanding of the object in two ways: first, as an intellectual schema that leads to subtle and detailed visual comparisons; second, as a mechanical armature around which to build the form and wrap the irregular surface. A schema also helps keep surface irregularities from dominating the form because it emphasizes clarity and readability in place of the visual chaos that can easily occur when superficial details take precedence over the structural integrity of the form.

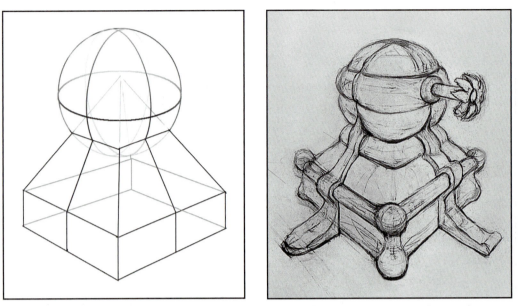

12.5a-b Make sure to include cross-contour lines to the basic geometric forms that you are using before you begin adding abnormalities and irregularities. Cross-contours that make the transitions from one basic geometric form to another are particularly helpful. In fact, it is an especially good idea to keep the idea of cross-contour transitions in mind when you begin inventing new surface variations so that every form or surface variation you add integrates with the overall structure of the form and contributes to the readability of the object you are creating.

Applying a simplified imaginary geometric schema to an irregular object is a drawing technique that finds considerable reinforcement in perceptual psychology. According to studies in that discipline, projecting simplified organization onto complicated and irregular patterns is a mechanism at the very heart of our perceptual processes; we have an inherent need to compare and contrast immediate perceptions and pre-existing ideas (**Figs. 12.5a-b –12.8**). Mentally projecting conceptual models onto irregular form doesn't enable us to see,

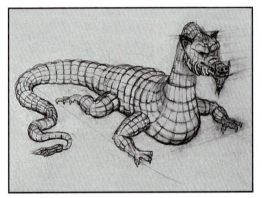

12.6 A dragon-like creature can be successfully constructed by connecting cylindrical schemas of varying sizes. The schemas serve as a guide for establishing cross-contours that communicate the volume of the form.

CONCEPTUAL ARMATURE

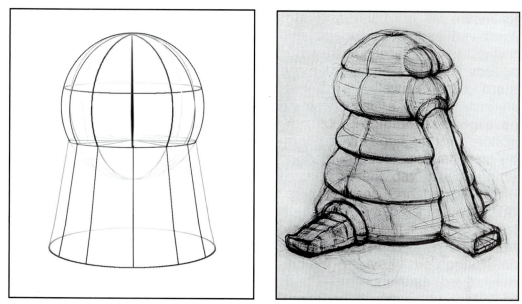

12.7a-b The more you apply cross-contours to the surface of simplified schemata (left), the easier it will be for you to calculate how they will change direction when you irregularize the surface (right). The most common error in cross-contour is to apply the cross-contour to only a small portion of the surface of the form without regard for the form's overall structural integrity. All parts have to work together.

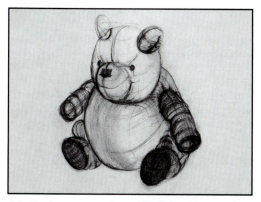

12.8 Images of stuffed animals can be constructed from a variety of ovoid shapes with cylindrical attachments for the arms and legs. These same schemata also help determine the direction of the cross-contours that convey the fullness of the forms. We are attracted to objects that convey a sense of volume and tactility.

but it does enable us to discriminate between what we see and what we expect. This need to compare percepts and concepts is so pervasive that the perceptual act itself has been described as "modification of an anticipation." In other words, the conceptual expectations that we carry into a situation play a major role in our ability to interpret what we see. Using schemata as conceptual templates for our perceptions is far more common than most of us might think. In fact, the very notion of irregularity is comparative and depends entirely on an implied comparison with a preconceived understanding of regular-

179

ity. When we compare biomorphic forms to regularized geometric forms, our ability to discriminate nuances of surface and volume is substantially enhanced.

To experience how helpful these conceptual schemata are when interpreting your perceptions you are once again encouraged to create your initial biomorphic drawing from your imagination (**Fig. 12.9**). Working from your imagination allows you to work from the inside out. This approach builds on the previous lessons involving imaginary birdhouses. It also provides an opportunity to experiment freely with the complicated relationship between surface and structure before having to deal with the added pressure that comes from having to identify and construct highly specialized armatures for specific irregular forms in your visual field. Drawing from observation is substantially more complicated. Basic geometric forms (cylinders, spheres, rectangular solids, cones) can be used individually or in combination to create a unifying core of your choice. You can begin with an idea in mind or just start combining geometric forms with no clear goal in mind and let the underlying geometric schema suggest possible irregularities (**Figs. 12.10, 12.11a-b**). To give your geometric schema structural integrity, you need to

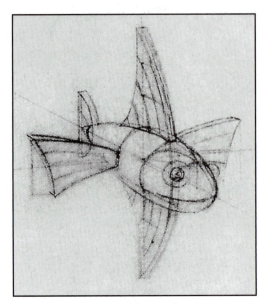

12.9 M.C. Escher, *Study for Depth* (M.C. Escher Foundation, Baarn, The Netherlands. © 2001 Cordon Art B.V., Baarn, Holland). All rights reserved. A preliminary sketch of a fanciful flying fish relies heavily on a simplified geometric schema for structural clarity.

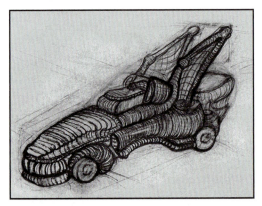

12.10 One method for generating ideas for imaginary irregular three-dimensional forms is to base the composite structural schema on familiar everyday objects. This illustration of a fanciful race car was modeled after a bedroom slipper.

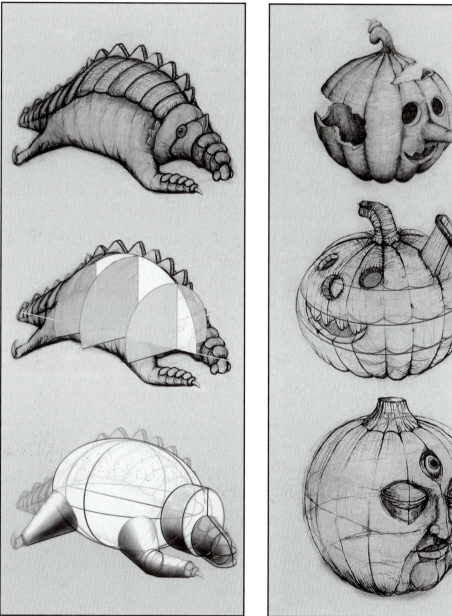

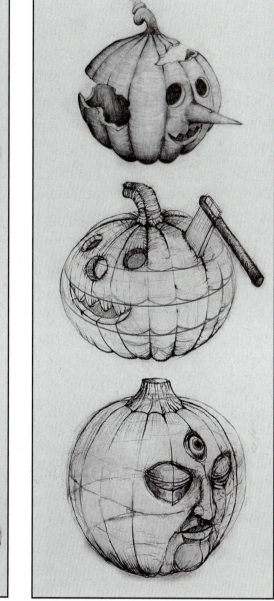

IRREGULARIZED GEOMETRY

12.11a-b When constructing a three-dimensional creature from imagination, it is important to have a clear and consistent sense of the underlying geometric schema (in the drawing on the left, a compressed sphere [ellipsoid] that tapers at each end and is flattened at the bottom; on the right, spheres form the basic armature). Start with a quick sketch (gesture) that emphasizes the basic underlying structures before adding any idiosyncratic details and/or structural anomalies (deviations from underlying form). Start simple, work toward complexity.

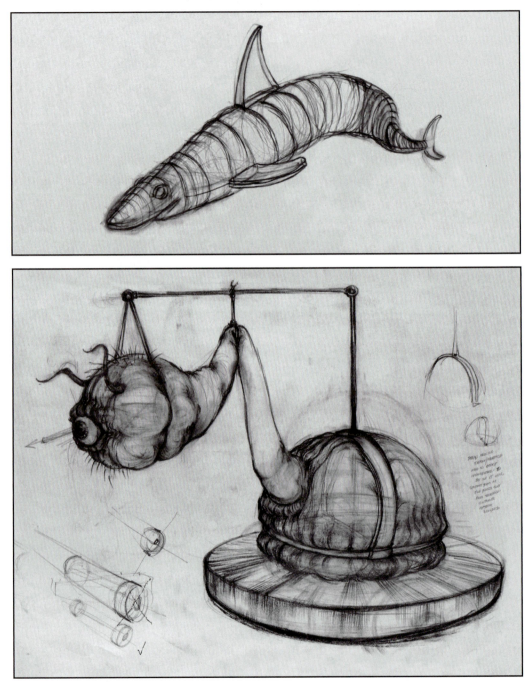

12.12a-b To maintain a sense of structural integrity be sure to add structural abnormalities and surface irregularities only after you have established clearly defined geometric forms at a specific eye level. Evolve toward complexity.

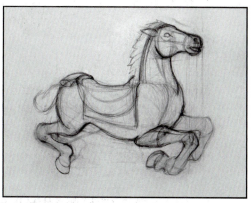

12.13 To render a complicated form it is essential to identify the underlying schema. Often this includes combining rectilinear as well as curvilinear forms. Concentrate on the cross-contour transitions where the forms come together.

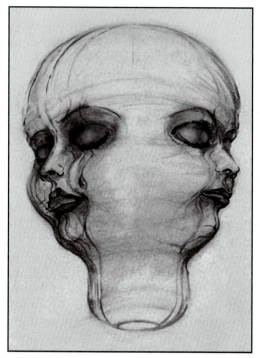

12.14 Cross-contours are most effective when they appear to be cutting through the forms 90° to the vertical and horizontal axes of the basic geometric schema.

establish your eye level as soon as you begin to draw. Your choice of eye level affects every aspect of your drawing. A consistent eye level allows your simplified schema to appear as unified and integrated form in space. Be sure to apply a generous and delicate grid of cross-contours over and around each of the basic geometric forms. Where you position your eye level has a direct impact on movement of each and every cross-contour. The greater your familiarity with the three-dimensional surface of the simplified schema, the easier it will be for you to determine how any surface irregularities can best be depicted (**Figs. 12.12a-b–12.14**).

The imaginary form can go in any number of directions. Especially in your initial attempts it is recommended that you let it grow spontaneously. Enjoy your freedom. Try every combination you can think of, and don't be afraid to fail. That's what erasers are for. Your job is to accumulate information about the ways that imaginary geometric forms can be put together into a clear and readable three-dimensional illusion.

As the core evolves, you are encouraged to gradually add irregularity to the surface. Apply new cross-contours to each new irregularity that not only conform to the structural essence of the larger

183

forms but also indicate localized surface changes. Each cross-contour on a biomorphic form must be consistent with the volume of the whole. The most common error in this type of drawing is to concentrate the cross-contour lines solely on the surface where the irregularity occurs without any consideration of how those lines relate to the overall form. While this approach might accurately depict a localized change in surface, it won't produce the sense of integrated wholeness that is the key to a superior volumetric drawing. As you apply the new cross-contours to irregularities, draw your cross-contours completely around (and through) the form. Make the surface undulate, bulge, ripple, droop, dip, and sag. Add bumps, lumps, craters, and crevices. **Remember, open-ended experimentation encourages discovery.** Take chances and strive for a considerable amount of surface irregularity but not so much that it compromises the clear structural character that allows the form to be easily readable (**Figs. 12.15a-c, 12.16a-c**).

There are two slightly conflicting guidelines to follow when establishing a geometric schema for a biomorphic form: it must be as simple as possible but not restrict the irregular character of the form that you are intending to create. The challenge is to find a balance between unity and complexity.

12.15a-c In these drawings the cross-contours have been applied in a somewhat contrived fashion so as to appear as either a grid of vertical and horizontal lines or as stripes that have been painted across the surface of the form.

12.16a-c Here the cross-contours have been applied a little more subtly. The cross-contours have been integrated into the form itself, like threads woven directly into the surface.

As you create your imaginary biomorphic form, define the form quickly with light, loose gestures that not only delineate the outside edge (shape) of the form but also create a sense of its volume by introducing an extensive web of cross-contours that go completely around the emerging form. **Think volume, not flat shapes.** Remember that the apparent movement of each cross-contour will depend on its position relative to eye level. **Decide at the very beginning whether you intend the object to appear above, at, or below eye level.** Only when there is a consistent eye level will you be able to intuit the appropriate directional changes as the cross-contours define the irregularized surface.

Keep in mind that regardless of how clever and engaging your ideas might be, the forms must translate to the drawing surface as clear, readable three-dimensional forms. Personalized content is encouraged, but not if it compromises a clear, consistent, convincing illusion of three-dimensional form in space.

To maximize the clarity of the illusion in your imaginary drawing, you also need to be sensitive to how the viewing angle affects the readability of the illusion of three-dimensional space (**Figs.**

THINK VOLUME, NOT SHAPE

185

12.17a-c Complicated forms are easier to integrate if you "draw through" each of the constituent parts with gestural cross-contours that go completely around each element. By approaching the objects as though they are transparent, you are more likely to grasp how the forms integrate and how the cross-contour lines change direction as they move across the surface.

12.17a-c–12.22). When conveying a spatial illusion not all viewing angles are equal. Some viewpoints enhance the three-dimensional qualities of a given form; others detract from them. For example, avoid placing important dimensional information or volumetric transitions at eye level, on a vertical axis directly in front of the viewer, or on the apparent edge of the form (profile). Such placements contribute little in the way of volume and can actually compromise the suggestion of dimensionality.

Drawing biomorphic forms from observation is similar to drawing them from imagination with the one difference we noted earlier. When you draw from observation the simplified geometric framework that is used to establish structural integrity must correspond closely

12.18 Although the illustration above is more likely to have been inspired by exposure to comics than to masterpieces from the history of art, the clarity of the forms relates directly to Michelangelo's figures on the Sistine Ceiling.

186

12.19 The horizontal spherical cross sections not only guarantee accurate placement and curvature of the features, but they also serve as a way to establish consistent curvature for each of the bulging segments on the pumpkin's surface.

to the pre-existing structure of the object you intend to draw.

The effectiveness of any geometric schema depends primarily on the appropriateness of its correspondence to what you see. For your schema to work, it must reflect the object's dominant visual character. This analysis consists mainly of mental comparisons between the observed form and possible geometric forms that share structural similarities. The analysis concludes when you have found the most appropriate match(es). Your

12.20a-b Your final image will be only as good as it is spatially clear, consistent, and understandable. Start with clear geometric schemata with a consistent imagined eye level relationship. Place the important surface variation where there is greatest potential for change in direction of the cross-contour lines as they move across the surface. A three-quarter view that is slightly below eye level usually works best. The three-quarter portrait was popularized in Renaissance Italy, and it reflects this historical period's dominant interest in the depiction of a clear and rational space.

RENAISSANCE CLARITY

187

12.21 When creating fanciful creatures keep in mind that lateral symmetry is a common structural characteristic of most living organisms. You will find considerable success in creating convincing combinations of strange and unexpected elements if the appendages and protuberances of your newly constructed life-form are distributed in a manner that is consistent with the real-world experience and expectations of the viewer.

12.22 Of all the cross-contours that we use, those that are understood to bisect the form (usually referred to as center lines) are the most important. Center lines should be added at the very earliest stages of your gesture drawing because they contribute directly to the determination of eye level, rotation of the figure relative to the viewer, and volume. Consistent use of center lines also makes it easier to maintain lateral symmetry throughout the figure, thereby contributing to a sense of visual logic.

choices are much more restricted than when you are drawing from imagination, but the goal is very much the same. You must keep the conceptual geometric core simple while making sure that it is complicated enough to maintain an easily understandable relationship with the essential structural character of the observed form (**Fig. 12.23a-d**).

Because a geometric schema is an abstract approximation of the observed object, there are often times when two or more geometric armatures function with comparable degrees of appropriate structural correspondence (**Fig. 12.24a-c**). When more than one schema can be applied, you are encouraged to apply several to the same drawing. Applying multiple schemata provides greater insight into the structural character and integrity of the observed object because each schema allows for slightly different ways of thinking about the form. When you apply multiple schemata to a single object, you strengthen your ability to distinguish variations in structure and surface. Rarely is there a problem in applying two separate schema to the drawing, but you might also try combining the two schemata into a more specifically tailored composite structure that more closely parallels the important characteristics of the object (**Fig. 12.25a-c**).

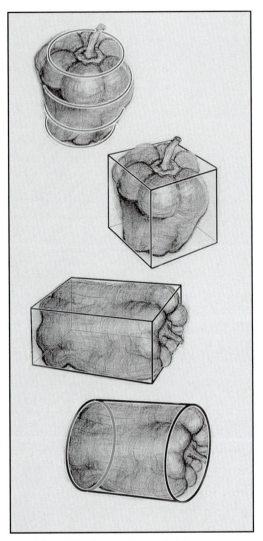

12.23a-d Fruits and vegetables are sensuous subjects with considerable surface variation and recognizable geometric structure. As you will quickly realize, there are often multiple geometric solutions for any particular form. While one may turn out to be slightly more helpful than the others, each attempt to find a match provides new and useful insights into the biomorphic form's structural integrity.

NATURE'S SCHEMATA

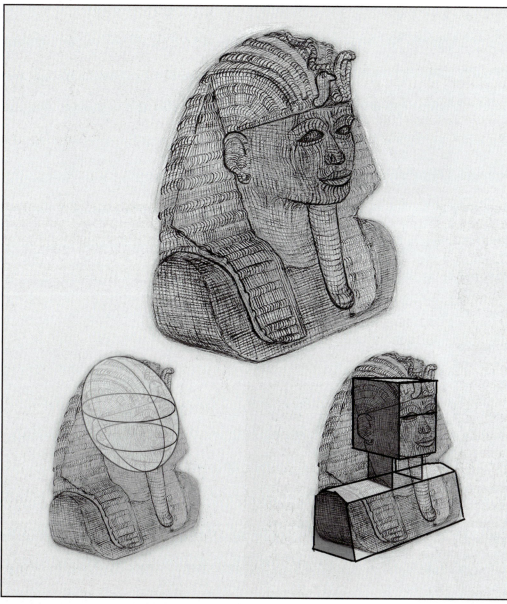

12.24a-c This carefully rendered cross-contour drawing was done with a clear sense of the underlying geometric structure of a gold-plated reproduction of the portrait on Tutankhamen's (1334–1325 BCE) sarcophagus lid. The cross-contour lines in this drawing are used very effectively to define the simplified masses of the form, the transitions between the larger masses, and the localized variations of the surface. In all three instances the cross-contours are effectively integrated in a manner that clearly establishes a unity between the many constituent elements.

MULTIPLE ARMATURES

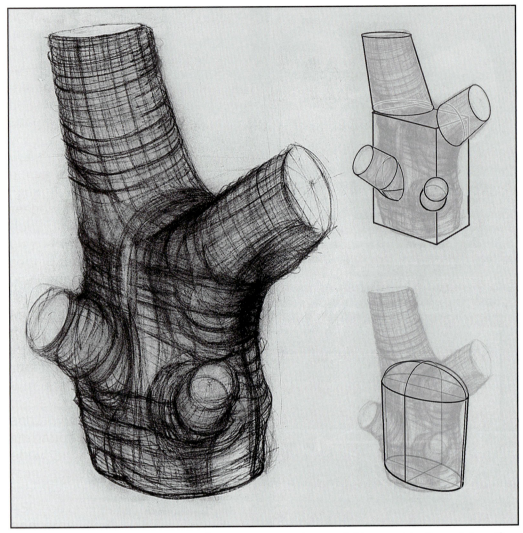

12.25a-c Applying geometric schemata to an observed biomorphic form intensifies your perceptual engagement with that object. As you analyze its structure, you begin to categorize and differentiate the complex visual patterns that make up the object. As noted earlier in this chapter, it is only after you have focused your conceptual expectations through the use of simplified schemata that you become appropriately sensitized to the object's eccentric irregularities. Trees make particularly good subjects for biomorphic form drawings. They combine the structural characteristics of cylinders, ovoids, rectangular solids, hemispheres, and cones with a surface that swells, undulates, puckers, bulges, stretches, ripples, and droops as it wraps itself elastically around the core. Every cross-contour must be spatially consistent with every section of the form, not just the localized irregularity it is defining. In order to achieve this, the relative curvature of a cylindrical or spherical cross section, or the relative steepness of the angles of rectilinear convergence must increase as the segment it is defining gets further away from eye level.

192

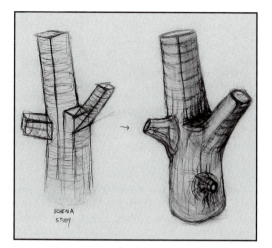

SCHEMA STUDY

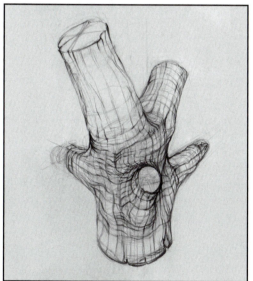

12.26a-b Although you are encouraged to be accurate in the details of the objects you are drawing, achieving clarity of form is far more important. When drawing a complicated irregular form, start out oversimplifying the basic geometric schema (uppermost images) with an emphasis on how the elements intersect one another before getting involved with subtle changes on the surface (lower image). While it might sound somewhat heretical in a book on perceptual drawing, the fact is that structure is more important than detail.

Exaggeration plays as important a role in the application of a geometric schema as it does with any of the previous illusionistic drawing techniques you have covered. There are times when you will have to rely more heavily on your geometric schema than on what you are observing, because sometimes it will be absolutely necessary to "correct" (clarify, reformulate, or even delete) certain irregular forms or surface variations whose appearance conflicts with a clear and readable depiction of an object (**Fig. 12.26a-b**). You will want to maintain as much of the unique and idiosyncratic detail from the object as possible, but structural and surface changes have to be made if and when the surface irregularity compromises the structural integrity and readability of the drawing.

One of the phrases most often heard in a perceptual drawing class is "*Draw through the form.*" It is specifically directed toward increasing your ability to embrace the fullness of the three-dimensional form with your analytical mind. Direct perception is the cornerstone of drawing from observation; but the rational mind, properly applied, can contribute to your understanding of what it is that you are looking at and in the process sharpen your perceptions (**Figs. 12.27a-b–12.29a-c**).

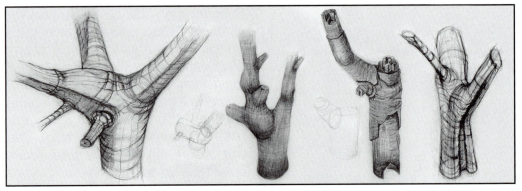

12.27a-d Tree branches are excellent subjects with which to practice cylindrical cross-contour, contour line variation, as well as the proportion of foreshortened cross sections and their axial relationship to the central axis of the branch.

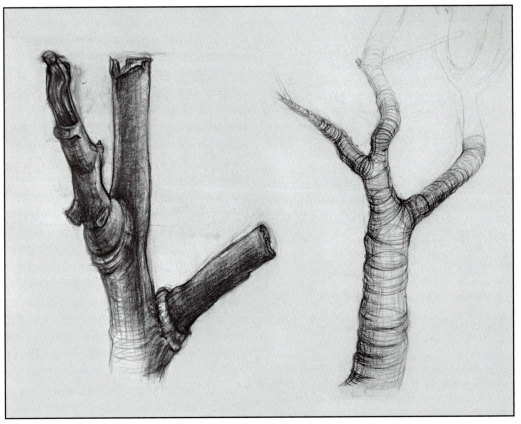

12.28a-b As with all observational drawings it is important to focus on the touch of the drawing tool as it makes contact with the surface of the paper. This ensures that the marks are sensitive and varied. Drawing through the form with light, gossamer-like lines enhances the three-dimensional illusion of forms in space.

194

CLARITY AND INTEGRITY

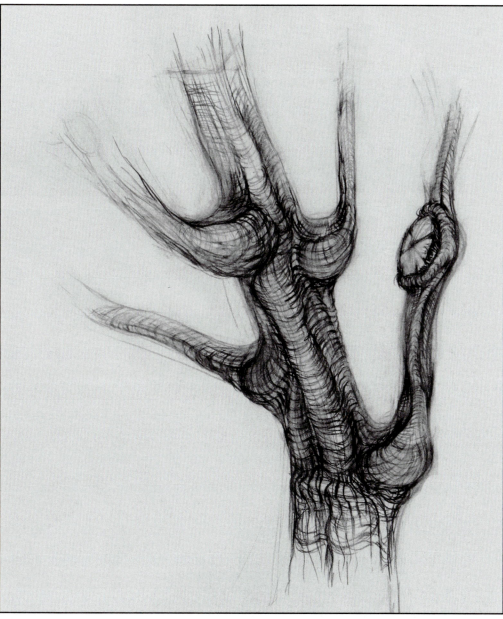

12.29 When drawing complicated biomorphic forms it is essential that you keep the underlying structure of the subject in mind as you establish cross-contours to describe particular surface irregularities. It is crucial that the cross-contours first convey straightforward information about the geometric organization underlying all the variety. Of special note are cross-contours that bridge transitions between two separate elements. When cross-contours move across the connection where two elements join together, they literally weave the two surfaces together.

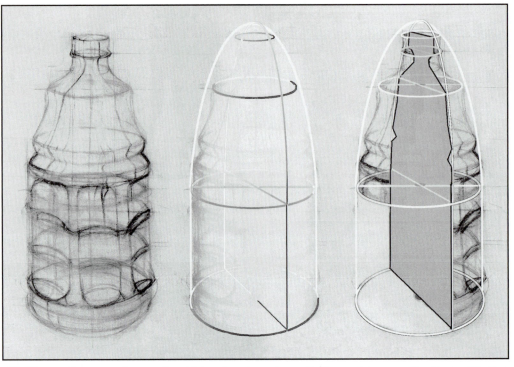

12.29a–c Cross-contours should be developed gradually and in coordination with the underlying schema. Start with generalized cross-contours on the simplified geometric forms before moving on to any idiosyncratic details of form or surface. Once the core is established, cross-contours should be used to reinforce transitions between elements of compound geometric forms. Emphasizing transitions is an excellent technique for creating a unified wholeness and for describing structural anomalies and surface irregularities. The most effective cross-contours are sets of straight lines that are applied to the surface of a form either vertically or horizontally. When these lines are viewed from an oblique angle, they provide revealing information as their apparent direction changes in response to the object's volumetric mass, structural transitions, and surface variation. Cross-contour is most effective when it is understood to go completely through the form. It is helpful to think of cross-contours as lines that cut cleanly through the form on either the vertical or the horizontal axis. It helps to approach each object as though it were transparent, with each cross-contour and cross section moving back beyond the contour edge to the back side and then coming back out to the front around the other side. Because you have extensive sensory experience in dealing with objects in space, you have a natural ability to imagine intuitively how a line running across the surface of a form should appear. Rely on your tactile memory to "feel" the movement of a particular cross-contour and trace its path around, across, or down the surface. If you have difficulty in figuring out how a cross-contour changes its direction in any particular situation, try holding your hand in front of you as though on the surface of the observed object and "feel" your finger move across the surface. If you carefully watch the vertical and/or horizontal movement of your finger and then reproduce that same movement in your drawing, you will be able to decipher the surface characteristics of even the most complicated of irregular forms.

CHAPTER 13 CHIAROSCURO

Continuous-tone drawing . 197
Value scale. 198
Squint till it hurts 199
Perceptual baseline 200
Compressed tonal range . 201
Ten-step value scale 202
Simultaneous contrast . . . 203
White on white 204
Lighting conditions 205
Directional light. 206
Inverse Square law 207
Reflected light. 208
Shadow games 209
Deceiving appearances . . 210
Rounding cylindrical edges 211
Exaggerating contrast . . . 212
"Painterly" application . . . 213
Tonal relationships. 214
Leonardo's drapery 215
Hatching/cross-hatching. . 216
Dramatic lighting. 217
Exaggerated contrast I . . 218
Exaggerated contrast II . . 219
Baroque lighting 220

The term *chiaroscuro* is an Italian word meaning literally "the combination of light and dark." Chiaroscuro is a drawing technique where subtly blended shades of gray are applied to imitate the varying intensities of light and shadow that occur when light illuminates and is reflected off three-dimensional forms (**Fig. 13.1a-c**). It is also sometimes called *shading*. When a drawing sensitively duplicates the tonal variation on and around an illuminated object or group of objects, it is referred to as a *continuous-tone* drawing. Chiaroscuro is a powerful tool for defining the mass and volume of individual forms, for describing surface texture, for creating mood, and for establishing and clarifying the space that exists between objects. It is so effective at describing the volume of individual forms and the illusion of space around those forms that it is commonly referred to as *modeling*. This term originally comes to us from sculpture and ceramics where it is used to describe the physical manipulation of the clay or wax (or other malleable materials) in fashioning sculptural forms or vessels.

CONTINUOUS-TONE DRAWING

When you are applying tones of gray to imitate the subtle gradations of light and dark in your visual field, it is helpful to know that the iris of the human eye instantly and automatically adjusts its aperture as it scans by opening or closing in reaction to the intensity of light it perceives. This involuntary aperture adjustment moderates the amount of light that reaches the sensors at the back of the eye (retina). The lens closes down when it is looking toward light areas (reducing the amount of light that enters the eye) and opens wider when it is looking at darker areas (increasing the amount of light) (**Fig. 13.2a-c**). This involuntary aperture adjustment is helpful in that it makes us better able to distinguish tonal information (detail and texture) in both the brightest and the darkest areas in a broad range of lighting conditions. This ordinarily beneficial perceptual mechanism, however, causes us to experience a compressed tonal range throughout our visual field (light areas appear slightly darker, and dark areas appear slightly lighter). This compression of the tonal range impairs our ability to accurately differentiate relative values in different parts of our visual field. To effectively use chiaroscuro in a drawing, it is essential that you find a way to overcome the value compression and accurately identify the

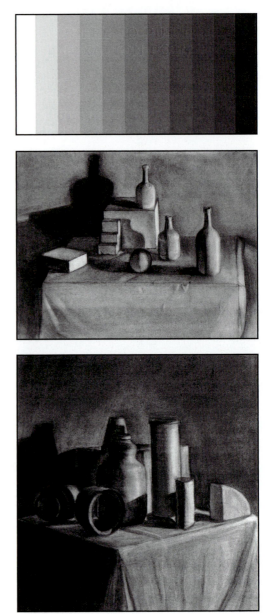

13.1a-c The top image is an eleven-step value scale containing a gradation of tones of gray, starting with white on the left and ending with black on the right. Below are two continuous-tone drawings that utilize this value scale to imitate the intensity of light reflecting off of forms in space.

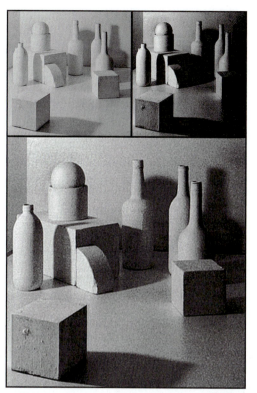

13.2a-c The iris automatically adjusts the aperture of the eye's lens depending on the intensity of light entering the eye. This means that you experience a slightly compressed tonal range across the visual field (highlights get darker and dark areas appear lighter) (top left). To draw with chiaroscuro, you need to be able to identify more accurately the relative brightness of each tonal element in your visual field. This can be done only by squinting to the point at which everything is just about to disappear. Squinting makes everything except the extreme highlights darker, allowing you to identify the brightest highlights and the full amount of contrast that exists between those highlights and the deep shadows (top right). Combining what we experience with our eyes open with what we experience from squinting produces a more descriptive and informative tonal range (bottom).

relative brightness of each tonal element in the visual field. To do this you need to **standardize the aperture** through which light enters the eye. You can't control your iris, but you can use your eyelids to standardize the amount of light you let in. By squinting tightly, to the point where you see your eyelashes twitching, you can see only highlights and deep shadows. Squinting allows you to estimate accurately the relative difference between any two value gradients. Squinting quickly identifies the very lightest of highlight areas as well as the range and depth of the shadows.

If you approach chiaroscuro without squinting, your tonal estimates will be seriously distorted by the involuntary expansion or contraction of your iris. Squinting compensates for those involuntary fluctuations. The difference in perceived tonal relationships when you are and when you are not squinting is substantial. If you've never tried squinting, you will be pleasantly surprised by how effectively it clarifies comparative value relationships. Not uncommonly, surfaces that initially appear to be highlights when your eyes are wide open are revealed to be middle tones or even shadow tones once the amount of light entering the eye is standardized. Recognizing that certain areas are actually closer

PERCEPTUAL BASELINE

in value to shadows than high-lights helps maintain consistency in the shadow areas and prevents areas of reflected light (secondary illumination) from "jumping out" of the shadows. Squinting is particularly important because without a standardized aperture the self-adjusting iris can't help but overestimate the brightness of any lighter tone located within a shadow. This overestimation of the value level of reflected light is pervasive: someone who draws only with the eyes open often applies so bright a tone to an area of reflected light that it appears as bright as a highlight (primary illumination). **Reflected light, for all practical purposes, is never as bright as direct, primary illumination. Reflected light is almost always much closer to the value of the shadow areas than it is to the value of the highlights. Reflected lights almost always disappear into the shadows as you squint.** The importance of squinting cannot be overemphasized. It is nearly impossible to arrive at accurate relationships across the entire tonal range of a chiaroscuro drawing if you do not squint frequently throughout the process.

Every day we experience more than two thousand measurable gradations in the intensity of observable illumination, ranging from the brightness of the noon-

HYMN TO THE SOLAR DISK

O living Aten, creator of life!
You fill every land with your beauty.
You are beauteous, great, and radiant,
High over every land;

You are in my heart,
There is no other who knows you,
Only your son Akhenaten,
Whom you have taught your ways

Akhenaten
Ancient Prayer
Egyptian
(circa 1345 BCE)

This is the first historical record of a belief in an abstract (no idols), universal, and monotheistic deity. It pre-dates the Jewish Torah's written pronouncement of a single god by nearly two hundred years.

IN THE BEGINNING

In the beginning, God created the heaven and the earth. And the earth was without form, and void; and darkness was upon the face of the deep. And the Spirit of God moved upon the face of the waters. And God said, Let there be light: and there was light. And God saw the light, that it was good; and God divided the light from the darkness. And God called the light Day, and the darkness he called Night. And the evening and the morning were the first day.

Book of Genesis

DIVINE LIGHT

"At the center of all things resides the sun. This most beautiful of all temples. Rightly it is called the lamp, the spirit, the ruler of the universe. For Hermes Trismegistus it is the invisible god, the all seeing."

Alchemical Text
17th century

day sun (never look directly into the sun or at a direct reflection of the sun with your naked eye—you can seriously damage your retina) to the absolute blackness of a sealed interior closet on a moonless night (this you can try). However, since your value range in a chiaroscuro drawing is limited to the reflectance of your newsprint paper (which is not really white), the measurable gradations of tone available in your drawing are considerably less than two thousand. Leonardo da Vinci was said to be able to distinguish more than two hundred gradations on a value scale (the subtlety of the value ranges in his paintings and drawings suggest this is true), but you will do extremely well in most artistic endeavors if you can differentiate twenty gradients. Some suggest that you will do well with only ten. Ten tonal gradients are what Minor White recommended in *The Zone System* as the qualifying characteristic of a well-printed black-and-white continuous-tone photograph. Some drawing texts suggest that the tonal range can be reduced to as few as six values: highlights, light tones, halftones (surfaces parallel to the direction of the light), base tones (darkest shadow), reflected light, and cast shadows. Although the six-tone system is compact and well defined, it is probably a bit too limited, inasmuch as each defined

category generally represents a range of grays rather than a single value shift.

Another interesting fact about tonal scales is the way one value can affect another's appearance when they are juxtaposed. When a dark value is next to a lighter value, the dark value will appear to be darker along the edge separating the two. Conversely, the lighter value will appear to take on a subtle but obvious glow (lighter) along the shared edge. These perceived shifts in value are called Mach bands (**Fig. 13.3**).

A closely related visual mechanism can actually cause a powerful perceptual misreading of the relative lightness or darkness of a particular value gradient. When any value gradient is surrounded by a sharply contrasting value gradient, it will be perceived to be lighter or darker than it actually is depending on the nature of the contrast. The value contrast between the gradients "pushes" the neighboring shade of gray up the tonal scale if the surrounding area is darker and down the scale if it is lighter (**Fig. 13.4**). This perceptual shift in contrast is referred to as **simultaneous contrast** and is the reason most people perceive reflected light in shadow areas as brighter than it actually is. This perception of exaggerated (simultaneous) contrast

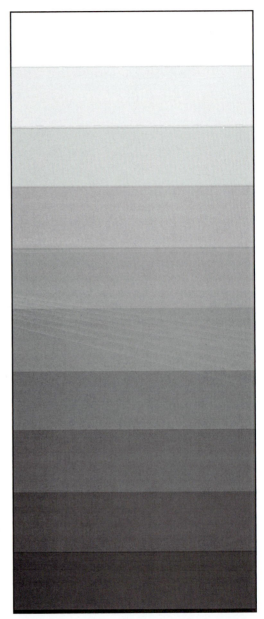

13.3 Illustrated above are Mach bands, a perceptual mechanism that causes a particular value gradient to shift in value at its edge when placed next to a gradient of a lighter or darker tone. This phenomenon is more commonly referred to as fluting.

13.4 When a particular shade of gray is surrounded by a sharply contrasting value, our perception of its position on a tonal scale is skewed so that we read it as being a lighter or darker tonal gradient than it actually is. In this illustration the center gray bar is a constant middle gray tone from top to bottom.

can, as we will soon see, be helpful in carving out and amplifying dimensional space around solid objects, but it certainly wreaks havoc with our perception of reflected light in shadows.

Before you begin a continuous-tone drawing, there are several mechanical issues to consider that can help make the entire process easier, more direct, and more productive. For starters, it will simplify your initial chiaroscuro exercises if, before you start to draw, you paint all your objects white, place the white objects on a white ground plane, and put the white objects and the white ground plane in front of a white background. Having everything in your visual field start out white allows you to concentrate solely on tonal changes. When everything is white, all observed changes in tonal range are the direct result of variations in the amount of light reflecting off of and around the three-dimensional forms. Drawing from objects that vary in value and/or color complicates the process immensely. Using objects of different values seriously complicates estimating value gradients, but determining the values of objects that are highly chromatic (intense colors) is exponentially more difficult. This is because the receptors in the eye that respond to color (cones) are completely different

from the receptors (rods) that register gray scale value. It is quite common for the human eye to mistake the intensity of a color for its value. Even the terms we assign to colors point to a certain confusion between value and color. "Bright red" is often used to describe intense fire-engine red. Bright red is intense but it is quite dark when you squint, being closer in value to a very dark gray on the value scale. (Even panchromatic black-and-white photographic film, whose name suggests that it should be sensitive to all colors, has difficulty translating color to its equivalent value gradient—red appears darker than it appears to the eye, and blue, lighter.) While every color does have an equivalent value on the gray tonal scale, it is surprisingly difficult to determine accurately what that value is. Although the difficulty that black-and-white film has in translating color to gradients of gray is not the same as that of the human eye, it can still serve to suggest how difficult assigning value gradients to different colors can be. The best solution, as stated earlier, is to paint your still-life objects white (**Fig. 13.5**). What is being asked of you is work-intensive, but any inconvenience that this creates will be more than offset by the clarity and focus that it will bring to the chiaroscuro exercises.

13.5 In many respects, chiaroscuro is more about light, and the way light behaves when it comes into contact with dimensional objects, than it is about objects themselves. But by duplicating patterns of light, we can effectively indicate mass, volume, texture, degree of surface opacity, angle of surface planes, distance from the light source, number of possible light sources, and even spatial relationships to other objects. There is a tremendous amount of useful information packed into the bouncing behavior of photons. To study this, it will be helpful to restrict the number of variables affecting the way light reacts. This can be done most effectively, even if it upsets Alice's Queen of Hearts ("Paint the roses red!") or the Rolling Stones' Mick Jagger ("I want it painted black"), by painting the objects white!

WHITE ON WHITE

ZARATHUSTRA

According to the teachings of the Iranian prophet Zoroaster (1000 BC), the history of the world is viewed as the struggle between *Ahura Mazda*, the good creative force expressed in the <u>LIGHT</u>, and *Ahriman*, the evil force that is expressed in <u>DARKNESS</u>.

PHOEBUS APOLLO

Apollo was the Greek and Roman god of poetry, prophecy, medicine, and LIGHT. He represents all aspects of civilization and order. The SUN is sometimes described as Apollo's chariot as he moves across the sky.

You can use any flat white latex interior house paint to do the job. Two or three coats are sometimes necessary for good coverage, but the paint dries quickly and cleans up easily with water. White objects on a white background will enable you to identify remarkably subtle tonal variations in your visual field. Only when you can identify these variations accurately can you begin applying corresponding shades of gray to your drawing.

The overall effectiveness of a chiaroscuro drawing also depends on the quality of the light that is illuminating the objects. The more control you have over the lighting conditions in the room where you are working, the greater the likelihood of success. For example, most of the chiaroscuro drawings in this chapter were done in a room where all the overhead lights were turned off and the window blinds were lowered and closed. The room wasn't totally dark, but it could certainly be described as having "low light." When classes were held at night, it was necessary to aim a low-intensity lamp at the ceiling in the back corner away from the still life so as to provide sufficient light for the students to see their drawings while making sure not to affect the play of light on and around the white setup.

LIGHTING CONDITIONS

CHAPTER 13: CHIAROSCURO

To create dramatic shadows and the broad range of continuous-tone gradients that are the hallmarks of chiaroscuro drawing and painting, you need a directional light source. A standard incandescent bulb or a floodlight works well. If you use floodlights, it is important that the wattage of the bulb not exceed the tolerance of the lamp's socket. It is best to be cautious and use only lamps that have ceramic sockets for any bulb greater than 60 watts. Check the specifications of the equipment you use. A reflecting hood is quite helpful at increasing the directional intensity of the light while simultaneously reducing the glare off the bulb. Reflecting hoods are available at hardware stores, home stores, and photo equipment stores. If you rig your own version of a hood to your lamp, remember that the bulb gets extremely hot. Don't use any material near the bulb that could ignite if it were to accidentally come into contact with the bulb.

Knowing several characteristics of how light behaves can be helpful as you determine the tonal variations in your drawing. The first is known as the **inverse square law.** It comes to us from physics and simply states that the amount of light falling on the surface of an object is inversely proportional to the square of the relative distance of the object from the light source

NOT ALL LIGHT IS CREATED EQUAL

Avoid using fluorescent lamps to illuminate objects in your visual field when you are working on a continuous-tone drawing using chiaroscuro.

Fluorescent light is ambient (surrounding) light. It does not generate suitable shadows for communicating form and space with chiaroscuro. Use directional lamps with regular incandescent bulbs or halogen bulbs. Sunlight works well in theory, but it changes so quickly that most of the shadows will change drastically before you can finish a drawing.

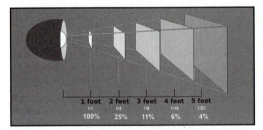

13.6 The intensity of light that reaches the surface of an object is proportional to the inverse square of the object's relative distance from the light source. This means that if one object is twice as far from the light source as is another, it only receives one-quarter as much light. Three times further away receives one-ninth, and so on.

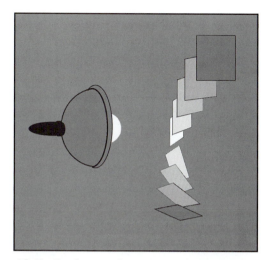

13.7 Surfaces that are perpendicular to the direction of the light rays reflect more light and appear brighter than do surfaces that are at an oblique angle to the direction of the light.

13.8 Both the inverse square law and angle of incidence are at work when you view surfaces that curve away from the light source. Both of the aforementioned guidelines describe the variety of illumination on every cylindrical and/or spherical surface. The size of the highlight (that portion of the object's surface that will appear the brightest) is more restricted than might be imagined. You will be well served if you restrict the highlight to those segments of the cylinder or sphere that are perpendicular to the light and reduce the overall intensity of the light as the distance from the light source increases.

(**Fig. 13.6**). This means that if an object is twice as far as another object from the light, it will be receiving one-quarter as much light as the closer object. This should serve as a reminder that highlights on objects at different distances from the light source will be different in value. Planes get darker as they get farther from the light source. The second characteristic of light that affects tonal variations is the **angle of incidence** where the apparent brightness of an illuminated surface is affected by the angle of the light striking the surface (**Fig. 13.7**). Surfaces perpendicular to the direction of the light appear brighter than surfaces that are oblique to the light even when they are equidistant from the light source. When a surface tilts back so that its surface is parallel to the light rays, it appears as a midrange value. This tonal gradient shift in response to a change in the angle of incidence underlies the gradual shift in the gradient tones on an illuminated cylinder or sphere (**Fig. 13.8**). The constant curvature of cylinders and spheres allows only a small area of the surface to be parallel to the light and thus appear as a highlight. As the surface curves away from the light, the values deepen. Keep in mind that even surfaces facing away from the light rarely appear as solid black shadows but vary in value relative to their

REFLECTED LIGHT

angular relationship to sources of reflected light. **Reflected light** is a secondary light source caused by light bouncing off of the surface of other objects. **Capturing the subtle variations that occur when light reflects off neighboring objects is perhaps the most important element of a chiaroscuro drawing** (**Fig. 13.9a-b**). Reflected light takes what would otherwise be individually illuminated objects and integrates them, by means of a delicate dance of bouncing photons, into a consistent and coherent illusion of spatial relationships. As mentioned earlier, when you are evaluating value relationships, you must compensate for the effects of simultaneous contrast that involuntarily causes a substantial overestimation of the brightness of reflected light within a shadowed area (**Figs. 13.10, 13.11**). The best way to accomplish this is to (say it with me) **squint!**

To distinguish subtle tonal variations you must work with your eyes open but you must also repeat the squinting process regularly throughout the drawing process to make sure that each value adjustment you are making with your eyes open also fits within the overall tonal pattern you see when you squint. This means that **the tonal relationships in your drawing must**

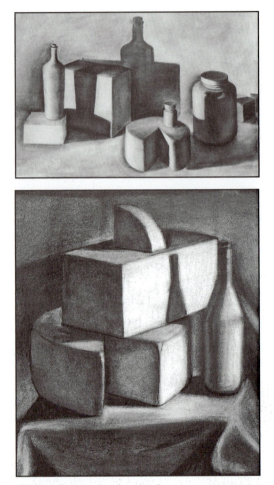

13.9a-b Rarely do shadows appear as a solid black. They usually reflect some light, and they usually have a subtle gradation that changes throughout the shadow area. It is usually slightly darker near the edges of the shadow where it comes in contact with lighter areas (simultaneous contrast) and lighter toward the center (core) of the shadow. The purest black that your charcoal can deliver should be reserved for accenting only those areas within a shadow that are the absolute darkest points in the composition.

13.10 In this image a bottle is casting a shadow across a checkered tabletop of dark gray and light gray squares. The square marked with an **A** is a dark square in the illuminated portion of the checkerboard, and the light gray square marked **B** is located in the shadow area. The perceived difference in value between squares **A** and **B** appears to be at least four steps (see bottom chart). Now try squinting and then turn the page.

DECEIVING APPEARANCES

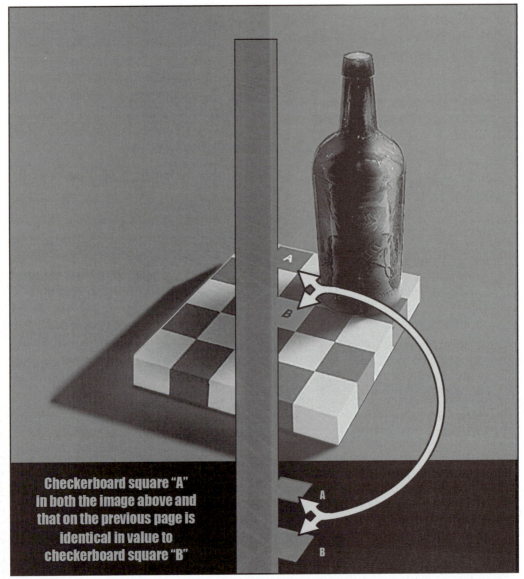

Checkerboard square "A"
in both the image above and
that on the previous page is
identical in value to
checkerboard square "B"

13.11 A single value gradient that is surrounded by a decidedly contrasting value gradient will be perceived to be lighter or darker than it actually is depending on the degree and direction of the neighboring contrast. As we can see in the illustration above and in Fig. 13.10 on the preceding page, the value contrast surrounding the squares labeled **A** and **B** "pushes" our perceptions of what is, in actuality, a single value gradient both up and down the tonal scale—up where the surrounding area is darker and down the scale where it is lighter. Because of this effect (simultaneous contrast) reflected light in a shadow area **always** seems brighter than it actually is. Squinting is the only mechanism that ensures accuracy in your ability to reproduce value relationships throughout the entire tonal range.

13.12a-b When light strikes a cylinder directly from the side, the highlight appears at the edge nearest the light. The location of this highlight is consistent with both the inverse square law and the relation of light intensity and the angle of incidence. Unfortunately, though, when the highlight appears right on the edge of a curved surface, the edge appears crisp and flat (top). To compensate for this misleading illusion it is often necessary to exaggerate the curvature by gradually darkening the leading edge in a way that makes it appear to recede back in space (bottom). This is a chiaroscuro version of lemming syndrome.

correspond to those of the still life both when your eyes are open and when you squint. To put it another way, when you squint at the still life and then squint at your drawing, their tonal pattern should be identical; and when you repeat the comparison with your eyes open, they should again be the same.

With the exception of the brightness of reflected light in the shadows, exaggerating value contrast in a chiaroscuro drawing generally helps increase the overall expressiveness of a drawing (both spatial and emotional). To increase the illusion of depth in a chiaroscuro drawing darken the value gradient you observe on the leading edge of a curved form (sphere or cylinder) even if that curved surface appears brightest as a result of its being illuminated from the side (**Fig. 13.12a-b**). When light hits a curved surface from the side, the surface does appear brightest on the outermost edge of the form where the surface is both perpendicular to the light (angle of incidence) and closest to the light (inverse square law). **However, even though the edge is the brightest you shouldn't draw it that way.** Without stereoscopic or parallax spatial information, rendering the edge of a curved surface with a highlight makes the curved form read like a flat cutout. If instead

the highlight is placed just inside the edge and the edge itself is made to be darker, the receding edge, which otherwise would have looked like a flat cutout, gets appropriately pushed back into space. Edges of rectangular forms, however, do not turn away from the viewer and should be rendered with crisper edges (**Fig. 13.13**).

Another instance where purposefully exaggerating contrast can maximize your ability to get the most from the range of values available from charcoal on paper while improving the illusion of depth occurs along any shared edge where two neighboring, contrasting values meet (**Fig. 13.14**). Exaggerating contrast at or near where values come into contact encourages variety in the tonal values representing the changes in degrees of illumination. Do not hesitate to exaggerate the value contrast between two neighboring areas beyond what you perceive. Exaggerating edge contrast compensates for both the eye's compression of the tonal range and the tonal limitations of charcoal on paper (**Figs. 13.15, 13.16a-b**).

When using compressed charcoal to create tonal gradations, there are essentially two approaches for applying the charcoal to the surface: by laying the charcoal

13.13 The simplified overall tones of a chiaroscuro drawing must be accomplished before attempting the subtle value changes that represent light bouncing on and around the surfaces of objects. Getting involved early on in nuanced and detailed value changes is frequently time wasted because careful modeling at the early stages rarely fits appropriately into the "big-picture" tonal relationships and will need to be reworked.

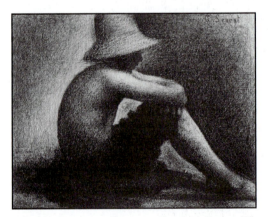

13.14 Georges Seurat, *Seated Boy with Straw Hat*, study for Une Baignade, Asnieres (Yale University Art Gallery.) Seurat purposefully exaggerated simultaneous contrast where the background is adjacent to the edge of the figure. Exaggerating this difference enhances spatial illusion by causing the figure to "pop out."

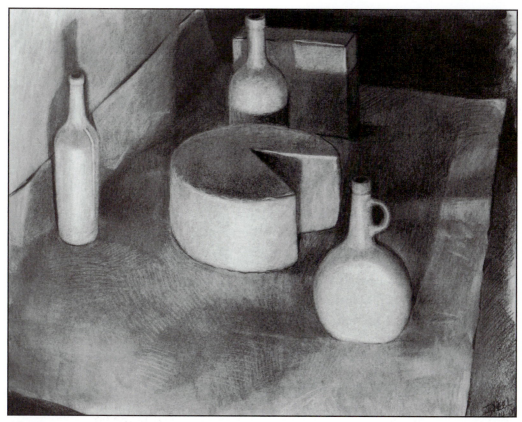

13.15 Exaggerating the value contrast at the edges were two contrasting values meet contributes to a strong sense of dimensional space making the objects appear as though pushed away from the background. It also adds a clarity and crispness to the overall impact of a chiaroscuro drawing.

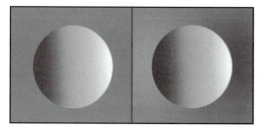

13.16a-b Despite the distinct perception of a subtle glow around the darker side of the sphere on the left, the background is comprised of a single value gradient. Exaggerating simultaneous contrast (above right) adds considerably to the illusion of depth.

down quickly and freely and then blending and erasing to create tonal variation, or by gradually building up the tone through delicate layering of sensitively rendered marks on the paper's surface.

The first approach, represented by the majority of the student projects in this chapter, resembles a "painterly" application where an extrasoft charcoal is applied

213

to the surface quickly in broad, generalized tones before being blended, smudged, and erased to mimic the subtle tonal variations that depict light bouncing off and around the objects. It is important to ignore small details as you begin. Go after broad, simplified value relationships and leave the subtleties until everything is shaded with an appropriate value. Covering the surface in this manner concentrates your attention on deep shadows, middle tones, and highlights. It can be thought of as a value "gesture" in that you start out with rough tonal approximations and work your way toward subtle tonal variations. Obviously, this is easiest to accomplish if you squint, because squinting obliterates subtle differences in value and allows you to see in terms of generalized "big picture" tonal relationships. Wrapped or wooden barreled charcoal can be used for laying down broad tones, but it is far quicker and easier with softer, larger blocks or cylinders of compressed charcoal (**Fig. 13.17a-b**).

Start by establishing broad tones over the entire drawing that approximate what you see when you squint and then open your eyes and address the subtle value changes that are visible within the broad tones. If this is your first experience working this way, you are likely to be pleasantly

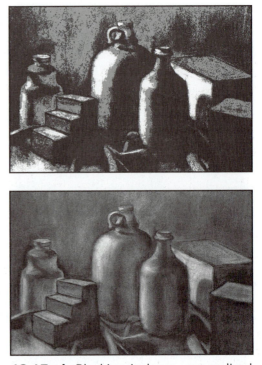

13.17a-b Blocking in large, generalized tonal relationships that you see when you squint at the earliest stages of a chiaroscuro drawing helps control the natural tendency to overestimate the number of highlights and especially the brightness of the reflected lights in the shadow areas. Only after you have identified and established the general tones are you in a position to make the necessary subtle adjustments within the larger tonal passages by blending, erasing, or adding more tone. It is important to resist the natural tendency to begin applying delicate tonal variation to a single object before laying in the generalized tones of the entire composition. Carefully putting in the tones of a bottle, for example, before filling in the approximate tone of the surrounding areas usually results in having to redo the entire bottle once the surrounding areas are shaded.

TONAL RELATIONSHIPS

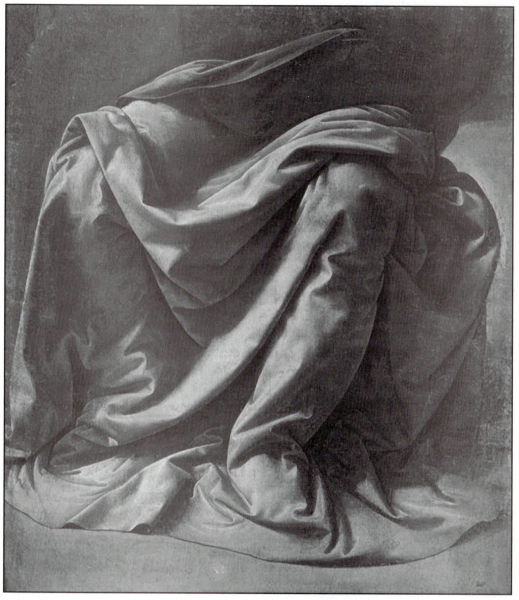

13.18 Leonardo da Vinci, *Drapery Study* (Louvre, Paris). When the term *modeling* is used in drawing, it refers to the ability of chiaroscuro (continuous-tone value manipulation) to carve out convincing illusions of three-dimensional form on the flat surface that imitates those achieved through three-dimensional manipulation of a malleable material like wax or clay. Nowhere is the term more appropriately applied than in the subtle gradations of value in Leonardo's study of draped cloth.

surprised by the amount of control you have in adjusting tones by blending, erasing, or applying more charcoal. Paper towels are effective blenders; kneaded erasers are very versatile for both blending and removing tone (**Fig. 13.18**).

Tonal gradients can also be established by delicately drawing the charcoal across the texture of the paper's surface to build up the tone slowly. This works best if your paper has a pronounced tooth like that of papers made especially for charcoal and pastel. The paper texture gives the tone a freshness that doesn't occur when you blend, but keep in mind that this technique demands a painstaking, gradual buildup of value and does not respond well to erasing. An alternative method of creating tone that can be used on any surface is to create shades of gray by using parallel lines (**hatching** or **cross-hatching**). This tone can be varied by drawing the lines closer together or farther apart, by making the individual lines darker or lighter, or by placing sets of lines on top of one another at differing angles (**Fig. 13.19a**). A related but more complicated technique involves sets of evenly spaced and delicately modulated cross-contour lines that define the form by changes in their apparent direction and thickness (**Fig. 13.19b**). This technique is

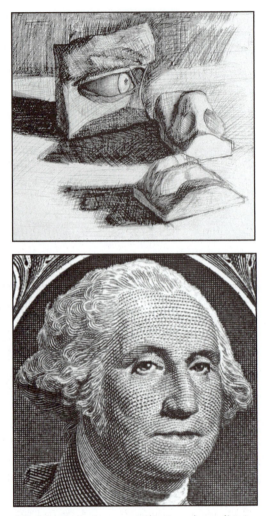

13.19a-b In image **a** the tonal gradients have been created by gradually building up successive crisscrossing layers of parallel line sets (cross-hatching). In image **b** the tones of George Washington's face (from the dollar bill of U.S. currency) have been created by varying the darkness and thickness of a delicately rendered set of cross-contours (cross-contour modeling). Interestingly, for the purpose of creating greater psychological presence from the portrait, the cross-contour modeling technique was abandoned in the rendering of the eyes and mouth.

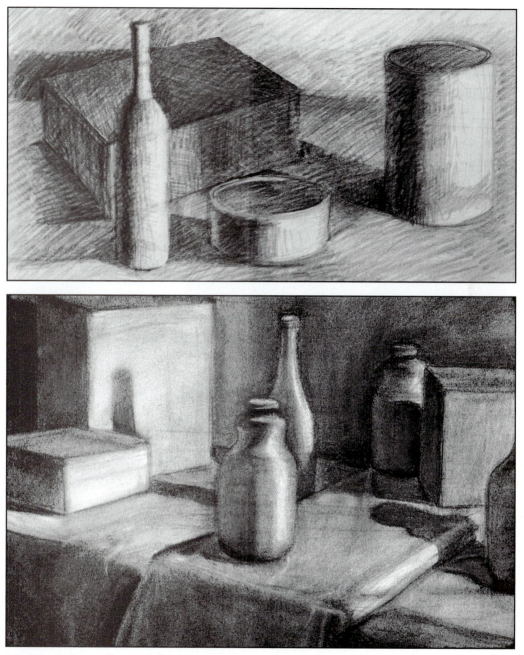

13.20a-b Regardless of the technique you choose for applying chiaroscuro, the clarity of the three-dimensional space in a continuous-tone drawing is enhanced when the light strikes one set of the planar surfaces of the objects closer to a 90° degree angle than it does any other set. Arranging the light this way allows sets of surface planes with varying spatial orientations to reflect different amounts of light.

DRAMATIC LIGHTING

217

EXAGGERATED CONTRAST I

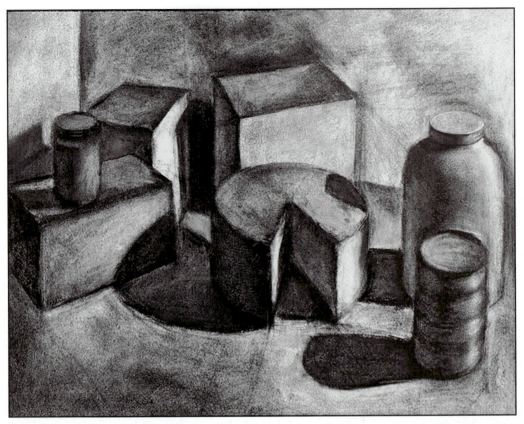

13.21 Squinting, though tiring to the muscles around the eyes, is an effective technique for identifying the increased contrast that occurs when two contrasting areas meet. The exaggerated contrast between the highlight on the large jug on the right and the darker background surrounding it add drama to the illusion of light as well as help to reinforce the illusion of space by carving the background tone in behind the bottle.

known as **cross-contour modeling**. You might recall that you saw some cross-contour modeling applied to a few of the flag drawings earlier in the book.

In addition to communicating surface texture, volume, three-dimensional space, and light intensity, chiaroscuro can also communicate a sense of antici-

"The artist cannot copy a sunlit lawn, but he can suggest it. Exactly how he does it in any particular instance is his secret, but the word of power which makes this magic possible is known to all artists—it is 'relationships.'"

E. H. Gombrich
Art and Illusion

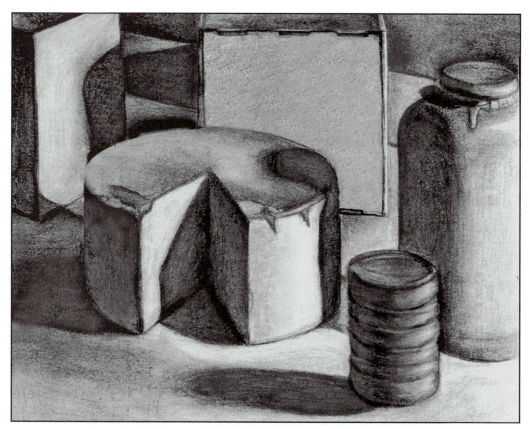

13.22 Because the white of the paper is no match for the intensity of a brightly illuminated surface, you cannot reproduce in a drawing an exact duplicate of the range of tonal gradients that you see in your visual field. Planes of objects that are in shadow always appear darker along those edges that are shared with brightly lit planes. Pushing each and every shade of gray down the value scale one or two gradients and further exaggerating the values where the edges come into contact allows your drawing to glow with the same intensity and clarity as your perceptual experience.

pation. In painting this is called *tenebrism,* from Latin meaning "dark and mysterious." It was introduced by Caravaggio in the 17th century, and its expressive power has continued to influence image makers in painting, drawing, photography, and film (film noir) up to the present day (**Figs. 13.20a-b–13.23**).

BAROQUE LIGHTING

13.23 Caravaggio, *The Calling of St. Matthew* (San Luigi dei Francesi, Rome). The theatrical side lighting, stage-like shallow setting, deep shadows, and sharply contrasting highlights that were popularized by Caravaggio's emotional and dramatic paintings during the 17th century became the hallmarks of Baroque painting. The dramatic effectiveness of Caravaggio's paintings and of those of the many artists who have been and are influenced by him (known as *Caravaggisti*) suggests there is something in the very nature of light and dark that when pushed to extremes can create a spiritual or emotional tension reminiscent of the ancient mythic interpretations in which light and dark are presented as primal cosmic forces.

"More light!"
Goethe
(on his deathbed)

CHAPTER 14 HISTORICAL PERSPECTIVE

Underlying traditions . . 221
Visual field 222
Visual world. 223
Philosophical questions 224
No "realists" allowed. . . 225
Heraclitus's river 226
Iconoclasts 227
Ancestral imagery 228
The power of images . . 229
Neoplatonism. 230
Iconodules. 231
The sanctity of sight. . . 232
Divine omnivoyance . . . 233
Brunelleschi's vision . . . 234

Although arguments can be made as to the benefits of introducing linear perspective at an earlier learning stage of observational drawing, there are several good reasons for postponing its introduction until after you have accumulated extensive observational drawing experience. Familiarity with intuitive gesture, perceptual grid, foreshortening, and especially **clock-angles**, provides a solid experiential framework for understanding the technical aspects of linear perspective. It can also be argued that having hands-on observational drawing experience prior to learning linear perspective acts as a safeguard against being intimidated by the surprisingly synthetic nature of the spatial coding system that was developed during the Renaissance.

However, before we begin our in-depth study of the mechanical inner workings of linear perspective, let's first take a broad overview of the psychological, theological, philosophical, historical, and mythological premises underlying the scientific linear perspective system discovered by Filippo Brunelleschi.

UNDERLYING TRADITIONS

221

To begin our study of perspective, let's compare some of the essential structural features of scientific linear perspective (*Visual Field*) with how 20th-century perceptual psychologist J. J. Gibson observed we actually process visual information (*Visual World*). When comparing his observations with the principles of linear perspective, it becomes immediately apparent that the defining characteristics of these two systems rarely coincide. An item-by-item comparison reveals that the Renaissance linear perspective system is remarkably limited in its ability to address the majority of what actually constitutes direct visual experience despite the fact that images that utilize this system are generally referred to as "realistic." This observation is not intended to diminish the long and revered tradition of scientific linear perspective but only to, in the spirit of full disclosure, acknowledge its undeniable limitations. Although later in this chapter we will address linear perspective's unique strengths, for now it is important to acknowledge that this comparison reveals linear perspective to be an artificial (synthetic) system that is incapable of translating substantial amounts of what constitutes our visual experience. Linear perspective is a limited, synthetic, mechanical spatial system that offers a rational presentation of

VISUAL FIELD
(Linear Perspective System)

◆*Based on the use of only one eye so we see depth through monocular cues.*

◆*Our eye must look straight out at the horizon, parallel to the ground plane.*

◆*We can see only the things within a 45° cone of vision around our line of sight.*

◆*We must stand absolutely still so that our viewing position remains in the exact same spot.*

◆*We must stare (fixate) straight ahead at a single point throughout the course of the drawing.*

◆*The entire system is predicated on there not being any change at all. Everything is static, including time. The instant becomes frozen.*

◆*The basic element of linear perspective is the imaginary picture plane that floats before our eye at 90° to our line of sight. It is the "window" upon which we see all the things in our visual field.*

VISUAL WORLD
(Direct Perceptual Experience)

◆*We normally use two eyes and experience spatial depth binocularly (stereoscopic vision).*

◆*We are by nature fidgety creatures, and we commonly look up, down, and all around.*

◆*We can actually see out of the corners of our eyes (peripheral vision—up to a 200° angle).*

◆*We generally use side-to-side movement (parallax) to help determine distance between objects.*

◆*The eye is the most restless and fickle organ in the body and by nature is constantly moving.*

◆*The world itself is in a constant state of flux. We sense the world around us because we are attuned to things changing. We become numb when we are subjected to a constant stimulus.*

◆*We are actually IN our environment. It is a multisensory experience in which sight is only a part. We are not just looking—the world is breathing and moving all around us.*

space that provides an effective graphic substitute for the complex way that the eye and the mind process visual information. **Acknowledging the limitations of linear perspective is important at the outset because much of the frustration and difficulty people encounter when applying this system is the direct result of losing sight of its limited and artificial nature.** Recognizing the limitations and artificial nature not only provides insight into what linear perspective cannot do but also helps sensitize us to the expressive implications of what is nonetheless a remarkable system for capturing and communicating valuable types of three-dimensional information.

The limitations of linear perspective are not restricted to conflicts in how we process visual information. There are also multiple philosophical issues to consider. The very nature of pictorial illusion has generated intense opposition from some of the major contributors to Western culture, not the least of which is one of its most influential philosophers, Plato. While it is certainly true that Plato predated the discovery of a fully functioning system of perspective by nearly two thousand years, he opposed the mimetic art of his own era in carefully reasoned arguments that serve as the basis

for a long-running philosophical debate on the value of images that are commonly referred to as "realist."

Plato (428–348 BCE) responded to the popular art styles of his day (**Fig. 14.1**). Those styles are understood to have imitated the appearances of material things. Unfortunately, no original Greek painting has survived. It is believed that these paintings relied heavily on monocular cues like line variation, chiaroscuro, transparency, cross-contour, atmospheric perspective, and overlap to create the appearance of forms in space. Plato's opposition to mimetic imagery grows out of his *Theory of Ideal Forms*. He describes ideal forms as abstract ideas that, while having no material form, do have a greater reality than physical concrete things because they are timeless and unchangeable and, as such, were understood to interpenetrate with the divine. He believed that *Good*, *Truth*, and *Beauty* exist at the highest pinnacle of a hierarchy of ideal forms. Plato's belief in Ideal Forms grew out of a mystical understanding stemming from the teachings and geometric principles of Pythagoras. From this mystical base Plato reasoned that the soul of a living person could, through intellectual contemplation of Truth, Beauty, and the Good, recollect its pre-life knowledge of the divine that had been driven

14.1 According to Plato, artists who imitated the appearances of things were harmful to the betterment of mankind because their mimetic images compromise a soul's ability to contemplate the eternal. Although no ancient Greek paintings have survived into the modern era the descriptive writings from Plato's time indicate that the Greek paintings that imitated appearances were the most popular. The image above is a detail of the 19th-century painting *Le Grande Odalisque*, by Jean Dominique Ingres. Given Plato's writings on the subject it is certain that Plato would have been very critical of Ingres' remarkable skill in depicting appearances of things.

from conscious awareness by the shock of being born into the realm of space and time. For Plato, anything in this world that triggered the soul to recall its pre-life participation with the divine was to be encouraged, and anything that distracted it from that end was to be discouraged (**Fig. 14.2**). In Plato's model the material world is capable of triggering recollections of the changeless reality of the divine, but anything that imitates the appearance of material things (mimetic art) only encourages recollections of the depicted material thing. As a result, when Plato designed his ideal political state (*The Republic*), he described artists as dangerous individuals who, by their propensity to create misleading illusions, confuse souls with images that interfere with recollections of the Divine. As a result of this reasoning, (mimetic) artists were to be prohibited from participation in his ideal state (for the record, such a state never happened). Were Plato around today, he would most likely have little appreciation for the improved effectiveness with which linear perspective creates mimetic illusion. Linear perspective would be totally unacceptable because of its lack of reality.

There is another philosophical position that, while differing considerably from that of Plato, also has difficulty relating to the

14.2 Kasimir Malevitch, *Red Square* (Russian State Museum, St. Petersburg). While we can only speculate about what Plato would think about all the different styles of art that have been made since the 4th century BCE, a reasonable case can be made that he would rescind his ban on artist participation in his Republic if they all made images like the Red Square painting of Russian suprematist Kasimir Malevitch, because it can be argued that this painting does not imitate a square but actually is a square.

NO "REALISTS" ALLOWED

supposition that images made with linear perspective are accurate reflections of the world around us. This second philosophical position began with **Heraclitus** (540–475 BCE). He proposed the notion of change (flux) as the defining characteristic of reality. Heraclitus once observed that **you can't bathe in the same river twice** because everything is constantly changing. This position was restated in the early part of the 20th century by **Henri Bergson** when he wrote that the essence of life was to be found in our experience of time (duration) and that reality was simply the flow of life and the accumulation of experience through time (knowledge). From this perspective, life is fluid and the individual is a being constantly in the "act of becoming" (**Fig. 14.3**). So, with one energetic, philosophical stroke, Heraclitus and Bergson challenge both the eternal timelessness of Plato and the "frozen instant" that is captured by linear perspective. But wait, there's more.

Linear perspective also finds itself to be a target of a variety of theological traditions. Although religious traditions that oppose mimetic imagery often contain conflicting and contradictory attitudes with regard to the appropriateness of mimetic images, opposition to images that imi-

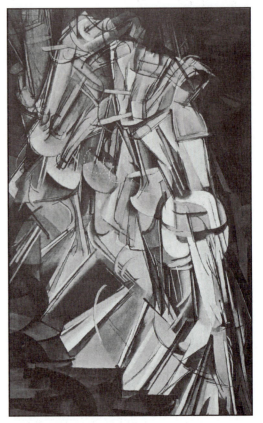

14.3 *Nude Descending a Staircase #2*, 1912 by Marcel Duchamp (The Philadelphia Museum of Art) reflects the continued fascination with the depiction of movement through space and time. This painting has been positively described as a "technological Venus in motion" and sarcastically as an "explosion in a shingle factory." Either way, Duchamp seems to have successfully engaged Bergson's issues of "life, action, and freedom."

"Thou shalt not make unto thee any graven image, or any likeness of any thing that is in heaven above, or that is on the earth beneath, or that is in the water under the earth."
Book of Exodus

14.4 When the prehistoric cave paintings were first discovered (Altamira in the late 19th century and Lascaux in the mid-20th century), they were dismissed as a hoax because the sensitivity of technique that they reflected was believed to be beyond that thought possible for Neolithic man. Interestingly, one of the ways they were authenticated was by anatomical detail that was so specific and accurate that species of animals that were extinct, and whose skeletons were uncovered only after the discovery of the cave paintings, could be identified from their depictions on the walls. Although there is no suggestion of rational space between the depicted animals the individual drawings, in isolation, do suggest strong illusion of depth through contour line variation and overlapping forms. These images are at least 15,000 years old and their discovery has caused many to reformulate their estimation of the aesthetic, spiritual, and intellectual life of our Neolithic ancestors.

tate material form by means of illusionistic techniques has been constant and intense over the last three thousand years. If you go back to the Jewish Torah, there are at least a dozen strongly worded prohibitions of graven images. Vestiges of this biblical opposition have survived right up to the present day in a majority of Protestant Christian denominations as well as in Islam. At times throughout history each of these groups has been so fervent and aggressive in their opposition that their adherents have been known to destroy any representational images they can get their hands on. Such zealots are called iconoclasts.

While there has obviously been and continues to be opposition to mimetic imagery, there are other traditions that derive intense enjoyment, satisfaction, and even profound meaning from images that rely on a wide variety of monocular techniques for creating convincing illusions of three-dimensional form on a flat surface. These techniques are found in the very earliest surviving pictorial artifacts of our species. They begin with the skillful renderings of large animals drawn on the walls and ceilings of caves throughout southwestern Europe (15,000 BCE) (**Fig. 14.4**). Very little is known about the origin of these images, so

ANCESTRAL IMAGERY

we don't really know the purpose for which they were created. Purpose aside, though, if we concentrate on the sophistication of technique and consider the fact that they were painted in relatively inaccessible portions of the caves, we can deduce the importance these mimetic images had to have had for those who made them. The incredible sensitivity, consistency, and delicate detail of these drawings is proof that our distant ancestors made these drawings in celebration of and in intense participation with the wondrous world they observed around them.

Throughout history we find myths, superstitions, cultural traditions, and religious beliefs from all around the globe that reflect a belief in the power of mimetic images to generate spiritual and/ or physical energy (**Fig. 14.5a**). In ancient Egypt, for example, the tomb walls of those who were being prepared for an afterlife were painted with images of the material items that would make life enjoyable in the next world. Also painted on these walls were written prayers intended to ensure a successful journey to the eternal resting place. As it turned out, many of these prayers used words that contained hieroglyphs depicting dangerous species of animals (lions, scorpions). Whenever such a hieroglyph was to be entombed

14.5a-b If you have ever placed the picture of a loved one face down because you were angry with him or her, or felt a surge of patriotism while in the presence of Daniel Chester French's statue of Abraham Lincoln in Washington, D.C., you have had the kind of experience that provides direct insight into worldwide cultural traditions that are built upon a belief in the power of representational images for generating emotional, spiritual, and/or physical energy.

AN ESKIMO LEGEND

"Once there was an Eskimo man whose mother-in-law was a powerful magician. The man often had trouble with his kayak, which kept capsizing, and so he asked her for her help. She didn't like him very much, so she refused. When the old woman died shortly thereafter, he decided to try to use the powers she had in her to keep his boat from capsizing. He proceeded to flay her corpse and glued the skin spread-eagle to the bottom of his kayak. Amazingly, the flayed skin of the magician kept the boat steady in the water. Unfortunately, however, his mother-in-law's skin gradually decayed and wore off, and his kayak once again began to tip over. In desperation he painted an outline around where the skin had been on the bottom of his kayak. It worked! The painted image had exactly the same effect. The kayak never again turned over."

The historical validity of the preceding story is open to question, but to this day the bottom of the kayaks in the Nunivak region of Alaska are adorned with the outline of a human figure that is placed there to provide balance.

with the body, a deep line was carefully and completely incised through the middle of the glyph (**Fig. 14.5b**). This incision was believed to neutralize the danger that resided in the creature's representation. In a similar vein, Satan and Judas in Byzantine mosaics were always depicted in profile so that only one eye was visible. This was in stark contrast to depictions of blessed characters who were presented full face looking out toward the faithful with both eyes. These were fashioned in the belief that a figure with two eyes functioned as a device for establishing direct spiritual contact with the personality behind the image. Evil characters were only allowed to be depicted fragmented (with only one eye visible). This was understood to prevent them from harming the faithful.

The belief in the power of mimetic images is also found in various folk traditions where the artist is encouraged to refrain from finishing a mimetic image for fear that, if completed, it will walk away in the night or that its completeness will bring down the jealous wrath of the divine creative forces. These myths and stories point toward a long and curious fascination with the belief in a connection between mimetic images and an energizing spirit of life.

THE POWER OF IMAGES

Although much of the fascination and wonder that people attribute to mimetic images does seem to originate in superstitions and in unconscious realms of the mind, the obvious appeal of illusionistic images has also been found to be of interest among rational thinkers. Six hundred years after Plato, **Plotinus**, an Egypto-Roman philosopher, revived the Theory of Ideal Forms but reinterpreted the philosophic role that mimetic art plays in the contemplation of beauty. In his updated version of Plato's ideas, *Neoplatonism*, the representational artist becomes an invaluable facilitator in the contemplation of Beauty. As Plotinus sees it, the representational artist has the ability to inject Beauty into matter, and therefore the artist's activity should not be interpreted as a lowly copying of nature but rather as a creative act that reaches out directly to the underlying principles (unity–divinity) of nature. In redefining the role of the artist, Plotinus was the first to unite *aesthetics* (study of Beauty) and philosophy.

Mimetic art also found considerable theological support during a heated 8th-century Christian debate in the Orthodox tradition known as the *Iconoclastic Controversy*. Whereas the Iconoclasts held that images were not co-essential (they were not one with the object or person

"No lesson in psychology is perhaps more important for the historian to absorb than the multiplicity of layers, and the peaceful coexistence in man of incompatible attitudes. There never was a primitive stage of man when all was magic; there never happened an evolution which wiped out an earlier phase. Different situations bring out different approaches in which artists and public learn to respond. Beneath these new attitudes or mental sets the old ones survive and come to the surface."

Jose Arguelles
The Transformative Vision

NEOPLATONISM

PYGMALION AND GALATEA

Pygmalion was a pious and disciplined young Greek sculptor from the island of Cyprus who was so devoted to Venus (Aphrodite) that he shunned the company of women because he believed them to behave in a manner disrespectful of the goddess. In her honor he began to fashion an ivory statue of the most beautiful woman he could imagine. When it was nearly complete, he began to pray that the goddess would send him a wife that was in the image of his statue. Touched by his devotion, Venus came to his studio and as the young sculptor made his final adjustments she miraculously turned the cold marble of the statue into responsive living flesh. Pygmalion's commitment to the goddess was rewarded.

Greek Myth

depicted and were therefore useless and should be destroyed), the Iconodules (those who revered mimetic images) came to the debate heavily influenced by Neoplatonic ideas, arguing that a representational image "participates" in the original. They pointed to a biblical passage that mentions demons fleeing in fear from the shadows of saints and presenting it as an argument to support the notion that images carry the power of what they depict. The Iconodules carried the day. Unlike the Orthodox Church, the Roman Church always supported the beneficence of images and was not involved in the controversy. **St. Augustine** (AD 354–430) preached that beauty in this world led faithful to the Beauty that is above. **Abbot Suger** (circa AD 1150) taught that art transforms and transports the faithful from an inferior to a higher world in an anagogical (mystical) manner by means of an inherent redemptive power. **St. Thomas Aquinas** (AD 1225–1274) wrote that the three elements of Beauty were integrity, proportion, and clarity. **Roger Bacon** (AD 1220–1292) in *Opus Majus*, his "compendium of all knowledge" included a chapter on the geometric laws of optics. These laws, he wished to show, reflected the manner in which God's grace spread through the universe. He encouraged artists to use geometry to "make literal

231

the spiritual sense" nearly two hundred years before the discovery of perspective.

While many of the rational thinkers who supported mimetic imagery were influenced by Neoplatonism, others followed the philosophical position known as **nominalism**. Unlike idealists, nominalists do not believe ideal forms have an independent reality. For them, ideal forms are simply a method of ordering and classifying the individual things that actually do exist. Each thing exists, uniquely and in direct relation to the divine. Artists influenced by nominalism specialized in rendering material objects accurately and in minute detail (**Fig. 14.6 a-b**). **Nicholas of Cusa** (AD 1401–1464) observed that because light was the first thing God created, it should be understood to be the energizing force of the universe. He concluded that *sight was the divine essence, and that to understand optics was to understand the very nature of God*. Sight is sanctified. As understood by Nicholas of Cusa, divine omnivoyance is the basis for the relationship between each particular thing and God (**Fig. 14.7**). A thing exists because God sees it. It should come as no surprise that this theory encouraged intense scrutiny of the visible world and promoted images that contained remarkable detail in as much as

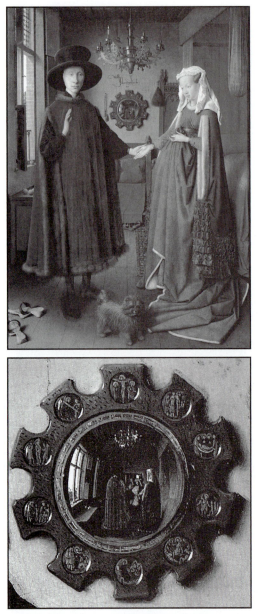

14.6a-b The paintings of Jan van Eyck are a tour de force of obsessive observable detail. He was influenced by nominalism and the theological ideas of Nicholas of Cusa that stressed that sight was synonymous with the divine essence.

"For me the subject of the picture is always more important than the picture. And more complicated. I do have a feeling for the print but I don't have a holy feeling for it. I really think that is what it is about. I mean it has to be of something. And what it is of is always more remarkable than what it is."

Diane Arbus

14.7 The reverse side of the Great Seal of the United States of America depicts the "all-seeing eye of Providence" (it can be seen on the left-hand side of the reverse side of the dollar bill). Our founding fathers felt that success in their political experiment would depend on Providential favor.

detail was understood to express the interrelatedness of matter and intangible cosmic order. As incredibly detailed and convincing as these images are, the space they suggest only approximates the linear perspective system that was being developed by Filippo Brunelleschi in Rome.

If you take into account the spiritual reverence accorded mimetic images during the intensifying intellectual climate of the 14th and 15th centuries and add it to the fascination that always seems to accompany representational images, you can begin to appreciate the intense cultural forces that gave birth to an imaging system (linear perspective) that not only closely imitated the appearance of the material world but did so with a clear, ordered, unified, and mathematical precision.

By AD 1425 Filippo Brunelleschi, a sculptor, architect, and engineer, had rediscovered linear perspective while rendering antique architecture. It is said that he rediscovered linear perspective because there is substantial evidence to suggest that geometric perspective was known to Ptolemy of Alexandria, a scientist and philosopher, as far back as the 2nd century AD. It seems, however, that this knowledge of perspective was applied only to mapmaking and stage designs prior to

DIVINE OMNIVOYANCE

233

the 15th century. Brunelleschi, after his rediscovery, worked only as an architect and engineer. He did not use his system but instead passed it on to three of his friends, the painters Masaccio and Masolino and the sculptor Donatello. These were the first artists to apply linear perspective to art images (**Fig. 14.8**).

In a world that was experiencing social, political, and theological upheaval, the early users of Brunelleschi's system heralded linear perspective as a tool for restoring the moral authority of the Church. Its early practitioners used it only to present religious subjects set in imaginary, architectural settings. These images were intended as visual representations of the immutable law of order that reveals the presence of the divine.

Although the modern world is no longer quite as accepting of linear perspective as the embodiment of the divine, as you will see in the next chapter, Brunelleschi's system still offers an effective depiction of a visual world that is remarkably satisfying in its clear and predictable rationality.

14.8 *The Holy Trinity*, Masaccio, 1426–1427, (fresco, Santa Maria Novella, Florence, Italy), is the very first painting to utilize Filippo Brunelleschi's discovery of a fixation point as the location for the convergence of all the receding edges that are going back in space at a 90° angle to the picture plane.

Alberti's *Della Pittura* . . . 235
Monocular cues I 236
Monocular cues II 237
Alternative perspectives 238
Fixation point 239
45° cone of vision 240
Perspective machines . . . 241
1-, 2-, 3-Point 242
One-point perspective . . . 243
Finding the fixation point 244
Orthagonals 245
Two-point perspective . . . 246
Fixation location 247
Brunelleschi's catch-22 . . 248
Shifting perspectives 249
Vanishing point left 250
Vanishing point right 251
Rotating solids 252
Clock-angles revisited . . 253
Shared vanishing points . 254
Unique vanishing points . . 255
One and two together . . . 256
Extreme convergence . . . 257
Flag revisited 258
Individualized convergence 259
One and two together . . . 260

It was Filippo Brunelleschi who rediscovered linear perspective, but it was Leon Battista Alberti who made it widely accessible to artists through his book *Della Pittura* (*On Painting*). Alberti's text is also noteworthy because it was the first time anyone had proposed that the art of painting was a profound intellectual exercise. Painting, he declared, required the artist to blend technical skill and observations of nature with an intellectual understanding of the order, harmony, and proportion found in the mathematical sciences. In large measure, it was the introduction of geometric perspective as a tool for creating the illusion of three-dimensional space that dramatically expanded the prestige of the artist. By 1445, *perspectiva*, as studied by painters, was being referred to as a branch of philosophy and taught in Renaissance universities as an attachment to the traditional quadrivium of the "liberal arts."

The introduction of Brunelleschi's perspective added to, rather than replaced, most of the older perspective methods that were being used by artists to create the

MONOCULAR CUES I

illusion of space. These older monocular spatial techniques are not only compatible with linear perspective but serve as valuable enhancements (**Figs. 15.1a-c, 15.2a-f**). So much so, in fact, that the full meaning of Renaissance perspective is best understood as a combination of techniques and not limited to the rules outlined by Alberti. Although artists generally hold to the belief that "less is more" (economy of means), the opposite is true when the goal is to create an illusion of space. The more space-creating techniques that you can squeeze into a given drawing, the more likely it is that the illusion of three-dimensional space will be effective and convincing.

As you saw in the previous chapter, linear perspective is a synthetic visual language, a rationally systematized method of communicating complex spatial perceptions on a flat picture plane. Since Brunelleschi's system does not reflect the way we actually experience our environment, it should come as no surprise to find that alternative perspective systems have been devised to convey types of spatial information that Brunelleschi's system cannot. Inherently, no one system of perspective is superior to any other system. They are just organized differently to do different things. A perspective system sets up

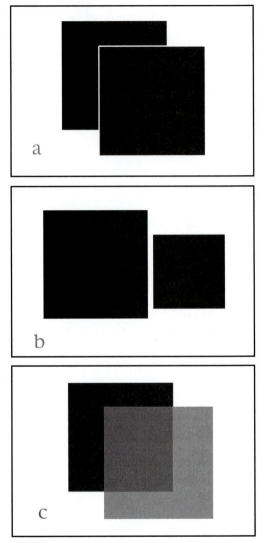

15.1a-c The illusion of three-dimensional space can successfully be created by a variety of monocular perspective techniques. These techniques are effective when they are used one at a time and even more effective when used in combinations. The illustrations above depict (**a**) overlap, (**b**) disproportionate scale, and (**c**) transparency.

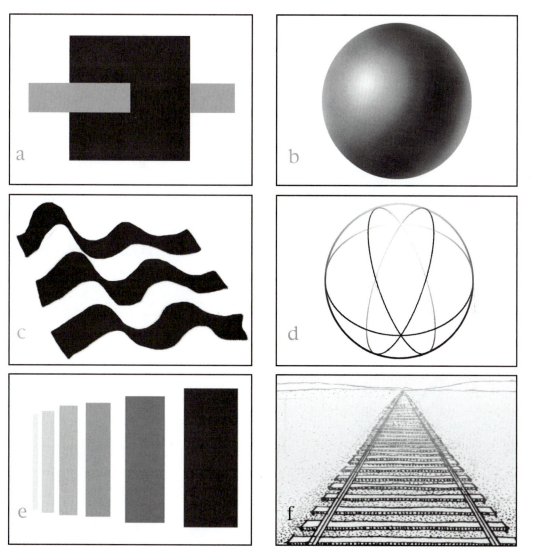

15.2a-f As you have experienced in the preceding chapters and can also see in the illustrations above, interpenetration (**a**), chiaroscuro (**b**), cross-contour (**c**), line variation (**d**), and atmospheric perspective (**e**) are as effective at creating three-dimensional illusions as is linear perspective (**f**), but it is important to acknowledge that linear perspective is more effective for describing relationships of forms in a rational, continuous space.

rules. If the system is consistent and logical and is applied with appropriate expectations, it will convey a solid understanding of the spatial relationships it intends to convey (**Fig. 15.3a-d**).

MONOCULAR CUES II

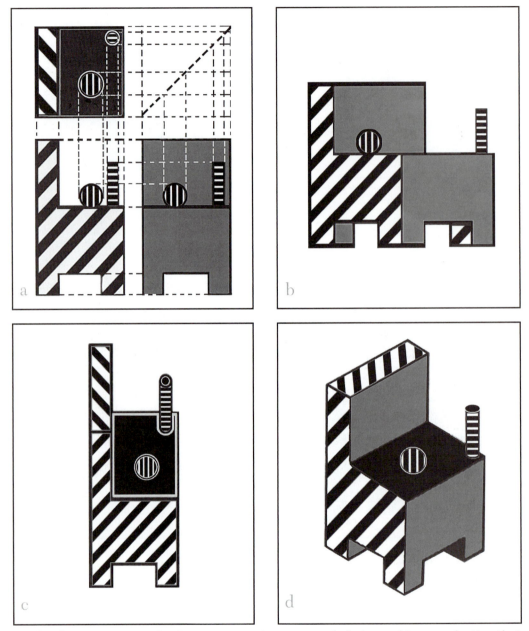

15.3a-d Linear perspective is so common in our age of photographic reproduction that we often take it to be the only way to visually communicate reliable information about material things, when in fact it is only one of many possible modes of representation. Illustration **a** features interrelated images depicting front and side elevations and a plan view, **b** combines views of front and side elevations, **c** combines a side elevation with a plan view, and **d** is an isometric projection in which the front edge is vertical and nonconverging sides go back left and right at 30°.

ALTERNATIVE PERSPECTIVES

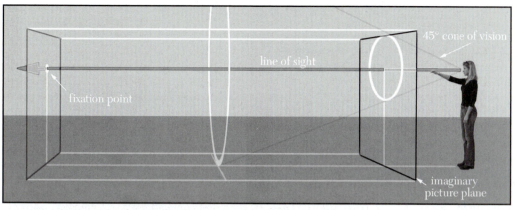

15.4 The entire system of linear perspective is based on the concepts of the fixation point and the picture plane. In the synthetic system of linear perspective we must keep our eye unnaturally locked on a single point in space directly in front of us at eye level (fixation point). Staring at the fixation point establishes the line of sight, and the picture plane is always perpendicular (90°) to the line of sight.

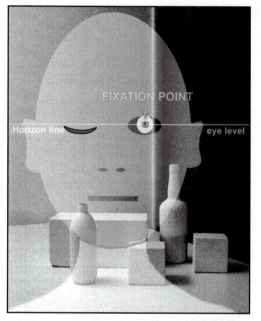

15.5 A Brunelleschian fixation point is established by staring straight ahead and with your line of sight parallel to the ground plane. Drawing a line horizontally through this point illustrates the viewer's eye level, which is also called the horizon line.

Brunelleschi's system grew out of the realization that the integrity of an object's spatial relationship with the observer and with other objects within the illusionistic space is enhanced when the image contains only what can be seen with a single eye while fixed on a single point (fixation point) and when the line of sight from the viewer's eye to that fixed point is parallel to the ground plane and perpendicular to the picture plane (**Fig. 15.4**). Because the fixation point, in Brunelleschian perspective, is always at the viewer's eye level, a line that is drawn horizontally through the fixation point is the same as the horizon line (**Fig. 15.5**). This means that if you were to implement Brunelleschi's system while on a beach looking out toward the ocean, your fixation point will

occur precisely where the sky meets the ocean (it makes no difference whether you are standing, sitting, or lying down).

In your everyday visual experience peripheral vision provides you with approximately 180° of visual information. With the linear perspective system, as defined by Brunelleschi, however, you can respond only to visual information that falls within a 45° cone of vision (**Fig. 15.6**). This 45° visual cone was chosen because it generates a minimum amount of distortion in size, shape, proportion, and rectilinearity of the depicted objects when the perspective information is being transferred to a two-dimensional surface. As a result, what you can draw in this system is much less than you actually see. To understand this limitation you will need to think of your physical picture plane (the surface of your paper) as the area that passes through this 45° cone so that as you reach out and draw you can draw only the objects that are visible within the 45° cone (**Fig. 15.7**).

If you were to actually replace your imaginary picture plane with a plexiglass window, you could create an accurate perspective drawing by staying in one place, closing one eye, and then tracing the objects you observe directly on

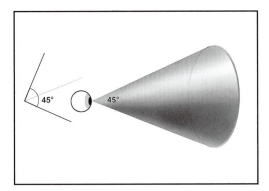

15.6 Linear perspective contains the least linear distortion when it depicts only those things that an eye sees when the cone of vision is limited to 45°. With two eyes open our peripheral vision is frequently greater than 180° in some directions. Many errors (distortions) in perspective are the direct result of drawing objects that appear outside this limited 45° viewing range.

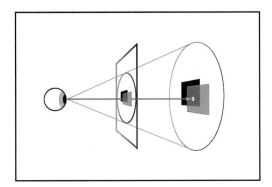

15.7 Alberti was the first to compare the imaginary picture plane to a "transparent glass window" through which the viewer observes the environment. This imaginary window intersects the cone of vision at a 90° angle. Only the information that is visible within the intersection of the imaginary picture plane and the 45° cone of vision can be included distortion free in your drawing.

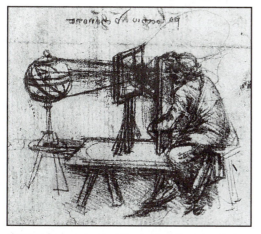

15.8 Leonardo da Vinci, *Draftsman Using a Transparent Plane* (1510, Biblioteca Ambrosiana, Codice Atlantico, Milan). Leonardo's notebook sketch depicts an artist using a linear perspective device that has a fixed viewing position (fixation point) and a transparent picture plane that cuts through the cone of vision at a right angle. The image of the globe on the left is being traced on a surface that simultaneously serves as the imaginary picture plane and the picture plane of the drawing.

the window. This procedure would duplicate Brunelleschi's system as long as you remembered to limit your tracing to what was visible inside the 45° cone of vision. Using a physical window as a substitute for the imaginary picture plane duplicates Brunelleschi's system so well that in the early days of linear perspective, artists actually designed portable mechanical tracing devices to assist them in applying the principles of Brunelleschi's perspective (**Fig. 15.8**). These drawing machines were not very practical, but they were used right up until the 19th century when they were rendered obsolete by the invention of photography. Cameras used in photography are essentially very sophisticated mechanical "tracing" tools based on Brunelleschi's optical principles. Cameras generally have one eye (lens), can't be moved when rendering an image, and normally record only what falls within a 45° visual cone.

The two basic principles that are the foundation of Brunelleschi's system are the imaginary picture plane and the fixation point. These elements establish your spatial relationship to any rectilinear object in your visual field. So before you begin to draw, you must choose a fixation point and project your imaginary picture plane out toward that fixation point, keeping it perpendicular

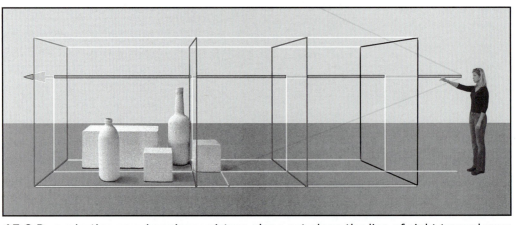

15.9 By projecting your imaginary picture plane out along the line of sight toward your fixation point, you can determine its alignment to the edges of each rectilinear object in your visual field. The nature of the perspective relationship between each object and the viewer depends on the number of sets of its leading edges that are parallel with the picture plane. In the example above, the picture plane is parallel with both sets of leading edges (verticals and horizontals) of each of the rectilinear solids. When this condition is met, the rectilinear solids are in a one-point perspective relationship with the viewer. As you might have noticed, because this image is being viewed from a vantage point that is 90° from that of the viewer depicted on the right, each of the rectilinear solids also appears in one-point perspective as you view this picture.

to your line of sight. By projecting your picture plane you can determine the alignment of the edges of rectilinear forms relative to your imaginary picture plane (**Figs. 15.9, 15.10**). As the imaginary picture plane "comes into contact" with each rectilinear object you are looking at, check to see if any sets of leading edges of those objects are parallel with the picture plane. The perspective relationship between you and any of the objects will depend on whether your picture plane is parallel to two sets, one set, or no sets of leading edges of the rectilinear solids in your visual field.

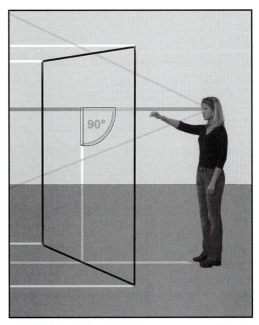

15.10 Brunelleschi's linear perspective is a rational spatial system.

a

b

c

15.11a-c Brunelleschi's perspective system not only provides specific information about the nature of the depicted objects, it also tells us about the angular relationship of the rectangular objects to the observer. Illustration **a** is in one-point, **b** is in two-point, and **c** is in three-point.

When the picture plane is parallel with two sets of leading edges of a rectilinear object (or flush with the front surface), you are in a **one-point perspective relationship** with that object (**Fig. 15.11a**). When only one set of leading edges (usually vertical) is parallel to the picture plane, you are in a **two-point perspective relationship** with the object (**Fig. 15.11b**). When there are no sets of edges that are parallel to the picture plane, you are in a **three-point perspective relationship with the object** (**Fig. 15.11c**). You will be introduced to one- and two-point relationships in this chapter. Three-point is somewhat more complicated and will be covered on its own in Chapter 16. It is worth repeating that all perspective relationships are based on a fixation point and a picture plane perpendicular to the line of sight. When these conditions are met, the number of leading edges on the rectilinear solids that are parallel to the picture plane determines the perspective relationship between the object and the viewer.

When one or more rectilinear object is in a one-point perspective relationship with the viewer, the object's edges that are parallel to the ground plane will always appear as horizontal lines and the edges that are perpendicular to the ground plane will

15.12a-d To establish a one-point perspective relationship with a rectangular object (or group of identically aligned rectangular of objects), you need a focal point at eye level that allows for your picture plane, as it moves imaginarily forward along your line of sight, to be parallel with both sets of leading edges of the rectangular object. For the illustrations above that point is directly above the small box that is closest to the viewer (**a**). As the picture plane moves out toward that point, it makes parallel contact with all four leading edges of the closest box (**b**) and, as it continues back in space, with the four leading edges of the other two rectangular solids as well. For all objects in a one-point perspective relationship the bottom and top edges will appear horizontal and the sides will appear vertical (**c**). They will also share a powerful sense of spatial integrity because their receding edges (orthogonals) all converge at the fixation point (also referred to as the central vanishing point) (**d**).

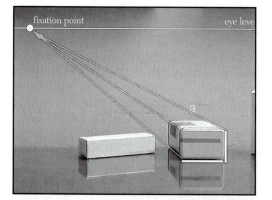

15.13 For an object to be in a one-point perspective relationship with the viewer the picture plane must be parallel with two sets of leading edges (flush with the front rectangular surface). To create such a relationship you must choose a fixation point that allows the vertical edges to appear vertical and the edges parallel to the ground plane appear horizontal, as can be seen above where the imaginary picture plane aligns flush with all four leading edges of object **a**. To achieve that alignment with object **a** it was necessary to position the fixation point near the left-hand edge of the picture plane. With this fixation point location you must take great care not to look in the direction of the objects when establishing clock-angles. **You must always look toward the fixation point when checking the clock-angles.** If you turn your head and look toward the objects, you will alter your perspective relationship with the objects, thereby altering the angle at which you see the edges recede. To prevent the angles from being altered stare straight toward the fixation point and align your clock-angle tool with the edges while looking out of the corner of your eye. It is slightly uncomfortable at first, but the accuracy it provides makes it worth the effort.

always appear as vertical lines (**Fig. 15.12a-d**). In one-point perspective there will be no foreshortening of the proportions of any edge that is parallel to the picture plane. The proportions that we perceive are the actual proportions of the leading edges of the rectilinear solid. What is most interesting and remarkable about a one-point perspective relationship is that all edges of the observed rectangular solid moving back away from the viewer (and are therefore perpendicular to the front surface) will appear to converge precisely on the fixation point. An object does *not* have to be directly in front of the viewer for this to happen. The rectangular form can be located on the left or right side of the picture as long as it remains inside the 45° cone of vision and its leading vertical and horizontal edges are parallel to the picture plane (**Fig. 15.13**). If a receding edge of an object in one-point perspective relationship is located directly below the fixation point, it will appear as a vertical line. All other receding edges with which that line is parallel in the physical world will be tilted in order that they may converge at the fixation point.

Two-point perspective relationships begin with the same premises that formed the basis of one-point perspective. You must establish a fixation point at eye

245

level and imagine a picture plane that is perpendicular to the line of sight. Again, the perspective relationship will be determined by imaginatively projecting this picture plane out into the visual field and seeing how it aligns with the edges of the rectangular forms (**Figs. 15.14, 15.15a-b**). If the picture plane is parallel with one, and only one, set of the object's leading edges (usually the verticals), the viewer is in a two-point perspective relationship with that object.

The most annoying characteristic of Brunelleschi's synthetic perspective system is that when you are staring at the fixation point, it is very difficult to see the objects you are intending to draw. When you shift your line of sight to look at the objects, you can't help but rotate your picture plane. This rotation alters all the perspective relationships of the objects to your picture plane. What we have here is a catch-22 because this entire system is predicated on staring directly at the fixation point, but it sure is difficult to draw what you can't see. The only solution is to bite the bullet (gently) and CHEAT! Well, at least bend the rules. You have to look at the objects if you are going to draw them. It is possible, however, to keep the fixation point in mind while you draw, especially when you are establishing the

WHERE TO PUT THE FIXATION POINT

There is considerable flexibility in where you choose to put the fixation point on the drawing surface. It doesn't have a proscribed location. It can go anywhere, even outside the edges of the paper, as long as once you decide where you want it, you maintain accurate spatial and proportional relationships between the fixation point and the objects you are drawing. Once you have established your fixation point, the size and placement of the objects relative to the fixation point in the drawing must correspond to the position and proportion of the objects relative to the fixation point in your visual field. While the fixation point has no actual physical presence, it is, nonetheless, very real. It serves as the mechanical glue that holds the perspectival and proportional relationships together. The fixation point must be taken into account each and every time you draw from observation if your goal is to capture the subtle nuances of the spatial relationships in your visual field.

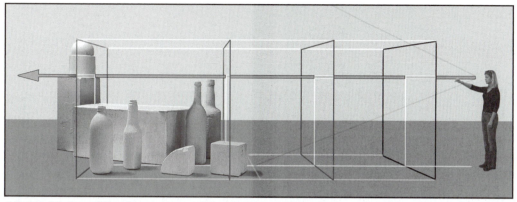

15.14 All Brunelleschian perspective drawings must have a fixation point at eye level and an imaginary picture plane perpendicular to the line of sight. In this image the imaginary picture plane is parallel with only one set of leading edges of the rectilinear objects (only the verticals), so all of the rectangular solids above are in a two-point perspective relationship with the viewer on the right.

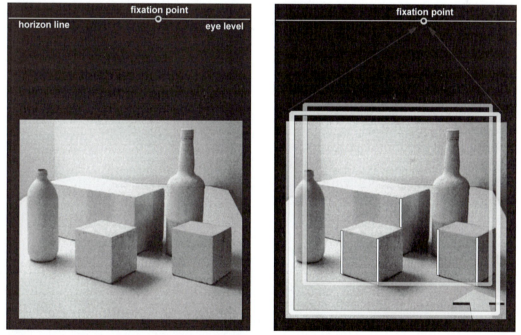

15.15a-b When your imaginary picture plane aligns with only one set of edges of a particular rectangular form (usually it will be the verticals) as it moves forward along your line of sight toward your chosen fixation point, then you are in a two-point perspective relationship with that object. All vertical edges that are parallel with the picture plane appear straight up and down while the edges that are moving away from the picture plane appear to tilt (orthogonals).

FIXATION LOCATION

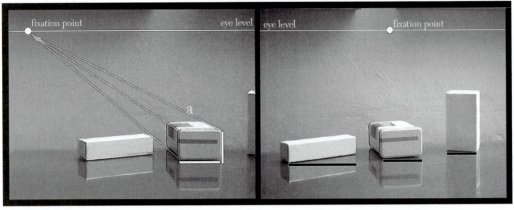

15.16 When applying the clock-angle tool to any edge of a rectangular solid, always be sure to be staring straight out toward the fixation point (left). Turning your head to more easily see an object to the right or left of the fixation point changes the perceived angular tilt of those edges (right).

angular tilt of receding edges. All this requires is that when you are calculating clock-angles, you need to make a conscious effort to look toward the fixation point and calculate the angle out of the corner of your eye (**Fig. 15.16**). This particular phenomenon makes accurately determining clock-angles something of a challenge but certainly not an insurmountable one. Just remember to look in the direction of your fixation point when determining clock-angles (**Fig. 15.17a-c**).

When an object is in a two-point perspective relationship with the observer, it has two sets of parallel receding edges (**Fig. 15.18a-b**). Each set converges at a point on the horizon line somewhere other than the fixation point (only edges of objects in one-point

WORKING IN REVERSE

One-point perspective does not originate in an object. It originates in the relationship of the observer to that object. To establish a one-point relationship, you need to choose the fixation point that allows your picture plane to be parallel to two sets of leading edges of a particular object. With one-point perspective it is easiest to work backwards by first aligning your picture plane to the object. When the vertical edges appear straight up and down and the edges parallel to the ground appear horizontal while you are looking toward the horizon (eye level), the point toward which you are looking is the fixation point.

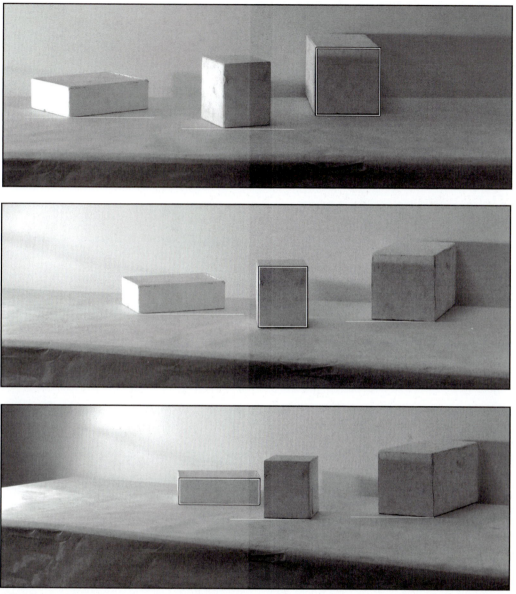

15.17a-c Objects in the visual field do not exist in a perspectival relationship until an observer establishes a fixation point. The choice of a fixation point locks in the objects' perspectival relationship with the observer's imaginary picture plane and, by definition, with the observer. These three images each depict an identical arrangement of boxes. In each image a different box has been made to be flush with the observer's picture plane, thereby creating a one-point perspective relationship with the observer. This was achieved by progressively moving the viewing position to the right as the fixation point was moved slightly to the left.

SHIFTING PERSPECTIVES

VANISHING POINT LEFT

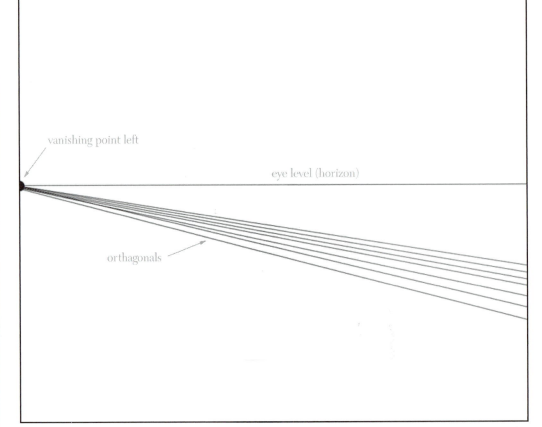

15.18a A fixation point is essential even when none of the rectilinear objects in the drawing are in a one-point perspective relationship with the viewer. Brunelleschi's system requires that you draw from a single position and that you look toward a single fixation point throughout the entire drawing. This means you need to establish a fixation point at the very beginning of the drawing and maintain it throughout the entire process. Otherwise there is a tendency to change the direction of your line of sight, and shifting your line of sight (fixation point) even slightly causes marked changes in the angle at which your picture plane aligns with the edges of the objects in your visual field. Changing your line of sight changes the apparent angles of the orthagonals as they converge toward their respective vanishing points. Once you have chosen a fixation point and have calculated the perspectival relationship of the objects in your visual field, you should begin your drawing by gesturing, applying Mondrian lines, checking proportions, and using your straight-edge as a clock-angle tool to establish the angles at which the receding edges converge. It is also a good idea to pay special attention to your line quality so as to prevent the mechanical character of the system from dominating the expressive character of the drawing.

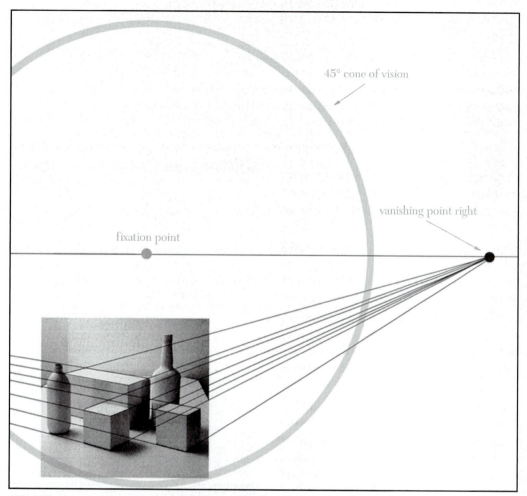

15.18b In a two-point perspective relationship your imaginary picture plane is parallel to only one set of leading edges (usually the verticals). Any edges that are parallel to the ground plane are, by definition, receding and will appear tilted. Sets of parallel receding edges will converge at some point on the horizon other than the fixation point. As can be seen above, one set of these receding parallel edges has a vanishing point to the right of the fixation point and the other to the left. This is always the case with a two-point perspective relationship. Vanishing points rarely appear within the drawing surface unless you draw very small or have an incredibly large piece of paper. As a result, Brunellesci's system of a horizon line with two vanishing points actually turns out to be more helpful as a conceptual aid than as a mechanical tool for determining the angle of convergence. You will generally be much better off relying on clock-angles to calculate the angular tilt of receding edges than actually looking for vanishing points. Because all the rectilinear objects in this illustration are aligned squarely with one another, there are only two sets of receding parallel edges (orthogonals). Each receding edge converges with all the other edges with which it is parallel.

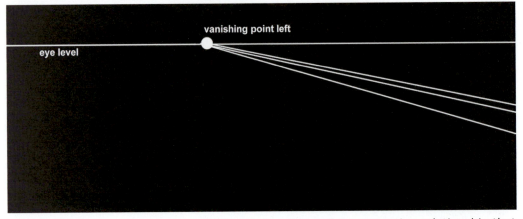

15.19a Edges of a rectangular solid that is in a two-point perspective relationship that are parallel to the imaginary picture plane are, by definition, perpendicular to the ground and appear as verticals on the drawing surface. The two sets of edges that are parallel to the ground plane and are receding from the imaginary picture plane will appear to converge at two distinct points on the horizon on opposite sides of the fixation point. The position of the two vanishing points on the horizon is determined by the particular characteristics (size, rotation, relationship to eye level) of the rectangular solid.

perspective relationships can converge at the fixation point). One set always converges to the right of the fixation point and the other somewhere to the left. The point at which each set converges is called a vanishing point.

Every rectangular object in a two-point perspective relationship has two vanishing points. These points are always on the horizon and always on opposite sides of the fixation point. If your paper is large enough (it rarely is), you can locate the vanishing point by using your clock-angle tool to calculate the tilt of the receding edge and then extending that edge until it meets

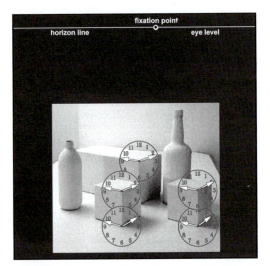

15.20a To reproduce the angular tilt of the receding edges in two-point perspective, either superimpose a clock face on the leading vertical edges or mechanically transfer the angles with a straight-edge.

ROTATING SOLIDS

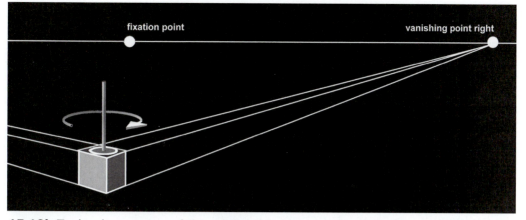

fixation point vanishing point right

15.19b To develop a sense of the relationship between the respective vanishing points, try imaginatively manipulating the rectangular solid in the illustration above by rotating it on its vertical axis. As the object turns clockwise, the vanishing point right glides outward along the horizon away from the fixation point, while the vanishing point left shifts horizontally toward the fixation point. As one point gets closer to the fixation point, the other gets further away. This reciprocal shift continues as you rotate the cube until the vanishing point left reaches the fixation point. At that instant, the vanishing point left becomes the fixation point, and the vanishing point right ceases to exist because the rectangular solid is now, by definition, in a one-point perspective relationship.

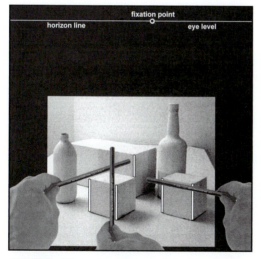

horizon line fixation point eye level

15.20b When the two-point perspective vanishing points are located outside the drawing surface, you should rely on the clock-angle tool to calculate the angle of each of the receding edges.

the horizon. The point where the receding edge crosses the horizon marks the precise location of the vanishing point for that edge and for any other edges with which it is parallel (**Fig. 15.19a-b**). Typically, however, relying on precisely positioning one or both of the vanishing points on the horizon in order to establish accurate convergence is highly impractical because the respective vanishing points are more than likely going to be located well outside the drawing surface. Fortunately, there is an alternative to using vanishing points for establishing the tilt of receding edges (**Fig. 15.20a-b**). You can achieve identical results by applying the

clock-angle tool to establish the tilt of any receding edge after having gestured the object, determined its proper position and size relative to the fixation point, applied Mondrian lines, and checked its proportions. In other words, you are best served by relying on all the good stuff we learned in the first half of the book. When it comes to creating a two-point perspective relationship drawing, Brunelleschi's system functions better as a conceptual guide than as a mechanical tool for establishing the angular tilt of receding edges. To take full advantage of what this conceptual system has to offer, it is still necessary to periodically step back from your drawing. Getting a "fresh eye" is always helpful, but it is particularly

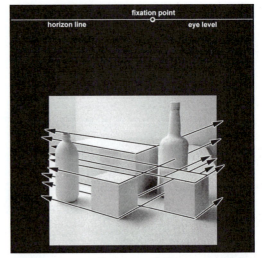

15.21 Since all three of the rectangular solids above are aligned with one another, all of their corresponding edges are parallel. All sets of edges that are parallel converge at a single vanishing point on the horizon even when they are part of different rectangular solids.

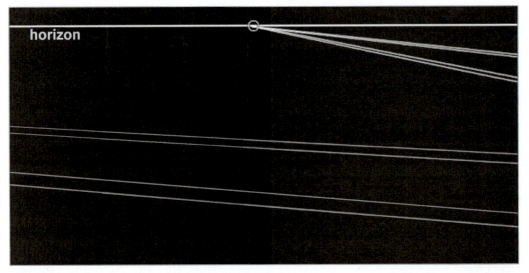

15.23a When each of the rectangular objects is aligned uniquely with the viewer's picture plane, each object will have either a unique point (one-point perspective relationship) or a pair of points (two-point relationship) toward which its edges converge.

15.22 When rectangular furniture in a two-point perspective relationship is flush against the walls of a room, the edges of the objects are aligned with the walls, floor, and ceiling, and they all share the same pair of vanishing points on opposite sides of a fixation point on the horizon.

important for determining whether sets of receding edges in your drawing are converging at a single vanishing point and whether that point is appropriately positioned on the horizon line.

Two-point perspective is a variation of the railroad track phenomenon (all physically parallel, receding edges appear to converge). This shared convergence includes edges from other rectangular objects when those objects are squarely aligned with one another. **When rectangular objects are squarely aligned, they share identical vanishing points** (**Figs. 15.21, 15.22**).

In contrast to the above, a rectilinear object that is in unique

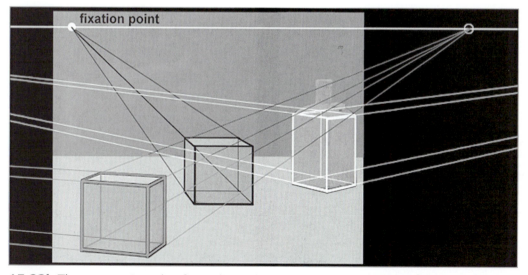

fixation point

15.23b The apparent angle of receding edges is dependent on the rectangular object's rotation relative to the picture plane, its distance from eye level (horizon), its distance from the picture plane, and its distance to the right or left of the fixation point.

UNIQUE VANISHING POINTS

orientation to the picture plane will have a unique pair of vanishing points toward which its two sets of receding, parallel edges converge (**Fig. 15.23a-b**). Edges that are nearly parallel converge in the same general vicinity, but as you saw earlier, any slight variation in the rotation of a rectilinear form in a two-point perspective relationship causes both vanishing points to shift correspondingly along the horizon. This means that if each of the objects in your visual field is in a unique orientation, there can be twice as many vanishing points in a perspective drawing as there are rectangular objects within your 45° cone of vision (less if there are one or more objects in one-point perspective relationships) (**Fig. 15.24a-b**).

The most common error in two-point perspective relationships is placing the two vanishing points closer together in the drawing than they actually are in the visual field. This occurs when you force both vanishing points to appear within the edges of the drawing. It also happens when you include objects in your drawing that are outside of the 45° cone of vision, like when you are standing too close to the objects you are drawing (**Fig. 15.25a-b**). Any of the above situations causes the rectilinear objects to appear as though twisted, stretched, or shaped like a trapezoid with a

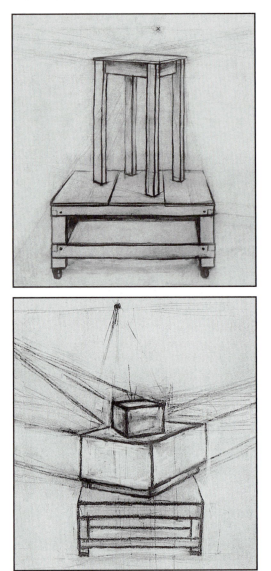

15.24a-b The distance between the fixation point and objects in the drawing must be proportionate to the distance that exists between the fixation point and objects in your visual field. It is not uncommon for a fixation point to appear within the borders of a drawing, but it is rarely the home of vanishing points.

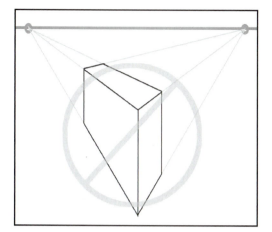

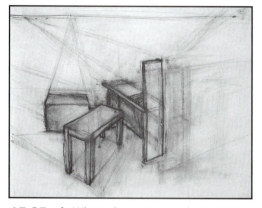

15.25a-b When the two vanishing points of a rectilinear object are positioned too close to each other on the horizon, the rectilinear planes appear twisted, stretched, or even trapezoidal. In the upper image the corner begins to look as though it is the tip of a sword blade. When this happens, it's a good idea to makes sure the objects are all within your cone of vision. For the lower drawing, the student was so close to the objects that they were not wholly visible within a 45° cone when looking at the fixation point. When one is too close to the objects, the clock-angle tool suggests vanishing points that are too close together and the bottom edge of the table starts to appear exaggeratedly pointy. It is similar to the distortion from a wide-angle lens.

bottom, forward edge that looks more like a sword blade's tip than a rectangular corner.

Even though undesirable perspectival distortions can occur when your vanishing points are too close to one another on the horizon, a subtle exaggeration of convergence can be an effective way to strengthen the overall illusion of spatial recession. Gently accelerating the convergence of parallel receding edges compensates somewhat for drawing's lack of stereoscopic experience, parallax, and the experience of depth that comes from feeling the muscles of the eyes contract as we focus on objects at different distances from the observer (**Figs. 15.26–15.28a-c**). Delicately tweaking the rate of convergence and combining it with an exaggerated reduction in size of objects as they recede in space substantially enhances the illusion of space in a drawing, similar to what one experiences when looking through a wide-angle lens. Obviously, there is a point at which the exaggeration ceases to add to the illusion of space and instead compromises the integrity of the image by making the objects appear distorted. Therefore, the general rule for exaggerated convergence should be **Goldilocks' Rule** for spatial exaggeration: **not too much, not too little, exaggerate until it is just right.**

FLAG REVISITED

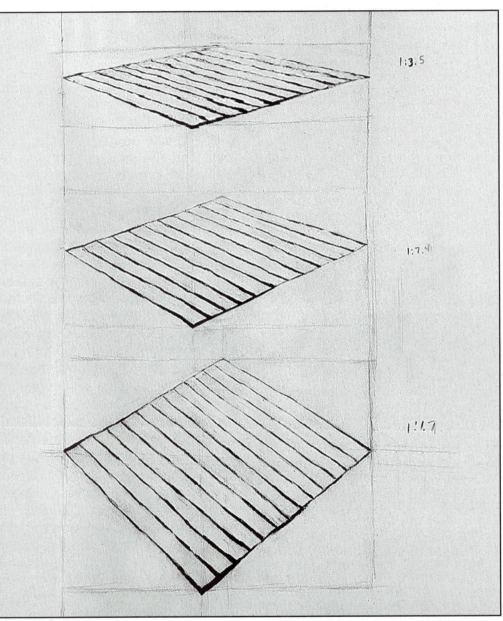

15.26 The effectiveness of the clock-angle tool for determining the angular recession of parallel receding edges is clearly demonstrated in the three-flag drawing above. This drawing was completed during the first third of the semester from a single flag positioned successively at three different heights well before the mechanical aspects of Brunelleschi's system were introduced. Despite that fact, not only are the sets of parallel edges converging appropriately for each flag, but the convergence is consistent throughout all parallel edges shared by the three flags.

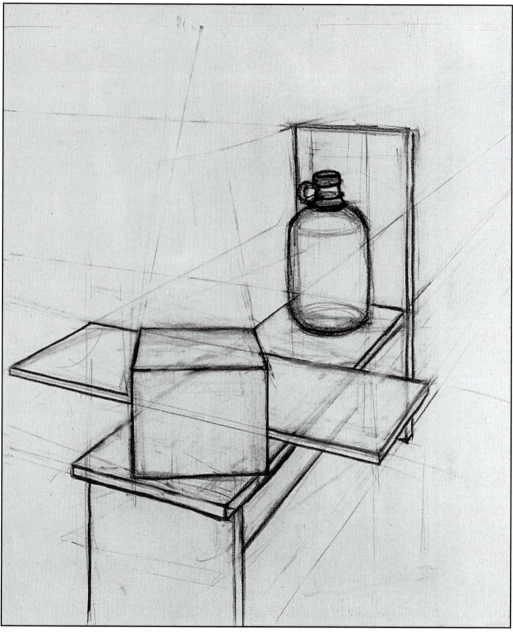

15.27 In this illustration of objects in one- and two-point perspective relationships, only the fixation point is located within the borders of the drawing surface. Both vanishing points for the two-point perspective relationships are located off the paper. Note that the illusion of depth in this drawing has been solidly enhanced by a slight exaggeration in the convergence of receding parallel edges, by the variation in line quality, and by drawing through the forms.

INDIVIDUALIZED CONVERGENCE

ONE AND TWO TOGETHER

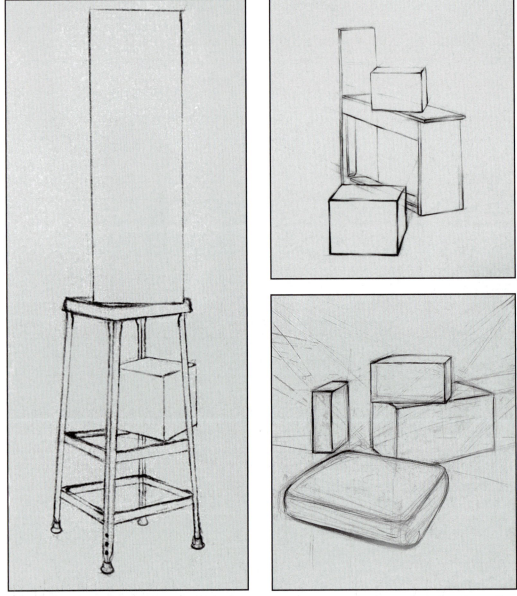

15.28a–c For these drawings the students were asked to position their fixation point so there would be at least one rectilinear object in a one-point perspective relationship and at least one in a two-point perspective relationship. In the drawing on the left, the choice of a fixation point directly behind the tall, one-point perspective box on top of the stool seriously compromised the readability of that box because this choice of fixation point severely limits the range of available information with which to interpret the volumetric character of the object in question.

CHAPTER 16 3-point PERSPECTIVE

Beyond Brunelleschi . . . 261
Three-point perspective 262
Law of receding edges . 263
One, two, and three . . . 264
Precariously positioned 265
Arrows point the way . . 266
Perspectival hybrids . . . 267
Non-Brunellescian 268
"Losing" your horizon . . 269
Bird's-eye view 270
Worm's-eye view 271
Comparative perspective 272
Comparative perspective 273
Perspectival playfulness 274
Perspectival rejection . . 275
Picture plane integrity . . 276
Mondrian's structure. . . 277
Crowding the surface . . 278

Brunelleschi's system of linear perspective is a synthetic, rational construct that is inconsistent with your sensory experience in any number of ways. Nowhere is this more obvious than when you are drawing objects in three-point perspective relationships. Brunelleschi's original system was designed to deal only with rectilinear forms that sit flat on the ground plane or have one entire side (four edges) that is parallel to it. This restrictive characteristic reflects the fact that Renaissance perspective grew out of a mystical belief that divine order was most effectively revealed by means of upright, stable, rectilinear geometric forms. These mystical beliefs influenced the use of perspective for the first hundred years that the system was used, but as the strength of this mystical tradition eroded, artists began to experiment with geometric forms in any and all orientations. Some artists simply modified the system Brunelleschi created, whereas others challenged the system's fundamental canon that the picture plane must always be perpendicular to the ground plane. As a result, the term *three-point*

BEYOND BRUNELLESCHI

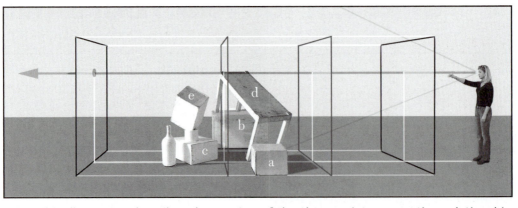

16.1 This illustration describes the version of the three-point perspective relationship that is based on Brunelleschi's system. The viewer stares straight out to the horizon at a fixation point with the line of sight parallel to the ground and imaginatively projects her picture plane into the visual field to determine her perspectival relationship with the rectilinear forms. She is in a one-point perspective relationship with boxes **a** and **b** of the still life and in a two-point perspective relationship with box **c**. All three of these rectilinear solids have two sets of edges parallel to the ground and the requisite number of sets of edges parallel to the picture plane. The tilted table **d** and the box sitting precariously in the cylinder **e** have no sets of edges that are parallel to the picture plane. This is determined by the fact that the picture plane contacts these objects only at the corner where the edges come together. As a result, all three sets of the edges of each of these rectilinear solids are tilting back away from the picture plane and will appear to the viewer to be converging at three separate points.

linear perspective winds up describing two very different approaches to perspective relationships. The first approach builds upon what we have already discussed. It is simply an expanded version of Brunelleschi's system. In this version, the viewer establishes a fixation point at eye level, projects the imaginary picture plane into the visual field, and watches to see how the picture plane aligns with the rectilinear objects (**Figs. 16.1, 16.2**). The viewer is in a Brunelleschian three-point perspective relationship with a rectangular solid when his/her picture plane is not parallel with any of

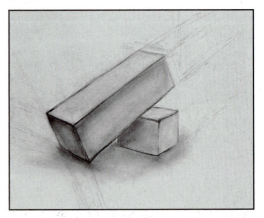

16.2 This drawing is based on the traditional Renaissance system of linear perspective that has been expanded to include rectilinear objects that have no edges parallel to the viewer's picture plane. It also includes an object in a two-point perspective relationship.

BRUNELLESCHI'S UNIVERSAL LAW OF RECEDING EDGES

In all perspective relationships, every set of receding edges of a rectilinear solid that is parallel to the ground plane will always converge at a point located somewhere on the horizon. For one-point perspective, there is always one set of edges parallel to the ground plane, and they converge at the fixation point. For two-point perspective, there are two sets, and they converge on the horizon on opposite sides of the fixation point. For three-point perspective, there can be, at the very most, one set of edges parallel to the ground plane. When that occurs, the set of edges parallel to the ground plane will converge to either the right or the left of the fixation point on the horizon. If the rectilinear object is positioned so that only a corner is touching the ground plane, none of its edges will be located at eye level (on the horizon line).

an object's sets of edges. Edges that are not parallel to the picture plane are, by definition, receding from the picture plane. In this spatial relationship the initial point of contact will be the closest corner of the rectilinear object. This corner has three separate receding edges. Each of these three receding edges converges with every other edge with which it is parallel. For any rectilinear object in this relationship there will always be three sets of edges converging toward three separate vanishing points. Unlike one- and two-point relationships, though, three-point perspective vanishing points are most often not found on the horizon line. In fact, it is possible for only one set of receding edges of any one object in a three-point perspective relationship to converge at a point on the horizon line, and this happens only when a rectilinear object has one edge that is flush with or parallel to the ground plane (**Fig. 16.3a-d**).

Because there are always at least two and often three vanishing points floating off in space in three-point perspective relationships, it becomes necessary to rely on your clock-angle tool to establish the tilt of each and every receding edge.

Even when you use the clock-angle tool to calculate the angle

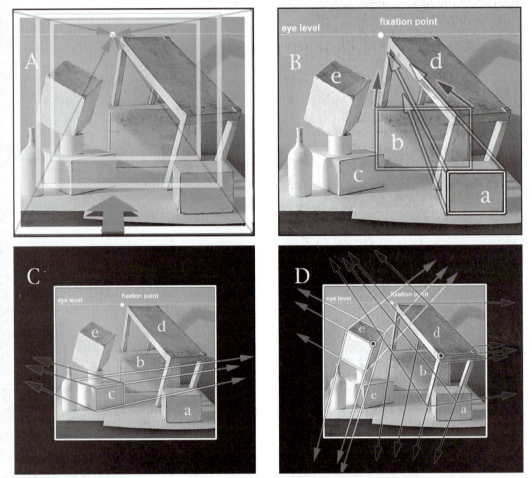

16.3a-d In Brunelleschi's system you start with a fixation point at eye level and project the picture plane toward it to see how it aligns with the edges of the rectangular solids in your visual field (image A). If it aligns with two sets of leading edges, the rectilinear object is in a one-point perspective relationship (image B, boxes **a**, **b**) and the orthogonals converge on the fixation point. If it aligns with one set (usually the verticals), the object is in a two-point perspective relationship (image C, box **c**) and the two sets of orthogonals converge on the horizon at points on opposite sides of the fixation point. However, if it aligns with *no* set of leading edges, the rectilinear object is in a three-point perspective relationship. When the picture plane first makes contact with a corner, each edge that is connected to this corner is receding back into space, as are the edges with which it is parallel. With three-point perspective, each set of receding parallel edges converges toward a vanishing point that can be almost anywhere (image D, boxes **d**, **e**). These vanishing points are difficult to pinpoint, so you are best served using a clock-angle tool to determine the tilt of each of the receding edges.

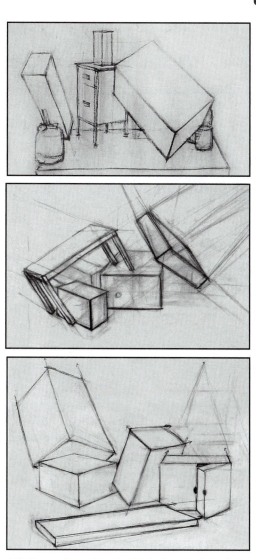

16.4a-c An object that is depicted in a three-point perspective relationship is generally more emotionally charged than an object in one-point or two-point. As a species we are more comfortable with verticals and horizontals because we rely on them for maintaining balance and equilibrium. Three-point orientation is intrinsically unstable in its appearance, and as you will find out from your attempts to set objects up to draw, they are intrinsically unstable in the physical world as well.

of tilt of the receding edges of objects in a three-point perspective relationship, it is surprisingly common to mistakenly reverse the direction of the convergence of those edges. To prevent this from happening, you need to walk around the object so that you can view it from the side (90° to your original line of sight). From this new position you can analyze the tilt of the object more precisely and identify the corner of the object that is closest to the original drawing position. After you have identified the closest corner, you can return to where you started secure in knowing in what direction each of the three edges recedes. After loosely gesturing the object, use the clock-angle tool to calculate the tilt of each of the three receding edges. **At this early stage of the drawing it is highly recommended that you put arrows at the ends of each of the three diverging edges that recede from the leading corner of the object.** The arrows indicate the direction of their recession from the initial point of contact with your picture plane and serve as helpful reminders of the direction of convergence (**Figs. 16.4a-c, 16.5**).

Precariously positioned rectangular solids come in so many different orientations that they often challenge Brunelleschi's clear-cut

ARROWS POINT THE WAY

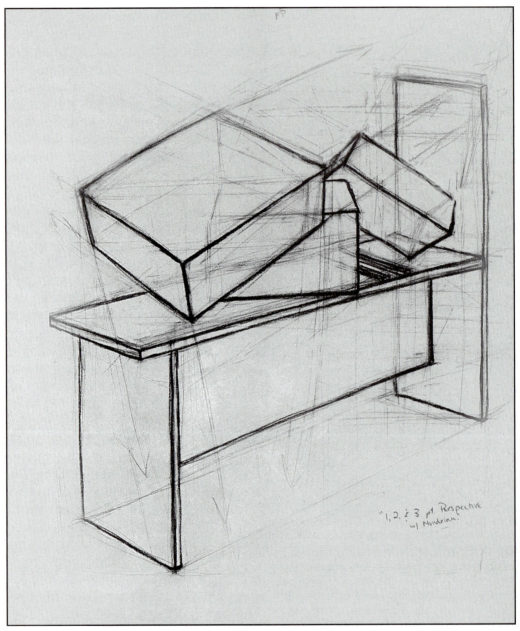

16.5 Putting directional arrows on the ends of the orthogonals of the receding edges of a rectilinear object that is in a three-point perspective relationship is the best way to avoid the surprisingly common mistake of reversing the convergence. The drawing above expands on Brunelleschi's linear perspective theory with the addition of three-point relationships while making good use of Mondrian gesture, proportion boxes, clock-angles, and line variety to establish a clear and readable illusion of these complex three-dimensional spatial relationships.

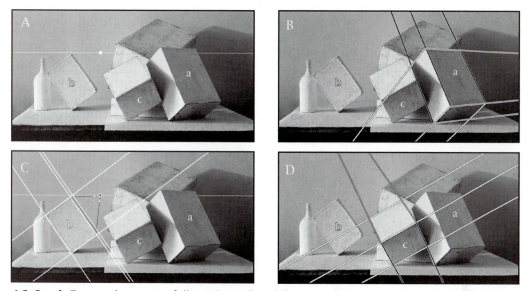

16.6a-d Even when you follow Brunelleschi's perspective system religiously, once the rectilinear solids in your field of vision start tilting and turning you will eventually encounter *hybrid perspective relationships* that don't conform to the defining characteristics of the three major perspective relationships. In illustration B, box **a** qualifies as a typical example of a three-point perspective relationship. None of the edges are parallel to the picture plane. One vanishing point is on the horizon (because one set of its edges is parallel to the ground plane), while each of the others are found far above and below the horizon, respectively. Box **b** in illustration C, however, while it is tilted on its edge, is actually not three-point perspective at all because both sets of leading edges are parallel to the picture plane, and the orthogonals are converging at the fixation point. This is a "weird" one-point. Box **c**, illustration D, is even a little harder to define. It has one set of edges that is parallel to the picture plane (two-point?), but these edges are not vertical and the points where the two sets of receding edges converge are nowhere near the horizon as would ordinarily be the case. Perhaps you can think of this as "two-point with an attitude" or maybe "three minus one-point."

distinctions between one-, two-, and three-point perspective relationships (**Fig. 16.6a-d**). There are a surprising number of possible variations that can occur when a rectilinear form is tilting or rotating freely in space. Fortunately, with careful analysis and a solid understanding of linear perspective's basic principles, you should be able to make visual sense of them all.

PERSPECTIVAL HYBRIDS

There is an second approach to creating three-point perspective relationships that is somewhat radical in that it begins by rejecting Brunelleschi's fundamental rule that the line of sight must always be parallel to the ground plane and that the fixation point must be on the horizon. This approach can be argued to be a little more natural inasmuch as it allows you to look directly toward objects that you are drawing. In this variation the viewer is allowed to tilt her/his head up or down when looking into the visual field. It is important to note that even though you have "lost" your horizon line, you still have an imaginary picture plane that is always perpendicular to your line of sight. When you tilt your head, the picture plane tilts with it (**Fig. 16.7**). The imaginary picture plane always remains perpendicular to the line of sight but is now oblique to the ground plane. Before you begin to gesture, you will need to establish a *visual reference point* (previously known in one- and two-point perspective relationships as the fixation point) that establishes the direction in which you are looking. Knowing precisely where this central reference point is not only defines the outer boundaries of your 45° cone of vision but also allows you to maintain a consistent line of sight, thereby guaranteeing consistent spatial relationship with all

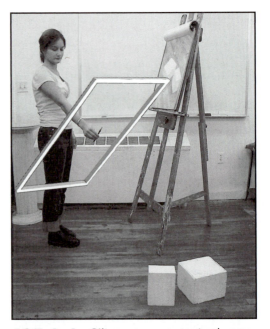

16.7 J. J. Gibson, a perceptual psychologist, has pointed out in detail how human visual experience differs from the requirements of Brunelleschi's perspective system (see pp. 222, 223). One example of the difference is that Brunelleschi's system is predicated on the observer always staring straight out at the horizon, whereas in the physical world we all share a natural tendency to look up or down as we survey our visual field. If you decide to draw what you see while looking up or down, you will need to use a non-Brunelleschian perspective that requires that you keep your imaginary picture plane perpendicular to your line of sight so that the imaginary picture tilts correspondingly either forward or back. Ordinarily, an imaginary picture plane in this orientation creates a three-point perspective relationship with the vast majority of objects in your visual field because most objects sit flush with the ground, thereby causing the imaginary picture plane to make initial contact with the corners of the objects rather than aligning with any of the edges.

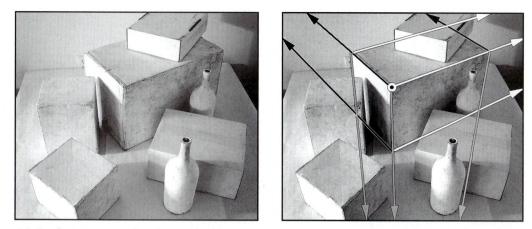

16.8a-b It is natural to look down at objects that are below eye level. In this situation there is no horizon. It is important to understand that the picture plane does remain at a 90° angle to your line of sight. Generally, whenever the picture plane tilts relative to the ground plane, the vast majority of objects in the visual field will appear in a three-point perspective relationship, because as you project your picture plane forward it first makes contact at the corners of each of the rectilinear forms. The three edges that meet at these corners are each part of parallel sets that are receding from the picture plane. Since there is no guideline for where the vanishing points will be, it is best to establish the tilt of each edge by relying on the clock-angle tool. There are three separate vanishing points for each object. Because of a surprisingly common tendency to have the receding edges converge in the wrong direction, it is also a particularly good idea to put arrows on the first set of orthogonals as they recede from the initial point of contact. As each set of edges recedes, it appears to converge at a unique vanishing point (rarely in the visual field). Remember that all "vertical" edges of objects (meaning those perpendicular to the ground plane) will all share a common vanishing point.

the edges of all the rectangular forms in your field of vision. It's a lot like a fixation point, but there is no horizon.

When you tilt your imaginary picture plane by looking up or down from the horizon, every rectangular object that would have been in a one- or two-point perspective relationship using Brunelleschi's system is now in a three-point perspective relationship (**Fig. 16.8a-b**). Tilting your picture plane means it rarely ever

16.9a-b When you look up or down rather than straight at the horizon, your picture plane tilts as your line of sight shifts, and therefore the picture plane is rarely flush with any of the edges of rectilinear objects that are sitting flat on the ground plane. In this three-point perspective relationship, all of the vertical edges of rectilinear forms sitting on the ground plane are receding. Since the vertical edges are, by definition, parallel with one another, they will all converge at a single point below the observed object.

aligns with any edges and instead makes first contact with the corners of objects (**Fig. 16.9a-b**).

Some drawing texts suggest that an image of a tall building in which the horizontal edges appear to be in a two-point perspective relationship, but whose vertical edges converge at a point in the sky, represents an accurate example of a three-point perspective relationship (**Fig. 16.10**). This is somewhat misleading. These images start out using Brunelleschi's system and then, without warning, shift to the tilted imaginary picture plane approach. Unfortunately, when you combine two separate lines of sight in a single image,

16.10 A fairly common error in non-Brunelleschian perspective occurs when multiple viewing angles are combined into a single drawing. In the image above, the horizontal edges of the building are presented as though they are in two-point relationship with a fixation point on the horizon, while the vertical sides appear as though the observer is looking up toward the top of the building.

BIRD'S-EYE VIEW

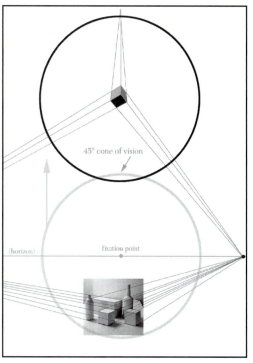

16.11a-b Including perspective information about rectilinear forms that are both inside and outside the 45° cone of vision compromises the logical integrity of both Brunelleschi's system and the non-Brunelleschian system because it violates the essential principle that the viewer must maintain one and only one fixation point throughout the entire drawing process. In Charles Scheeler's *Delmonico Building* (lithograph, 1926) (above right), he has established a non-Brunelleschian three-point perspective relationship with all of the buildings in his visual field by looking up toward the sky rather than straight ahead at a fixation point on the horizon.

"Genius begins where rules end."

William Blake

it creates a lack of consistency and integrity when compared to drawings with a fixed gaze. The only way you could be looking up at an object that was high above your original line of sight would be to shift your line of sight above the horizon (**Fig. 16.11 a-b**). Mixing two lines of sight in the same drawing tends to make the picture plane feel as though it is curving away from the viewer. We saw this kind or distortion

COMPARATIVE PERSPECTIVE

earlier with exaggerated bird-houses whose ellipses opened too quickly as they moved away from the horizon. This is similar to the distortion that results from a wide-angle lens. When you move your line of sight during the drawing process, your drawing is closer to curvilinear perspective than Brunelleschi's system of rationally structured and internally consistent spatial relationships.

Because we are upright, bipedal creatures our perceptual circuits respond most comfortably to visual stimuli that reinforce our sense of vertical and horizontal stability. One-point perspective communicates a sense of stability, order, and calm both from the clarity of its horizontals and verticals as well as from the structural integrity created by every object sharing a single, central fixation point (**Fig. 16.12**). Two-point perspective is slightly more emotionally charged because it is dominated by receding diagonals, but it does offer a substantial level of satisfying orientation through its defining vertical edges (**Fig. 16.13**). Three-point perspective relationships, on the other hand, are by their nature, unstable, disconcerting, and disturbing. In the three-point perspective relationships built on Brunelleschi's structured approach, the visual field is stable but the depicted objects have broken free of the horizon

16.12 Jacques-Louis David, *The Death of Marat* (Musée Royaux des Beaux-Arts de Belgique, Brussels). By using the stability and calm inherent in one-point perspective, David depicted Jean-Paul Marat as a noble hero despite the fact that he was murdered in his bathtub.

16.13 In George Tooker's painting of a veterans hospital, *Ward*, he has structured his composition around the emotionally charged diagonals from two-point perspective relationships to convey an uncomfortable observation concerning a nation's neglected heroes.

16.14 In Gene Bodio's computer-generated graphic, *New City*, 1992, the artist has taken advantage of the underlying sense of disorientation that non-Brunelleschian three-point perspective relationships generate. The viewer experiences the dizzying thrill of hanging hundreds of feet above an urban intersection while at the same time feeling the upward thrust of the architecture.

16.15 Gustave Caillebotte, *Le Déjeuner* (1876, Private Collection). The dominant spatial mechanism in this painting is the exaggerated opening of the ellipses of the plates, serving dishes, carafe, and glasses as they come toward the viewer. This exaggeration caused the picture to appear curved, unfolding in the lap of the observer.

line and attract your attention with their precarious orientations. In the three-point relationships where the picture plane breaks free from the fixation point on the horizon, the ground gets "pulled out" from under you and you are left to search for clues to reliable orientation (**Fig. 16.14**). Three-point perspective relationships are highly energized and attract a disproportionate amount of visual attention. In addition to one-, two-, and three-point Brunelleschian perspective relationships and three-point non-Brunelleschian relationships, some artists choose to create their illusions of three-dimensional space applying the spatial and emotional expressiveness found in curvilinear perspective (**Fig. 16.15**).

As a postscript to the study of Brunelleschi's system of linear perspective in particular and drawing from observation in general, some of the most important images of the last hundred and fifty years have been constructed by artists who either exploit the formal and expressive limitations of Brunelleschi's system or flat-out reject its conventions altogether (**Figs. 16.16–16.18**).

Although outstanding, culturally important works of art based on the rational spatial conventions of Brunelleschi continued to be made throughout the 19th and

PERSPECTIVAL PLAYFULNESS

16.16 William Hogarth, *Perspective Absurdities, 1754*. Hogarth, an 18th-century painter and printmaker known for his social commentary, playfully compiled an image that illustrates many of the inherent ambiguities in the various techniques that are traditionally used for creating the illusion of three-dimensional space on a two-dimensional surface. Your ability to recognize and explain the anomalies created by William Hogarth will constitute your final exam. You may begin now.

16.17 Claude Monet, *The Morning*, 1919–1926, from the Water Lily series. Musée de l'Orangerie, Paris. Monet's preoccupation with light and color led him to apply his paint in small, comma-like brush strokes. His revolutionary approach forced the viewer to acknowledge the paint, brush strokes, and color on the flat surface.

16.18 Paul Cézanne, *Mont Sainte-Victoire Seen from the Bibemus Quarry*, oil on canvas, 1897. Cezanne moved toward an intuitively structured reorganization of form that emphasized the flatness of the painting surface.

20th centuries, the art movements that dominated this period (a wide variety of *isms* under the umbrella of Modern Art) generally share a heightened reverence for the flatness of the artwork's surface. The motivation behind this change in attitude concerning pictorial space was to some extent a re-emergence of the philosophical and psychological controversies that were discussed earlier but it was also an intuitive reaction to the visual power and physical immediacy of a flat surface as opposed to a surface that is understood as a transparent window through which the depicted objects can be seen. In many respects, the two-dimensional art of the last hundred and fifty years can be understood as a lively

PICTURE PLANE INTEGRITY

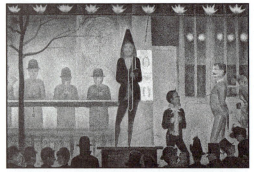

16.19 Georges Seurat, *Circus Sideshow* (1887–1888 The Metropolitan Museum of Art, New York). Fascination with the structural integrity of the picture plane led to the absence of linear perspective and gridlike linear organization.

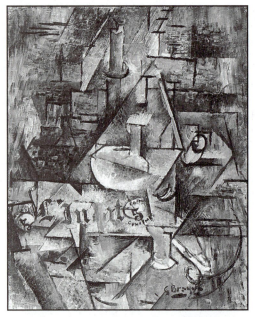

16.20 Georges Braque, *Mozart Kubelick*, 1912. As a co-inventor of Cubism, Braque analyzed, fragmented, and reassembled the objects and the space surrounding them and in the process created a highly structured image with considerable surface integrity.

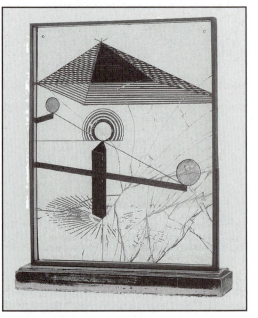

16.21 Marcel Duchamp's *To Be Looked at (from the Other Side of the Glass) with One Eye, Close to, for Almost an Hour* (1918, The Museum of Modern Art, New York) is, among other things, a Dada parody of Brunelleschian perspective.

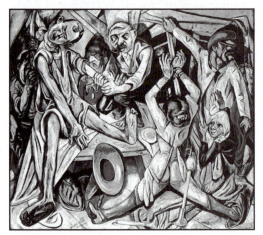

16.22 Max Beckmann, *The Night* (oil on canvas, 1918–1919). Flattened space and unrelenting diagonals create a gruesome image of inhumanity where both the aggressors and the victims are trapped in a claustrophobic tableau of visciousness.

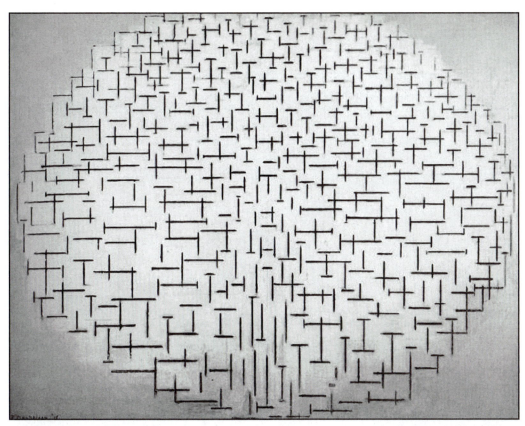

16.23 Piet Mondrian, *Pier and Ocean*, 1914. Oil on canvas. The flatness of the picture plane was guided by a belief that reality could be expressed only through "dynamic movements of form and color." © 2008 Mondrian/Holtzman Trust c/o HCR International Warrenton VA.

and productive debate centered around the conflict between the visual power of illusionistic space on one hand, and the "sense of presence" contained in the integrity of the picture plane (**Figs. 16.19–16.25**). This conflict is at the core of how artists approach pictorial space, and fortunately the value and strength of both approaches becomes clearer when the underlying premises of each is contrasted to those of the other.

CROWDING THE SURFACE

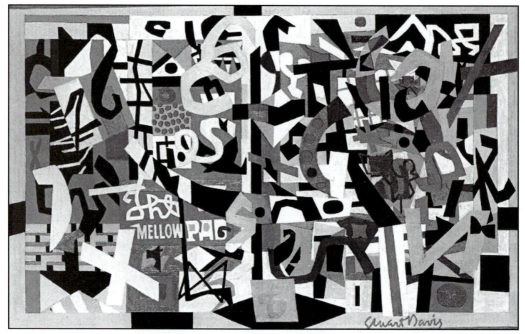

16.24 Stuart Davis, *Mellow Pad* (1945–1951, oil on canvas, Brooklyn Museum). The roots of Davis's work are closer to jazz music than metaphysics, but by the time he made this painting, the tradition of flattened space was well established. Art © Estate of Stuart Davis/Licensed by VAGA, New York, NY.

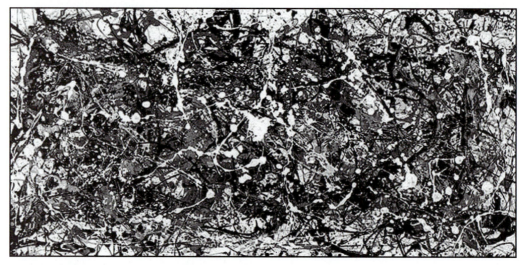

16.25 Jackson Pollock, *Number 8* (1949, Private Collection). In the work of Pollock the two-dimensional emphasis developed in response to his experiences with Jungian psychology and Native American sand painting as he sought to "deal with the moment and eternity."

CHAPTER 17 COMPOSITION

Disegno279
Gestalt principles. 280
Perceptual imperative . 281
Physiological balance . . .282
Symmetry / Asymmetry 283
Picture plane dynamics . 284
Spatial magnetism. . . . 285
Tangency.286
Kissing the Sphinx 287
Emphasis by contrast 288
Emphasis by contrast 289
The weight of emptiness . 290
The weight of depth291
Gestalt revisited 292
Repetition 293
Continuation. 294
Underlying structure . . 295
Geometric structure 296
ϕ (phi) revisited297
Rule of thirds 298
Rule of odds. 299
Thumbnails300
Viewing frames. 301
Harmonizing sight. . . . 302

"Disegno was an ordering of visual elements so that they reflected or re-created an ideal (divine) order. 16th century artists punned, in a medieval manner, on the derivation of disegno from di segno, that is, segno di Dio (blessing of God)."
Terrence Heath

Now that you have successfully worked your way through the full array of perceptual drawing projects, your final challenge is to apply your newly acquired knowledge and skills to the creation of pictorial compositions that attract, engage, stimulate, and entertain the viewer's eye. Organizing visual elements in a way that maximizes their compositional attractiveness is frequently referred to as **design.** The word design comes from *disegno*, which during the Italian Renaissance originally meant "to draw," but gradually came to mean the organization of pictorial elements into a unified, coherent whole. This dual usage apparently grew out of the practice of using drawing as a preparatory study for paintings, sculptures, and architecture before attempting the final project. Disegno also implied an *ideal order*, as the source of the artists' inspiration and as the goal of the workings of the artists' imagination (sometimes referred to as a *divine spark* or *spark of genius*).

Successful visual design relies primarily on intuitive responses (quick, keen insights independent

DISEGNO

of reasoning) to combinations and permutations of form, shape, color, value, and line, as well as representational and psychological content. However, while acknowledging the pivotal role of intuition in organizing a picture, it will be necessary to start our discussion of composition with a rational understanding of Gestalt perceptual principles, the dynamic forces that energize the pictorial field, and the many organizing formulas (underlying compositional schemata) that have been applied for centuries as guides for making works of art pleasing and attractive.

The compositional principles, forces, elements, and organizing methods in this chapter are not to be taken as formulaic recipes that can be slavishly applied to produce engaging compositions. To compose a picture you must rely on your emotional response and direct visual experience. There is no predetermined checklist of prescriptive compositional rules that can guarantee success. That being said, however, it is equally true that any artist who willfully disregards perceptual principles, pictorial dynamics, design elements, and organizing schemata risks losing the attention of his/her viewer.

The goal of visual perception is to successfully negotiate the physi-

<div style="writing-mode: vertical-rl">GESTALT PRINCIPLES</div>

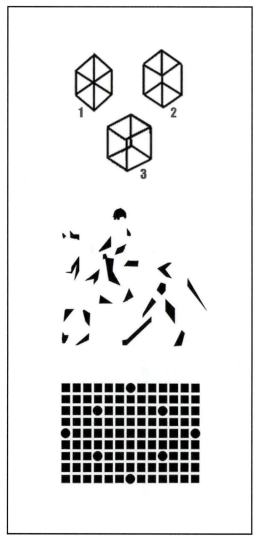

17.1 The uppermost geometric forms illustrate the **simplicity** principle where the brain seeks the simplest solution interpreting what it sees. **1** is most easily read as a set of flat triangles, **2** reads equally as flat shapes or a dimensional cube, and **3** reads most easily as a dimensional cube. The center image demonstrates how our brain applies **closure** to supply meaning to incomplete visual data. The lower figure reveals a diamond shape that demonstrates the strength of **similarity** in establishing implied spatial relationships.

17.2 The uppermost image illustrates the strength of our satisfaction when easily recognizing **figures** against the **ground** in our visual field. The grouping of shapes in the middle image reveals our tendency to group shapes or objects that are in close **proximity** regardless of their individual characteristics. The image at the bottom is an effective example of the organizing power of **continuation** where implied rather than specified linear connections lead the eye around the design.

cal world. To assist in this process the human central nervous system has evolved to identify meaning in our perceptions by searching for object recognition and/or purposeful organization. This is known as **the perceptual imperative,** and you have experienced it firsthand anytime you looked at billowy clouds and found instead castles, animals, or faces. **Gestalt perceptual principles** are the specific mechanisms by which the human brain organizes visual information into meaningful experience. Unity, harmony, coherence, and wholeness in the visual field contribute to a satisfying, pleasurable, and engaging perceptual experience. The mechanisms that help us organize perceptual information were first identified by German psychologists in the 1920s (**Figs. 17-1, 17-2**). Gestalt means "unified whole." Because of these mechanisms the eye finds a well-organized visual field engaging and derives pleasure in repeatedly scanning it. However, when the brain is unable to make sense of a visual experience, the eye quickly becomes impatient and frustrated and driven to look somewhere else. **Organized pictorial fields attract and engage the eye; disorganized fields repel it.**

In addition to the six Gestalt principles (simplicity, closure, similarity, figure/(back)ground,

proximity, and continuation), it is important to give particular attention to the foundational pictorial dynamic of **physiological lateral balance.** We respond positively when we identify lateral balance in our visual surroundings or in two-dimensional images because an acute sense of gravity is woven into our shared central nervous system. As a result, every two-dimensional image we encounter is experienced as though divided in half vertically and positioned on a fulcrum directly under the imagined bisection (**Fig. 17-3**). To establish equilibrium in any pictorial field, every element that attracts visual attention on one side must be offset by the addition of an element of equal visual weight on the other. When an equal distribution of visual weight is achieved by arranging elements of identical size, contrast, shape, color, value, position, and orientation, the composition is said to be symmetrically balanced (**Fig. 17-4a**). **Symmetrical balance** is generally regarded as pleasing but it is considered to be predictable and therefore less emotionally engaging than asymmetrical balance. With **asymmetrical balance,** equilibrium is achieved by an uneven distribution of forms where the sense of balance is maintained by increasing or decreasing the visual potency of constituent elements by means of selective application of pictorial

17.3 The human sensitivity to lateral balance in the environment extends to pictorial fields. We react to rectangular fields containing forms as though the rectangle was delicately perched like a see-saw on a center fulcrum. We react most positively when the distribution of forms conveys a sense of equilibrium.

17.4a-b Symmetrical balance (on the left) results when two identical elements (elements of equal size, shape, color, contrast, position, and orientation) are equidistant from the bisecting axis of the picture frame (mirror image). Asymmetrical compositions can achieve the same sense of equilibrium but do so by taking advantage of picture plane dynamics that affect the overall sense of lateral balance of the composition by readjusting the visual weight (importance) of the individual elements.

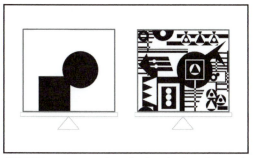

17.5 Eyes crave visual stimulation through variety of size, shape, color, value position, and orientation in the pictorial field. As can be seen above, however, too little or too much variety can be visually distracting.

dynamics (**Fig. 17-4b**). Because asymmetrical balance contains visual elements that are different from one another and because variety engages the eye more than constancy, asymmetrical compositions are considered to be more exciting and dynamic than symmetrical ones. Too little variety tends toward the static and dull. Too much variety tends toward visual confusion (**Fig. 17-5**). Your job, Goldilocks, is to find the amount of variety in your composition that feels "just right."

Picture plane dynamics are perceptual predispositions that influence the amount of attention (*visual weight*) that visual

elements generate in a composition. These include scanning patterns of the eye, proximity, tangency, continuation, the weight of empty space, the Rule of Thirds. The number of these compositional forces is small, but they can interact in any number of complex combinations. The end goal of this lesson is to control these interactions, and the best way to achieve that control is to address the fundamental dynamics one at time.

When viewing a blank rectilinear picture plane, the areas that attract the most attention are, in order of visual potency, the outside edges, the center, the top-right quadrant, the bottom-right quadrant, the top-left quadrant, and finally, the bottom-left quadrant (**Fig. 17.6a**). In response to our acute awareness of gravity, we are inclined to prefer a "center location" slightly above the actual center of the rectangle. This adjusted position is called the comfort center. Our predisposition toward a comfort center is what informs the popular tradition in picture framing to proportion the mat board so that the bottom measurement is slightly fuller, thereby "comfort centering" the artwork (**Fig. 17.6b**).

Adding a new visual element to a pictorial field immediately triggers a perception of visual tension

17.6a-b Studies suggest that optical scanning patterns are shaped by the way an individual's language is written. When Westerners scan a blank rectangle, their eyes tend to move around the outside edges, starting in the upper left and proceeding in a clockwise direction while periodically jumping diagonally across at the corners. This scanning pattern attaches disproportionate visual importance to the outside edges, the center, the top, and right-hand side. Visual elements that are placed in these locations are automatically awarded more visual weight.

PICTURE PLANE DYNAMICS

17.7a-b Elements placed in a rectangular field immediately generate visual tension (*spatial magnetism*) with the edges of that field. The strength of the visual attraction depends on the closeness of the object to the edge, the shape of the object, and/or the orientation of the object relative to the frame. The greater the vibration, the more attention the interaction demands. When the picture contains two or more elements, the spatial interaction between and among the objects generates the same kind of visual interest as does the interaction of the objects and the outside edges.

between that object and the outside edges of the picture plane. The greater the proximity of a visual element to the edge, the more attention it demands and the stronger its visual weight becomes. This attraction is like magnetic vibrations whose frequency becomes more intense as the visual element gets closer to the edge of the picture plane (**Fig. 17.7a-b**). When there are multiple elements in the composition, this spatial magnetism occurs not only between those elements and the outside edges but also between the elements themselves. Elements with straight edges that are parallel to the frame "vibrate" more strongly (demand more attention) than those with edges that are oblique to or curve away from the edge (except when those elements are tangent to the edge; *see below*). Varying the proximity of visual elements to the edges or to one another is a subtle yet potent technique for altering the visual importance of an object in the pictorial field.

Tangency is a unique type of proximity that is particularly useful when the composition calls for an intense increase in visual weight to counteract existing elements. **Tangency refers to lines, curves, or shapes that touch but do not intersect (Fig. 17.8a).** As we have seen,

SPATIAL MAGNETISM

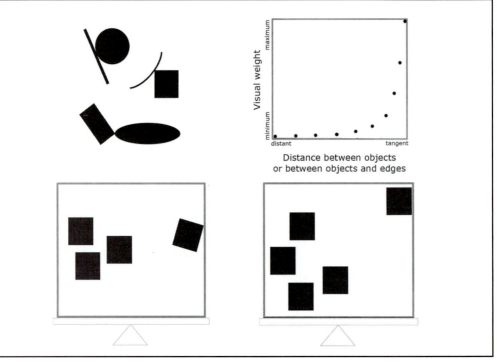

17.8 Image **a** shows variations of possible tangent relationships. Image **b** is a chart that looks scientific but is actually an intuitive visual metaphor for the rapid increase in the emotional importance that we attach to an object as the distance between that object and the edge (or another object) diminishes. In images **c** and **d,** tangency plays a large role in establishing the distribution of visual weight. In both cases a single black square is holding its own against multiple black squares of identical size. While tangency plays a major role in this balancing act, it is not the only dynamic that contributes to the increase of visual weight of the isolated elements. Both squares gain visual weight because of their position in the upper right-hand quadrant. The tangent square in image **c** has a unique orientation that attracts attention and the square in image **d** seems glued to the right side and is also uncomfortably close to the top edge.

the increase in visual weight that results from proximity is inversely proportionate to the distance between the elements. The maximum amount of visual attraction is created when visual elements are tangent with an edge or with one another (**Fig. 17.8b**).

17.9a-b As effective as tangencies are for adding excitement and variety while contributing to pictorial equilibrium, you must remember that tangencies can compromise illusionistic spatial relationships. The intentionally contrived images above are powerful illustrations of our natural tendency to read two elements that are tangent as being in physical contact with one another. Unless you are pathologically gullible, you know that the top picture does not depict a giant young female locking lips with the Sphinx of Giza any more than does the bottom image depict a man on the beach polishing the setting sun.

Tangency is the strongest of proximate relationships. Humans, as creatures that rely strongly on touch for emotional stability, are extremely sensitive to visual relationships that suggest spatial intimacy. In images, tangencies recall the excitement of touch and produce powerful attractions that increase visual weight. Tangencies can be effectively used to move the eye through the composition and establish equilibrium in what might otherwise be a disturbingly unbalanced pictorial field. Tangencies accomplish this in a way that is dynamic, exciting, fresh, and unexpected (**Fig. 17.8c-d**). However, because of the intensity of their visual attraction, tangencies must be applied cautiously. When applied without proper consideration, tangencies can contribute to unintentional compositional imbalance. This is an issue particularly for those of us who draw from perception. In representational imagery tangencies seriously compromise illusionistic space. Unintended tangencies often lead to a flattening of space where the viewer sees an apparent physical connection of forms in space when they are actually separated by several feet, several yards, or even 93 million miles (**Fig. 17.9a-b**).

There are other mechanisms that are effective in adding visual weight to individual pictorial

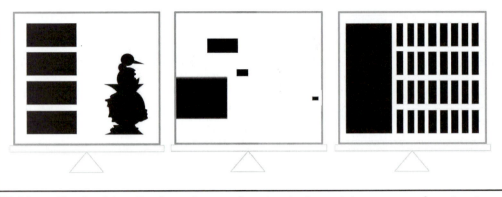

17.10a-c Emphasizing the importance of a visual element by means of contrast can take many forms. In the composition on the left, the contrast used to create balance consists of changes in shape (geometric vs. irregular) and contour activity (calm vs. busy). The center composition, while displaying contrasts in size, is able to add considerable visual importance to the smallest element by means of its location (isolation). In the image on the far right, contrast of size is the primary tool in its search for asymmetrical equilibrium.

elements. These mechanisms add emphasis, weight, and importance to visual elements by using different modes of **contrast** (*juxtaposing forms that are different*) to make them stand out. Because our central nervous system makes us acutely responsive to change in our environment, contrast in a composition carries considerable visual weight. This contrast can include (but is not limited to) contrast of shape, location (isolation), size, value, orientation, focus, or visual texture (**Figs. 17.10a-c–17.12**).

Visual contrast based on change is a defining characteristic of our perceptual experience. In fact, it can be said that without at least a small amount of change, there can be no perception. As

PERCEPTION EXPERIMENT

You can try a little experiment at home that clearly demonstrates how dependent your perceptions are on *contrast*. You'll need three bowls. Fill the first with iced water, the second with water at room temperature, and the third with *comfortably* hot water from the tap. Place your left hand in the iced water and your right hand in the *comfortably* hot water, and leave them there for 30 to 60 seconds. When time is up, place both hands in the water at room temperature. Amazingly, the left hand will tell you the water is hot, and the right hand will tell you it is cold.

17.11a–c In the composition on the far left, the fact that the light gray rectangle is located in the upper right quadrant (location) and is in greater value contrast to the background than the darker gray column of rectangles gives it sufficient visual weight to suggest equilibrium. In the center image, the gray rectangle exhibits greater value contrast and a more dynamic location (upper right quadrant, very close to the top edge), but its potency is in large measure balanced by the contrasting orientation of the tilted black rectangle. In the far right image, the sharply focused rectangle in the left-hand column contributes a sense of balance to what otherwise would be weighted to the right

17.12 Despite the fact that the solid black rectangle above is further away from the fulcrum and is also made stronger by its proximity to the top edge of the picture frame than the rectangle on the right, the eye-catching visual texture of the rectangle on the right goes a long way in making the pictorial arrangement appear balanced.

we discussed briefly in an earlier chapter, the ancient Greek philosopher Heraclitus acknowledged the central role of change in consciousness that he called **flux,** and more recently the early 20th-century French philosopher Henri Bergson spoke of the central role of the accumulation of information through time (**duration**) as the formative element of human awareness. While static two-dimensional images do not usually come to mind when we think of change, scanning a visual image does unfold in time. Since we can focus sharply on only about 2% of the visual field at any moment, the eye must constantly move to collect detailed data from around the pictorial field. Contrast is a time-based experience.

The more contrast that a given visual element exhibits, the more attention-grabbing potency that visual element generates.

One of the most surprising and dramatic methods for creating asymmetrical equilibrium is to balance identifiable shapes with empty space. In order for this contrast to work, there needs to be a sufficient volume of empty space to counterbalance the visual weight of identifiable forms (**Fig. 17.13**). It is true, as well, that if certain compositional conditions are met, even relatively small empty spaces can be made to hold their own against serious attention-grabbing visual elements. The viewer's attention can effectively be directed to what would otherwise be lackluster locations in the composition by applying any of the three following spatial mechanisms: (1) implied triangulated forms (arrows) that appear to converge in the direction of the location needing emphasis; (2) perspectival recession where the orthogonals add visual weight to the point at which they converge; (3) figurative psychological emphasis where the gaze of depicted figures or their implied movement carries the attention of the viewer to a location of the artist's choosing. (**Figs. 17.14, 17.15**).

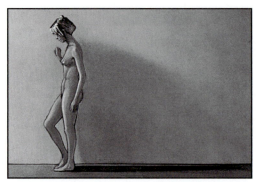

17.13 Brian Curtis, *Compositional study #5* (oil on paper, 1995). A sizable volume of empty space can balance a human figure near the edge of the pictorial field.

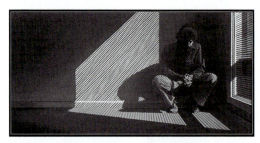

17.14 Brian Curtis, *Timekeeper* (oil on panel, 1984). The arrow-like shape of the sunlight lends considerable visual weight to the empty space on the left.

17.15 Jean-Léon Gérôme, *L'Eminence Grise (The Grey Cardinal)* (oil on canvas, 1873, Museum of Fine Arts, Boston). All eyes of the depicted characters, compositional triangulation, and perspective converge on the isolated figure on the right.

THE WEIGHT OF EMPTINESS

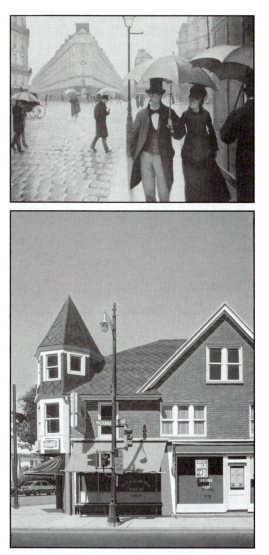

17.16a-b In both Gustav Caillebotte's *La Place de l'Europe, temps de pluie,* (oil on canvas, 1877, top) and Brian Curtis' *The Blue Front* (acrylic on masonite, 1984, bottom) the suggestion of spatial recession of the left-hand side of each painting provides sufficient visual weight to offset the strength of the visual elements positioned in the right-hand side of the respective compositions.

Interestingly, even without the convergence of receding orthogonals, we attribute increased weight to depictions of deep space. Despite the fact that we know the images we are viewing are flat, we are predisposed to attach considerable visual importance to illusions of deep space even when that part of the image contains little or no additional information of obvious interest. The specific mechanism triggering this reaction is unclear, but it appears that we react intuitively to the cubic volume of empty space suggested by the spatial illusion and that the greater the cubic volume, the greater the visual weight that we attach to it (**Fig. 17.16**).

When attempting to create increased visual weight with an illusion of spatial recession, the most effective monocular cues are atmospheric perspective, disproportionate scale, overlap, and linear perspective (see pages 236–237, **Figs. 15.1a-c, 15.2a-f**).

Two of the Gestalt organizing principles that were mentioned at the beginning of this chapter deserve closer scrutiny: *repetition* (similarity) and *continuation* (implied underlying linear or geometric structure). These principles can be purposefully employed as mechanisms for directing the viewer's eye through the composition.

THE WEIGHT OF DEPTH

CHAPTER 17: COMPOSITION

As we discussed earlier, the perceptual imperative causes us to take pleasure in identifying visual connections between and among elements in our field of vision. It is this positive reinforcement that motivates the eye to actively scan the composition in search of spatial relationships that reveal this purposeful organization. Our predisposition toward making connections between elements that share visual similarities makes **repetition** of shape, directional lines, value, pattern, size, texture, or color a highly effective method for guiding the viewer's eye through the composition (**Figs. 17.17–17.19**). When

Fig. 17.17 Our need to identify purposeful organization in our visual field causes us to attach heightened visual weight to forms that appear visually similar. As we encounter repetition in a composition, our eye jumps from one similar form to another. In the illustration above, this recognition causes the eye to move in either a diamond pattern, smaller triangles, or a rectangular pattern of circles.

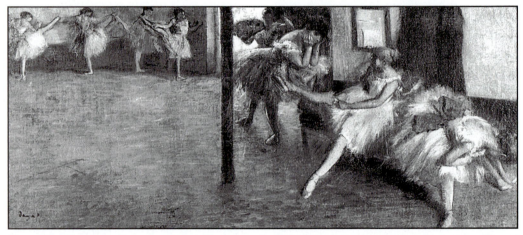

Fig. 17.18 Edgar Degas, *Ballet Rehearsal*, 1891. Degas, a master of compositional dynamics, unified this composition by guiding the viewer's eye through his image from left to right and from background to foreground by means of repetition of the value and shape of the dancers' tutus along with a variety of diagonal and vertical forms sprinkled strategically throughout the image. Degas was particularly adept at devising ways that provide variation within the repetition. To further activate the surface dynamic, Degas boldly applied tangency to direct our attention to the top left, center, and right-hand bottom corner. With the majority of large shapes concentrated in the right side, Degas is able to add considerable visual weight by contrasting that busy area with the deep space on the upper left and the open space in the lower left quadrant.

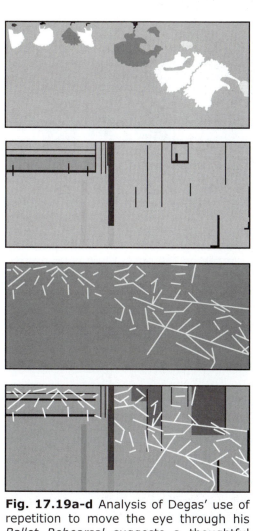

Fig. 17.19a-d Analysis of Degas' use of repetition to move the eye through his *Ballet Rehearsal* suggests a thoughtful distribution of irregular shapes (the dancers' tutus), a variety of vertical and horizontal elements, as well as an exciting progression of diagonals unfolding from the upper left to the lower right corner.

applying repetition as a organizational tool to a composition, again remember the *Goldilocks challenge* presented earlier in this chapter and stay sensitive to the fact that too much repetition of identical elements easily becomes predictable and boring. A checkerboard is a prime example of repetition pushed too far. A sure-fire way to avoid predictability is to inject variety into repetition whenever possible **(Fig. 17.19a-d)**.

A subtler but equally effective compositional mechanism for creating pictorial organization is **continuation.** Continuation occurs when two or more linear elements or edges are aligned in a way that implies connections across sectors of the composition. Continuation is sometimes reinforced by the **closure** mechanism that occurs when the alignment of multiple line or edge segments suggests the presence of an identifiable negative shape (most commonly geometric). The simpler the implied negative shapes are (circle, ellipse, square, rectangle, triangle), the more powerful is the visual pull from one segment to the other **(Fig. 17.20a-b)**. Although continuation is often established by alignments that are ruler-straight, the perceptual imperative to find structural organization in our visual field also encourages us to make

REPETITION

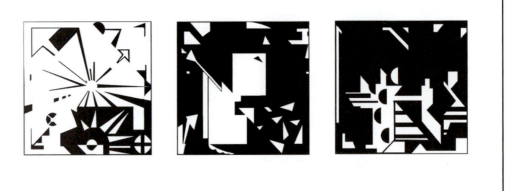

Fig. 17.20a-c In the left and center images, the lines and edges have been precisely aligned around basic geometric shapes. In the image on the right, there is no precise alignment of line segments or edges, but our eye still finds pictorial organization.

CONTINUATION

connections between lines and/ or edges that are slightly askew (**Fig. 17.20c**).

Because of the effectiveness of continuation and closure, artists have long relied on geometric shapes as underlying compositional schemata for all styles of image making. Certainly, Western art traditions from the Renaissance through the French Academy taught the importance of clear geometric organization (**Figs. 17.21, 17.22a**), but the modern aesthetic reaction against those structured teaching methods makes it unclear whether the organizational geometry that occurs in images of the 20th and 21st centuries was rationally or intuitively derived (**Fig. 17.22b-c**).

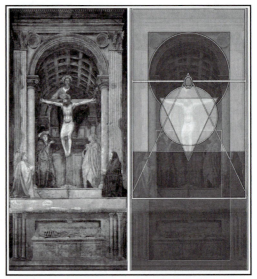

17.21 Masaccio's *Trinity* was the first Renaissance image to incorporate rational, geometricized sight to create the illusion of depth. The use of geometry not only had roots in mystical symbolism but was also understood to be an excellent way to organize the composition. Masaccio seamlessly wove together his rationalized spatial system, his geometric organizational system, and his spiritual symbolism—and in the process created a visually and intellectually engaging image for the ages.

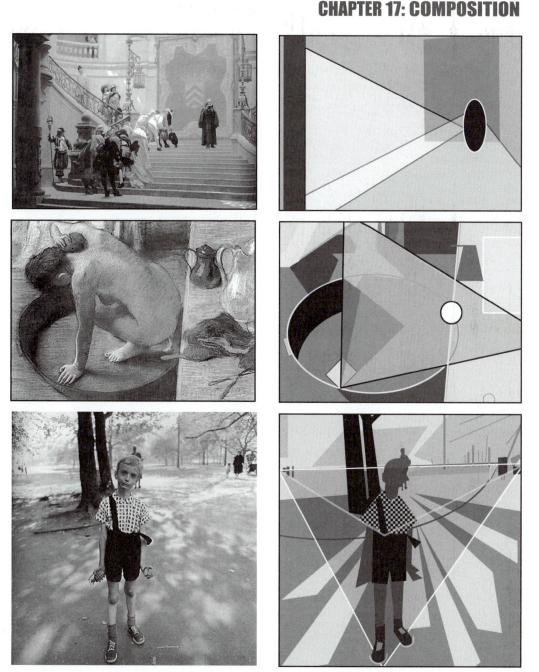

17.22a-c Top: Jean-Léon Gérôme, *L'Eminence Gris* (*The Grey Eminence*), 1873. Museum of Fine Arts, Boston. Center: Edgar Degas, *The Tub*, 1886. Pastel on paper. Musée d'Orsay, Paris, France. Bottom: Diane Arbus, *Child with a Toy Hand Grenade in Central Park*, N.Y.C., 1962, Gelatin silver print on Agfa, Addison Gallery of American Art, Andover, Massachusetts. Three distinctly different images, each of which derives considerable compositional integrity from underlying geometric shapes.

GEOMETRIC STRUCTURE

TRADITIONAL FORMS FOR CREATING UNDERLYING GEOMETRIC STRUCTURE

A clear underlying geometric organizational schema adds clarity and a sense of pur- posefulness to a composition.

Circle perfection, complete, well-being, plenty, opulence
Sunrise Motif buoyancy, expansion
Triangle strength, perma- nency, most stable, tran- scendent
Square orientation, earth, mankind
Star excitement, signifi- cance

PSYCHOLOGICAL FACTORS AFFECTING VISUAL WEIGHT

Figure recognition (being able to name something) attracts attention.

Among recognizable things that have considerable visual weight are

Suggestion of presence of figure outside the picture's edges
Violence (if it bleeds, it leads)
Lovers
Nudity
Beauty
Celebrities
Children
Family members (personal)
Spouse
Children
Friends
Ethnicity (people of other races)
Humans in general
Pets
Favorite things (personal)
Food
Phobias (personal)
Topical issue
Work animals
Primates
Exotic animals
Vegetables
Fish
Insects

(rankings are altered by individual's personality)

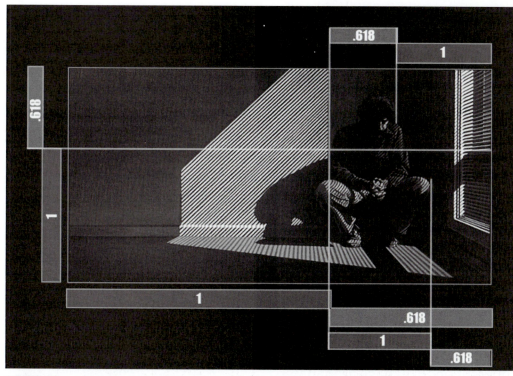

17.23 The arrangement of the pictorial elements in the oil painting *Timekeeper* was based entirely on intuitive judgments. No proportional measurements whatsoever were used at any stage of the paintings production. The artist's focus was to create a composition that produced a dynamic equilibrium. Interestingly, though not surprisingly, given the artist's goal, multiple visual elements of considerable importance align perfectly at Golden Mean divisions of the pictorial space. It is also worth noting that the ratio of dark areas to light areas falls in or around a 60:40 ratio that again references the Golden Mean.

In terms of underlying structural organization, take another look at the Golden Mean ratio (1:618) that was discussed in depth in Chapter 9. This ratio is uniquely effective for generating dynamic tensions in a composition that are both engaging and satisfying (**Fig. 17.23**). Not only can this unique proportion be applied to the distribution of visual elements across the pictorial field,

Φ (PHI) REVISITED

but the Golden Mean can also be used as a ratio between contrasting elements (light/dark, geometric/biomorphic, figure/[back]ground, curved/angular, focused/unfocused, etc.). For practical purposes this ratio can most easily be applied as a 60/40 distribution.

Curiously, the Golden Mean ratio is now known in art circles as the *Rule of Thirds* (**Fig. 17.24**). This change in terminology is most likely due to a 20th-century modernist reaction to the structured learning of the 19th-century art academies as well as the fact that some have mistakenly confused this long revered geometric tradition with bizarre metaphysical superstitions like those propagated by the Nazis during World War II (think *Indiana Jones and Raiders of the Lost Ark*). Regardless of what name you choose to use for

17.24 Many artists working today, whether by conscious design or by intuition continue to rely on the long and successful tradition of adding visual weight to important pictorial elements by locating them at or near the *Rule of Thirds* (Golden Mean) divisions of the picture plane.

17.25a-d While it is generally agreed that even numbers of similar visual elements in pictorial composition **a** makes for a less engaging arrangement than odd numbers in pictorial composition **b** (with three being the most attractive odd number of elements), please keep in mind that an even number of elements can be organized in groupings (through proximity, color, or orientation) so that the overall visual effect is one of odd number attraction **c,d**.

17.26 Claude Monet, *The Morning*, from the Water Lily series (Musée de l'Orangerie, Paris, 1919–1926). Monet applied both the *Rule of Odds* and the *Rule of Three Edges* in his positioning of five major groupings of elliptical forms, four of which are going off three of the four edges.

17.27a-b Sam Knecht, *The Retreat of Winter* (above) and *Leila's Kitchen* (below), egg tempera. In both of these paintings, Knecht energized his compositions by keeping the horizon out of the middle and by distributing the elements of visual importance away from the center of the pictorial field.

this unique proportional guideline, remember that a balance of dominant and subordinate visual forces based on the Golden Mean is consistently more pleasing than a contrast of forces in which the dominant element is far stronger than the subordinate.

The increased visual dynamism of asymmetrical composition is paralleled by a general preference for visual elements that repeat in odd- rather than even-numbered groupings. This is called the *Rule of Odds* (**Figs. 17.25a-d, 17.26**). The same underlying visual preference also contributes to the *Three Edge Rule,* which stipulates that the maximum visual interest in a rectangular composition is generated by arranging the elements so that they accentuate three of the four edges either by proximity (including tangency) or by having the visual elements continuing beyond the edge(s).

There are two simple cautionary design guidelines that, though implied in what we have already discussed, are nonetheless so useful that it is worth stating them explicitly. The first is a prohibition against dividing your composition in half (vertically or horizontally), and the second is a prohibition against placing elements of visual importance in the center of the picture (**Figs. 17.27a-b**). Take

these prohibitions to heart: many a still life has been rendered lifeless due to the most important element appearing in the center, and many a landscape sketch by a horizon line bisecting the picture plane.

One way to break the habit of placing the horizon line in the middle of the page is to shift your *point of view* (POV) away from the horizon line. As we learned in the previous chapter, looking up or down when choosing a composition causes the elements to appear in more dynamic and unexpected arrangements. The effectiveness of the Degas composition we saw earlier illustrates how visually engaging this approach can be (**Fig. 17.28**).

When creating a composition from observation, experiment with a variety of pictorial arrangements before settling on a final design. The best for generating pictorial experimentation is to draw an extensive series of **thumbnail sketches**. Thumbnails are quick compositional drawings developed like intuitive gestures: rapid, abbreviated drawings concentrating only on the distribution of major elements with little or no concern for corrections. Thumbnails should always be small (2 to 5 inches maximum), and the first thing you draw should be multiple rectangular formats in

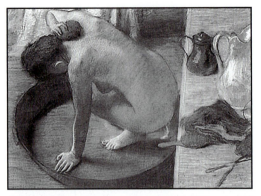

17.28 Edgar Degas, *The Tub* (1886, pastel on paper, Musée d'Orsay, Paris, France). Degas generated considerable visual interest in his depiction of a woman at her bath by combining a non-Brunelleschian *point of view* that is looking down on the figure from above with a daring use of tangencies around all four edges of the pictorial field.

17.29 Before beginning a thumbnail, it is essential that you first draw a border in the proportions that you feel will be most appropriate for the objects you wish to draw. Thumbnails are small (3 to 5 inches), rapidly drawn, simplified images that focus on the distribution of forms in relation to the outside border. Shifting your drawing position, rearranging the objects, or changing your POV are all methods that can encourage compositional variation.

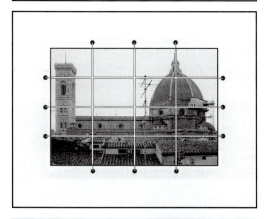

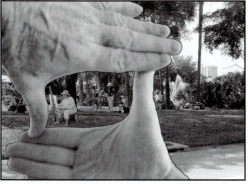

17.30a-c Mechanical devices can be extremely helpful in isolating and identifying engaging arrangements of forms within the border of the picture: the open viewing frames, the gridded viewing frames, or the always available hand viewing frame.

the proportions that you are considering for your finished work. If you are planning a composition for a project on a specific canvas or piece of paper that you have already purchased, make sure to proportion each of your thumbnail templates to match the proportions of your chosen surface (**Fig. 17.29**).

A *viewing frame* is a very simple tool that can be helpful when doing thumbnails. Viewing frames are generally small rectilinear openings in pieces of paper or cardboard (openings from 1.5 to 12 inches). Although 35mm slide mounts are not quite as common as they once were, they do make handy, pre-cut viewing frames (**Fig. 17.30a**). Smaller sizes are more portable, but the larger ones are more practical to use in that you don't have to hold them so close to your eye. However, if the viewing frame gets too large, your arms won't be long enough to allow you to crop the composition as tightly as you might desire. To transfer the composition to your thumbnails faster and more accurately, try fitting your cardboard viewing frame with a grid of horizontal and vertical threads that divide the viewing frame (**Fig. 17.30b**). If you find the urge to sketch without a cardboard viewing frame available, you can always use the *sliding hand frame* (**Fig. 17.30c**). One last option

for a viewing frame is to cut out two cardboard 8.5 x 11 inch "L" shapes. Sliding these against each other while preserving a right-angled opening between them allows maximum viewing flexibility (**Fig. 17.31**).

With repeated application, each of these viewing tools should increase your understanding of the compositional dynamics in the rectangular pictorial field.

As we close our discussion on pictorial composition, remember that despite all of the compositional principles, forces, mechanisms, rules, and tools that are now available to you, it is **your intuitive judgment that is the key to creating engaging, stimulating, entertaining, satisfying, and dynamic compositions.** Your composition has to feel right when you look at it—it is that simple. The principles and mechanics covered in this chapter can never be as important as your sensitivity to integrity, harmony, and energy. Only your intuition will allow you to summon order and pleasure out of all possible combinations of form, shape, color, value, texture, line, and content. **Composing a picture is intuitive.** Trust your intuition. Go with what feels right (**Fig. 17.32, 17.33**).

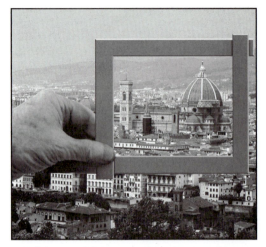

17.31 In addition to the viewing frames introduced on the preceding page, perhaps the most flexible mechanism for identifying dynamic compositions in your visual field is the sliding "L" frame.

17.32 Peter Kaniaris, *Blue Reprise*, oil on canvas. With simple elegance Kaniaris balances his symbolically charged subject matter with both a large expanse of empty darkness in the top left and a dramatic diagonal shadow in the lower left quadrant.

17.33 Sharon Allicotti, *Pears with Pairs* (charcoal and conté on paper, 1997). In this drawing the psychological weight of the figure is amplified by being wedged tightly into the upper right-hand quadrant by three tangencies. The considerable visual weight that the figure generates is balanced dynamically by the three pears (two tangent with outside edges) in the lower left quadrant and by the visual weight generated by the illusion of deep space in the upper left. There is also some skillful application of repetition (figure/reflection, pears/relfection), the rule of odds (three pears, three eyes), and continuation (a distinct curve suggested by the placement of the pears, the arched doorway curving around to the hairline on the silhouetted face, and the vertical mirror edge aligning with juncture between reflections of arms leading directly to the pear stem, that leads the eye actively through the composition. Interestingly, the point in the composition that appears to be at the center of much of the eye movement (the juncture of the vertical mirror edge, the intersection of the arm and the bureau top, and the far end of the lower diagonal edge of the mirror) occurs precisely at the intersection of a horizontal and vertical Golden Mean division of the picture plane.

You have reached the end of the lessons in **Drawing from Observation.** We began with the importance of a heightened awareness to the marks you make and then moved through a series of progressively complex techniques that were aimed at increasing your ability to distinguish between what you see and what you know. We then finished with an overview of compositional dynamics. Hopefully, the text and the illustrations have broadened your understanding and appreciation of spatial relationships and provided you the ability to create convincing and engaging images from anything you might see or imagine.

While this book is intended as a vehicle for developing the ability to accurately record your perceptions in a drawing, it is also meant to provide an understanding of spatial representation in general. Perceptual drawing, because of its rational organization, is an excellent conceptual baseline against which to compare and contrast all alternative approaches to image making. In the final analysis, it is the freedom that comes from understanding how images make spatial meaning that is the most fundamental and therefore the most important of all artistic tools.

Hail Mondrian!

Chapter 2: MATERIALS

Buying art supplies: Local retail stores can usually provide you with everything you need, but the required materials, including easels, are also available by mail-order or online. The following list of merchants is not intended as an endorsement but only as information. I have done business with all of these art suppliers and have found them to be prompt and reliable. I have purchased A Best easels for my students over the last ten years and have found them to be sturdy and reliable, but the other manufacturers do offer less expensive alternatives that are worth consideration.

Drawing Supplies and Easels

Daniel Smith	www.danielsmith.com (their catalogue has excellent descriptions of their products as well as broad-based descriptions of media and techniques —highly recommended!) **1-800-426-6740**
Dick Blick Art Materials	www.dickblick.com **1-800-828-4548**
Utrecht Art Supplies	www.utrechtart.com **1-800-223-9132**
Pearl Art Supply	www.pearlpaint.com **1-800-221-6845 x2297**
ASW (Art Supply Warehouse)	www.aswexpress.com **1-800-995-6778**

Easel Sites
http://easelconnection.com/shopsite_sc/store/html/page2.html
1-800-916-2278 24 hours a day
www.theeaselshop.com/ e-mail link on home page
www.dixieart.com/FineArts/A_Best_and_B_Best_Easels.html
1-800-783-2612

Holding the pencil in the drawing grip takes a little getting used to. The first exercises are aimed at familiarizing you with the touch of the pencil on the paper surface, so it is best to initially forgo any attempts at drawing what you see and instead concentrate entirely on familiarizing yourself with the feel of the drawing tool as it moves across the paper's surface. The two most important elements in this stage of the process are to develop the ability to constantly alternate the amount of pressure you apply to the tip and to develop a constant awareness of the ever-changing shape of the tip of the charcoal.

Exercise 3.1 As softly and delicately as possible, draw a large circular form on your paper that fills up most of the page. It should resemble a circle, but don't worry if it develops a somewhat eccentric shape. It's the marks that count. At the very beginning try to make contact with the surface of the paper so lightly that you barely leave any marks on the surface. Move your arm from your shoulder, and take advantage of the sweeping, smooth arc that it can provide. Go around and around multiple times, periodically reversing directions, continuing to keep the touch gentle. If you have already made heavy marks, turn the page (or turn the paper over) and try again. Once you have a feel for a delicate touch, increase the pressure on your pencil as it approaches the bottom of the circle and then decrease the pressure as you move back toward the top. Ideally your "circle" will remain very light (nearly invisible) at the very top and gradually get darker and thicker at the bottom, with smooth transitions throughout.

Exercise 3.2 On a new page, make a series of five closely spaced, delicate, nearly invisible vertical lines that run from near the top of your page to the bottom. Then try five more that are moderate in their degree of pressure and then five with heavy pressure. Finally try a series or ten or more lines in which the pressure constantly changes every 2 or 3 inches from delicate to moderate to heavy and then back again in the next 2 or 3 inches from heavy to moderate to delicate. The important element here is to control the changes in pressure so that the transitions between the differences in line thickness and in the darkness of the line occur smoothly and gradually. Avoid "breaks" in the line that start resembling dots and dashes.

Exercise 3.3 Use your different erasers to vary the line variety of the moderate and heavy lines in the previous exercise. Erasers are not just to remove marks from the surface of the paper but are actually valuable drawing tools in that they give additional control over the quality and variations of marks on the surface. Erasing is particularly helpful to those of us who are somewhat heavy handed and tend to use more pressure than we intend.

DRAWING ASSIGNMENTS

Exercise 3.4 Start out by using the masking tape to create five small rectangular boxes on the surface or your paper (with sides between 5 inches and 8 inches long). Use your pencils, charcoal sticks, and erasers to make as rich a variety of marks as possible as you "illustrate" a different concept in each box in any manner that you think appropriate. The concepts are EXCITEMENT—BEAUTY—SPEED—TENSION—MYSTERY.

Chapter 4: INTUITIVE GESTURE

Exercise 4.1 Begin gesturing very quickly from a small (three to five) group of still-life objects so that when you stop after thirty seconds there is the start of some sort of delicate linear notation that relates to your initial estimate of the size, location, and correct spacing that exists among the objects you are observing. If you don't have everything included, you have to work faster. Drawing rapidly helps stimulate intuitive (perceptual) thought processing and restricts logical processing, so gesture as fast as you can. Don't worry about accuracy: that will develop over time. For now, just learn to let your intuition guide your gesture. After the initial thirty seconds take a look at the marks you've made and determine if there are any major discrepancies between your gesture and the arrangement of objects in your visual field. If so, make the appropriate correction and continue on for a full minute adding more specific information about size and placement. Stop at the end of one minute and evaluate the accuracy of your gesture. Repeat in one-minute increments to a total of five per drawing. Do this exercise six times, and then do it three times where you continue the gesture for ten minutes (rearranging the objects each time you begin a new gesture).

Exercise 4.2 The next gesture exercise doesn't include using your pencil and paper. It can be done anywhere there are things to look at that are relatively close by. Look carefully at any object and concentrate on how rapid and constant is the movement of your eye as you visually absorb the information it offers.

Exercise 4.3 All gesture drawings proceed the same regardless of how long you intend to work on them. Whether you stop after the first thirty seconds, work for five or ten minutes, or continue estimating and correcting your perceptions for an hour or more, a gesture is always a progressive process of estimating, evaluating, and correcting. Try two extended half-hour gestures, but make sure that the marks you are using remain sketchy and incomplete until you are absolutely sure the relationships in your gesture matches the arrangement in your visual field. Look, don't think.

DRAWING ASSIGNMENTS

Chapter 5: INTUITIVE PERSPECTIVE

Exercise 5.1 Start an extended intuitive gesture from a still life (three to five objects) that is composed primarily of rectilinear solids. Arrange the solids so that no more than two of the rectilinear solids have sides that are parallel with one another. Begin with loose, rapid, sketchy marks that estimate the size and placement of the forms in space; and once you have a notation for each object, apply an intensive grid of Mondrian lines to evaluate your initial drawing. Make all needed corrections and continue the gesture process. As the drawing develops and the character and details of the objects gradually emerge, apply the cock-angle tool to all receding edges to determine their proper tilt. Do two one-hour drawings of differently arranged objects using all the steps mentioned above.

Chapter 6: POSITIVE/NEGATIVE SHAPE

Exercise 6.1 To strengthen your ability to identify the shape of the negative spaces between objects, set up your still-life objects against a solid colored wall. Choose relatively large objects that have distinctive and irregular shapes (toys, lamps, cooking utensils, plants, garden utensils, sporting equipment, etc.) and some that are relatively large. Set the objects close to the wall and with a fair amount of overlap among the objects. Then take several pieces of masking tape and create a rectangle on the wall whose overall dimension is slightly smaller than the area taken up by the arrangement of objects (before putting the tape on a painted surface, it is a good idea to lessen its adhesive potential by first pressing it against a piece of cloth several times—this way it won't take paint off when it is removed). Once you have set up your still life, the next step is to concentrate on the shapes of each of the sections of exposed wall that are visible within the area marked off by the tape rectangle. Carefully reproduce each one. Look only at the wall shapes and not at the items you've placed against the wall. If you slip and draw the edges of the objects, you will inadvertently draw lines that have nothing to do with the wall segments. This is probably the only exercise in this entire text where line variation doesn't play a major role. You are drawing wall shapes, not dimensional objects, so the line is an outline and can be quite mechanical in character. If you do this extremely carefully, you will have a very interesting image that will strongly suggest those things that you haven't drawn, thereby illustrating the effectiveness of an awareness of negative space. This exercise can easily take an hour or more. Do it at least twice to make sure that you can "flip the perceptual switch."

Chapter 7: PERCEPTUAL GRID

Exercise 7.1 Identify five symbols (religious, political, scientific, or corporate logos) that reflect an underlying design motif that emphasizes the vertical and horizontal axes of our perceptual grid. The ones already found in the text don't count.

Exercise 7.2 Start an extended intuitive gesture (place the objects at different distances from you). Make sure that everything in your still-life setup appears within the edges of the paper. Work rapidly and keep the lines as sketchy as possible as you gradually work toward an ever more accurate estimation of the size and placement of the objects in your drawing. Gesture for at least a full minute before applying the Mondrian tool. This *x-y* axis tool is to be used primarily as a method to evaluate the accuracy of your perceptions. Apply this tool only after you have gestured everything in your visual field; do not rely on it to systematically construct the spatial relationships in the drawing. Overreliance on the Mondrian tool usually means that you will take much longer to arrive at an accurate arrangement of forms, because the tool, by its very nature, forces you to concentrate on individual relationships instead of the "big picture."

Only after you have a fairly complete estimation of everything in your visual field should you begin to apply the Mondrian tool and the Mondrian lines. The Mondrian lines on the drawing surface should represent each and every relationship you test with the tool in your visual field. They should be extremely delicate so as not to dominate as the drawing develops, but they should not be erased inasmuch as they add both visual texture and perceptual content to the image. In this way, the gesture is not only about things but also about the very act of visual perception. There should be a Mondrian line for every edge of every form and for every change in shape. Twenty Mondrian for three to five objects is a conservative number. Go for more. There can never be too many Mondrian lines, but there can certainly be too few. Do two extended one-hour intuitive gestures with extensive Mondrian lines.

Exercise 7.3 (*optional for those who are mechanically minded*) You might enjoy constructing a simplified version of Alberti's veil and do it like they did in the Renaissance. It consists of a woven grid of parallel squares that can be used, like the Mondrian tool, for the transcription of spatial relationships from the visual field. This can be constructed using a stiff piece of cardboard with a square hole cut in it, some tape, and either string or thread. If you do make such a drawing device, remember that it doesn't do anything that a clean straight-edge held intuitively to what you know to be horizontal or vertical can't do just as well, if not better. Whether you use Alberti's veil or a Mondrian straight-edge, always remember to face in exactly the same direction every time you apply it to the objects in your visual field.

Chapter 8: PROPORTION

Exercise 8.1 Drawing a blackboard (or a white board) is an excellent first exercise for heightening your sensitivity to proportion. First, gesture the overall dimensions of the blackboard until you think you've accurately duplicated the correct size relationship between the sides. Once this is accomplished, proceed

to measure the board's overall proportion using the straight-edge proportion tool. Draw first, measure second. At this stage use a yardstick to make a vertical line down the actual blackboard at some position other than the center. Estimate where that line would be on your drawing. There are now two new rectangles to measure. When all measurements are the same for the blackboard and the drawing, it's time to add a horizontal line to the actual board. Repeat procedure. You can add as many as three lines in each direction. The challenge comes in keeping everything proportional as it gets more visually complex. If this exercise is done in a classroom with a number of participants, those at the edges of the room are likely to be looking at the board from an oblique angle and will see substantially different proportions than those viewing the board straight on. Not only will the proportions change, but the top and bottom edges will appear to tilt (railroad track convergence).

Exercise 8.2 Arrange four or five cylindrical objects at slightly different distances from you. Gesture the objects as we have done in previous exercises. When you are satisfied with the general placement, and the objects start to emerge into more recognizable forms, compare the proportions of the entire grouping as well as those of the individual cylinders in your drawing with measurements taken directly from the still life.

Exercise 8.3 Spend at least two hours making gestural studies of as many different types of rectangular doors and windows as you can. You can do several on a single page. After drawing each door or window, measure the actual object with your proportion tool and then write down the proportions next to your drawing. It is hoped that your drawing and the window share identical proportion. Draw some of the doors and windows while standing at an oblique angle. Remember that receding dimension will appear foreshortened and the receding edges will appear to converge.

Chapter 9: THE GOLDEN MEAN

Exercise 9.1 Your mission, if you should decide to accept it, is to locate the perfect person. Start with your own body proportions. Carefully measure your overall height (no shoes), and then carefully measure the height of your navel by placing a pencil against your navel and moving forward in order to make a small mark on a wall (you will need help measuring this because you need a spotter to guarantee that your pencil is parallel to the floor). After collecting this information use a calculator to divide your overall height into the height of your navel. If you match the perfection described by Leonardo in his *Vitruvian man,* the answer will be .618. Disappointingly most of us are a little over or under that magical number, but the average of humankind is a lot closer than most of its individual members. Don't be too disappointed if you are not proportioned like the *Vitruvian man.* Instead, go, tape measure in hand, and track down that illusive specimen of human perfection.

DRAWING ASSIGNMENTS

Chapter 10: CROSS-CONTOUR

Exercise 10.1 Draw a cross-contour globe from your imagination. It starts out much like the circular line exercise in Chapter 3 with the outside contour line getting heavier and darker toward the bottom. Once the outside contour is complete, gesture in an equator and several more lines (like latitude lines) that are parallel to it. These lines should get darker and thicker when they are closest to the viewer and become nearly invisible (fading into the background) when they are farthest away. The final step is to gesture in several longitudinal lines that pass through the poles. By following these directions your globe will look similar to the globe in Fig. 10.1a.

Exercise 10.2 Place your "official drawing flag" flat on the floor at least five steps away from where you are working, with one corner pointing toward you. Gesture the flag. Use Mondrian lines to check the alignment of the corners, establish the tilt and convergence of the receding edges using the clock-angle tool, and check to see that the proportion is the same in both the flag you are observing and the one in your drawing. (HINT: The stripes on the flag are all parallel with one set of edges and will therefore converge at the same point as those edges.)

Exercise 10.3 Find a place where you can alternately position the "official drawing flag" at shoulder height, hip height, and knee height. On a single piece of paper, draw the flag three times, once for each different height. Keep the flag approximately the same width in each attempt. Concentrate on the changes in proportion as the flag changes position. Gesture, Mondrian, clock-angles, and line variation are all important as well.

Exercise 10.4 Use your masking tape to arrange the "official drawing flag" on the floor (still five steps away) so that it has a swelling curve in its surface. The first challenge is to find a way to arrange the flag so that the stripes on the flag react visually to the curved surface. If the stripes look predominately straight from your drawing position, you need to change the flag or change your drawing position. When you are looking at your flag, you want to be able to imagine that the stripes are tracks of a roller-coaster and see them move up and over the one curve. The illusion will work better if the flag is arranged so that you can see the majority of the stripes from one end to the other rather than having them disappear behind an overlapping curl.

Exercise 10.5 Same exercise as above, but this time arrange the flag so that it has two curls in the surface. Apply some atmospheric perspective to fade the back of the flag into the background.

Exercise 10.6 Same exercise as above, but this time arrange the flag so that it has one curl and one crisp fold in the surface. Apply some atmospheric

perspective to fade the back of the flag into the background. Arrange the flag so that the stripes do disappear over either the curl or the fold, and use chiaroscuro to indicate changes in the way light strikes the flag and exaggerated "lemming syndrome" when the lines disappear over the edge.

Exercise 10.7 Arrange the flag any way you wish so that the stripes clearly communicate a convincing illusion of three-dimensional form and try adding a cylindrical object to the still-life setup. Gesture the objects using the appropriate techniques

Exercise 10.8 (*optional—can take as long as 6 to 12 hours*) Get two or three yards of cloth with anywhere between a 1" and 2" stripe. Drape the cloth over a distinctive-looking object (chairs work well). Tape (or staple) the cloth in place, once again concentrating in arranging the cloth so that the observable changes in direction of the stripes clearly reflect the underlying structural characteristics of the chair.

Chapter 11: FORESHORTENED CIRCLES

Exercise 11.1 Draw 25 ellipses on one page. Draw them small, large, and in-between. Draw them narrow, wide, and medium. After you draw each one, add a major and a minor axis to the ellipse to test for the appropriate bilateral symmetry.

Exercise 11.2 Draw six foreshortened circles of equal width directly above one another with three appearing above eye level and three below. Increase the line thickness and darkness where the circle is closest to the picture plane, and let the line fade gradually as it goes back in space.

Exercise 11.3 Draw a group of three to five glasses that are standing upright below eye level. Gesture, Mondrian, line variation, and proportion boxes are important steps to utilize as you draw. Concentrate on the progressive decompression of the ellipses that you are using to represent the cylindrical cross sections.

Exercise 11.4 Draw a group of three to five cylindrical forms at below eye level. Leave only one standing and lay the others over on their sides, each pointing in a different direction. Gesture, Mondrian, line variation, and proportion boxes are important steps to utilize as you draw. Locate the central cylindrical axis for each cylinder (HINT: The central axis is parallel to the sides of the cylinder and will converge toward the same point as the sides if they are receding from the picture plane), and tilt the ellipses that represent the cylindrical cross sections accordingly. Remember, too, that the cylindrical cross sections of a single object will become less compressed the further they recede from the picture plane.

DRAWING ASSIGNMENTS

Exercise 11.5 Draw an imaginary birdhouse that is below eye level with a cone on top, a torus (donut shape) around the central cylinder, and a birdhole and a perch. The most important thing to keep in mind is to make sure the cylindrical cross sections become less compressed the further they are from eye level. It is also important to make sure there is a smooth progression in the rate of decompression. As the birdhouse begins to take shape, apply some vertical cross-contour lines that start at the top of the cone and move directly down the side of the birdhouse, changing direction whenever the surface of the birdhouse changes.

Exercise 11.6 Draw an imaginary globe that is below eye level and has a ring of holes around any cross section of the sphere, and then attach a column of protruding dowels on what would be a longitude line. Remember that because the globe is below eye level, the central axis of the sphere (north pole) will appear inside the edge of the sphere and not on the contour edge.

Exercise 11.7 Same as Exercise 11.5, but imagine the birdhouse to be above eye level with a sphere in the middle of the central cylinder.

Exercise 11.8 The ultimate birdhouse is one that is imagined to be so large (or close to the observer) that the top is above eye level and the bottom is below eye level. Any extra elements that you can work into your fanciful construction are encouraged, but remember that clear, readable space is the goal and any added content is valuable only if it enhances the consistency of the illusion of space.

Chapter 12: BIOMORPHIC FORM

Exercise 12.1 Practice combining basic geometric forms (spheres, cylinders, cones, pyramids, and rectilinear solids) into compound schema. As with the birdhouses of Chapter 11, you must establish a clear idea of eye level as you begin to assemble the forms in your imagination. Include cross-contours that define each of the basic forms as well as some that define the transitions where the forms are joined together. Draw through the forms as though they were transparent, being sure to vary the line quality to maximize the illusion of volume and depth.

Exercise 12.2 Take the most successful of the previous compound schemas from the previous exercises and irregularize the surface by creating undulations in the surfaces, add protuberances (lumps and bumps), and add additional forms (cylinders, cones, rectilinear solids) where appropriate. Make use of extensive cross-contour and line variation in order to maximize the illusion of a clear, consistent, and readable volumetric construction.

Exercise 12.3 Repeat the previous exercise with one of your other compound schema from Exercise 12.1.

Exercise 12.4 Create a compound schema using a familiar volumetric object as inspiration. For example, a hamburger on a bun could be interpreted as a short, wide cylinder on top of another short, wide cylinder, with a half sphere on top. An athletic shoe could be the top half of a cylinder with a half cone at the tip and a rectilinear solid attached at the back. Take a look around and see what you can come up with.

Exercise 12.5 Start with a large sphere (include cross-contours right at the start so you know where you want the eye level to be) and gradually carve away at the surface of the form to create your own version of the "Great Pumpkin." Feel free to add any irregularities and eccentricities that you can dream up as long as each addition furthers a clear, consistent, and readable illusion of volume.

Exercise 12.6 Find a vegetable or a piece of fruit that is clearly volumetric and has a balance between a clear underlying schema and an irregular surface. Some fruits and vegetables, like oranges, are often too regular, and others like green peppers, often get so distorted they are hard to make sense of. Cruise the produce isles at your local market and bring home some produce that suggests a regularized underlying form while still offering some sensuous surface varations. Start out gesturing the underlying schema with a good amount of cross-contour and then gradually add the irregularities.

Exercise 12.7 Find a tree outdoors (if weather permits) or bring a section of a dead branch into the studio. Look for a form with a moderately complex assortment of basic elements (cylinders, cones, rectilinear solids, half spheres). Start with highly simplified forms and gradually add the irregularity. Line variation, cross-contour, and atmospheric perspective can give it convincing volume.

Chapter 13: CHIAROSCURO

Exercise 13.1 Draw three 2" x 11" rectangles above one another on one sheet of newsprint.
 (a) In the first box, use your compressed charcoal pencils to make dark straight lines over one another (hatching and cross-hatching) in an attempt to create as even a progression as possible from left to right of dark to light. Build up the tones gradually. Try to avoid using an eraser.
 (b) In the second box, use your compressed charcoal pencils to create a similar value range, but this time smudge (blend) the charcoal on the newsprint using the twisted end of a paper towel or paper napkin. Erasing also works well for modulating the tonal range with this method of applying darks to your drawing.

(c) Same exercise as above, except this time use one of the sticks of compressed charcoal.

Exercise 13.2 Set up a single white cylinder or rectilinear solid on a white ground against a white background and shine a directional light on it. Draw the object and then apply both the value range that you see when you squint and the one you see when your eyes are wide open.

Exercise 13.3 Same as above, but this time, before you start to draw, lay down a medium-dark tone over the entire surface of the paper and then create the tonal drawing by erasing out the highlights and adding dark areas where necessary.

Exercise 13.4 Set up a still life of several objects that already are or have been painted white on a white ground in front of a white backdrop in a moderately darkened space. Shine a directional lamp (incandescent bulb) onto the objects so that the light strikes the vertical edges of the objects more directly than the horizontal surfaces. Start with a rapid gesture, apply Mondrian lines, clock-angles, and proportion boxes to establish the size, character, and placement of the forms in your field of vision. Once this is done to your satisfaction, you need to squint at your setup to identify the areas in your drawing that will remain white. Every other part of the drawing will appear darker than white. Apply the values rapidly. Work all over and do not get hung up on any single section of the drawing. You can't make subtle discriminations in tonal variation until you have closely approximated the overall tonal value relationships. Don't stop applying tone until what you see when you squint at your drawing is identical to what you see when you squint at your still life. Once you accomplish this, begin modulating the subtler tones that you can see with your eyes wide open. Take care not to let the reflected lights get as bright as direct illumination, and remember to exaggerate your darks so as to enhance the intensity of the light. Repeat as necessary.

Chapter 15: 1- & 2-POINT PERSPECTIVE

Exercise 15.1 Collect images from magazines and/or newspapers that can be used to illustrate the nine different monocular cues described in this chapter (two illustrations for each cue).

Exercise 15.2 Set up a series of three rectilinear forms, sitting flat on the ground plane, so that all of their sets of edges are parallel, and then choose a drawing position and a fixation point (at eye level) that puts you in a one-point relationship with the still life. Gesture, Mondrian, clock-angles, proportion boxes, and line variation are still essential elements in developing the drawing in spite of the fact that we are using Brunelleschi's synthetic spatial system.

Exercise 15.3 Set up a series of four rectilinear forms, sitting flush with the ground plane, so that three of the solids are aligned squarely (their sides are parallel) with one another but not with the fourth rectilinear form. Find a drawing position and a fixation point that puts you in a one-point relationship with the uniquely positioned object. Gesture, Mondrian, clock-angles, proportion boxes, and line variation are still essential elements in developing the drawing in spite of the fact that we are using Brunelleschi's synthetic spatial system. Draw the four boxes.

Exercise 15.4 Set up a series of three rectilinear forms, sitting flush with the ground plane, so that none of the edges of the different solids are parallel with those of the other solids, and then choose a drawing position and a fixation point at eye level that puts you in a one-point relationship with one of the rectilinear forms. Gesture, Mondrian, clock-angles, proportion boxes, and line variation are still essential elements in developing the drawing in spite of the fact that we are using Brunelleschi's synthetic spatial system. This drawing will contain objects in both one- and two-point relationships. Once you have completed this drawing, move to another drawing position and establish yourself in a one-point relationship with one of the other boxes. Draw the setup again from this new position.

Chapter 16: 3-POINT PERSPECTIVE

Exercise 16.1 Take five rectilinear objects and arrange them so that one will be in a one-point relationship, two will be in two-point relationships, and the last two are in a three-point relationship with your imaginary picture plane. Of the objects in three-point perspective relationships, arrange one so that it rests on its edge and figure out a way to balance the other one on one of its corners.

Exercise 16.2 Take five rectilinear objects and arrange them so that they are sitting parallel with the floor plane with no more than two of them sharing alignment (parallel edges). Stand close to the setup and look down at the arrangement. All five objects will now be in a three-point perspective relationship with your picture plane. Gesture, Mondrian lines, clock-angles, proportion boxes, and line variation are all essential elements in developing the drawing, and these steps are made even more important given that we have moved outside of the familiar structure of Brunelleschi's synthetic spatial system. Remember, all sets of parallel edges that recede from your picture plane will converge at a single point, and each object in bird's-eye view will have three vanishing points.

Chapter 17: COMPOSITION

Exercise 17.1 To develop sensitivity to asymmetrical lateral balance in a pictorial field, try arranging simple geometric forms (circles, squares, and

triangles) of varying size (small, medium, large) and value (light gray, dark gray, black) within a variety of rectangular fields (backgrounds of white, gray, and black) in a variety of proportions (squarish, longer than high, higher than long) so that the distribution of forms establishes a satisfying sense of equilibrium. This exercise can be performed by cutting out geometric shapes from paper and then choosing three or more to move around inside a chosen rectangle until you feel the arrangement to be both evenly balanced and visually engaging. The goal of the exercise is to achieve asymmetrical equilibrium with a maximum of variation in shape, value, and placement. Remember to take full advantage of the visual weight enhancing potential of proximity/tangency, vertical placement, the spatial hierarchy proscribed by your optical scanning pattern, the weight of empty space, repetition, emphasis through contrast, continuation/closure, geometric schemata, the rule of thirds, and the rule of odds. Once you establish a pleasing asymmetrical arrangement, apply small drops of rubber cement to fasten the shapes to the picture plane so that you can view your geometric composition with a fresh eye by placing your composition in a vertical position, and view it from a distance of at least ten feet. Rubber cement allows for subtle adjustments in object placement if changes become necessary after seeing it with a fresh eye.

For those with access to and a basic working knowledge of *Adobe Photoshop,* the exercise above can be accomplished with considerably greater ease and flexibility on a computer than by the physical manipulation of cutout paper shapes. Since the image files for each composition can be kept to a maximum of 10 inches in the larger dimension and limited to 72 dpi, you should have no difficulty applying a generous number of transparent layers (one for each color, shape, and/or size variation). Once you have created the full series of size, value, and shape variations, one to a layer, you can simply use the *move tool* (keystroke = v) to change the position of any individual item as long as that item's layer is highlighted. When the *move tool* is selected and the proper layer highlighted, the keyboard arrows can be used to make subtle adjustments in position.

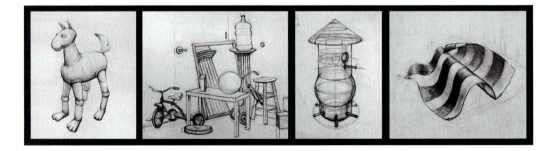

DRAWING ASSIGNMENTS

3.14	© Scala/Art Resource, NY
3.15	© Musee Toulouse-Lautrec, Albi, France, Giraudon/The Bridgeman Art Library International
3.16	Willem de Kooning. *Excavation,* 1950. Oil on canvas. 205.7 × 254.6 cm (81 × 100 1/4 in.), unframed. Mr. and Mrs. Frank G. Logan Purchase Prize Fund; restricted gifts of Edgar J. Kaufmann, Jr., and Mr. and Mrs. Noah Goldowsky, Jr., 1952.1. Art Institute of Chicago. © 2008 The Willem de Kooning Foundation/Artists Rights Society (ARS), New York
4.6	© Bridgeman-Giraudon/Art Resource, NY. © 2008 Artists Rights Society (ARS), New York/ADAGP/FAAG, Paris
4.9	© Foto Marburg/Art Resource, NY
7.9a	Theo van Doesburg, *Study for Composition (The Cow),* 1917, Pencil on paper, 4 5/8 × 6 1/4" (11.7 × 15.9 cm), The Museum of Modern Art, New York. Digital Image © The Museum of Modern Art/Licensed by Scala/Art Resource, NY
7.9b	Theo van Doesburg, *Study for Composition (The Cow),* 1917, Pencil on paper, 4 5/8 × 6 1/4" (11.7 × 15.9 cm), The Museum of Modern Art, New York. Digital Image © The Museum of Modern Art/Licensed by Scala/Art Resource, NY
9.10	© Art Resource, NY
9.12	© SEF/Art Resource, NY
9.14	© Alinari/Art Resource, NY
9.16	© Bildarchiv Preussischer Kulturbesitz/Art Resource, NY
9.17	Benjamin West. *The Death of General Wolfe,* 1770. National Gallery of Canada, Ottawa. Transfer from the Canadian War Memorials, 1921 (Gift of the 2nd Duke of Westminster, Eaton Hall, Cheshire, 1918) Photo © NGC (no. 8007)
9.20	© Réunion des Musées Nationaux/Art Resource, NY
9.23	Georges Seurat, *Circus Sideshow,* 1887–8, The Metropolitan Museum of Art, New York Bequest of Stephen C. Clark, 1960 (61.101.17). Image copyright © The Metropolitan Museum of Art/Art Resource, NY
10.4	M.C. Escher's *Cubic Space Division.* © 2008 The M.C. Escher Company-Holland. All rights reserved. www.mcescher.com
10.20	© Katherine Liontas-Warren
11.7	Janet Fish, *Three Restaurant Glasses,* 1974, pastel on paper, 30 1/4 × 16", Collection of the Minnesota Museum of American Art, Acquisition Fund Purchase, (74.43.08). Art © Janet Fish/Licensed by VAGA, New York, NY
11.8b	© Scala/Art Resource, NY
11.21	M. C. Escher's "Study for House of Stairs," 1951. © 2008 The M.C. Escher Company-Holland. All rights reserved. www.mcescher.com
11.26	© Erich Lessing/Art Resource, NY
11.37	© Katherine Liontas-Warren
12.9	M. C. Escher's *Study for Depth.* © 2008 The M.C. Escher Company-Holland. All rights reserved. www.mcescher.com
p. 200	From *Ancient Egypt* by George Rawlinson
p. 205b	© Scala/Art Resource, NY
13.14	Georges Seurat, *Seated Boy with Straw Hat, study for Une Baignade, Asnieres,* 1883–84, Yale University Art Gallery, Everett V. Meeks, B.A. 1901, Fund. © Yale University Art Gallery/Art Resource, NY
13.18	© Réunion des Musées Nationaux/Art Resource, NY
13.23	© Scala/Art Resource, NY
14.1	© Réunion des Musées Nationaux/Art Resource, NY
14.2	© Erich Lessing/Art Resource, NY
14.3	© The Philadelphia Museum of Art/Art Resource, NY. © 2008 Artists Rights Society (ARS), New York/ADAGP, Paris/Succession Marcel Duchamp
14.4	© Scala/Art Resource, NY

SELECTED BIBLIOGRAPHY

Essay on Drawing

Hill, Edward. *The Language of Drawing*. Englewood Cliffs: Prentice-Hall, Inc., 1966.
 (hard to find but worth the effort)

General Drawing Instruction

Chaet, Bernard. *The Art of Drawing*. New York: Holt, Rinehart and Winston, Inc.,
 1970.
Betti, Claudia, and Teel Sale. *Drawing: A Contemporary Approach*. 2nd ed. New York:
 Holt, Rinehart, and Winston, 1986.
Goldstein, Nathan. *The Art of Responsive Drawing*. Englewood Cliffs, New Jersey:
 Prentice-Hall, Inc., 1973.
O'Connor, Charles, Thomas Kier, and David Burghy. *Perspective Drawing and
 Applications*. 2nd ed. Upper Saddle River, NJ: Prentice-Hall, Inc., 1997.
Wakeham, Duane. *Mendelowitz's Guide to Drawing*. New York: Holt, Rinehart and
 Winston, 1976.
Wood, Dan. *The Craft of Drawing*. Orlando, Florida: Harcourt Brace Jovanovich
 Inc., 1988.

Perspective Theory and History

Cole, Allison. *Perspective*. London: National Gallery Publications, 1992.
Dubery, Fred, and John Willats. *Perspective and Other Drawing Systems*. New York:
 Van Nostrand Reinholt Co., 1972.
Dunning, William. *Changing Images of Pictorial Space*. Syracuse, New York:
 Syracuse University Press, 1991.
Edgerton, Samuel. *The Renaissance Rediscovery of Linear Perspective*. New York:
 Harper and Row, 1976.
Hockney, David. *Secret Knowledge*. New York: Viking Studio, 2006.
White, John. *The Birth and Rebirth of Pictorial Space*. London: Faber and Faber Ltd.,
 1957.

Design Texts

Goldstein, Nathan. *Design and Composition*. Englewood Cliffs, NJ: Prentice-Hall, 1989.
Laurer, David. *Design Basics*. Fort Worth, TX: Harcourt Brace Jovanovich, 1990.
Martinez, Benjamin, and Jacqueline Block. *Visual Forces: An Introduction to Design*.
 2nd ed. Englewood Cliffs, NJ: Prentice-Hall, 1995.
Myers, Jack Fredrick. *The Language of Visual Art*. Fort Worth, TX: Holt, Rinehart,
 and Winston, 1989
Roukes, Nicholas. *Design Synectics*. Worcester, MA: Davis Publications, 1988.
Roukes, Nicholas. *Art Synectics*. Worcester, MA: Davis Publications, 1982.

SELECTED BIBLIOGRAPHY

Art and Culture

Berger, John. *Ways of Seeing*. London: The British Broadcasting Corporation, 1977.
Dissanayake, Ellen. *Homo Aestheticus*. New York: The Free Press, 1992.
Gombrich, E. H. *Art and Illusion*. Princeton, NJ: Princeton University Press, 1969.
Pirsig, Robert. *Zen and the Art of Motorcycle Maintenance*. New York: Bantam Books, 1974.

Art and Myth

Arguelles, Jose. *The Transformative Vision*. Berkeley: Shambhala Press, 1975.
Campbell, Joseph. *The Power of the Myth*. New York: Doubleday, 1988.
Walker, Barbara. *The Women's Encyclopedia of Myths and Secrets*. San Francisco: Harper and Row, 1983.

Art and Science

Deutsch, George, and Sally Springer. *Left Brain, Right Brain*. San Francisco: W.H. Freeman and Co., 1981.
Hoffman, Howard. *Vision and the Art of Drawing*. Englewood Cliffs, NJ: Prentice-Hall, Inc., 1989.
Kemp, Martin. *The Science of Art*. New Haven, CT: Yale University Press, 1992.
Schlain, Leonard. *Art and Physics*. New York: William Morrow & Co., 1991.

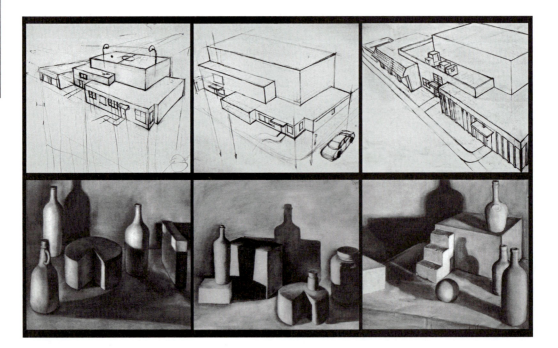

acute (of an angle), 52, 53, 54
Akhenaten, 200
Alberti, Leon Battista, 70, 235
Allicotti, Sharon, *Pears with Pairs*, 303
alchemy, medieval, 96
alignments, intuitive/rational, 64–66
American flag, Golden Mean and, 109
American Revolution, 108, 109
amorphous forms, 174
angle of incidence, light and, 207, 211
ankh (hieroglyph), 61, 62
Aquinas, Thomas, 231
arm movement, fluid, 24; *see also*
 intuitive gestures
armature, imaginary, 174–180, 183–187,
 190–196
astrological symbol, 62
asymmetrical balance, 282
astronomy, study of, 62, 98, 99, 114
athletic activities, drawing and, 44
atmospheric perspective technique, 116,
 117, 129, 130, 132, 291
awareness, purposeful, 2–3
axes
 cylinders and, 144, 148–151, 156,
 158, 159
 ellipses and, 147, 148, 157, 158
 picture plane and, 54

background, 57–58
 figure-(back)ground relationships, 58,
 60
 negative shapes and, 58, 60
Bacon, Roger, 231
bees, Golden Mean and ancestry of, 105,
 110, 111
benches, for drawing pads, 20, 21
Bergson, Henri, on perception, 226, 283
"big picture" sensitivity, 38, 39, 43–44, 67,
 71, 72, 214
binocular cues, loss of, 122, 211; *see
 also* monocular cues
biomorphic forms, 173–196; *see also*
 geometric forms; objects, drawing
 conceptual analysis and, 174–176
 cross-contour technique, 178, 184–196
 geometric forms, 173–174, 180–183,
 190–193, 196
 imaginary forms, 177–189
 observation and, 190–193, 196
 Renaissance clarity and, 186
 schema, 174–185, 187, 190–193, 196
 spatial illusions, 183–190
birdhouses, drawing imaginary, 164–172
Bodio, Gene, *New York City*, 273
Braque, Georges, *Mozart Kubelick*, 276
Brunelleschi, Filippo, 233–234, 262–263
Brunelleschi's Universal Law of Receding
 Edges, 263

Caravaggio, *Calling of St. Matthew*, 220
cave paintings, mimetic illusions and,
 227–228
Cezanne, Paul, *Mt. Sainte Victoire,* 275
chairs, drawing (draped in striped fabric),
 136–138
charcoal drawing tools, 8–10, 27–28,
 213
chiaroscuro technique, 197–220
 cross-contour technique and, 131,
 132
 and flag, official drawing, 118–135
 light and, 204
 modeling technique and, 197, 214,
 215, 216, 218
 spatial illusions, 211–213, 215
Christian culture, 61, 62, 106–107
Circe, 139
circles, drawing, 139
 cylinders and, 145–159
 ellipses and, 141–164
 foreshortened, 139–164
 and orientations, alternate, 148,
 148–153, 149
 parallel, to ground, 142, 142–147, 143,
 145, 146, 147
 rectilinear shapes and, 163, 164, 163–
 164
clock-angle, linear perspective system
 and, 46, 47, 48, 50, 51, 52, 53, 54, 55,
 45–55, 253, 254,
clock-angle tool, 46–56, 46, 47, 48, 50,
 51, 52, 53, 54, 55, 253, 254
 263, 264, 265, 266, 263–265
closure, shapes and, 58, 58, 280, 293, 294
comfort center, 284
cognitive styles, 32–34, 39, 42–43
composition 280–302
 continuation and, 292, 293, 294
 contrast and, 288, 289, 288–289
 Gestalt principles 280, 281, 280–281
 Golden Mean ratio and, 297, 297–298,
 picture plane dynamics and, 283, 284,
 283–284
 point of view (POV) and, 300
 psychological weight and, 296
 repetition and, 292
 rule of odds and, 299
 rule of thirds and, 298
 tangency and, 285, 286, 287, 285–287
 viewing frame and, 301, 302, 301–302
 weight of empty space and, 290,
 291, 290–291
 underlying geometry and, 294,
 295, 296
conceptual thinking, 30, 31, 30–33, 64–66,
 82–83, 90–91, 90, 91, 175; *see also*
 percepts
Conte, Nicholas, 10

continuous-tone drawing, 197
contour lines, 117
contrast, simultaneous, 202–203, 209–210
convergence, of parallel lines, 45, 45–46,
 51, 52; *see also* rate of convergence
cross-contour technique, 115–138
 biomorphic forms and, 182–196
 chiaroscuro technique and, 122–138
 and flag, official drawing, 118, 119,
 118–136
 and illusions, spatial, 237
 modeling technique and, 216
 and objects, drawing, 115–138
 schema and, 174, 175, 176, 177,
 174–177, 193, 196
 spatial illusions, 237
 and trees, drawing, 192, 193, 194, 195
crucifixes, 61, 62
cylinders, 139, 140, 143, 144, 146, 147,
 148. 149, 150, 139–150
 angle of incidence, light and, 207,
 211–214
 axis of, 148–151, 148, 150, 156, 157
 circles and, 156, 157, 157–160, 158,
 159
 proportions and, 82, 83, 84, 85, 82–85,

dancing, drawing and, 15–16, 16, 17, 44
David, Jacques Louis, *Death of Marat*, 272
David, star of, 61, 62
Davis, Stuart, *Mellow Pad*, 278
Della Pittura (Alberti), 70, 235
design, 279
Diodorus, writings of, 98
Divina Proportione (Pacioli), 106
Doesburg, Theo van, *Study for
 Composition: the cow,* 67
Donatello, 234
Duchamp, Marcel,
 Nude Descending the Staircase, 226,
 To be looked at, 276
duration, 226, 289

Earth, symbol for, 62
easels, drawing and, 16–18, 18, 20
ebony, 25
economy of means, and spatial illusions,
 236
Edges, Brunelleschi's Universal Law of
 Receding, 263
Egyptian culture, 61, 62, 95–97, 96, 97,
 228–229, 228
ellipses, 141–146, 141–150, 149–150,
 153, 153
energized mark making, 3–4
erasers, 13–14, 13, 14, 216
Escher, M. C., 172,
 Study for Depth, 180,
 Study for House of Stairs, 152

Eskimo legend, mimetic illusions and, 229
extended gesture drawing, 71–74, 71, 72, 73, 74
eye level, 51–55, 142, 142, 143, 145, 145–147, 147, 149, 151, 159, 161, 164, 166–172, 176, 183, 185–187, 189, 192, 239, 244, 246–247, 249, 252, 255, 262, 264, 269
eye structure, 39–40, 198–200, 199, 204, 240, 240, 241

Fibonacci, 105
Fibonacci sequence, 105, 110, 111, 114
figure-(back)ground relationships, 57, 58, 59, 60, 57–60, 281
fixation point, 234, 239–247, 249–253, 255–257, 259–260, 262–264, 267–269, 271–273
fixed gaze, linear perspective system and, 271
flag, official drawing, 118–135
 atmospheric perspective technique, 117, 126–130, 132
 convergence, of parallel lines, 125, 127, 125–128
 cross-contour technique, 116–138, 116, 120, 121, 122, 123, 124, 125, 126, 127, 128, 129, 130, 131, 132, 133, 134, 135, 136, 137, 138
 depth, illusion of, 115–117, 120–121, 123, 125–129, 131–132, 136, 131
 foreshortening, 119, 124–126, 130,
flower sermon, 2, 111
foreshortening, 83, 85–88, 119, 124–126, 130, 139–143, 145–165, 167, 170, 172, 194, 221, 245
fovea, visual field and, 39–40, 289
flux, 223, 226, 289
fractice, erasers and, 13
Freemasonry, Order of, 104, 108–109
"fresh eyes," 17–19, 41, 254
furniture, and drawing pads, 20, 21, 21, 23

geometric forms, 115, 165, 173, 176, 178, 180, 182–183, 190, 196, 261, 280
geometry, study of, 92–95, 99–101, 104, 108–109, 112–113, 174–175, 231, 294
Gestalt psychology, 33, 58, 280–281, 291–292
gesture drawing, 8, 33–44, 46, 56, 66–69, 71–74, 78, 80, 115, 118–119, 121, 141, 143, 181, 185, 189, 214, 221, 253, 266, 268, 300, 303
Giacometti, Alberto, 38
Gibson, J. J., on perception, 222, 268
Golden Mean, 76, 93–114, 297–299
 American Revolution and, 108–109
 architecture and, 96–104,
 and astronomy, study of, 114
 characteristics of, 94–95
 construction of, 94, 95, 96
 compositional dynamic, 297–299
 drawings and, 106
 humanism and, 100, 103, 105–106

nature and, 105, 110–112, 114
paintings and, 108, 112–113
spiritual awareness and, 93–104, 106–109, 113–114
graphite pencils, 9, 10, 120
Greek culture, 9, 43, 62, 95, 98, 102–105, 139, 205, 224, 231, 289
grids
 Mondrian gridlines, 46, 54, 63, 65–69, 74, 115, 118, 119, 121, 123, 128, 249–250, 253, 266, 277
 perceptual grid, 54, 61, 62, 66, 68, 61–62, 66–69, 71, 73, 78, 145, 221, 303
grip, drawing, 21–23, 22, 23
ground (background), 12, 25, 56, 52, 57, 58, 59, 60, 57–60, 88, 91, 91, 116–117, 117, 129, 146, 203, 212–213, 218, 218, 281, 281, 289, 292, 292, 298
ground plane, 66, 84, 142, 145, 147, 147–148, 166, 203, 205, 222, 239, 239–240, 245, 245, 249, 251–252, 263, 261–263, 268, 267–269, 273

Hagia Sophia, 104
Heraclitus, 226, 289
hermeticism, 100, 108
Hindu culture, star of David and, 61, 62
Hogarth, William, Perspective Absurdities, 274
horizon (line), 45, 63, 107–108, 222, 239, 249, 252–255, 257, 262–265, 263, 264, 265, 267–269, 268, 269, 270, 270–273, 291, 299, 300, 301
human figure, proportions of, 103, 106
humanism, golden mean and, 100, 103, 105–106
"Hymn to the Solar Disk" (Akhenaten), 200
Hyperboreans, 98–99

iconoclasm, 230–231
ideal forms, theory of, 103, 106, 224, 230, 232
illusions; spatial illusions, 73, 123, 126–127, 129, 145, 150, 152, 154–155, 164–166, 169–172, 183, 185–186, 193, 197, 208, 211, 211–212, 212, 213, 215, 218, 218, 223, 225, 227, 227, 230, 235–236, 236, 237, 239, 257, 259, 266, 273, 287, 287, 291
illustration board, 13
imaginary forms
 armature, imaginary, 174, 175, 177, 177–178, 180, 181, 190, 191,
 biomorphic forms and, 173–174, 176, 180, 187
 birdhouses, drawing imaginary, 164–172, 165–172
 pumpkins, drawing, 187
Ingres, Jean-Auguste-Dominique, Grand Odalisque, The, 112, 224
intelligence, types of, 5, 15, 30, 32–33, 34

intuition, 24, 39, 40, 42, 66, 75, 78, 280, 298, 302; see also intuitive
 alignment, intuitive, 66, 294
 cognitive styles, intuitive, 33
 comparisons, intuitive, 76
 composition, intuitive, 279, 302
 perspective system, linear, 45–60
 proportions and, 75–79
intuitive gestures, 29–44; see also gesture drawing, extended; intuition
 arm movement, fluid, 24
 cognitive styles, 30–33, 33
 concept and perception, 30, 31, 30–33
 drawing in progress, 35–44
 evolution of, 40–43
 Mondrian gridlines and, 64, 65. 69, 74
 Mondrian tool and, 63, 64, 66, 67, 68, 63–67
 progressive process, 38–44
 sci-fi transporter images and, 40
 and "big picture" sensitivity, 38, 39, 43–44
inverse square law, light and, 206, 207, 207, 211

Jewish culture, 61, 62, 100–101, 101, 104, 236–237

kinesthetic sensitivity, 5–6

lateral balance, 282
Law of Receding Edges, Brunelleschi's Universal, 263
lemming syndrome, cross-contour technique and, 130–131, 211
Leonardo Bigolo da Pisa, 105
Leonardo da Vinci, 26, 70, 106, 201, 215, 241, Vitruvian Man, 106
Liber Abaci (Fibonacci), 105
light
 angle of incidence and, 207, 211
 chiaroscuro technique and, 197–220
 inverse square law and, 206, 207, 207, 211, 211
 quotations on, 200–201, 205, 218, 220
 reflected light, 200–201, 208, 210, 211, 214
 sources and direction of, 204, 206–208
line of sight, 20, 24, 46, 47, 46–48, 50, 50–51, 63, 66, 70, 78, 85, 86
linear perspective relationships
 1-point, 50, 242–246, 245, 249, 253–254, 256, 262–264, 272
 2-point, 243, 243, 246–247, 249, 252, 254, 255, 251–255,259–260, 262, 263, 262–265, 268–269, 272
 3-point, 65, 243, 243, 261–265, 262, 267–273, 268, 273
 Brunelleschi's Universal Law of Receding Edges, 263
 clock-angle tool and, 46–56, 46, 47,

48, 50, 51, 52, 53, 54, 55, 253, 254
263, 264, 265, 266, 263–265
fixation point, 234, 239, 241–257,
242, 244, 246, 256, 259–260, 262,
263, 262–264, 268–269, 269, 271,
271, 273
history of, 221–234, 244
intuitive perspective, 45–56
picture plane and, 46–48, 50, 51, 50–
51, 54, 54, 54, 56, 70, 150–152, 152,
222, 234, 236, 239, 240, 241, 242,
245, 239–247, 249–252, 254–255,
261–265, 267–271, 268, 269, 270,
273, 276, 277
spatial illusions, 223, 225, 227, 230,
235–236, 236, 237, 239, 257, 259,
266, 273
lines
contour lines, 54, 56, 64, 117, 123,
143, 160, 196, 227, 288
line variation, 3, 5, 26–27. 54, 56, 64,
72, 123, 125 ,128, 130, 154, 169,
194, 224, 227, 237
spatial illusions, 73, 123,
126–127, 129, 145, 150, 152, 154–
155, 164,–166, 169–172, 183, 185–
186, 193, 197, 208, 211, 211–212,
212, 213, 215, 235–236, 236, 237,
239, 257, 259, 266, 273, 287,
291
Liontas-Warren, Katherine,
East Texas, 129,
Global Watcher, The, 164
Lorraine, Claude, 107

Mach bands, 202
Malevitch, Kasimir, *Red Square*, 225
mark making, 3–5, 5, 25–28
Masaccio, 234, 294
Masolino, 234
materials, for drawing, 7–14
mechanics, of drawing, 15–28
Michelangelo, 107, 186
Creation of Adam, 107
Mondrian, Piet, 63, 294
*Composition in Blue, Yellow, And
Black*, 62
Composition in Line and Color, 277
Mondrian gridlines, 64, 65, 69, 74, 118,
119, 121, 123, 250. 253
Mondrian tool, 63, 64, 66, 67, 68,
63–67, 119, 128, 249
Monet, Claude, 113
The Morning, 275, 299
monocular cues, 88, 123, 125–126, 129–
131, 154, 222, 224, 236,–237, 291
musicians, drawing and, 44
mystic way, Vasari and, 106

negative/positive shapes, 24, 25, 57–60,
58, 60, 68, 71, 73, 115, 293
Neoplatonism, 230, 232
Nicholas of Cusa, 232
nominalism, 232

objects, drawing; *see also* biomorphic
forms; geometric forms
cross-contour technique and, 178, 184,
185, 184–185, 186, 187, 188, 189,
191, 192, 193, 194, 195, 196
Mondrian gridlines and, 64, 65, 69,
74, 118, 119, 121, 123, 250, 253
proportions and, 20, 23, 27, 38, 41–42,
45, 60, 63, 67, 73, 75–92, 76, 77,
78, 79, 80, 81, 82, 83, 85, 88, 90,
92, 94, 118, 119, 118–119, 121,
123, 125–126, 135, 142, 142–147,
154–157, 168, 194, 240, 245, 246,
250, 253, 256, 266
oblique (of an angle), 50, 53, 65, 86,
88, 132, 149–150, 196, 207, 268,
285
obtuse (of an angle), 51, 52, 53, 55
orthogonals, 244, 245, 247, 250, 251, 264,
266, 267, 269, 290, 291
oscilloscopes, 3, 3

Pacioli, Fra Luca, 106
paper, for drawing, 10, 11, 12
paradox, 29, 33, 133
parallax, 55, 69, 69, 117, 211, 223, 257
parallel convergence, 45, 51, 87–89,
125–128, 127, 151, 166, 173, 192,
234, 251, 253, 255, 259, 265, 266,
291
parchment, 11
Parthenon, Golden Mean and, 102,
102–103, 110
pencils, types of, 8, 9, 10
perceptions
direct perception, 29, 31, 34, 66, 175–
176, 194
extended gesture drawings and, 71–74,
71, 72, 73, 74
figure-(back)ground relationships, 57,
58, 59, 60, 57–60, 281
perceptual grid, 54, 61, 62, 66, 68,
61–62, 66–69, 71, 73, 78, 145, 221,
303
perceptual imperative. 281
switch, perceptual, 59
visual world and, 81, 222, 223, 234,
240
percepts, 30–31, 178–179; see also
concepts
perspective; see linear perspective system
Phi (φ), 95, 98, 103, 107, 110–113, 112
Phidias, Golden Mean and, 95
physical sensations, 6
pictorial balance,
contrast, 288
empty space, 290
repetition, 292
continuation, 292
picture plane
Alberti's veil, 70, 240, 241
axes and, 61–64, 67, 69, 78
fixed viewing position and, 55, 69,
69–71, 152, 241

flatness, of artwork surface, 275,
276, 277, 278
foreshortened planes and, 83–84, 86–
89, 124–126, 125, 126, 130, 140–
143, 140, 141
imaginary, 70, 222, 240–242, 240,
241, 242, 245, 247, 251–252, 262,
268–270, 268.
linear perspective systems and, 222,
240–242, 240, 241, 242, 245, 247,
251–252, 262, 268–270, 268.
planes; *see* picture plane
Plato, 24, 93, 102–103, 103, 104, 110,
223–226, 225, 230, 232
Plontinus, 230
points
fixation points, 234, 239, 239–247,
241, 242, 245, 246, 249, 249–253,
252, 255–257, 259–260, 262,
263, 264, 267, 268–269, 270,
271–273
picture plane, and fixation, 242
vanishing points, 45, 244, 249–257,
252, 253, 255, 256, 257, 263, 264,
267, 269
Pollock, Jackson, 278
Polyclitus, canon of, 102–104
positions
for drawing, 15–23, 17, 20, 21, 23
for pads, of paper, 20, 21, 23, 20–23
and posture, drawing, 20, 21
viewing position, 30, 55, 69, 70, 121,
152, 222, 241
positive/negative shapes, 24, 57–60, 57,
58, 59, 60, 71, 73
posture, drawing and, 20, 21
POV (point of view), 300
proportions, 75–92
comparison, basic unit of, 79–81, 79,
80, 81
cylinders and, 82, 83, 84, 85, 82–85,
duplication of images and, 77
flag, official drawing, 118–119, 118
foreshortened planes and,83, 85–88,
119, 124,–126, 130, 139–143, 145–
165, 167, 170, 172, 194, 221, 245
intuition and, 75–79
inverse proportions, 80–81, 80, 81, 92
ratios and relationships, 75–77, 76, 77
spiritual awareness and, 93–114
and tools, to determine, 78, 78–80, 79,
proximity, 285, 286
psyche, visual stimulation and, 4
psychology, and figure-(back)ground
relationships, 58, 281, 293
purposeful awareness, 2–3
Pygmalion, 43, 240
pyramids, 96–97, 97
Pythagoras, 101–102, 102, 103, 111, 224
Pythagorean star, 61, 62, 102

rate of convergence, 45, 51–55, 87–89,
125–127, 125, 127, 192, 251, 255, 257
ratios/relationships, 75–77, 76, 85

rectilinear shapes
 1-point, 50, 242–246, 245, 249,
 253–254, 256, 262–264, 272,
 2-point, 243, 243, 246–247, 249, 252,
 254, 255, 251–255, 259–260, 262,
 263, 262–265, 268–269, 272
 3-point, 65, 243, 243, 261–265, 262,
 267–273, 268, 273
 circles and,163, 164, 163–164
 foreshortened planes and, 83, 86–89,
 76, 87, 88, 89, 118, 119,
 proportions and, 83, 83
 vanishing points and, 244–245, 249–
 255, 252, 253, 254, 255, 257
 Red Square (Malevitch), 296
Rembrandt, *Peter at Deathbed of Tabitha,*
 44
Renaissance period, 34, 46, 61, 105–107,
 113, 152, 169, 187, 221–222, 235–236,
 261–262, 279, 294
Roman culture, Golden Mean and, 103,
 103
Rule of Odds, 299
Rule of Thirds, 298

Saint Augustine, 231
St. Mark's Cathedral, 104
Scheeler, Charles, *Delmonico Building,*
 271
schema, 174, 175, 176, 177, 178, 179,
 180, 174–180, 183–187, 190, 191,
 192, 193, 194, 195, 196
 cross-contour technique and,174, 175,
 176, 177, 174–177, 193, 196
 multiple, 190, 190–193
sci-fi transporter, intuitive gesture
 drawing and, 40
scientific perspective, 221–278
sensitivity, drawing
 and drawing tools, touch of, 1–2, 39,
 kinesthetic sensitivity, 5–6
 line variation, 26–27, 28
 physical sensations and, 6
sensitivity, to touch of drawing, 1–2, 39
Seurat, George,
 Seated Boy with Straw Hat 113,
 Circus Sideshow, 212, 276
sheepskin, 13
size constancy, and objects, drawing, 91,
 90–91
smudging, avoiding, 23, 23
Solomon's temple, 100–102, 101, 102
soma, visual stimulation and, 4
spatial ambiguity, 58, 59, 58–59, 146, 152,
 166, 169, 172
spatial illusions, 73, 123, 126–127, 129,
 145, 150, 152, 154–155, 164,–166,
 169–172, 183, 185–186, 193, 197, 208,
 211, 211–212, 212, 213, 215, 218,
 223, 225, 227, 230, 235–236, 236,
 237, 239, 257, 259, 266, 273, 287,
 287, 291
spatial magnetism, 285
spheres, 82, 116, 116–117, 139–140, 140,

159–163, 160, 161, 162, 163, 169,
 173, 174, 180, 207, 207, 211, 213
spiritual awareness, geometry and,
 American revolution, 108–109, 109
 chaos theory, 114 squinting
 Early Christian culture, 104
 Egyptian culture and, 95–98, 96, 97
 Freemasonry, Order of, 108–109, 109
 Greek culture and, 101–103, 102, 103
 Jewish culture, 100, 101
 Neolothic culture, 98–99, 98, 99
 proportions and, 92
 Renaissance period and, 105–107,
 106, 107
 Roman culture, 103, 103
 squaring the circle, 94, 97–100, 97, 98,
 100
squinting, chiaroscuro technique and,
 198–200, 199, 204, 208, 209, 210,
 211, 214, 218
Star of David, 61, 62
Stonehenge, 98, 98–99, 99
Suger, Abbot, 231
sunflowers, Golden Mean and, 111, 112
supply list, materials, 14
symmetrical balance 282

tangency, 286
Ten Books on Architecture (Vitruvius),
 103
tenebrism technique, 229, 230
three-dimensional space,
 chiaroscuro, 197–220
 cross-contour technique, 115–138
 horizon and, 45, 222, 239, 249, 251,
 252, 252–257, 253, 257, 262, 263,
 263, 264, 265, 268, 269, 271–273
thumbnail sketches, 300
Timaeus (Plato), 103
tonal relationships, chiaroscuro technique
 and, 131, 197–208, 199, 203, 210,
 211–214, 216
Tooker, George, *Ward,* 272
tools
 charcoal drawing tools, 7–10, 8,
 27–28, 214
 clock-angle tool, 46–56, 46, 47, 48, 50,
 51, 52, 53, 54, 55, 253, 254, 263,
 264, 265, 266, 263–265
 drawing tools, types of, 7–10
 Mondrian tool, 63, 64, 66, 67, 68,
 63–67, 119, 128, 249

Toulouse-Lautrec, Henri, 27
trees, drawing, 192, 192–195, 193, 194,
 195
Tutankhamen, 191
Two-point linear perspective system, 243,
 246–247, 249, 252, 254, 255, 251–
 255, 259–260, 262, 263, 262–265,
 268–269, 272
Thee-point linear perspective system,
 65, 243, 261–265, 262, 267–273,
 268, 273

Universal Law of Receding Edges,
 Brunelleschi's, 263
universal symbols, 61–62

value scale, 198, 201, 202, 204, 209,
 210, 219
van Eyck, Jan, *Arnolfini Wedding*, 232
vanishing points, 45, 244, 249–257,
 252, 253, 255, 256, 257, 263, 264,
 267, 269
 2-point linear perspective system, 243,
 246–247, 249, 252, 254, 255,
 251–255, 259–260, 262, 263,
 262–265, 268–269
 3-point linear perspective system, 65,
 243, 261–265, 262, 267–271, 268
 fixation point and, 234, 239, 239–247,
 241, 242, 245, 246, 249, 249–253,
 252, 255–257, 259–260, 262, 263,
 264, 267, 268–269
Vasari, Giorgio, (Lives), 106
veil, Alberti's, 70, 241
vellum, 13
Vesica Pisces, 61, 62
viewing frame, 301
viewing position, 30, 55, 69, 70, 71, 121,
 152, 22, 241
visual field, 232
 eye structure, 39–40
 fovea, 39–40
 linear perspective systems and, 232
 scanning, 39, 39–40
visual world, perceptions and, 222
visualization, power of, 4–5
Vitruvius, 103, 106
volume, perception of, 116, 116–117, 117
 120, 121, 124, 125, 128, 129, 132, 135,
 138, 140, 145, 174–196

West, Benjamin, *Death of General Wolfe,*
 108
White, Minor, 201
Wilde, Oscar, 6, 43

x-y axes, 61–64, 62, 63, 64, 67, 68, 69

Zone System, The (White), 201